Museums, the Media and Refugees: Stories of Crisis, Control and Compassion

KATHERINE GOODNOW WITH
JACK LOHMAN AND PHILIP MARFLEET

First published in 2008
Copyright © Museum of London and Berghahn Books
The moral rights of the authors have been asserted.
Designed by Ole Kristian Øye

ISBN 978-1-84545-542-2

This publication is published with the support of the
Norwegian Research Council, Bergen National Academy
of the Arts and the University of Bergen.

Cover image: An artist's impression of a Vietnamese
refugee. From the exhibition *Twist of Fate* at the
Migration Museum in Adelaide, South Australia.

Table of Contents

Introduction

MUSEUMS HAVE BEGUN to acknowledge the difficult, varied and sometimes incomplete journeys asylum seekers and refugees take. Some museums, albeit in a limited way, have become involved with contemporary debates on migration and the treatment of refugees and have moved beyond static images of refugees to include the stories of place and the voices of younger generations.

These moves do not take place in a vacuum. They are often responses to broader debates within our media on asylum seekers and refugees. *Museums, the Media and Refugees: Stories of Crisis, Control and Compassion* includes therefore two introductory essays and two complementary sections. The introductory essays, by Jack Lohman and Philip Marfleet, draw together a range of experience from community to national museums. In the first essay, a special focus is given to *Belonging* – a major exhibition developed at the Museum of London in collaboration with the Evelyn Oldfield Unit. The second essay, by Philip Marfleet, provides a backdrop for this work – a description of the changing political situation for asylum seekers in Europe and the United Kingdom and a brief consideration of the prevailing narratives in other media.

The first major section of this book, *Traditional Methods and New Moves: Migrant and Refugee Exhibitions in Australia and New Zealand*, delves deeper into the issues of gaps and silences in refugee representation. It offers as well an overview of standard narratives and emerging strategies. While this study is limited to two countries, the design strategies and responses to media images are relevant beyond their borders.

The exhibition case studies are followed by an analysis of the common refugee stories and images present in other media that form the backdrop for museum exhibitions and their interpretation. In this second section, *Contexts: Refugee Narratives in Other Media,* the focus is on the stories of Afghan and Iraqi asylum seekers and refugees sent by the Australian government to offshore detention camps on Nauru and Papua New Guinea. Their journeys and arrival were described by media and in political rhetoric as part of a crisis – "Our shores will be flooded by boat people" – calling for control – "We will decide who comes and who doesn't and under what circumstances". Dissent led to alternative stories appearing in a variety of media including museums – stories and frames of compassion. The stories of these refugees, and the varied interpretations of them, offer a good base for considering the contested representation of asylum seekers and refugees.

These stories, while related to particular parts of the world, are present and prevalent in political rhetoric and the media elsewhere. They are essential for us all to understand in our further work with asylum seekers and refugees and moves towards a more compassionate society.

Jack Lohman
DIRECTOR, MUSEUM OF LONDON

How Do We Sing Our Song in a Strange Land? Belonging: Voices of London's Refugees in the Museum of London

Jack Lohman

THE FORCES WHICH shape our increasingly globalising world are bringing about both incredible benefits and massive upheavals. International migration is one such upheaval. Globalization is not only about increased and rapid flows of services, goods, technology, ideas and finances in a world without borders. It is also about the mass movements of people in a world in which borders are very real. Those very borders, which are removed to allow the free flow of finance and trade are hastily re-erected when human beings in search of sanctuary arrive at the gates.

Sadako Ogata, the former United Nations' High Commissioner for Refugees in a recent lecture entitled "The ethical challenge of refugee protection", points out that migrant workers are increasingly required in developed nations. Their arrival has led to a significant surge in humanitarian concerns and a disconcerting rise in xenophobia which has made her work more difficult in determining who is a refugee from starvation and violence and who is a poor person responding to better opportunities elsewhere. "Since the end of the Cold War, the world has seen increasing xenophobia, or fear of foreigners, fed by what scholars have called 'an identity crisis' among people that is related to economic globalization. In Europe, especially, many citizens now believe all refugees are really migrants and push for their exclusion. Many refugees have become easy prey for a growing criminal smuggling network", she said.

High Commissioner Ogata has gone on to urge U.N. member states, non-governmental organizations, and economically-secure individuals to commit themselves to "helping and enabling others to make choices". She has urged students not to limit their concerns to their own future security but to realise that everyone's security depends partly on providing more secure living arrangements for what she calls "the bottom strata of globalised society". Private-sector employees, she says, also need to take responsibility for providing adequate working conditions for migrants. Helping people migrate in more humane conditions will benefit refugees.

There is estimated to be somewhere in the region of 200 million people around the world who live (for at least a year) outside the countries of their birth. These migrant people are made up of over 100 million women. Many of these migrants move about the world freely and by choice. They are in pursuit of reaping the benefits which their skills and knowledge can bring them. This is very much the situation as it plays itself out among the nations of the North. These are the global citizens of the global village, inducted into the global tribe. They have their accepted place within the community because they are seen to be of value to its growth and well-being. Their contribution to the global community is acknowledged and rewarded and many of them enjoy all the benefits of 'naturalization' and their global citizenship status. If there was a global national anthem, they could raise their voices and sing gustily along with

the rest of the global society.

Then there are those, estimated to be over 20 million in number, who are not accorded these same courtesies, rights, privileges or benefits. They bring with their meagre belongings the traumatic baggage of war, genocide, poverty, political and social upheaval. Bowed under this load, they wander the world seeking entry, a gate in the solid walls of prejudice, suspicion and apathy, which are raised at the first signs of their approach. These are the homeless, the aliens, the refugees, mostly from the South, for whom there is no domicile, alienated from the rest of us by the scars of their traumas, refused the refuge they seek amongst the human tribe which does not count their millions as part of our number. Theirs is not a song of belonging. It is a chorus of lament, most aptly expressed in the popular song of the Seventies:

> "By the waters of Babylon
> Where we lay down
> There we wept
> As we remembered Zion"

Globalisation has greatly exacerbated the disparities between North and South, in particular as it relates to income and human security. The new reality of liberalised economies in which multi-nationals continue the relentless expansion of their interests and influence, is impacting on the global environment, changing the face of the world with which we were once familiar. The South has felt the negative impact most where industrialization has undermined the traditional modes of production, creating forced mass movements of rural people to urban areas. This only marks the beginning of what then becomes the global phenomenon of people migration. When work is not to be found in the cities, these people either become refugees within their own cities or move on to continue to seek survival beyond the borders of their countries of birth.

We may rightly ponder what all the fuss is about. Has not the story of human progress been one beginning with the migrations of people tens of thousands of years ago out of Africa? Are we not essentially all refugees, one way or another, virtually all coming from some other place than where we now find ourselves? Is globalisation not an old process which has marked our ever-expanding social and economic interactions over centuries?

This may all well be so. Yet what differentiates the global citizen from the global alien – the world refugee – has to do with one profound human reality – the sense of being accepted, of fitting in. It is the deep human and humanising experience of *belonging*.

The reference in the song made famous by the group "Boney M", finds its origin in one of the ancient Jewish songs of the Second Exilic period. It is a song of deep longing, not only for home but also, and more poignantly, for the place where they had experienced a profound sense of belonging. It holds a deep nostalgia, with all the heightened emotional and sensory memory that this heart-sickness brings. On the banks of the Mesopotamian River, a people forced into captivity and exile, sang a song of lament as they considered their plight and longed for the place from which they had been forced and where they had once experienced this sense of belonging.

The song, a Hebrew psalm, is filled with pathos and bears being read here:

> "By the rivers of Babylon
> We sat and wept
> When we remembered Zion.
> There on the poplars we hung our harps
> For there our captors asked us for songs,
> Our tormentors demanded songs of joy;
> They said, 'Sing us one of the songs of Zion!'
> How can we sing the songs of the Lord
> While in a foreign land?"

There is universality in both the experience and the sentiments expressed here. It is as true today as it was then that, when 'in a strange land', where people find themselves adrift in a world *of which they are* part but to which they do not *belong*, they struggle to give expression to their deeper creative selves. Even while yet in possession of their harps, 'There on the poplars we hung our harps....' they are unable to make the music demanded of them by their *captor*-audience. For to sing the songs which speak of that which shapes one's sense of identity and meaning, requires a sense of connection to people and place or else the only song is that of lament

– of pain, sorrow and loss.

The UNHCR challenge is one to which the museum community in Great Britain and elsewhere is also seeking to respond for we are as much part of the global reality as others are and, it could be argued, we have contributed much to a sense of globalization through the role we play in bringing together collections representative of the global cultural, historical, social and scientific experience into spaces such as the British Museum, the Museum of London and a host of others.

Our response takes many forms. During the summer of 2007 summer, museums throughout the UK, celebrated the contribution of refugees to Great Britain in a week-long focus. Part of the motivation was in response to the all too often negative reporting in the media and the sometimes hostile public debate around refugees. Through a focused Refugee Week, museums are attempting to bring some balanced perspective to this issue by encouraging people to appreciate the rich contribution of refugees to making Great Britain 'great'.

One can embark on a museum trail through the city of London beginning in the nearby Spitalfields area, rich in migrant history, and visit the small but important Museum of Immigration and Diversity. Successive migrations of people from firstly Europe and later from the East can be traced here. One can study the Huguenot flight from France and the French nobility's flight from the French Revolution. You can visit the Karl Marx Memorial Library where Lenin wrote while in exile, read about Russian Jews who fled the pogrom and probably soon read about those who fled the communist machinations of Marx and Lenin. The trail takes you through London in the wake of waves of immigrants from Belgium, Poland, Hungary, Africa, Asia and Latin America, indeed from almost every continent in the world.

This city, as with every city in Great Britain and the cities of our globe, would not be what it is but for the drama which has played out repeatedly in the movement, forced or otherwise, of these displaced people who have brought with them their rich histories which have enriched our own, their diverse and generously manifest cultures which have permeated our own, creating not only a richer Great Britain but indeed a 'Greater Britain'.

Such is the importance of this contribution to who we have become as a city and a nation, that we, at the Museum of London, desire to continue that which the week long focus in June 2007 began, namely, to open up ourselves and this city not only to the richness of our refugee history, but also to the ongoing contribution of these London's refugee citizens who have adopted this place and made it their own.

I deliberately speak of those 'who have adopted this place and made it their own'. To speak in these terms is to reject the conventional notion which would have us think that it works the other way around; that refugees are adopted by a place and have been granted a space within it. Such a notion requires those who consider themselves to be 'native' to learn tolerance, to absorb the other into the self. But 'tolerance' smacks mainly of *endurance*, of *having to put up with pain or hardship*.

'Absorption', is also too suggestive of being 'swallowed up', of the one being consumed by the other. Too often, this is the experience of displaced people who have been required to give up their ways, and take on the ways of their new community in order to fit in and have any chance of making a new future for themselves.

In speaking of *adoption,* as in the root meaning of that word, I mean the exercise of *choice,* of free will, even of desire. This means that we at the Museum of London, rather than adopting the cause of refugees, are opening ourselves to be adopted by the refugee community which is part of the greater London community. We have made available exhibition space for the free expression of twenty-five curators representing refugee communities here in London (the exhibition *Belonging*). This is a major departure from how we and most other museums go about the business of creating exhibitions. In taking this approach we hope that the power of refugee narrative, so much part of London's mega-narrative, will speak to us all in a direct way, not lost in the translation of proxy or vicarious curatorship, but through the undiluted telling of the stories which have shaped them and which they carry with them from the places from which they have been displaced. Their voices are at the heart of this exhibition, telling some 150 stories in personal interviews. These are the stories told in words, images and artefacts all pertinent and rich with significance for those who offer them and for the city into which these offerings have been woven and have become

integral to its rich tapestry. They include contributions from more than fifteen communities representing Africa, Asia, the Middle East, Europe and Latin America and tell of the challenges faced by refugees as they learn to build new lives against great odds involving loss and struggle, of adaptation and the hard work of earning the respect of their adopted country men and women. It is indeed about learning to sing their song in a new land, not as a lament but as a joyful triumph over extraordinary odds.

A blanket from Ethiopia that provided comfort for its owner when he was forced to sleep at Heathrow upon first arriving in the city; paintings by an Ecuadorian artist awed by the sight of a red telephone booth and the unnerving exposure to London's punk culture are among the exhibits as are the awards won by a Tamil local councillor for his contribution to combating anti-social behaviour among his constituency. You will be enthralled by images of people at work – a hairdresser, a bus driver, a restaurateur, a scientist and many others, people who have suffered loss but who are now contributing significantly to the London experience which the world has come to know and love.

The exhibition also includes work created through collaborations between local museums and community organizations as part of the London Museums Hub Refugee Heritage Programme, complemented by some of the Museum of London's earliest audio recorded interviews with Jewish refugees from Eastern Europe who arrived in London in the late nineteenth century.

In a 2004 study entitled 'Life History and personal narrative' commissioned by the UNHCR, Oxford researcher Julia Powles of St. Catherine's College wrote:

"Life history and personal narrative are valuable tools for research and evaluation. Whilst not commonly used in refugee contexts, they do offer a number of advantages;

• They allow for the communication of refugees' voices in a powerful and relatively direct way
• They enable us to capture the particularity, the complexity and the richness of an individual refugee's experiences
• They help to restore, both to the teller and to the audience, a sense of the refugee's own agency, however limited by events and external interventions
• They highlight refugees' most serious concerns and can challenge us to think creatively about ways to address them
• They are a means to discover unexpected gaps in our knowledge of particular situations
• They tend to create a strong bond between the researcher and the subject, which can be empowering for vulnerable refugees
• They can help us to understand the impact of trauma, and in some cases the process of recording may be cathartic."

If this exhibition achieved any of these, then this will be in part measure of its success. The true success story, however, must be seen and heard as the triumph of the human spirit in those who have taught and continue to teach us the great truth as expressed in the African philosophy of Ubunthu: "People are people because of other people" and in the Sanskrit teaching: "I am known, therefore I am". It is an invitation and an opportunity for us all to acknowledge that, from wherever we have escaped and for whatever reason we are here, we have a deeper bond, which is our common humanity – our mutual and inescapable belonging.

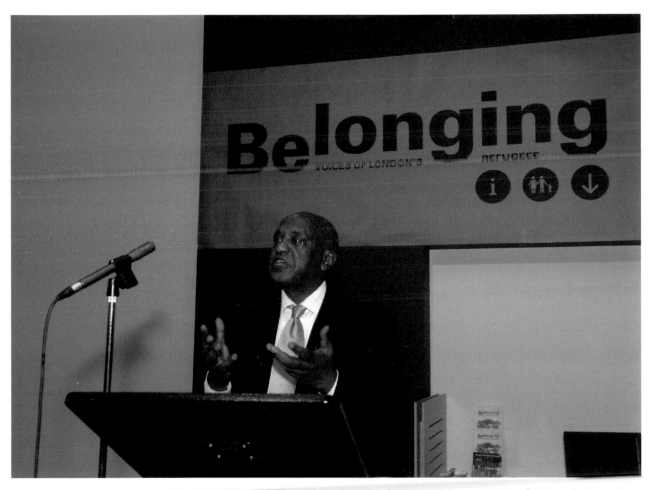

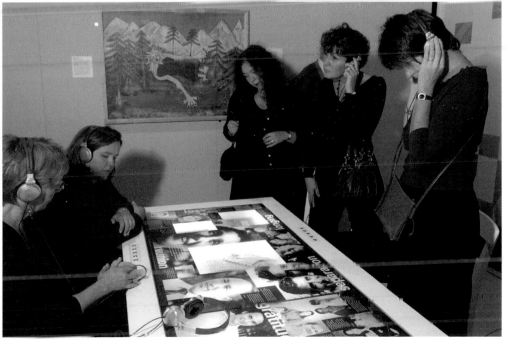

Top: Tzegggai Yohannes Deres, Director of the Evelyn Oldfield Unit, officially opening *Belonging: Voices of London's Refugees* at Museum of London on 26 October, 2006.

Inside the 'Families' section of *Belonging: Voices of London's Refugees* at Museum of London; images and objects on the table linked to buttons which visitors could press to listen to extracts from oral history interviews.

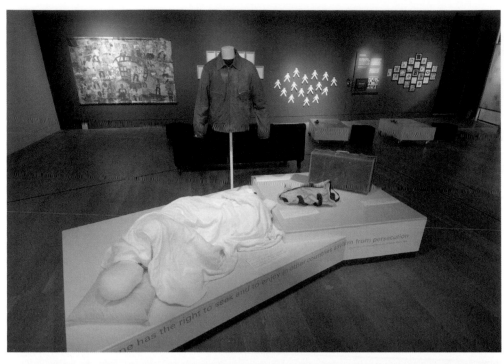

A display in *Belonging: Voices of London's Refugees* at Museum of London; all of the objects were donated or loaned by people interviewed as part of the Refugee Communities History Project. Behind the island display is an activity area and performance space.

Below: Shabibi Shah gave an oral history interview for the Refugee Communities History Project, in the exhibition *Belonging: Voices of London's Refugees* at Museum of London and was one of the community advocates helping to create the exhibition.

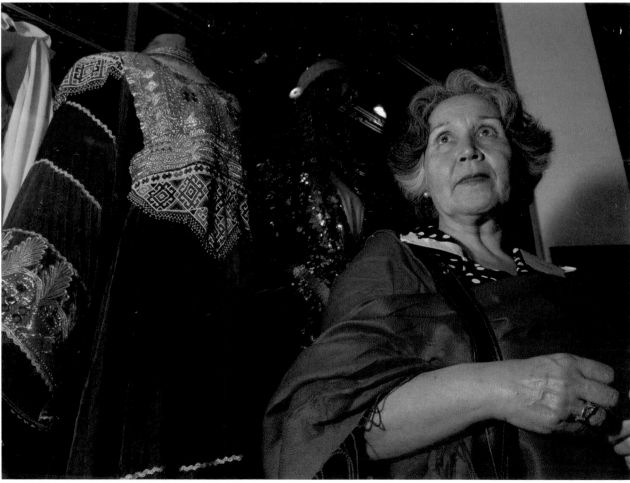

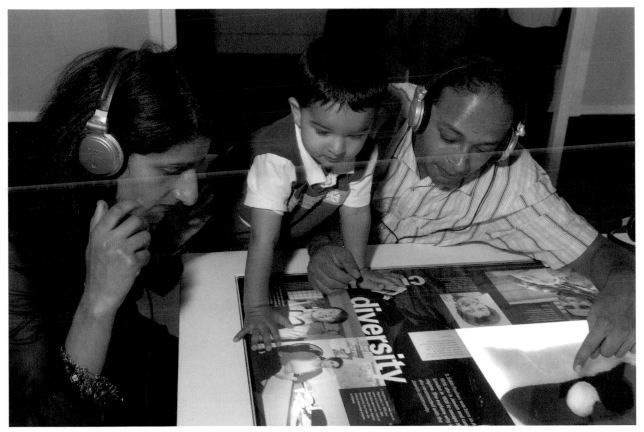

Inside the 'Communities' section of *Belonging: Voices of London's Refugees* at Museum of London, where people talked about ideas of 'community' and the importance of communities in providing support and services and maintaining and sharing cultural traditions.

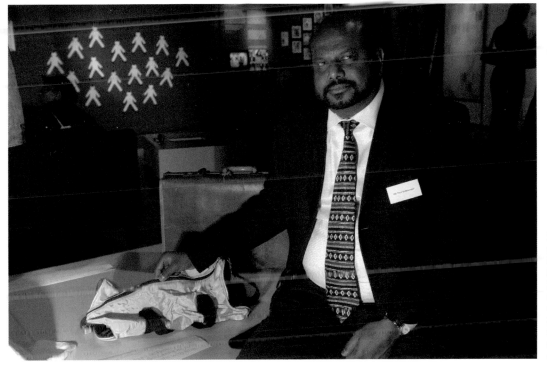

Paul Sathienesan, who gave an oral history interview for the Refugee Communities History Project; everything he brought with him to Britain was in this gym bag, which he has now donated to Museum of London's collections.

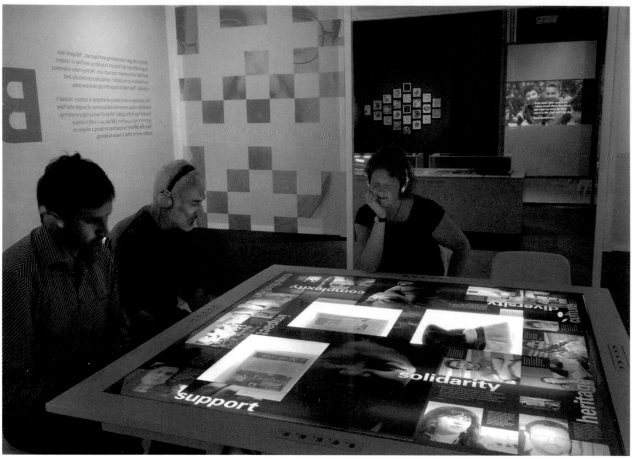

Inside the 'Communities' section of *Belonging: Voices of London's Refugees* at Museum of London. The area features an interactive table allowing visitors to access refugee stories in a variety of languages including Polish and Persian.

The conclusion to *Belonging: Voices of London's Refugees* at Museum of London takes the form of a giant timeline that explores global political events and their impact on migration to London.

Forgotten by History: Refugees, Historians and Museums in Britain

Philip Marfleet

IN 1993 THE MUSEUM of London organised a pioneering exhibition, *The Peopling of London*. This tackled controversial themes: the cultural diversity of the city; the histories and experiences of its people; and the implications for ideas about immigration and national identity. It also set out to attract new audiences, in particular members of London's "ethnic minority" communities. Nearly 100 000 people attended an event widely seen to have been successful and considered by evaluators to have achieved its main aims.[1] But some Londoners were absent from the displays and seldom appeared among the visitors: the city's refugees made only a passing appearance.

The absence of refugees from public spaces is part of a longstanding problem of their low visibility in society in general. Although they have recently been the focus of close attention on the part of politicians and mass media, especially in Europe, North America and Australia, refugees occupy marginal social statuses and have a low profile in national cultures and histories. This can be seen as a paradox: it is consistent, however, with the contradictory character of refugees as a social phenomenon, as people who are Outsiders but whose presence may be of real significance in states they have fled and in those they enter. It is reflected in the historical record: while a few refugees have become high profile, even iconic figures, most are entirely absent from history.

The British historian Tony Kushner observes that refugees are "the forgotten of history".[2] This is not accidental, he suggests; rather, it reflects a malaise in society as a whole: "general inability and unwillingness to confront the awkward questions posed by the existence of refugees and our relationship to them".[3] Writing on developments in Australia, Neumann makes a similar point: historians have failed to identify refugees as participants in the country's long history of immigration. Despite heightened interest in refugees today there has been "almost no mention" of their significance in the past: "it is astounding that the debate about current Australian refugee policies has not spawned detailed histories of their antecedents".[4] The Indian historian Gyanendra Pandey sees the same pattern in South Asia. Although refugees have been present across the region for at least 60 years, events associated with their displacement are widely viewed by historians as "non-narratable", with the result that forced migrants are absent from what he calls "historians' history".[5]

This presents curators who wish to address refugee issues with a serious difficulty – they can seldom make use of official archival material or historical accounts and analyses. The problem goes further, however, for museums have been part of the process by which refugees have been marginalised and even excised from the historical record. Asylum crises, mass arrivals of displaced people, and their interactions with the wider society have rarely featured in any form in exhibition galleries, even when migration has been a matter of intense public interest. Kushner comments that the

largest exhibition on immigration ever organised in Britain was unable to find a significant space for refugees. With certain "predictable" exceptions, he observes, *The Peopling of London* ignored them.[6]

Refugees have been present in Britain for over 300 years. During this period there have been repeated mass immigrations, sometimes involving hundreds of thousands of people. Significant numbers of refugees have settled and have had a profound impact upon the wider society. Why have they been excluded from mainstream history and what are the implications for curators and others who wish to reassess their lives and experiences?

Réfugiés

Refugees as distinct, named groups of people have been recognised and recorded since the early modern era. Although the institutions of refuge, sanctuary and asylum have ancient histories and appear in a wide range of cultures worldwide the refugee is a relatively new phenomenon, associated with the emergence in Europe of proto- nation-states and later the rise of nation-states "proper".[7] Mainstream histories describe long processes of incremental change through which these states evolved into mature national societies. Invariably, however, the process involved social upheaval and often included mass forced migration: refugees were present at the birth of the nation-state and have since had a continuous presence within the state system.[8] They are *part* of the modern world.

The first refugees, or "refugee-like" persons, appeared in the emerging Iberian states. In the late 15th century unification and centralisation of the kingdoms of Aragon and Castille produced a new Spanish state. As part of the process of socio-political and cultural consolidation joint monarchs Ferdinand and Isabella targeted minority religious communities. In 1492 they demanded that all Jews should convert to Christianity or face banishment, with the result that some 150 000 of Spain's 200 000 Jews were expelled. Ten years later Muslims faced a similar ultimatum and a third of the population of some 1 million left Spain. Initially the migrants were accepted in Portugal but a Portuguese monarchy engaged in similar centralising projects also expelled them. Later, Jewish and Muslim converts to Christianity,

the *conversos* and *moriscos*, were ejected from Spain. All these initiatives were demonstrative acts: they were statements about political authority and the cultural integrity of new national societies. The expulsions were part of national campaigns in which specific groups were made to demonstrate the costs of non-conformity to society at large.

Jewish and Muslim victims of the Iberian monarchies can be regarded as "proto-refugees": people compelled to flee one state and to seek sanctuary in another. They were not described formally as refugees, however: it was not until the late 17th century that emigrants from France first described themselves in this way – as *réfugiés*, a term that was soon in widespread use. These refugees were Calvinists: like the Jews and Muslims of Spain they were members of a religious minority long accepted by the wider society but which was now declared alien to the nation-in-formation. As the monarchy in France attempted to unify large numbers of people with diverse traditions they focused upon Catholicism as a key marker of French national authenticity. Repression came to a head in 1685 when hundreds of thousands of Calvinists, the Huguenots, fled to neighbouring countries. Some had already obtained protection in neighbouring states, notably Switzerland, which they described as *la réfuge*, calling themselves *réfugiés*. Now large numbers moved to the Netherlands and to England, where the political authorities officially offered "an asylum" to those who wished for protection.[9] The Huguenot migration to England was a development of great significance. Here too a new nation-state was coming into being and religion played a key role in shaping ideas about national culture. Like authorities in other European states the rulers of England (shortly to become the Unified Kingdom of Britain) were increasingly concerned about both territorial and cultural borders of the state. As Colley (1992) observes, they were engaged in *forging* a nation – setting out markers of national authenticity and deciding who was to be included and who excluded from the new state.[10] They too removed people deemed unacceptable because of their religious beliefs, deporting to colonies in the Americas religious dissenters including certain groups of Quakers and political dissidents who opposed their rule in Ireland.

The Huguenots were a windfall for the British state. They were subjects of the Louis XIV, the ruler of Britain's main economic and political rival within Europe and its main competitor in the colonial arena. They not only brought capital and skills[5] but also ideological resources – they could testify to the iniquities of the Bourbon state and bear witness to the intolerance of French society at large. At a time of heightened national consciousness they provided an opportunity to unify popular sentiments vis-à-vis France and to consolidate ideas about "English" liberties which had dominated the revolution of the 1640s and continued to play a key role in the new national politics. One writer of the period observed that accommodation of the French Protestants provided an unparalleled opportunity to damage the French Crown and to benefit the British state: the offer of asylum, he concluded, was "the greatest kindness that we can do to ourselves".[11]

The episode could have proved costly to the British state. Widespread sympathy for the refugees was accompanied by hostility towards them and by protests in areas settled by the first arrivals. Winder (2004: 75) comments that, "it wasn't always easy for the man in the street to combine his officially encouraged hatred of France (the national enemy) with a fondness for refugees".[12] Senior state officials nevertheless concluded that benefits to be obtained by integration of the Huguenots outweighed the risk of disorder. Together with the Church they organised a sustained propaganda offensive in support of the refugees. Using broadsheets, leaflets and pamphlets, and all the authority of the pulpit, this presented the immigrants as victims of persecution who, as fellow Protestants, should be welcomed and afforded protection. The French historian Bernard Cottret comments on the significance of this "wide ranging ideological campaign" and its key role in subduing public fears and resentments.[13]

Forgotten Strangers

The Huguenots had an instrumental value in both France and England. In the former they were mobilised in campaigns of exclusion; in the latter they were part of a public process of assertion of national identity in which refugees made an exemplary statement about the virtues of the English – their piety, sympathy, generosity and love of freedom – a process facilitated by their outsider status. The fact that they were victims of the leading rival power gave added value.

The refugees had a very substantial impact in England and its colony Ireland, especially upon the economy and military apparatus.[14] This went largely unrecognised, however: in the new national narrative there was little room for Strangers. The process of forging national identity and a national tradition meant that all manner of people were marginalised or even excised from the historic record: women, people of the colonies (notably Black Africans and Irish people) and aliens in general. By the mid-18th century the Huguenot immigration was a distant memory and it was more than 100 years before the episode was revisited by historians.

The Huguenots had nonetheless been accepted as refugees and, as we shall see, were eventually allocated

1 See evaluators' comments, Museum of London (1996) The Peopling of London: An Evaluation of the Exhibition. London: Museum of London/ University of East London: 14. The proportion of ethnic minority visitors increased fivefold during the exhibition, to 20 per cent - see ibid: 49

2 Kushner, Tony (2006) Remembering Refugees: Then and Now. Manchester: Manchester University Press: 15

3 ibid: 18

4 Neumann, K. (2004) Refuge Australia: Australia's Humanitarian Record. Sydney: UNSW Press: 10-11

5 Pandey, Gyanendra (2001) Remembering Partition: Violence, Nationalism and History in India. Cambridge: Cambridge University Press: 45

6 Kushner (2006) op.cit.: 59

7 See Soguk, N. (1999) States and Strangers: Refugees and Displacements of Statecraft. Minneapolis: University of Minnesota Press; and "Histories and Discourses" in Marfleet et al. (forthcoming 2008) Encountering Refugees. Policy: Cambridge

8 International law views the refugee as an "alien" – a person located in a place other than the state in which they have citizenship. In a strict sense therefore all refugees are "outside" the state system.

9 In 1681 the English King, Charles II, had appeal to Louis XIV of France to cease persecution of the Calvinists. If Louis persisted and the latter sought help, he said, "I offer them an Asylum in... England." Quoted in Lee, G. L. (1936) The Huguenot Settlements in Ireland. London: Longmans Green: 10-11

10 Colley, L. (1992) Britons: Forging the Nation 1707-1837. New Haven: Yale University Press

11 The refugees included many of the leading entrepreneurs in France, many leading merchants and financiers. Among them were several families prominent in the slave trade, a host of craft workers, and soldiers and sailors from the armed forces of the French state. Many refugees were impoverished but few lacked skills. For a full account see Cottret, B. (1991) The Huguenots in England. Cambridge: Cambridge University Press; and Gwynn R. D. (1985) Huguenot Heritage: The History and Contribution of the Huguenots in Britain. London: Routledge and Kegan Paul

12 Winder, R. (2004) Bloody Foreigners: The Story of Immigration to Britain. London: Little Brown: 75

13 Cottret (1991) op.cit.: 23

14 See Gwynn (1985) op.cit. for a full assessment of the Huguenot legacy

a place within the mainstream of the national narrative. Others had a different experience. Some 20 years after arrival of the Huguenots a further large group of religious dissenters sought protection in Britain, meeting a very different reception. The Palatines, Calvinists from Germany, provoked strong hostility from British politicians. Despite considerable public support, notes Olson, they were "ridiculed, scrutinized for character, discouraged from settling, and quickly assisted by the government in moving elsewhere".[15] Unlike the Huguenots they offered no obvious material or ideological benefits to the British state: almost without exception they were poor, landless peasants without special skills; in addition, they originated in a region of little political significance. The government accordingly treated them as unwanted aliens.

As before, there was an official propaganda campaign: The Palatines were "thrust before the public in proclamations, journal articles, sermons, tavern discussions, and street corner gossip".[16]

"Unlike earlier refugee groups [the Huguenots], who had carefully been kept away from an initially fearful populace or else displayed at their best, as dressed for church on parade, the Palatines were put up in open campsites in the parks so crowds of London strollers could see awesomely large encampments of them on the mundane rounds of daily life, eating, washing, disciplining children … English spectators came to stare at them with distaste for their slovenly appearance, and fights broke out between English and Palatines".[17]

Winder adds that they "became something like a fairground attraction", attracting Londoners who would "wander out to drink beer, lay bets and gawp at the unhappy campers".[18] The Palatine spectacle amounted to public exhibition of the refugees' deficiencies and an invitation to endorse the official decision to deport. Within a year they were gone – to Ireland, to the American colonies, or back to the Rhineland.

Forgotten Lives

The Palatines left no mark on the historical record in Britain. In 1709 Daniel Defoe published a sympathetic account of their experiences – *A Brief History of the Poor Palatine Refugees*. Little more was heard of them until in the 20th century genealogists and family historians began to investigate Palatine settlements in Ireland and the United States. They had been rejected by both the British state and by history in general.

The Huguenot and the Palatine episodes illustrate a key feature of most crises of forced migration and which has been evident through the modern history of Britain. People who flee repression, civil war, inter-state conflicts and environmental and economic crises, are highly vulnerable. They have been displaced from locations in which they had been able to mobilise all manner of resources of a material, socio-cultural and psychological nature. They are not rendered helpless (refugees are often energetic and innovative) but do stand in a position of extreme disadvantage in societies in which they seek security. They may be unable to communicate in the language of the receiving community; they may lack knowledge of its traditions and expectations; and they be unable to navigate its institutional landscape, including the structures of the legal system and of civil society. They are easily characterised by political authorities, media or popular opinion in ways which may be prejudicial or worse but in relation to which they have no ready response. Dependent upon the historic conjuncture they may be mobilised for ideological purposes by those who have an interest in exploiting their Otherness. On rare occasions they are lauded and celebrated; more often they are rejected and even reviled; in most cases they are "silenced" and are unable to express effectively their needs and aspirations.[19]

During the 18th and 19th centuries written history became increasingly important to the states of Europe. As political authorities in each sought to develop national frames of reference, historians produced work that emphasised more and more emphatically the national character of the past. They celebrated the specific religious, linguistic and ethnic character of people within the territorial borders of each state: those who could not be accommodated were marginalised or ignored. Those who worked as professional historians, archivists and curators were participants in this process – a sustained effort to construct "the

uncluttered national past".[20] Trouillot observes of such histories that they are "made of silences, not all of which are deliberate or perceptible as such within the time of their production."[21] Wittingly or unwittingly historians of the modern state *silenced* those unable to assist their project: unwelcome Strangers such as the Palatines disappeared from their accounts.

Political Exiles

In the mid-19th century Britain accommodated thousands of European refugees, then known as *émigrés* or "political exiles". National sentiment had been heightened by rapid imperial expansion and repeated conflicts with rival European states: foreigners in general were the object of mistrust. The émigrés were nonetheless accepted. Most were activists from movements seeking national independence; some were radical opponents of rival states. Despite intense hostility from some quarters, successive governments guaranteed asylum. Porter (1984: 27) comments that presence of the *émigrés* provided the state with significant propaganda advantages: "toleration of foreign refugees [highlighted] the openness, freedom and stability of Britain's society by direct and stark contrast with her European neighbours."[22] Like the Huguenots these refugees had an instrumental value.

In the face of growing criticism of the foreigners a series of writers produced the first sustained work on refugees for almost 200 years. They did not focus upon the Poles, Germans, Italians and Frenchmen then living in London but upon the Huguenots, who had been summoned from history to play a new role on behalf of the British state. Books, pamphlets and even poems celebrated the Calvinists. In 1868 Samuel Smiles published *The Huguenots: Their Settlements, Churches and Industries in England and Ireland*. This detailed account of the persecution, flight and settlement of the Huguenots was the first book on refugees written for a popular audience. It presented the immigrants as welcome guests in a country which offered hospitality and security: in return the refugees, "industrious strangers", brought skills, application and thrift to the benefit of all.[23] Some of the account was so much at variance with events of the 17th century that it amounted to an outright fiction. The petitions, protests and demonstrations that

had accompanied early Huguenot arrivals disappeared entirely:

> "Wherever [the Huguenots] landed, they received a cordial welcome ... The people crowded round the venerable sufferers with indignant and pitying hearts; they received them into their dwellings, and hospitably relived their wants... The sight of so much distress, borne so patiently and uncomplainingly, deeply stirred the heart of the nation, and every effort was made to succor and help the poor for conscience' sake".[24]

The Huguenots appeared as martyrs – "stout-souled onward Christian soldiers", suggests Winder (2004: 66) – whose qualities were matched only by those of the nation which offered them refuge. Concluding the book, Smiles reflected on the importance of the Huguenots in affirming British values, in particular an unbroken record of accommodating those in distress:

> "Assuredly England has no reason to regret the asylum which she has in all times so freely granted to fugitives flying from abroad ; least of all has she reason to regret the settlement within her borders of so large a number of industrious, intelligent and high-minded Frenchmen".[25]

Aliens

Smiles's work was less concerned with the Huguenots than with embellishing the image of government at home and abroad. Cottret dismisses the book as an attempt

15 Olson, A., (2001) "Huguenots and Palatines", *The Historian*, Vol 63. 2001: xx

16 ibid

17 ibid

18 Winder (2004) op.cit.: 79

19 For a fuller analysis see Chapter 1, *Mass Displacement*, in Marfleet et al. (2008) op.cit.

20 Amin, quoted in Pandey (2001) op.cit.: 4

21 Trouillot, M-R. (1995) *Silencing the Past: Power and the Production of History*. Boston: Beacon Press. 152

22 Porter, B (1984) "The British Government and Political Refugees, 1880-1914". In Slatter, J. (Ed.) *From the Other Shore*. London: Frank Cass: 27

23 Smiles, S. (2002) [reprint of 1874 edition] *The Huguenots: Their Settlements, Churches and Industries in England and Ireland*. Honolulu, Hawaii: University Press of the Pacific: 103

24 ibid: 182-183

25 ibid: 351

to incorporate the refugees into "the positive image of Britannia".[26] The impact was considerable however. *The Huguenots* ran to several editions and was widely read as a testimony to the virtues of Britain and the British people. Refugees, or particular refugees, now appeared as part of the national narrative. In a period in which large numbers of people were on the move, many displaced by complex economic/social/political crises, refugee authenticity was to be measured against Smiles' model. The refugee was to be a person victimised abroad who brought industry, energy and prosperity to their new home. The refugee *was* the "industrious Stranger".

No sooner had these ideas become general, however, than government policy began to change. In place of European nationalists seeking protection came unprecedented numbers of poor, ill-educated and desperate Jewish victims of rising anti-Semitism in Russia and Eastern Europe. They offered little obvious advantage to the British state: there were no paeans of praise and no attempt to mobilise the incomers for ideological purposes. Within a generation the tide turned sharply against refugees. By the turn of the century, immigration law (in the form of the Aliens Act of 1905) focused upon entry of inauthentic applicants for asylum: those who, rather than bringing prosperity, might be "a charge on the state".

The Huguenots have entered British history and popular memory as the "real" refugees. In the 1960s a history of the British immigration service could still observe (using words that might have been Smiles' own) that of all refugees, "one of the most beneficial and welcomed by the native population was the Huguenots, with their intelligence, steadfastness, culture and love of liberty".[27] These particular refugees are constantly invoked by British politicians, state officials and the media as the measure of authenticity for other migrants in search of security – and often as a means of dismissing the latter as inadequate, fraudulent, or worse. Kushner comments that the Huguenots are members of an "elite club" of people perceived as "genuine" refugees.[28] They are part of a migration discourse in which most applicants for asylum are viewed as illegitimate and are rejected.

The 20th century produced refugees in unprecedented numbers. The First World War and subsequent conflicts displaced tens of millions of people: the rise of fascism and the Second World War displaced at least 40 million people across Europe.[29] Conflicts between the colonial powers and movements for national independence subsequently produced a series of movements in and from Africa, Asia and Latin America, followed by continuous mass displacements associated with economic and political change worldwide. All have had a direct impact in Britain but, with the partial exception of those involving Jewish refugees from fascism, all have been marginalised by professional historians.

The scale of denial is extraordinary. During the First World War some 250 000 Belgians arrived in Britain as refugees from German military offensives. This movement, the largest refugee arrival in British history, has effectively disappeared from the record: after almost 100 years there is just one study of the Belgian episode.[30] Following the Second World War Britain imported some 80 000 refugees from Eastern Europe – Displaced Persons, later known as European Voluntary Workers, who played a key role in post-war reconstruction. They have similarly been ignored by mainstream historians. The sole attempt to examine these and subsequent refugee arrivals within a historical perspective is that of Kushner and Knox.[31] Their ground-breaking work notes that if the presence of refugees "'is one of the hallmarks of our time', then modern and contemporary historians have hardly noticed it".[32]

Refugees and Museums

For many years the only references to refugees in exhibitions and museums in Britain were to Huguenot designers and craft workers. The sophistication of Huguenot work, especially in silverware, instrument-making and silk-weaving, meant that in the mid-19th century artefacts with Huguenot associations appeared regularly at special events such as the Antiquaries and Works of Art Exhibition held at Ironmongers Hall in London in 1861.[33] They became highly desirable as collectors' pieces and some were eventually displayed in national institutions such as the British Museum and the Victoria and Albert Museum. Consistent with the preoccupations of curators it was the *product* of Huguenot labour that was of interest: as Hartop comments, "the true legacy of the

Huguenots was in providing a skilled and willing body of workers".[34]

Even the Huguenots, however, could not attract sufficient interest to generate a dedicated exhibition. This did not take place until the tercentenary of their exile: in 1985 the Huguenot Society Of London and the Museum of London organised *The Quiet Conquest, the Huguenots 1685-1985*. Art, design and fine craftwork were again central concerns, in particular silverwork, textiles, clocks and instruments.[35] The Huguenot experience was not a key issue: the circumstances and lives of refugees were still not matters of interest. In the same year Robin Gwynn, one of the few historians to undertake consistent research on the Huguenots, observed that they had been "shamefully neglected by British historians".[36] Other immigrants had fared even worse, he suggested: "in general such groups are ignored, or summarily dismissed, or confined to the pages of specialist journals".[37]

There was one other – and partial – exception to this rule in respect of both historical work and museums. Jewish immigrants to Britain had had a mixed reception. In particular, refugees who began to arrive in large numbers in the late 19th century had been greeted with increasing suspicion and sometimes strong hostility. The long historic presence of Jews, however, and the complex relations within and between Jewish communities and the wider society had facilitated a strong tradition of Jewish self-expression. Synagogues and related institutions maintained elaborate records and educated a cadre of religious leaders and community representatives. The first Anglo-Jewish periodical, *The Jewish Chronicle*, was founded in 1841; a theological seminary was created in 1851 and a Jewish Historical Society in 1893. In succeeding decades, as the pace of immigration increased, a host of Jewish schools and cultural organisations came into being and a mass of publications produced in English and Yiddish.

In 1932 a Jewish Museum was established. The exhibits were mainly artifacts of ceremonial significance – scripts and objects associated with ritual tradition, and decorative materials from the synagogue and the Jewish home which represented the fine craft skills of many communities. Although at this point most Jews in Britain were refugees or had refugee antecedents the museum was not concerned with migration and the immigrant experience. Consistent with attitudes in the wider society this was still marginalised or indeed silenced. In 1941, following the arrival in Britain of some 70 000 Jewish victims of Nazism, an Association of Jewish Refugees was established. The Museum of London *Jewish Life* (later to amalgamate with the Jewish Museum) undertook to bring to light the refugees' experiences and the long history of the Jewish presence in the city. This was pioneering work which relied upon the resources of the community itself, from which researchers brought forth informal records, photographs and testimonies. So too in Manchester, where the Manchester Jewish Museum, opened in a restored synagogue in 1984, assembled a photographic collection and began a series of oral history projects, including testimonies of Holocaust survivors and other local residents. Kushner (2006: 156) comments that the Manchester museum was the first body "to respect the heritage and history of ordinary refugees in Britain".

The Jewish museums were community initiatives. Institutions with formal public status, national or local, did not approach refugee issues until *The Peopling of London* in 1993. This examined a host of historical questions, challenging the idea of national ethnic homogeneity by demonstrating the impact of

26 Cottret (1991) op.cit.: 194

27 Quoted in Cohen, R. (1994) *Frontiers of Identity: The British and Others.* London: Longman: 194

28 Kushner (2006) op.cit.: 19

29 Estimate of the US State Department, cited in Loescher, G., & Scanlan, J. (1986) *Calculated Kindness: Refugees and America's Half-Open Door, 1945 to the Present.* New York: Free Press: 1

30 See Cahalan, P. (1982) *Belgian Refugee Relief in England During the Great War.* New York: Garland

31 There has been valuable work by researchers in Migration Studies and by feminist historians: see Kay, D. & Miles, R. (1992) *Refugees or Migrant Workers? European Voluntary Workers in Britain 1946-1951.* London: Routledge; See also a preliminary version, Kay, D. & Miles, R. (1988) "Refugees or Migrant Workers? The Case of the European Volunteer Workers in Britain", *Journal of Refugee Studies* 1988, Vol 1, Nos 3-4; and Webster, W. (2000) "Defining Boundaries: European Volunteer Worker Women in Britain and Narratives of Community", *Women's History Review* Vol 9. No 2. 2000.

32 Kushner, T. and Knox, K. (1999) *Refugees in an Age of Genocide.* London: Frank Cass: 4

33 Hartop, C. (1998) "Art and Industry in 18th Century London". In *Proceedings of the Huguenot Society of Great Britain and Ireland,* Vol 27, No 1

34 ibid

35 Murdoch, T.V. (1985) *The Quiet Conquest, the Huguenots 1685-1985.* London: Museum of London

36 Gwynn (1985) op.cit.: viii

37 ibid

migrations from 15 000 BC/BCE to the late 20th century. But refugees remained at the margins. Only the Huguenot and Jewish experiences were treated as significant. Others – Palatines; émigrés; Belgians; Displaced Persons; migrants of the Cold War era; refugees from conflicts of the 1970s in Chile, Vietnam and South Africa; and the mass of refugees from the Global South who had entered Britain over the previous 20 years were absent.[39] The impact of 300 years of historical denial, combined with an increasingly hostile official attitude towards those seeking asylum, appeared to have removed most refugees from the Museum's agenda.

'An Effort of Imagination'

In the 18th and 19th centuries large communities of Black Africans lived in London. Their lives were so ill-documented, comments Winder, that they "barely left a mark" on mainstream history. He concludes that "it requires an effort of imagination to picture them at all".[40] A similar effort is required to focus upon the lives of refugees. Young has concluded that life experiences which elude the methods of mainstream history can be approached productively by drawing upon informal materials.[41] In the case of the Holocaust, he argues, we know history through the means by which it is passed to us: through literary, fictional and artistic representation, and above all through personal testimony. Life-changing events such as displacement, flight and exile can be approached on a similar basis, giving due weight to those involved as people who, though highly vulnerable, do not lose their capacities to reflect and to draw meaningful conclusions about their experiences.

Over the past 10 years researchers and curators have begun to use all manner of innovative techniques, mobilising unofficial records, "grey" literature, letters, memoirs, community archives, family collections, personal photographs, creative writing, and above all the techniques of oral history, to reveal hidden histories of refugee life. Approaches pioneered by the Jewish Museum and later by the Imperial War Museum in collecting testimonies for its Holocaust exhibition of June 2000,[42] have been of great importance. Local curators have moved beyond the constraining influences of tra-

ditional historical method towards particular forms of history "from below" in which testimony plays a key role. In 2005 the Museums, Libraries and Archives Council (MLA) recognised some of these changes, producing a "toolkit" on refugees and libraries which encouraged curators, librarians and others to be aware of the circumstances and needs of refugees.[43] It encouraged staff to make their facilities attractive and relevant to refugees; to liaise with refugee community organisations and, where appropriate, to organise activity in which the use of texts, objects, photographs, music and storytelling facilitate self-expression.

Such an approach brings conceptual and methodological challenges. Curators and refugee participants have yet to discuss the complex relationship between representation of cultures from refugees' countries of origin (particular traditions in dress, cuisine, music and crafts, religious and ritual practice) and the modification of lifestyles and expectations that takes place in exile: here the issue of "cultural maintenance" is an important matter for debate. Meanwhile memory work – attempts to draw upon written and oral testimony – raises complex questions about how the past is "produced" in personal narrative.[44] A very wide range of approaches is now in use, largely without co-ordination and so far without efforts to reflect upon the comparative experience.

Local museums have nevertheless made great advances in the representation of refugee lives. Bolton Museum has investigated experiences of Sudanese refugees, using photographs and testimonies;[17] Rotherham Museum has worked with Kashmiri families in South Yorkshire, using the resources of the Internet;[46] in London the National Maritime Museum has worked with Vietnamese women, using an innovative combination of personal testimony and theatre.[47] Many museums participate in the Refugee Council's Refugee Week, an annual event in which the wider community is invited to celebrate refugee experiences.[48]

Conclusion

There is still far to go. In 2001 a first museum devoted to migrant issues was established in East London – in premises that were largely empty. The Museum of

Immigration and Diversity occupies a fine early 18th-century building in Spitalfields, the main area of Huguenot settlement. It was built by a Huguenot merchant family and later used by Irish and Jewish immigrants, making an eloquent statement about three centuries of migration and cultural flux in the East End.[49] The Museum opened without permanent displays, in part because of the fragility of the building but also, say senior staff, because of the wish to "let the building speak for itself".[50] This remarkable structure – part residence, part workshop, part a place of worship – does indeed testify to the presence of refugees but not necessarily in ways curators intended. The absence of materials found in most museums – artifacts, information displays, visual aids – expresses particularly well the absence of formal records of most refugee lives.[51]

Refugees are not merely groups of people dislocated within the system of nations – aberrants who have failed to find their place in the world of nations. Soguk comments that, "the figure of the refugee is much more than just a marginal body";[52] rather she is a key element within processes by which nations and national identities are constructed and elaborated. Refugee lives have much to tell us about key historical developments; in doing so they may challenge mainstream interpretations of the latter. Refugee experiences may indeed be subversive – one reason why historians have treated them with such disregard. British historians are particularly reluctant to address these problems; others, notably in South Asia, are less reticent. After over 50 years of silence the mass refugee movements associated with Partition of India are coming into view. A group of Indian historians has defied convention by using a host of sources including memoirs, letters and oral testimonies to bring refugee experiences to life. As the feminist historian Urvashi Butalia has observed, memories are a profoundly significant part of the history of Partition: "in many ways they *are* the history of the event".[53]

British historians may be able to learn much from scholars abroad – and perhaps from colleagues in museums and archives nearer home.

38 Kushner (2006) op.cit.: 156

39 Merriman, N. (Ed.) *The Peopling of London*. London: Museum of London

40 Winder (2004) op.cit.: 99

41 Young. J. E. (1990) *Writing and Rewriting the Holocaust: Narrative and the Consequences of Interpretation*. Bloomington: Indiana University Press

42 See Smith, L. (2005) *Forgotten Voices of the Holocaust*. London: Ebury Press. The Imperial War Museum conducted hundreds of interviews with Holocaust survivors, of which a small number played a key role in the exhibition: http://london.iwm.org.uk/server/show/nav.00b005

43 See http://www.mla.gov.uk/resources/assets//W/Working2_10338.pdf

44 Memory Studies and Narrative Studies have recently made major advances in tacking issues associated with written and oral testimonies. See for example Radstone 2000.

45 See: http://www.boltonmuseums.org.uk/news/sudanese-refugees

46 See: http://www.ferhamfamilies.com/intro.html

47 See: http://www.nmm.ac.uk/server/show/conWebDoc.6836/viewPage/9

48 See, for example, the work of Wolverhampton Museum: http://www.wolverhamptonart.org.uk/wolves/events/003083.html?category=737&name=Family?sid=9b560cd27db0d97cf1fbec3de43595ef. For details of Refugee Week, see: http://www.refugeeweek.org.uk/InfoCentre/Newsletters/Refugee+Week+Update+-+March+2007.htm

49 Museum of Immigration and Diversity: http://www.19princeletstreet.org.uk/

50 Personal discussion with Susie Symes, Director and Chair of the Trustees, June 2005

51 An exhibition on migration and settlement, *Suitcases and Sanctuary*, has been created by local schoolchildren and occupies part of the house.

52 Soguk, N. (1999) *States and Strangers: Refugees and Displacements of Statecraft*. Minneapolis: University of Minnesota Press: 244

53 Butalia, U. (1998) *The Other Side of Silence: Voices from the Partition of India*. New Delhi: Penguin

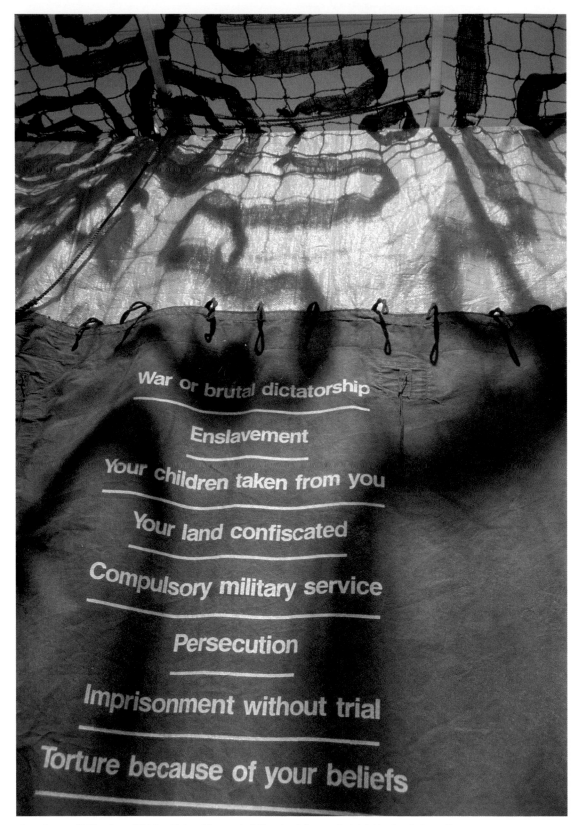

Introductory Wall at the exhibition *Twist of Fate* at the Migration Museum in Adelaide, South Australia.

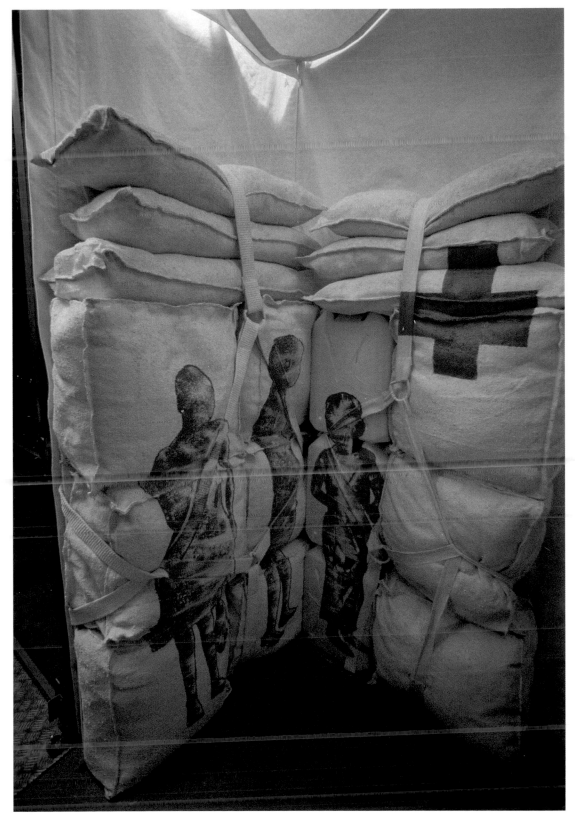

Twist of Fate: Chilean refugees wait outside a Red Cross Centre on the border.

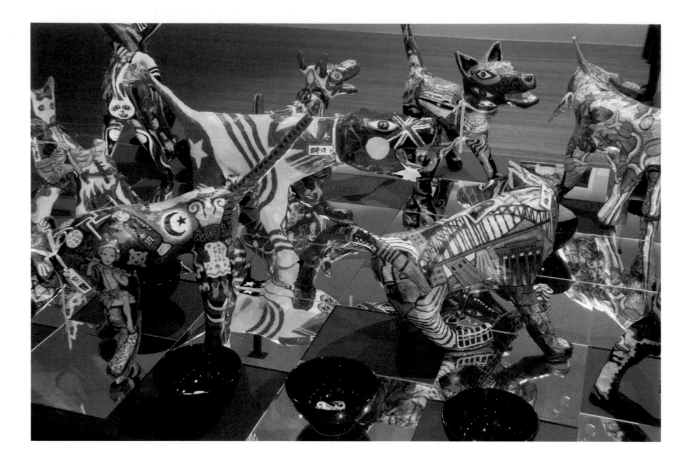

Top: "Pho Dog" by Mai Long. From the exhibition *I Love Pho* at the Casula Powerhouse Arts Centre, Sydney.

Left: *Viet Pop: Emergence* at the Casula Powerhouse Arts Centre, Sydney.

Top: "Drops of Compassion" by Cath Barcan. From the exhibition *Buddhism in Suburbia*.

Left: "Phogotten Memories" by Binh Truong. From the exhibition *I Love Pho* at the Casula Powerhouse Arts Centre, Sydney.

Traditional Methods and New Moves: Migrant and Refugee Exhibitions in Australia and New Zealand

Katherine Goodnow

MUSEUMS ARE CHANGING in their representations of cultural diversity, more specifically, in the migrant and refugee narratives that for many have carried the main burden of representing cultural diversity. These changes are the focus of this chapter.

Focusing on specific countries (in this case, Australia and New Zealand) makes it possible to take a closer look at issues relevant to all museums: issues, for example, of voice, narrative, and audiences. Made easier also is a closer look at the contexts within which standard narratives and departures from them take place (the focus of the chapters to follow).

The choice of these two specific countries has several bases. They are far from identical. For both, however, migration narratives are part of their history, with refugee narratives forming a more recent layer. Museums in both then face the challenge of how to adapt their usual emphasis on migration history to include, or at least to acknowledge, that narratives now often take a different form.

In both countries also, there are some groups that contain second or third generations of "new arrivals" who want new stories to be told: stories that go beyond points of arrival or early "settlement". And in both the mix of "old" and "new" cultural groups is the subject of political debate, framed in terms of what "multiculturalism" might mean and with whether the ideological goal should be one of a single national identity, enriched by the infusion of new blood, or the maintenance of

some degree of separateness. Museums then need to face demands for new stories and to develop an awareness of how the ideological debate shapes both the making and the reading of narratives.

A detailed analysis of how contexts change, altering the frames into which museums and exhibitions fit, will be deferred until a later part of this volume. The exhibitions considered at this point, however, inevitably point to the need to examine those larger frames, noting how they influence what is seen as important to cover, the kinds of approaches adopted or seen as possible, and how people – immigrants or refugees – are defined. Their definition as "invited" or "uninvited" arrivals, as "legals" or "illegals", for example, alters the receptions that each group meets and the forms that arrivals and life beyond arrival take.

The starting point for all the exhibitions in this chapter are comments on the ways in which migration history is conventionally presented.

Migration History and Standard Narratives

The rise of interest in migration history has prompted questions about the circumstances that lie behind it. Ian McShane's analysis of Australian museums provides one example. He sees their increasing attention to migration history as prompted by two circumstances. One was the broader rise of interest in social history. Migration history was then part of this rise. The other was more

political. This was the promotion of "multiculturalism as a dominant national ethic".[1]

Those specific circumstances may vary from one country to another, one historical period to another, and one form of population movement to another e.g. arrival as a selected immigrant or as an unexpected asylum seeker. The general relevance of both historical and political circumstances, however, seems likely to be widespread.

The rise has also prompted attention to the ways in which migration history is presented: its standard forms, its biases, and its gaps.

I shall condense a number of analyses of standard metaphors regarding migrant exhibitions by drawing mainly on two. One is by Ian McShane, the other by Ghassan Hage.[2] Both focus on Australian museums, but the relevance of their arguments goes beyond these.

McShane's reservations about most museum representations are essentially of three kinds. One is with the representation of migration as a one-way process, with little attention to outward migration: little attention, for example, to people who return.

The second concern is with the heavy reliance on some particular metaphors: the metaphors of barriers and of journey. Barriers he sees as exemplified by physical "portals" and by "regulatory and exclusionary processes".[3] Journey is the metaphor to which he gives more space. In his words:

"We are all familiar, perhaps overly familiar, with the suitcase as a design gesture in migration exhibitions. The journey is a favoured trope in migration literature; it underpins compelling stories, rich in personal memory and, importantly for museums, material associations".[4]

The drawbacks of the suitcase metaphor McShane sees as lying in the way its use isolates the journey from the rest of the individual's life, reduces people to the relatively passive state of "passengers", and – if the journey is given sole emphasis – sees them only as migrants: "migrants remain stubbornly migrants".[5]

McShane's third concern is with the emphasis on "enrichment": on migrants as "enriching" a previously impoverished but open Australia. A 1999 exhibition held at the Migration Museum in Adelaide on changing food patterns provides for McShane one example. Its title was *Chops and Changes* (Australia is seen as moving away from its limiting diet of lamb chops). Another is "the Powerhouse Museum's 1999 exhibition on the fiftieth anniversary of the Snowy Mountains hydroelectricity scheme, where the publicity material described the scheme as the 'birth of multicultural Australia' ".[6]

Neither analyst is happy with the "multicultural" message. In Ghassan Hage's terms, the narratives emphasise "having multiculturalism", almost for lunch, rather than "being multicultural".[7] McShane sees the emphasis as simplistic, as ignoring the influence of migration on source countries, taking no account of political forces, diminishing the importance and agency of immigrants, and being essentially assimilationist in ethos.

As if these limitations were not enough, museums now need to ask: How well do the standard migration stories fit refugee narratives? How well do the stories of older arrivals fit with those arriving more recently or with the current positions and perspectives of second or third generations? The journeys of refugees are often acknowledged as being somewhat more complicated or tortuous than those of immigrants. What more needs to be added when a receiving government adds such features as mandatory detention, waiting times in holding camps, or removal to offshore for "processing" before any decision is reached?

How can museums change to meet these several challenges? In the material that follows, I consider four ways in which various exhibitions have moved away from standard representation patterns.

[1] McShane, I. (2001) "Challenging or Conventional? Migration History in Australian Museums?". In McIntyre, D. and Wehner, K. (2001) *National Museums: Negotiating Histories*. Conference Proceedings. Canberra: National Museum of Australia, p. 123

[2] Hage, G. (1998) *White Nation: Fantasies of White Supremacy in a Multicultural Society*, Annandale: Pluto Press. McShane (2001) Op.cit. See also Boylen, P. J. (1995) "Heritage and Cultural Policy: The Role of Museums" – Research Paper for World Commission on Culture and Development (Perez de Cuellar Commission) Paris: UNESCO

[3] McShane (2001) Op.cit., p.129

[4] ibid, p.129

[5] ibid, p.129

[6] McShane (2001) Op.cit., p.128

[7] Hage (1998) Op.cit. p.140

Moves Away from Standard Metaphors and Narratives

The examples I shall consider come from eight museums. Two are in New Zealand: one a national museum, the other a migration museum. The other six are in Australia. Of these, two are explicitly labelled Migration Museums (one in Adelaide, one in Melbourne). The others do not carry that label. Two, however, are located in areas of Sydney where a large part of the population has non-English speaking backgrounds. They are also oriented toward representing those groups, and have been linked to a Migration Heritage Centre. The final two museums are a major regional and a national museum that in general deal only briefly with migration but have held temporary exhibitions of interest for this chapter.[8]

In list form, the moves these museums have taken are as follows:

- Stay with the standard metaphor (e.g. "the journey") but add to it
- Add some of "the negative side" to migrant and refugee narratives
- Break away from representations of separate identities and spaces
- Go beyond "frozen" identities: Combine past and present and add "young" voices

The first two of those moves are essentially modifications of standard approaches. The second two are more often expressions of the kind of view expressed by a curator (Nicholas Tsoutas) working in an area where second and third generations are emerging:

> "We've had two decades of migration stories – it is time to move on".[9]

Move 1: Stay with a Standard Metaphor e.g. "the journey" – But Add to It

I shall single out four examples of this move. Two focus on earlier waves of migration (in this sense, they are migration *history*) but they vary the standard form. The third and fourth pick up more recent difficult journeys. The exhibitions vary also in the phases of journey that they emphasise and in the methods they adopted to convey particular aspects of refugee experience and to meet the challenges these presented. Example 1, for instance, takes a fresh look at departures and – in an art gallery – uses a novel mixture of paintings, drawings, and text. Example 2 has more to say about journeys and arrivals, and uses as a base childhood memories of both. Example 3 covers departures, journeys, and arrivals, and uses a mixture of methods to physically evoke a sense of the trauma attached to departures and journeys especially and to personalise members of the groups known as refugees. Exhibition 4 again uses personal stories (noting again the difficulties these can present) and evocative materials. It also covers 12 phases in the sequence, with careful attention given to experiences after arrival and to what may represent an "ending" to being a refugee.

Exiles and Emigrants

The first example, which I will deal with very briefly, is an exhibition held at the National Gallery of Victoria in 2006. This exhibition had several conventional features. It was, for example, very Anglo-centric and the journey was a straight line by ship from England, Scotland and Wales to Australia (the time period covered was Queen Victoria's reign: 1837 – 1901). One less conventional feature was the form of presentation, mixing small amounts of text with many paintings and drawings.

The shifts I wish to emphasise were in the content covered: in the attention given to the sadness of the departure, the circumstances that gave rise to it (e.g. the English demolition of Scottish homes and the appropriation of land), and the situation of those left behind (the women and children left behind in poverty, for example, when the husband or father left for a distant country with little likelihood of return). The curator, Patricia Tryon MacDonald, describes one example:

> "a painting ... which shows the children left behind with bare feet while those that are leaving have shoes on and there they would say 'oh my god can you imagine saying goodbye to your grandmother and grandfather' …. It is that heart-wrenching moment, and it doesn't matter if you are stepping on a plane or a boat".[10]

This less than glossy image of departure resonated with a variety of audiences:

> "We had a section in the exhibition which was 'tell your stories'. We had a big table and pads of paper and pens and we got over a thousand letters in Victoria alone and they were from people who had come from 52 different countries from Zimbabwe to Afghanistan …. The letters … are personal stories of migration to the country and the different ways in which this took place …. Twentieth century waves who came forced out by economic or political reasons … they were all incredibly moving. Amazing stories. Outpourings".[11]

Childhood Memories of Migration: Images, Imaginings and Impressions

The second example, developed at the Fairfield City Museum and Gallery, illustrates a move to different voices and to a different way of representing journeys and arrivals. The period represented is still predominantly the 1950s to 1980s, before the period of asylum-seeking journeys that more often took zigzag routes, meant arrival with few or no material belongings, and ended in isolated detention camps surrounded by barbed wire. Added, however, are refugee stories and childhood memories, especially of arrival, that bring a new perspective on the nature of journeys and highlight the differences that can occur between one wave and another.

This exhibition was divided into 4 main parts and a timeline. The four parts covered leaving, titled *Homelands*; a description of the accommodation – *Hostel*; a description of activities the children participated in after school – *Pastimes*; and memories of the education system – *Schooldays*.

Homelands, like my first example – *Exiles and Emigrants* – acknowledged the pain of leaving:

> "It is not an easy decision to leave the country where your heart is Memories of leaving their home-lands are sad recollections of farewells from family and friends, not knowing if they would be united again".[12]

This section also acknowledged, in the text of the brochure, the different forms of journey for assisted migrants and refugees:

> "For those children who came as migrants on ocean liners in the 1950s and 1960s from Great Britain, Ireland, Scotland and Northern Europe, the journey is remembered as the 'holiday' that they had never had. The organised games, swimming and entertainment, the three course meals in large dining rooms, and exposure to different cultures in exotic ports were clearly recalled.
>
> However those fleeing from war ravaged countries and communist governments in the 1970s, such as Vietnam, Cambodia and Laos, made the risky journey on small boats endangering their lives and savings. These memories are particularly painful, of unknown destinations, no possessions, meagre rations, and a fear of the open sea".[13]

The second section, *Hostel*, also notes differences in expectations and experiences upon arrival. For *the migrants*, arrivals were more of a shock. In part, this was because the initial accommodation did not fit the picture painted by government-sponsored advertising to entice migrants. In the words of Terry Astor-Smith, former Hostel Manager of Villawood: "We had presented a somewhat false picture of what they could expect".[14]

> "For most the adventure and the fantasies turned into a harsh reality on arrival at the hostels … All hostels initially had Nissen huts, with curved corrugated iron roofs, bituminous floor covering, and

[8] By name, the museums are, 1) The Museum of New Zealand – Te Papa Tongarewa in Wellington; 2) The Petone Settlers Museum in Hutt City; 3) The Immigration Museum in Melbourne, 4) The Migration Museum in Adelaide, 5) The Fairfield City Museum and Gallery, 6) The Casula Powerhouse Arts Centre (both 5 and 6 are in the part of Sydney known as Western Sydney: an area with an estimated population of 1.7 million), 7) National Gallery of Victoria, 8) The National Museum of Australia. In 2006, the directors or the main curators responsible for particular exhibitions were Miri Young and Natasha Petkovic-Jeremic (Hutt City), Vivian Szekeres (Adelaide), Moya McFadzean (Melbourne), Patricia MacDonald (Gallery of Victoria), Susan Hutchison and Kim Tao (Fairfield City), and Nicholas Tsoutas and Cuong Le (Casula). All were interviewed by the author.

[9] Tsoutas is the artistic director of the Casula Powerhouse Arts Centre. The comment is from an interview with him by the author, February 2006

[10] Interview with Curator Patricia Tryon MacDonald by Goodnow May 2006

[11] ibid

[12] Exhibition brochure p.2

[13] ibid, p.2

[14] Exhibition panel – *Hostel*

masonite lining. The interiors were remembered as being all brown – the floors were remembered as being all brown – the floors, the lining, the furniture, and like a 'tin can' in summer. The rooms were small, the furniture basic, and the walls thin. There was little privacy. The communal areas are remembered as places where families not only got to know each other, but also where they discovered spiders and cockroaches".[15]

"Children remember their mothers crying every night or developing long-term illnesses because their expectations were not met ... Families were not encouraged to paint and decorate their rooms as management felt that they might 'settle in' and want to stay longer".[16]

In contrast, for *the refugees* arriving pre-1991 the Australian reception was seen as providing security:

"On arrival, children from South American countries remember the freedom to walk on the streets without being questioned or assaulted, possessions being safe in their rooms, and friendly police".[17]

This reception was quite different from that of many asylum seekers arriving in Australia post-1991. As I shall detail in the later chapters on the significance of changing contexts, in 1992 the Australian government introduced mandatory detention of all unauthorised arrivals (for example, refugees arriving by boat from Indonesia). Refugees arriving through humanitarian programs received better treatment. In general, however, the experiences of the pre-1992 asylum-seekers and refugees were comparatively idyllic:

"In the early years, the open fields and bushland around both Hostels was like a large adventure playground. Children kept horses in the paddocks at Villawood and went swimming, catching eels, and bird watching in the creek near Cabramatta Hostel Older children explored beyond the hostel by catching the train to the city and to beaches. Some excursions and holiday camps were arranged for children by the Management, but not on a regular basis".[18]

The exhibition travelled to the Powerhouse Museum in Sydney. There it was changed somewhat to focus mainly on individual stories of arrival. In addition, the general policy issues moved to the education program and the online support.[19] One notable difference was the loss of the timeline that highlighted changes in government response and the present situation of asylum seekers and refugees:

"1976: The first of small refugee boats arrived on Australian shores from Viet Nam.

1977: 24 more small boats arrived along the northern coast carrying Indo-Chinese refugees.

1979: To ease the continuing arrival of 'boat people' from Indo-China, airlifts were arranged from crowded refuges camps in South East Asia.

1982: Australia and Viet Nam developed an agreement for an 'Orderly Departure program' from Viet Nam to stop the flow of boat arrivals.

1989: A small boat arrived from Cambodia *illegally*.

1991: Mandatory detention introduced to discourage the increase in arrivals of Cambodians by boat without visas. Prior to this date, asylum seekers were processed in Australia and lodged in the hostels originally provided for assisted migrants.

1991: Woomera detention centre opened as boat arrivals of Afghans and Iraqis increase.

2001: Border protection legislation removes Christmas Island and other islands from Australian immigration zone to discourage asylum seekers".[20]

Dropped in the Powerhouse version were also the references to contemporary asylum seekers and refugees that were present in the *Postscript* of the Fairfield Exhibition. In the words of that text:

"The shared journey and history of the many residents of the former Villawood and Cabramatta Hostels are remembered privately. There are no plaques or monuments to mark that important episode in their lives. The few remaining physical reminders are locked away behind the high fences of Villawood Detention Centre We are reminded of the journeys still being made by children living at the former migrant hostel known as the Villawood Detention Centre. As for the

many migrants and refugees in the past, their futures are uncertain. What will their memories be?"[21]

All told, this exhibition of childhood memories is an opportunity to introduce questions to be returned to: How do museums respond to these later narratives? Would they find it easy to give up their customary narratives? What happens when they have to give up some of the material they have come to rely on: the "suitcases", for example, or the physical material representing ships and the hazards of storms? How are they to handle, for example, narratives where people arrive with little or nothing, where even small possessions – toys, clothes, treasured mementoes were lost, sold, or taken along the way?

The next two examples offer some first examples of how museums have moved toward changing their narratives. Further examples are offered in the analysis of Move 2: Adding the negative side to the standard narrative.

A Twist of Fate

The third example for this section comes from the Migration Museum in Adelaide. It was one of the earliest dedicated refugee exhibitions in Australia and came before the further hardening of government policy toward refugees and the rise of public awareness of what refugees endured both before and after arrival. The curator, Vivian Szekeres, regrets its timing:

"This was in 1995. It was way before its time, I'm afraid. I say that bitterly because it's probably the best thing I have ever done but not enough people got it …. if we had done it 5 years later it would have been huge".[22]

The exhibition was made up of three parts with a sequence similar to that in the exhibitions described so far – departure, journey and arrival – but with a more gritty edge to the story. The first section offered a first general introduction to the concept of refugees. In the second section, visitors could follow one of three stories: an Eastern European dated 1939 – 1945; A Vietnamese story 1970 – 1980s or a Latin American story dated 1970s – 1990s. A third section, titled "Sanctuary", dealt with arrival and settlement in Australia.

Section One introduced the physical reality and the extent of refugee experience. In Vivian Szekeres' description:

"We had the little space you walked through which was the bomb site – we had walled it off so that it was smaller than the space we had – and then at the far wall we had a projector going all the time and we had got from the UNHCR … about a hundred images – as recent as we could get – and in between each set of images we had one of their facts … that Guernica was the first bombing of civilians …. that there are now 17 million refugees and that sort of thing. It was just a black screen and white type and then a set of images. No sound at all and it was grim. And then you went into the long gallery – it had a false floor which was metal and went up and down and was very uncomfortable. Just the sound of your feet on it made you feel very uncomfortable and it echoed, which was deliberate, and this led to the Vietnamese story".[23]

The second section was equally hard-hitting:

"There was a boat which was at sea. The floor actually tilted so you had to walk sideways which was also uncomfortable. Underneath the floor there was a photograph of Vietnamese people looking up at you. It was really very dramatic …. We had also created in the middle a two-meter square padded cell. We bought a sewing machine and I had to learn to sew and we sewed carpet for the walls and we had a chair and a bucket and a light. You had to walk through each of these areas to get to where you were going".[24]

"It made people cry which was good. I came across a man just weeping. He had been in the Vietnam war and he said 'We used to bomb them, we had no idea'.

[15] Exhibition brochure p.2
[16] Exhibition panel – Hostel
[17] Exhibition brochure p.2
[18] Exhibition panel – Pastimes
[19] Susan Hutchinson in interview with Goodnow, February 2006
[20] Fairfield exhibition panel. Emphasis added on the word "illegally". It is not illegal to seek asylum but a human right.
[21] End Note and Postscript on the exhibition panels
[22] Vivian Szekeres in interview with Goodnow, December 2006
[23] ibid
[24] ibid

.... There were some kids who said 'My mum talks about this, my mum talks about running with bombs falling', particularly amongst the Vietnamese kids".[25]

A third section was created after discussions with a reference group. Its aim was to soften the impact and leave visitors less emotionally disturbed. Personal stories were at the centre of this section:

"The last section we had painted gold and we had white cutout Perspex figures and on the figures was a story".[26]

Here then is a mix of facts and images from the UNHCR, evocative reconstructions, and personal stories. The challenge once more was how to tell stories when there are no pre-existing objects and when recounting personal stories is itself painful (or even dangerous for those left behind):

"It is hard to work with the refugee groups because of the lack of objects so many people that I wanted to talk to did not want to talk about it. They had never talked about it and they were not going to start now. So that led me to think that what we had to do with the main stories were to create composite stories that didn't belong to any one person and they were mainly from secondary sources".

"The agreement was not to talk about how they had got here but to talk about their lives since they got here and they agreed to that. A Sudanese woman wanted to have that in writing twice – it was dreadful stuff".[27]

The hazards of personal stories also led the museum to put together a reference group that included mental health workers:

"People really don't want to talk about it and will only talk about it when they are ready and once they start they may not want to stop. They would need to go on until they had dealt with it and I don't know if it can be done in a straight ordinary exhibition."

"We had a reference group for this ... you need people who are working in different areas and have different views ... I was hell-bent on doing it one way so you need people who are able to say 'you can do this but not that' or 'this isn't going to work' ... so we pulled together a really great group ... people who were in education, people who worked with new arrivals, from mental health ... there were about 10 people and we only had to meet with them three times during the whole project and we just brought them all together and talked to them about what we want to do".[28]

The exhibition went on tour and then closed down. It was not stored, The museum lacked space. The exhibition had also not received the visitor numbers that the museum had hoped for: refugee issues were not yet a major controversy in Australia.

Walk With Me: The Refugee Experience in New Zealand

This exhibition is a fourth example of making a break from the standard metaphor of "journey" by adding to it. Three features mark the break. (1) The stories are specifically about refugees in their own right, rather than as an addendum to migration history. Four refugees invite visitors to the museum to "walk through" their journeys with them, with the "walking through" marked by an emphasis on visuals rather than text. (2) The flow of the journey goes well beyond the usual ending at the moment of physical arrival. In fact, 6 of the 12 phases that are walked through are phases that occur after arrival. (3) Attention is given to further stories that are usually under-represented in museum exhibitions: the stories of refugee children, and of those who are refugees within their own countries – the "internally displaced".

The site for this 2006 exhibition was the Petone Settlers' Museum in the northern island of New Zealand. For the curator, Natasha Petkovic-Jeremic, that museum's history was an important first consideration:

"The PSM (Petone Settlers Museum) is a social history museum (not a migration museum), often perceived as the museum that tells stories of first European settlement only, or/and local industrial history ('historical' and not contemporary). My interest was

focused on the continuum, or how stories from the past can be connected to the present and how contemporary stories can find their place in a traditional social history museum."

"The exhibition used a concept of a journey which has been previously used in other Petone Settler Museum's exhibitions (and overseas stories too). The journey in the *WWM* exhibition is used as a recognisable metaphor, one that visitors can readily engage with. However, the exhibition aimed at challenging the concept of a journey of refugees that finishes on their arrival to NZ".[29]

The stories told were deliberately varied. The people in the four main stories covered "a selection of ages, gender ... so that visitors may personally identify with them". Covered also was a variety both of past events and of experiences in New Zealand after arrival:

"There was a range of people/experiences (single men and women, families that arrived recently, a family that arrived 15 years ago, a widower who reunited with his children after many years etc). A woman who fled her country at the age of 13 and spent 15 years in refugee camps before coming to NZ. She had walked for three months, saw women leaving their children behind unable to care for them; experienced violence in camps. She has been living in NZ for many years and is still lonely and isolated (keeps her curtains closed during the day)".[30]

For stories like these, the usual supporting objects – the "suitcases" etc. – rarely exist. The exhibition solved that lack through the extended use of photographs and some physical structures:

"The exhibition was visually 'heavy' (it only had very limited text and all together 2-3 panels). It also had objects – some of which belonged to refugees (object with memories attached to them) and others that were used to re-create scenes/enhance engagement. Visuals consisted of hundreds of photographs acquired through research and given by interviewees; films from the Archives, personal and others filmed to re-create situations (view from Mangere – the emptiness of spaces etc; signing of documents and forms)".

Strikingly different from most representations of refugee journeys was the careful delineation of steps both before and after the moment of arrival. All told, the journey was broken into 12 phases:

1) *Home.* "Stories focusing on their homeland, family, traditions and everyday life when everything was 'normal'. This section had a peaceful, calm tone and served as a reminder that refugees are ordinary people who once led often different, but ordinary lives".[31]
2) *Fast departure.* "Life is normal, but a sudden event (or a range of events) changes it completely. This section focuses on events and situations that force people to leave their homeland".
3) *Travelling.* "The troubles and dilemmas people face on their way out. Visitors are put in a space that is small and dark".
4) *Transition.* "The field office and the processes refugees encounter before being granted a refugee status. This space was designed to recreate a tunnel which visitors enter by 'passing' some security procedures and seeing objects typical for a field office".
5) *Refugee camp.* "Life in a refugee camp – overcrowding, perhaps lack of food, water, security, uncertainty and no hope. The space was designed to recreate the look of a tent, or a temporary accommodation with a tin roof (or flax roof)".

The journey then moved into a new section – arrival to New Zealand: "You are moving to NZ. You don't know much about it".

6) *Coming to NZ.* "A brief history of refugee arrivals since 1870 such as refugees from Nazism during WWII, Polish refugees in 1944, Hungarian refugees in

[25] ibid
[26] ibid
[27] ibid
[28] ibid
[29] Unpublished paper by curator Natasha Petkovic-Jeremic, May 2007
[30] Unpublished paper by Petkovic-Jeremic, May 2007
[31] This description comes from email correspondence with Petkovic-Jeremic with Goodnow, May 2007

the 1950s, Chinese refugees in the 1960s, Asians from Uganda in 1970s and … a particular focus on more recent (1970-2005) arrivals".

6) *Mangere centre/ meeting NZ officials*. "Illustrates the first encounter with New Zealand, support received but also confusion and fear of life ahead".

7) *New Home*. "This is the middle point of the journey. Traumatic and fearful situations are behind, but other issues lay ahead such as cultural shock, isolation etc."

8) *Language*. "Highlights language issues-confusion, miscommunication and … problems people face because of inability to communicate. Many refugees speak 2 or 3 languages but not English".

9) *Jobs*. "Issues surrounding difficulties of getting a job, use of existing qualifications or lack of appropriate qualification … also explores attitudes of employers and issues of identity".

10) *Family*. "Issues such as grief due to family separation, family reunion, obligations and family expectations".

11) *Isolation and loneliness*. "Refugees often, and for a long time, feel isolated due to loneliness, mental health problems, lack of networks and friendships".

12) *The Future*. "Visitors again 'meet' the four refugees from the beginning of the story, now in a different 'setting', focusing on their future in NZ".

This phase also looks at multiculturalism policies and "generational differences (children of refugee parents) and issues such as at which point refugees feel accepted (stop calling themselves, or being called, refugees)".

As those descriptions indicate, the flow of the story followed the narrative structure of equilibrium, break up, new hindrances and then a return, for some, to a new state of equilibrium:

"The tone and feel was participative, slightly theatrical, establishing scenarios and choices that the visitor will have to make in order to get to the end of the journey … The journey has a 'middle point' at which the tone will change from shock and trauma to facing less traumatic but serious issues of resettlement".[32]

The descriptions point also to the careful examination of what counts as an "ending" to a refugee narrative. The journey here did not end with arrival but continued well

beyond that point. Significantly, the decision as to when their journey could be said to be over – or perhaps continue but take a different direction – is determined only in part by the refugee's own feelings. It is not something that the refugee defines alone:

"They … faced an issue of how long one can be called a refugee. For some it was defined by the 'other's' view. Generally, getting a job was defined as a cut-off point in the journey of resettlement".[33]

"The exhibition could be 'read' at different levels. Yes, on one side, NZ is accepting, programmes are in place and the general public does embrace those new migrants (in most cases). On the other, those personal accounts opened a question of the real impact of those programmes (or a lack of deeper engagement that programmes cannot compensate for). Meaningful engagement can only be achieved when embraced by the community in which refugees resettle – that was a challenge quietly placed upon visitors by the interviewees".[34]

Building those questions into the exhibition; What counts as an ending? Who defines it?, was one challenge. Challenging also were the concerns brought to talking about events after arrival (concerns that other curators have also noted). The refugees wished to present themselves as appreciative:

"All of the stories … overwhelmingly focused on positive experiences that migrants have when settling in NZ. My research showed (interviews) that the ethnic communities did not want to highlight their negative experience (to talk about it in a public arena) for a variety of reasons such as fear of not being accepted, being seen as ungrateful for what NZ offers to migrants and pressure to assimilate. That poses the question of how 'real' these exhibitions are when presented in traditional settings in which those groups feel the need to accommodate in order to 'comply' with the hosting culture".[35]

In addition, there was some concern about speaking at all, especially in ways that might compromise those left behind:

"Refugee migrants often thought that their stories are 'not important enough' to be told in a museum. Several refugee migrants were reluctant to disclose their names. This was due to a number of reasons. Fear of being singled-out in their own community (which often is seen as united from the outside, but quite fragmented on the "inside"), being seen by 'others' as a burden (one interviewee said that we can disclose his name only when he secures a job) by the community and by their own family (particularly men who take the role of providers). The more 'established' (year of living in NZ, having jobs etc) refugees were more prepared to share their stories as they believed they 'fitted in' and thus could contribute more. Only one interviewee, who has been living in NZ for more than 5 years and is unemployed, was particularly interested in making her story public in the hope that it would help her application for a family reunification".

Do the stories presented then cover all that a curator would wish for? Petkovic-Jermic felt that two other areas of under-representation needed to be given some space.

One of these consisted of children's representations: their stories of refugee journeys, in the eyes of children who made those journeys or those who, born in New Zealand, heard about them from others. This lack was countered by a high school writing competition on "hope" in which school children (both refugees and ethnic New Zealanders) were asked to write about the experiences of refugees – their journeys and their experiences after arrival. Within the finalists of this competition were refugee children whose stories of difficult journeys and arrivals add to the adult narratives that more often appear in museum representations.[36]

"From the start the issue of young people (refugees) was seen as an important one to include in the exhibition. Many of the children face different challenges to their parents – many were born outside the country of their parents (camps), many carry extra responsibilities of managing two cultures, translating for their parents, adopting to their peer culture etc. The writing competition aimed at addressing this side of the story".[37]

The other gap of concern to Petkovic-Jeremic was the position of those who are refugees within their own country. The step she took was one of complementing *Walk With Me* with an exhibition of photographs by Somalian photographer Amina Daud Timayare, titled *Displaced*:

"Over the past two decades, Somalian journalist and photographer Amina Daud Timayare has documented the experience of the people of the Horn of Africa – Somalia, Ethiopia and Kenya. Many of her images have captured people going on with their lives in this dynamic and volatile part of the world, at the same time as they are experiencing displacement within their own national borders. The UNHCR estimates there are some 25 million internally displaced people in the world; outnumbering 'refugees' for the first time since 1951".[38]

This was the last exhibition in this move. In the next section the concern is also with journeys and arrival but adding to it a particular concern with policies and contexts within the receiving countries.

Move 2: Add Some of "the Negative Side" to Arrival Stories

All narratives are incomplete. One of the particular omissions is often "the darker" or "negative side" of events: the parts of the story that, for various reasons, are felt to be out of line with the way a funding body, a community, or a museum wishes to see itself or others.

The conventional narratives are often "happy" ones. They omit what many feel should be included, and may readily be seen as biased toward "the sweet" rather than "the sour" (*Sweet and Sour: Chinese Families in the Northern Territory* was the title of a 1996 exhibition).

[32] ibid

[33] ibid

[34] ibid

[35] Unpublished paper by Petkovic-Jeremic, May 2007

[36] These stories may be accessed at: www.huttcity.info/council/services/recreation/settlers/refugee.html. Attached as an appendix is one such story, contributed by Fatima Al-Ghrabi. Visitors were also asked to send in their stories of settlement

[37] Unpublished paper by Petkovic-Jeremic, May 2007

[38] Petone Settler Museum Press Release, 2006

Seen as omitted, for instance, may be the extent to which immigrants encounter racism or religious prejudices, and the extent to which old ethnic or religious tensions persist.

The reasons offered for those omissions vary. Meighan Katz, for example, sees at least two influences at work. One is the political pressure to present a picture of "positive multiculturalism". The other is the reluctance of people to:

> "record the more troubling aspects of their experience or their community. Creating a reflection of self, particularly a highly public one, that includes an acknowledgement of prejudices or racism, is a great deal to ask of anyone".[39]

Both factors she sees as more important than the feeling of curators that they may have "an obligation to avoid hurting people": an explanation offered by one curator at a 1997 museums conference.[40]

Museums may have some distance to go before they reach the degree to which other media reflect the "darker" side of migration history. The narratives covered in two acclaimed novels of the U.S. meat-packing industry, for example, are very "dark" narratives about the working conditions that migrants encounter: the one, *The Jungle*, written in 1906 by Upton Sinclair, and the other written by Lance Compa in 2005 – *Blood, Sweat and Fears: Workers' Rights in the U.S. Meat and Poultry Plants*.

There are, however, several ways in which museums are moving toward a more effective balance in their representations of migration history. The open representation of arrival by slavery is one move. For that, the examples come mainly from outside Australia or New Zealand. Within the two countries, however, museums are moving toward more attention to narratives that apply to many countries. These are narratives that move away from a picture of welcoming inclusion and have more to say about difficult entry and exclusion.

In this section, on moves to add the more negative sides of the reception of migrants and refugees, I turn to further museums in Australia and New Zealand. As in the description of Move 1, I start with the broader theme of migration histories before focusing on refugees.

To illustrate those moves, I shall again offer four examples. One is from New Zealand. The other three are from Australia. The first two deal with migration in general. The final two are concerned primarily with asylum seekers and refugees and an arrival that leads to detention. The selection is again based on variations in the content covered – variations that often reflected shifts in government policies and public awareness – and in the methods chosen to represent this content.

Example 1 is an exhibition that notes how migration is not always successful or one-way and is affected by government policies and global events. (*Passports* at the Museum of New Zealand Te Papa Tongarewa).

Example 2 is an exhibition with a particular emphasis on the difficulties that entry can present and on the occurrence of exclusions. (*Getting In* – at the Immigration Museum in Melbourne).

Example 3 is an exhibition of political cartoons in which the prime focus was Australia's treatment of refugees and asylum seekers. (*Cartoons 2002: Life, Love, Politics* at the National Museum of Australia).

Example 4 focuses on children's representations of their experience in detention centres. (*Innocent Victims: Children's Drawings from the Woomera Detention Centre* – developed at the Migration Museum in South Australia).

Passports

This is a permanent exhibition at the Museum of New Zealand Te Papa Tongarewa. This is a world-famous museum, based in the city of Wellington, and opened in 1998. Its particular emphasis is on the significance of Maori culture within New Zealand. That emphasis makes the journey of Maoris from other Pacific Islands – the first migrants – a major topic. Major also is the interaction of Maori with Pakeha ("Anglo" or non-Maori) culture. At the same time, the museum features several examples of a search for other aspects of a changing population and population movement.

The exhibition titled *Passports* is one of these. It explicitly acknowledges that migration journeys are not always one way (people leave countries as well as come to them) and that entry is often excluded. It acknowl-

edges also the importance of changing government policies. The material on this point, however, is restricted to migration without specific comment on refugees and asylum seekers.

In the *opening room* of the exhibition is a timeline that shows how emigration from New Zealand was at times larger than immigration:

> "*1976–1990 Recipe for disaster*: An oil crisis hits, world prices for our exports drop, and Britain forges new economic links with Europe. With growing unemployment, New Zealand is no longer as enticing – people leave in droves. The government makes things harder for migrants, too. It stops assisting immigration for good, and cracks down on migrants who have outstayed their visas.
>
> *1991–2001 Recent ups and downs*: In the early 1990s, our economy picked up, and a new Immigration Act opened our country to all races and nationalities. Some migrants came from Western countries. Many more came from Asia. This inflow peaked in 1996, when almost 30 000 people came to live here. But the second half of the 1990s saw a swiftly declining rate of immigration. By the beginning of 2001, about 10 000 more people were leaving New Zealand each year, on a long-term basis, than were arriving".[41]

This opening space includes reasons for departure based on poverty, war and overcrowding. It also, however, includes a self-critical space on how New Zealand advertised itself to attract migrants – "The Pull" and not only "The Push". The text panel here includes quotes from government sources and government posters showing healthy children and wide-open agricultural spaces, and comments by migrants on the effect of these:

> "The Pull: 'This is the country for living – beef, mutton, eggs, and everything else that is good – we are happy as the day is long'."
>
> "I was thinking of my family and a better future. We had been shown films and pictures of New Zealand … It looked beautiful, colourful and green, away from all the destruction".[42]

In this *opening space* as well is a story of refugees whose journey was hazardous (but whose arrival is limited to the positive):

> "When World War II broke out, countless Polish children and their families were sent to labour camps in freezing Siberia. There many died from hunger, cold and beatings. Two winters later, those who had clung to life were released. They began a horrific journey across thousands of miles, travelling on foot, by train, and by boat, to Teheran. Many died on the way. The survivors spent another eighteen months in hospitals and orphanages. By now a lot of them had lost their entire families. Over seven hundred desolate children were finally sent on a voyage to the other side of the world. They arrived in New Zealand wondering – what next?"[43]

The images to accompany the text are predominantly of the arrival of happy children and a welcoming crowd.

The *second section* of the exhibition is a *journey space* divided into two rooms. The first is a small room titled *19th century crossings* complete with wooden floors and soundscapes suggesting the hardship of life at sea. The second half is a room with text panels including quotes of what the trip was like and a set of interactives that deal with migration and difficult journeys and arrivals.

The interactives include *The Voyage Out* – a game in which you are the captain and have to make a number of difficult decisions about what to take and what you would do if you encountered trouble e.g. if some of the passengers became ill. Your decisions affect whether you make a profit from the trip or whether delays lead you to be unsuccessful. The journeys here are less than easy and often lead to the death of many of the migrants due to disease, malnutrition, natural disasters and a drive for profits by shipping companies.

A further interactive in this space asks you to be a

[39] Katz, M. (2005) *History Under Construction: Curators and the Experience of Creating Accessible Public History* Melbourne: Monash University. Section 2: Chapter 2

[40] Cited by Katz, ibid. The original reference is: Diamond, G. (1999) "Chinese Whispers: ABC Territory". In I. Walters et al (Eds.) *Unlocking Museums: Proceedings of the 4th National Conference of Museums Australia*. Darwin: N.T. Branch Museums Australia

[41] Text panel from timeline in Entrance Room to Passports Exhibition, The Museum of New Zealand – Te Papa Tongarewa, Wellington

[42] Exhibition Panel, *Passports*, Museum of New Zealand Te Papa Tongarewa

[43] ibid

particular migrant and raises the issue of the difficulties facing early non-Anglo migrants. The visitor is asked to make some decisions about her/your life – what career you choose, who you marry etc. These decisions then lead you either to be a successful or unsuccessful migrant. In this period, if you marry outside of your ethnic group, for example, you may be ostracised and isolated. If you are from, for example, India and try to work in a non-domestic or professional field in the 1920s you are likely to be unemployed and therefore unsuccessful. All told, this interactive shows how historical attitudes and policies were likely to lead to difficult times after arrival, but no contemporary stories are included.

The *main room* is given over to individual migrant stories. It includes, however, a further small interactive that deals with immigration policy. Here visitors can test whether they would have been allowed into New Zealand.[44] Brought out is the extent to which current immigration policies are often restrictive, particularly in relation to age, trade and language ability. (A similar interactive, with the addition of policy notes and video interviews, is to be found in the Immigration Museum in Melbourne, and is described as part of Example 2)

More of the negative side of migration is visible in the temporary exhibitions at the museum. In an exhibition on Italian migrants, for example, *(Qui Tutto Bene)* the focus of the story is on their "enhancement" of the country through their skills, food and culture. Noted also, however, is their incarceration during the Second World War:

> "*The New Ground*: For Italian migrants, New Zealand proved to be a country of both promise and hardship. Over the decades some communities flourished, others faded away. Those who settled became valued for their many skills …. Italians continue to bring skills and a distinctive culture to New Zealand."
>
> "*Shell Shock*: These … shell ornaments were made by some of the thirty-eight Italians who were interned, mostly without warning, on Matiu/Somes Island in Welllington Harbour between 1940-44. Florindo Comis, one of those internees, had lived in New Zealand for years. His son Italo remembers 'two detectives who arrived at the house and put a

seal on our radio and then both of them leading Dad away, with the children and Mum crying.' The years of internment were long and tedious, but the men were well treated. They played cards, fished, swam, and learnt to make small items to sell or give away. For families left at home with no menfolk and little money, it was a very tough time".[45]

Journeys and arrivals for the Italians are also noted as complicated:

> "*Mismatch*: In the 1870s, an enthusiastic agent in Livorno recruited 367 Italians for a government scheme without matching their skills to the jobs available. A group of the migrants, mainly tailors and shoemakers, ended up at Jackson's Bay in Westland. The plan was for them to grow grapes and import mulberry trees to produce silk. But Westland, with its dense bush, high rainfall, and extreme isolation, was no place for these city dwellers or for their aspirations. Within three years they had all left. Another group was assigned to work on the Featherston railway. These men had never handled a pick and shovel, and refused to work for the pay, lower than they had been promised. Many were sacked after only a few weeks."

This first example then notes some of the hardships of arrival for migrants in general. The next example covers both migrants and refugees.

Getting In

This exhibition gallery is one section of a broader permanent migration exhibition at the Immigration Museum in Melbourne. It has a particular concern with issues of exclusion:

> "The broad exhibition premise is that the bottom line of Australian immigration policy over the last 200 years has been how to 'get in'. People's experiences have varied dramatically, from being welcomed, invited, assisted, accepted, discouraged and refused. Basic questions are addressed – why have some people been allowed in and others not? What rules and regu-

lations have been created over the years to determine a person's eligibility? How have these rules changed over time? How have these changing policies both reflected and shaped public opinion?" [46]

The plan for the exhibition began with an interest in how to include indigenous people: [47]

"Originally the space was dedicated to an exhibition on the impact of migration particularly on indigenous populations. This was deemed as 'tokenistic' and not really working. That was obviously not the intention but it had to be taken into account". [48]

The space was re-worked in 2001 and 2002 during a period of harsh debate regarding refugees and asylum seekers. That external factor affected visitor responses and museum decisions:

"Research was done that showed that people were looking for more of the facts and figures if you like of immigration and the curatorial feeling was that we hadn't gotten into the grittier side of the migration landscape". [49]

"So everyone agreed that looking at policy over time was an important thing to do. The challenge was getting the tone and the voice of the exhibition right. This was quite a challenge curatorially What we learnt from the search is that visitors don't want to be lectured and they don't want a curatorial soapbox. So even though Deb (the second curator) and I had our own feelings about the White Australia policy or *Tampa* or whatever, we didn't feel that it was our role to get up and tell people that *Tampa* was a national disgrace even if we felt it was. So we, and the museum, decided that it was our role ... to try and stand back from it as much as possible because that part of Australian migration history has been so controversial". [50]

This attempt to make an objective look at Australian migration policy, while the debate raging in the media outside of the museum was at a high emotional level, was questioned by some of the museum's critics and fellow curators:

"I remember when I presented this at a Museums Australia conference – the year that we were developing the exhibition – there were a couple of very high-profile museum people who had objections to that approach. And there was a whole discussion about the social role of the museum in terms of being pro-active and not only discussing contemporary social issues but actually taking a point of view, taking a stand. So they did take objection to our approach which was more about the balance of the various issues and letting visitors make their own decisions.

Nevertheless we stood by our own decision which I still think is the right one I still feel I would have liked to have done more. I think we have one panel about the *Tampa* and with hindsight I would have liked to have done more about it There is so much to be said. We are trying to cover 200 years of Australian migration policy in 115 square meters which was a challenge in itself". [51]

One further problem facing curators putting together this kind of exhibition is that both policy and the media debate outside of the museum keep changing:

"That exhibition opened in early 2003 and the policy is still changing and we need to decide how to deal with that. Detention centres are mentioned but there is a lot to do now with borders. Australia is redefining its borders and people can no longer land and we need to address that". [52]

The Getting In Interactives. Like the *Passports* exhibition in New Zealand, this exhibition includes a couple of

[44] Note the *Belonging* exhibition at the Museum of London also included a citizenship test. Many visitors to the exhibition discovered that they would not have passed the test. The interactive also kept a log of results which was displayed to new visitors.

[45] Exhibition panel notes

[46] McFadzean, M. (2004) *Beyond the Label: Museums, Histories and New Technologies – The Getting In Interactive Theatre Experience at Melbourne's Immigration Museum.* Paper given at the Festival Audiovisuel International Musie & Patrimoine AVICOM (ICOM) Taiwan 3 – 7 May 2004, p.4

[47] For a discussion on changing views on museum representations of Indigenous peoples see Goodnow, K. (2006) *Challenge and Transformation: Museums in Cape Town and Sydney.* Paris: UNESCO

[48] Moya McFadzean in interview with Goodnow, February 2006

[49] ibid

[50] ibid

[51] ibid

[52] ibid

interactives that deal with migration. One of these has to do with the dictation test used during the White Australia policy era to keep out non-Anglo migrants. In this interactive, visitors must try their hand at a dictation test given to potential migrants. Most fail as the level of difficulty is deliberately quite high:

"Using a dictation test to select who could come in or not was just extraordinary. We didn't feel we had to convince people. It is pretty self-evident by just presenting what was done ... It was much easier to do it historically".[53]

The exhibition also contains an interactive of particular interest when it comes to exhibition design. This consists of an interactive way of making inclusion and exclusion an emotionally effective experience. It covers both historical as well as contemporary stories:

"Visitors to the interactive find themselves in the role of a government official charged with the responsibility of interviewing people applying to migrate to Australia, and discovering whether or not they 'get in'. They can select from three significant periods in the development of Australia's immigration policies – the 1920s, the 1950s and the present day. They can choose who they wish to interview: a Chinese woman in all three eras; a Greek family in the 1920s or 50s; an English couple in the 1920s or 50s; a South African couple in the present day; or an Iraqi man in the present day. They may interview more than one applicant in the same era, or across eras, to compare how different people fared over the years (to see how the 'White Australia Policy' was applied over time, for example)".[54]

The interactive has attracted strong interest among the museum's visitors: both adults and children. It is "hands on". It allows the thrill of being able to say, "reject". It makes rejection or exclusion vivid. How could a country send back to China a woman who would have to leave behind her Chinese-Australian husband and the five children born in Australia? It makes such exclusions, and the official White Australia Policy that justified them, an acknowledged part of Australia's past history.

The interactive also makes it very clear that decisions about exclusion are still current and still harrowing for those waiting for them. An Iraqi man is a particular example. So also is the rejection decision for a white South African couple. Emotionally, it converts these narratives into people and the decisions into personal ones – What would you do? It also addresses, though in an oblique way, the issue of waiting and uncertainty in refugee camps outside of Australia:

"We tried at least to include a bit of that feeling certainly in terms of offshore refugee camps through the interactive with the Iraqi refugee. It becomes evident that he has been there for about 8 years The actor who did that was a refugee himself who had been through that experience and we used his story as well as a couple of other people He talked about how hard it was to keep retelling your story exactly the same way over and over again and over a period of years and it would come down to the minutiae of what you say at any particular time. So the idea of the script was to sort of subtly bring that out – that that sort of trivial detail could impact on somebody's life".[55]

Getting in, of course, is not the whole of the story. The "sour" or negative side often applies after arrival. Qualifications may not be respected. Access to services, and where you live, may be restricted. The established community may not welcome you and other migrant groups may regard you with traditional antagonism. This exhibition, however, makes inclusion/ exclusion an explicit part of the story and presents ways of making that real to others.

Cartoons 2002: Life, Love, Politics

This third example of the negative side of refugee and migration stories comes from the National Museum of Australia's exhibition of political cartoons (2002).

Topics covered in the 2002 exhibition included the Kyoto protocol, health care, the drought, stem cell research, internal disorder within two political parties (the Australian Democrats and the Australian Labour Party), the war on terror, and Australian/U.S. relations.

The exhibition's prime focus, however, was Australia's treatment of refugees and asylum seekers. Curator Guy Hanson explains this choice on the basis of 2001 events:

"The treatment of refugees was a major issue in the 2001 federal election campaign and continued to dominate domestic politics in 2002. The Government has implemented a policy that aims to prevent asylum seekers reaching Australia's shores illegally. Using mandatory detention and the so-called 'Pacific solution', whereby asylum seekers are detained on a number of Pacific Islands, the Government has both been praised for its firm stance and criticised for a lack of compassion. Cartoonists have been quick to engage in this debate".[56]

The exhibition included several cartoons on the impossibility of entry. Among those was the cartoon "Please queue here" with a signpost in the middle of the ocean and rickety boats approaching it.[57] Material on detention centres included a cartoon of Howard explaining to Germans that the detention centres were not concentration camps.[58]

The so-called *Children Overboard Affair* (an affair described in detail in the later chapters on contexts) was also given considerable space. A short text summarised this context. The government had described photographs of children in the water surrounding a small "refugee boat" as showing children who were "thrown overboard" in an attempt to "blackmail" the government. The correct interpretation, only slowly revealed, was that the boat was sinking and Australian Navy personnel were rescuing the children.

The cartoons depicting these events noted both the varying interpretations of these events and Prime Minister John Howard's utilisation in his election campaign of the supposed "throwing overboard".[59]

The museum followed up this exhibition with a similar exhibition in 2003. Important in both is the relationship between museums and contemporary debates and the various ways in which museums can and do respond to them.

For a quite different approach to the debates of the 2001 – 2002 period, I turn to exhibitions in the Migration Museum in Adelaide: a temporary exhibition in 2003 and the development of a new permanent exhibition in 2007.

Migration Museum of South Australia: Two Refugee Exhibitions

In the final examples of this move away from standard narratives (adding on the negative side), I will look at two refugee exhibitions at the Migration Museum of South Australia. Both are later than the one used as an example for Move 1 (expanding on the journey).

The first of the new pair was a temporary exhibition of children's drawings. The second is a current major overhaul of the permanent galleries of the museum, aimed at reflecting contemporary debates.

Innocent Victims: Children's Drawings from Woomera is an interesting contrast to an exhibition, mentioned earlier, that focused on children's memories of arrival during the period 1950s to 1970s to Sydney. In that exhibition many of the children have fond memories of the fields surrounding the migrant centre of Villawood. Villawood, however, changed character when it became a detention centre in later years. *Innocent Victims* reflects current life in such detention centres.

The children who drew the pictures for *Innocent Victims* were not in Villawood (part of the Sydney area) but in a rural, isolated region (Woomera). The exhibition consisted of 20 digitally enlarged pictures by children within the Woomera centre that had been passed to individuals working with the detainees:

[53] ibid

[54] McFadsean (2004) Op.cit., p.4

[55] McFadzean interviewed by Goodnow, February 2006

[56] Guy Hansen, *Refugees*. In *Cartoons 2002: Life, Love, Politics*. Canberra: National Museum of Australia, p.7

[57] By John Spooner published in *The Age* shortly before the 2001 general election 08/11/01

[58] Bill Leak's 3/07/02 cartoon *PM in Bierhalle*, published in *The Australian*

[59] Matt Golding's *Interpreting Photographs* shows the same drawing of the sun interpreted in differing ways. 1) The Australian Navy's interpretation: "It's the sun" and 2) Howard, Ruddock and Reith version: "A spider that's had its legs pulled off by desperate asylum seekers." Published in *The Melbourne Times* during the Senate inquiry 20/02/02. Also note Bruce Petty's *Children Overboard* in which Howard tells the media that "To the best of my knowledge I was completely ignorant and no one advised me otherwise" while the public service and Navy hide in the room behind. Published in *The Age* 04/02 as information emerged of the role of the public service in filtering information.

"Many of the images depict violence witnessed by children during the 2001 break-out at Woomera, when water cannon and batons were used against detainees. The drawings were created by the children as a way of communicating what they felt and witnessed during this time".[60]

Little text was added, leaving the audience to interpret the images themselves. Media interest and press releases surrounding the exhibition, however, brought out many verbal accounts from the children:

"One child is reported as saying: 'I never put the small bird in the cage – now they put the human beings, not one, not two, thousands in the camps.' Another: 'When I was in Afghanistan, I never seen a jail, a hand lock, a tear gas, nothing ... and not in Indonesia or Pakistan, but now I saw everything'".[61]

The aim of this exhibition was both to represent current social reality and to promote social change. That double aim is reflected in this exhibition developed by the Migration Museum in Adelaide in conjunction with the non-profit organization, Justice for Refugees, South Australia. Compared to the museum's earlier refugee exhibition, *Twist of Fate*, it attracted large audiences, and was later shown in both the Immigration Museum in Melbourne and a community gallery in Sydney.

Changes to *the permanent exhibition galleries* at the Migration Museum also reflect the desire to address contemporary politics and policies. The policy issues to be addressed start with the White Australia Policy (1901 – 1973), followed by two opposing stories: the rise of multiculturalism as government policy in the 1970s and the treatment of asylum seekers and refugees in the 1990s to 2007. Curator Vivian Szekeres outlines the plan:

"We are going to make that big gallery ... look at the period of the White Australia Policy ... and stories of what that meant. And then in the next gallery we want to look at two main stories. One covers the rise of the concept of multiculturalism in Australia and the agencies that delivered the programs that supported that policy and, through stories, looks at what that has meant. And on the other side we are going to

look at recent refugees and detention centres and the government's policy on that and how it changed ... We would like the visitors to leave the museum outraged about the truth of something".[62]

The moves reflect also changes in the rhetoric around migration in general – including the recent addition of concerns for the environment as a reason for restricting migration:

"When we first started work here the arguments about immigration history ... really went something like this: 'Immigration is really good for the economy, it creates jobs', and the absolute opposite: 'Immigration is terrible for the economy, they take our jobs' Nowadays the argument has shifted. Now it is: 'This continent isn't big enough, it can't sustain any more people'. We will look at both of those ideas and hopefully in a way that gets people thinking".[63]

This desire to juxtapose issues and perspectives is also reflected in the way in which a new timeline is being created – a move away from straight numbers of arrivals to one which links more closely global events and the movement of people in general:

"What we are trying to do with the timeline is to follow the idea we started in the museum about colonisation. To really rethink the concepts about movements of people. In the last century – with the exception of the end of the century – the main reasons for movement were about colonisation or the results of colonisation. Sudan was the result of colonisation whereas another country might just be undergoing that period And the way we will do it is with two lines: a visual line of world images with a text that you can read underneath it, and another line of text on Australia which you can read underneath and finally a further set of images on Australia underneath.

What you will see is the time lag between what goes on in Europe and what happens here. At times it is really noticeable, such as in the 1930s with Mussolini, Hitler, Franco and Stalin in Europe while in Australia you have pageants and debates about bodyline (a style

of bowling in cricket) although of course you had the Depression and a lot of people were out of work. And then in another decade you see the results with the war happening and as the century progresses – 1956 with tanks rolling into Budapest – and 8 months later refugees arriving by boat into Australia. Seeing that absolute cause and effect is really important to do"[64]

As with other exhibitions in this museum, the timeline was a result of collaboration with the various communities in South Australia and includes personal stories:

"I sent out as many letters to communities as I could, saying tell me three events that you regard as significant to you that happened in your country of origin and were connected to why you left, and three events here. So we do get the wars but you also get the personal or first person stories".[65]

For Szekeres then the new permanent galleries are clearly an attempt to take part in a debate about multiculturalism and new refugee policies rather than following the safer paths of enrichment narratives, stories oriented toward cultural maintenance, or exhibitions based on an historical past. The new route is a different way of looking at what may be selected to represent "the darker side":

"In the past the refugees say that they were abused. That it was not an easy acceptance but they were needed to build our infrastructure and that others didn't want to do it ... but now we have another layer ... which is media driven, Federal government driven, and it's about scare tactics and ... threats about the enemy within and outsiders".[66]

The move is also part of a general view of how museums should operate:

"I'm hoping that this will be more risky. My boss is more nervous than I am. I mean what are they going to do – take you out and shoot you? They will just say that they don't like it. I think we should be even more overt ... museums should be part of the debate".[67]

This then was the final example of this section on adding the more disturbing aspects of migration and refugee stories. I take up next two further moves away from standard metaphors and narratives, with reference again to both migrants and refugees.

Move 3: Beyond Separateness – Cutting Across Ethnic and Spatial Boundaries

I noted at the start that Moves 1 and 2 are essentially ways of adding to the conventional narratives of departure, journey and arrival and to their usual focus on "the journey". In contrast, Moves 3 and 4 are more moves toward breaking away from the divisions that these narratives often apply, and from the museum formats that stem from them: the emphasis, for example, on oral histories, on old customs and their maintenance, and on markers of difference (from dress to the regions in which various groups live).

Moves 3 and 4 are inter-related, and some exhibitions aim at both. I shall nonetheless separate them, partly because they take different museum forms, and partly because they are prompted by different circumstances.

For Move 3, I use as examples two sets of exhibitions.

Example 1 consists of exhibitions focused on themes that cut across cultural lines, moving away from formats based on separate communities or ethnic groups. The aim is to avoid promoting divisive lines of difference and, for museums, an endless line of groups with each seeking its own museum space. These exhibitions generally downplay difference in forms of arrivals either as refugees or economic migrants.

Example 2 consists of exhibitions that soften spatial boundaries. Emphasised instead is the presence of shared space, of people from diverse backgrounds living side by side even though their customs differ. They share the same landscape, even though they use it in dif-

[60] Immigration Museum Press Release on Innocent Victims: March 2004

[61] ibid

[62] Szekeres in interview with Goodnow, December 2006

[63] ibid

[64] ibid

[65] ibid

[66] ibid

[67] ibid

ferent ways. Their style of living is suburban, even when the physical expression of that common style consists of Buddhist temples. The title of one exhibition – *Buddhism in Suburbia* – in itself expresses that argument. Covered again is a mix of refugee and migrant narratives.

Migration Museum of South Australia: Migration Exhibitions

For *Example 1*, I will return a final time to exhibitions at the Migration Museum in Adelaide and an account of change offered by its director Vivian Szekeres.

At the start, Szekeres admits, they were "unsophisticated" in their approach:

"The museum's first two changing exhibitions, one about costume from the Balkans and one about lace, did little to investigate cultural difference or to explore different histories. They simply displayed pretty things from different cultures. They were more ethnographic in content, rather thin on social history and certainly lacked any political analysis".[68]

Later exhibitions had a much more rigorous historical analysis and included a variety of voices:

"Exhibitions were developed that focused on particular communities The complexities involved in such stories opened possibilities to represent issues with more subtlety, to explore multiple meanings, and allow voices to speak about previously silent areas".[69]

The focus on particular communities, however, opened the danger of separate representations of a large number of communities, each seen as distinct from one another.

The outcomes were both planning difficulties for the museum and a lack of fit with its goal of not promoting divisive differences:

"The planning of programmes emerged as a very sensitive area to navigate. On the one hand the museum was representing and even promoting cultural difference, but on the other hand it was desperately trying to avoid reinforcing stereotypical images and the potentially divisive aspects of difference". [70]

That concern echoes one expressed by Karp and Kratz in the U.S.:

"Stressing similarities produces an assimilating impression creating both familiarity and intimacy with representations and their subjects. Assertions of unbridgeable difference, on the other hand, exoticise by creating relations of great spatial or temporal distance, perhaps the thrill of the unknown".[71]

The Adelaide move was then to exhibitions focused on themes that cut across cultural groups:

"Exhibitions on themes such as sport or childhood were developed, for example. This enabled the inclusion of many groups and analysis of cross-cultural connections. Interestingly, these topic-based exhibitions had enormous popular appeal. For example, *Strictly Black*, which explored the many different cultural reasons and meanings behind why people have worn and still wear black clothes; an exhibition about sport, called *Fair Game*, which took gender and discrimination as its main theme; and recently a travelling exhibition about food, called *Chops and Changes*, which showed that the ubiquitous lamb chop was now off the menu, displaced by foods from all over the world, brought in by immigrants after the Second World War".[72]

At the same time, the museum kept some provision for separateness in the form of a gallery called *The Forum*.

"In the mid-eighties this was a very novel concept. By now there are few history museums in Australia that do not have a community access space The Forum raises the really big question of exactly who constitutes community. Who is it that the museum works with when we say we are working with the Slovenian, Indian or Cornish community? The answer is not straightforward. It would be possible to choose from dozens of different models to describe the protocols, procedures and levels of interaction that take place before even one of these displays can open".[73]

Western Sydney: Fairfield and Casula Powerhouse

Example 2 brings together several exhibitions from a part of Sydney known as Western Sydney. Common to these exhibitions is more than their location. Common also is an emphasis on the ways in which space is shared. I shall present first of all a series of examples and then draw particular attention to their shared conceptual base.

The first three of these exhibitions come from the Fairfield City Museum and Gallery. In the 1990s, Fairfield City Council established a strategic plan to encourage people to enjoy, invest in, live in, and respect the area as representing "the living face of multiculturalism".[74] As part of that plan, it encouraged the museum to strengthen its focus on cultural diversity.

The museum moved to three quite different ways of doing so. One is to indicate how diverse groups can live side by side and can come to know about and respect each other. An example is an exhibition called *A Sideways Glance: An invitation to explore deeper areas of commonality*. This exhibition was developed by the Interfaith Committee of Fairfield City. The group included The Interfaith Committee Fairfield, Islamic Foundation for Education and Welfare, Smithfield Catholic Parish & Fairfield City Council. It was convened by Susan Hutchinson, Coordinator of the Museum & Gallery:

"The artworks in the exhibition were created by Western Sydney artists from divergent religious traditions …. As the title suggests, the exhibition encouraged visitors to look sideways at the 'other' culture and religion, and resulted in networking for artists and religious leaders from different backgrounds".[75]

Illustrating the same kind of approach was the exhibition *My Culture, Your Culture* (2005). This was:

"a series of exhibitions and events aimed at creating interaction, conversation and understanding between these diverse groups. It is also a celebration of vibrant visual arts, crafts, dance, music and cuisine, and provides a venue for groups to express memories of migration and cultural values …. By celebrating their cultural traditions at Fairfield City Museum and Gallery, these groups bring their customs out of private spaces such as clubs and homes, placing their traditions within reach of visitors of all ages and cultural backgrounds.

My Culture, Your Culture allows community elders to share and pass on skills, helping young people to reconnect with their culture. The exhibitions highlight the unique nature of cultural traditions, as well as remind us of the needs and experiences that many of us share".[76]

A second approach from the same museum was less concerned with the maintenance of an original diversity and with change only in the form of coming to recognise the presence of others and to experience the shared sense of belonging to the one place. An example is the *Backyards Project* in which a variety of migrants were portrayed in their small suburban backyards which they had transformed in a variety of ways – from bonsai gardens to market gardens growing fruit from home countries to elaborate sculptures of Australian iconography such as the Sydney harbour bridge. Shared is an Australian orientation toward the outdoor space typically placed behind one's house. This is space normally dedicated to activities that are not part of one's usual work week. Wonderfully diverse are the specific forms that this orientation takes.

The third approach appears in the 2002 exhibition *Vietscape*. It again starts from some aspects of shared physical space: in this case, the Australian landscape. Now, however, the emphasis is on art. More specifically,

[68] Szekeres, V. (2002) Op.cit., p.146

[69] ibid, p. 146

[70] ibid, p. 144. The senior curator of the Immigration Museum in Melbourne expressed a similar concern with the potentially indefinite amount of separate ethnic groups, forcing the museum to maintain a large set of "rotating" exhibitions.

[71] Karp, I. and Kratz, C.A. (2000) "Reflections on the Fate of Tippoo's Tiger: Defining Cultures Through Public Display". In E. Hallam and B.V. Street (Eds) *Cultural Encounters: Representing 'Otherness'*. London and New York: Routledge, p. 198. Amartya Sen takes this argument still further. He attacks the multicultural view of society as one that emphasises human identities as based only on one dimension (their ethnicity) as divisive and encourage the development of violence and "ethnic cleansing". Sen, A. (2005) *Identity and Violence: The Illusion of Destiny*. London: Allen Lane

[72] Szekeres, V. (2000) Op.cit., pp.146-147

[73] ibid, p.147

[74] *Tune in to Fairfield City: A Multicultural Driving Tour*" Sydney: Fairfield City Council and NSW Migration Heritage Centre, p.3

[75] Fiona Starr, previous Curator of Social History, Fairfield Museum & Gallery (2004) "Many Faces, Many Stories: Celebrating Cultural Diversity at Fairfield Museum & Gallery". In *Museums Australia* May 2004, p.19

[76] Fiona Starr in exhibition catalogue for *Sudanese Diaspora: Voices of Freedom* 2005

the emphasis is on:

"an interpretation of the Australian landscape and experience through Vietnamese eyes. Their works are also a meshing of memories, as the artists confront a new culture. For the artists their past experiences are not to be forgotten but somehow transformed to represent a new meaning and hope for the future".[77]

I shall return to a theme within *Vietscape* – the emergence of a new identity – in Move 4. As the main example of the crossing of boundaries by way of representations of space, however, I turn to an exhibition from the Casula Powerhouse Art Centre – the major exhibition *Buddhism in Suburbia*.

The spatial change is now a change in landscape: the presence of Buddhist temples. These in themselves represent cultural diversity and cultural groupings. The most prominent is the Vietnamese Phuoc Hue temple, but Buddhism is a religion that cuts across several groups: e.g. groups from Vietnam, Laos, and Cambodia.

For the curators of this exhibition, however, the significance of temples lies in the way they are part of the social life of suburbia. Brought out by tours, art exhibitions and seminars, is their significance as social centres rather than as places for religious withdrawal:

"The temple visits quickly dispelled any expectations of exotic experiences and instead revealed a culture where community members and temple life fit comfortably in suburban Western Sydney".[78]

What prompts the attention to space and landscapes? The moves toward cutting across ethnic or community lines (the Set 1 examples) were noted as often prompted by museum concerns: concerns with the sheer number of cultural groups, each potentially wanting separate representations, and concerns with the possible promotion of divisive differences.

The moves toward cutting across spatial or landscape divisions reflect partly the emergence of curators who represent second generations and partly a conceptual view of what "diversity" and "multiculturalism" mean.

One expression of that view emphasises the need to avoid "exoticising" what is physically different:

"The notion of the temple as a manifestation of an exotic multicultural experience is anachronistic and inadequate: we must recognise temples as a living and integral part of suburban life".[79]

A broader expression takes the form:

"If the Multicultural Project has been in any way successful, then the right of cultural expression, including spatial manifestations of ethnic background and religious interpretation ... should be readable in the landscape".[80]

The landscape of Western Sydney provides the case in point:

"The cultural landscape of Western Sydney has progressively evolved through the multicultural contributions of migrant communities during the past thirty years. Through the participation and integration of these communities there are now more and more visual statements of different cultures in the local environment, although the terms by which these contributions are understood continue to stimulate cultural and political change. The perception of multiculturalism as an inert political policy has been transformed by the lived experiences of the many community groups that continue to enhance and develop Australian society".[81]

Does that picture, however, in itself contain omissions? If "the negative side" is always somewhat present, should the spatial representations not also include this? Surprisingly, the surrounding suburbia appears to have had little difficulty accommodating temples in the landscape. The large Vietnamese temple is in fact now regarded as "iconic" and regularly written up as attracting prominent overseas visitors (e.g., England's Prince Charles). The occasional tensions have been in relation to "house temples" where subgroups set up "temples" within smaller houses, giving rise to concerns on the part of neighbours and on the part of councils enforcing regulations with regard to the use of residential spaces.

That acceptance may reflect a general view of Buddhism as warranting little fear or antagonism. An

exhibition held at the Art Gallery of New South Wales, for example, (*Buddha: Radiant Awakening*), attracted an estimated 100 000 people.

The same level of acceptance, at least in the physical landscape, does not yet apply to mosques. Tensions and arguments continue to mark proposals and council decisions related to their becoming part of the physical landscape. Time or a changing image of Islam as peaceful and mosques as social centres may make them an equally accepted part of the suburban landscape. Global events and political rhetoric surrounding the Middle East, however, seem likely to slow this process: once more an example of the need to understand exhibitions – their development, reception and interpretation – in relation to broader contexts. Clear, however, is the emergence of museum representations of space as a way of breaking down images of division and separateness among cultural groups.

Move 4: Beyond Frozen Identities–Cutting across Generations, Adding Younger Voices

An exhibition presented as part of Move 3 – *Vietscape* – was noted there as a first indication of exhibitions moving beyond the orthodox boundaries of cultural groups. Its placement in Move 3 was because of its focus on interpretations of the Australian landscape. That exhibition also saw – on the part of the artists represented – a search for a balance between the old culture and the new and for an equilibrium between identities.

Example 1 makes that search more visible still. This is a painting and new media exhibition given the title, *The In–Between 1.5 Generation Viet-Aus* (Casula Powerhouse Arts Centre 2002).

Example 2 (*Generate: Youth Culture and Migration Heritage in Western Sydney*) continues the move toward representing mixtures of identity, again thought of as being "in-between". The participants now, however, are young adults (predominantly Middle Eastern and Asian in background). The emphasis is on social invention rather than artistic work, and on the ways in which these young adults turn to defining themselves by region, religion, gender or occupation rather than ethnicity.

Example 3 is an exhibition – interactive and collaborative in form – that again concentrates on young people and on the ways in which their experience of growing up in a region differs from that of other generations. It picks up especially their sense of regional affiliation. The title, *Bodgies, Westies and Homies*, reflects the terms often used by youth in this region – and by others outside it – to indicate their regional affiliations. In another form of change, the emphasis is also on the topic of "fun" rather than "heritage".

The In-between 1.5 Generation

This exhibition is one part of work initiated by Cuong Phu Le at the Casula Powerhouse Arts Centre, and a brief note on his activities and orientation is in order. He has worked on numerous exhibitions and events with Asian communities in Western Sydney. His projects range from what can be seen as "cultural maintenance" projects to a variety of projects that bring out dual, hybrid and fusional identities – from food markets and craft exhibitions to art exhibitions such as *Viet Pop: Emergence*, literature anthologies, and seminars by emerging Vietnamese Australian writers. Cuong Le was also the co-curator of the *Buddhism in Suburbia* project.

He describes himself, in interview, as interested in "exposing" culture, and in making demands for more permanent representation of Asian-Australians in Australia's galleries and museums.[82] He is also seeking new forms of expression (the arts form one of these) and ways of bridging old and new, supporting artists who wish to use cultural traditions in new ways rather than turning their backs on them. Needed, he argues, are new ways of working with refugee groups – beyond simply gathering their oral histories, their migration stories of departure, journey and arrivals.

One of his exhibitions was titled *Viet-Pop Emergence*.

[77] Exhibition catalogue 2002

[78] Project Director Cuong Le and Exhibition Curator Karen Greenhalgh (2005) "Enriching Suburbia". In *Buddha in Suburbia: Greater Western Sydney*. Sydney: Casula Powerhouse Arts Centre, p.12

[79] ibid, p.13

[80] Dunn, K.M. (1999) "Mosques and Islamic Centres in Sydney: Representations of Islam and Multiculturalism, PhD Thesis, The University of Newcastle, cited by Cuong Le and Karen Greenhalgh (2005) Op.cit, p.12

[81] Le, C. and Greenhalgh, K. (2005) Op.cit., p.12

[82] In interview with author, Liverpool Museum, February 2006

The focus was on "personal stories of young Vietnamese Australian living in Western Sydney. It included oral histories, music and objects which had stayed with the families of the participants since their leaving Viet Nam".[83]

In art critic Djon Mundine's words, this exhibition was:

> "alive with wit, colour, honesty and pathos …. this show is … one of the first (if not the first) to concentrate on young, emerging Vietnamese artists. It is this generation that articulates the changes in the way Australia constructs its ethnic and cultural identity at this moment".[84]

This playful attitude towards cultural mix was at the forefront of many of the works included. Among them was the work of Vietnamese-Japanese artist Nguyen Hatsushiba:

> "His work often deals with the experience of being a refugee and of statelessness, and of being Vietnamese in the world, whether you are in Ho Chi Minh City, in Paris, in California or in western Sydney. Yet what Jun shows is that having 2 cultures and 2 languages enables people to gain insights that they wouldn't normally. It's what is *added*, not what is lost".[85]

For the *In-Between 1.5 Generation* exhibition Cuong Le turned also to artists working in a variety of media – painting, installation, sculpture, miniature landscape, photography, digital media, film and video:

> "Nine artists, of nine different backgrounds and various levels of Vietnamese heritage, regularly met leading up to the exhibition to discuss their identity as Vietnamese Australians and artists …. At the first meeting, academic definitions about the term 1.5 Generation were presented and afterwards there was much discussion … They all had some recent experience of going back to Viet Nam … and puzzled over being Australian and/or Vietnamese, or neither. Before going back, each believed that Viet Nam was still the core they belonged to, but soon after returning they found things to be quite different.

> To the local Vietnamese they were not considered Vietnamese. After returning to their country of birth some then found that Australia was more 'home' to them and they started to realise how strong their bond with Australia was. However, others learned that they were neither Vietnamese nor Australian and this dichotomy provoked and haunted them for a while and has become the inspiration for their work.

> At the second meeting, the artists continued to talk about the term 1.5 Generation and this led then to the notion of 1.25 generation and then a 1.75 and so on. It was a good chance for people to exchange views and attempt to coin their own definitions". [86]

The term was also a way of recognizing that the Vietnamese group was no longer "new":

> "After twenty five years of Vietnamese settlement in Australia a new generation tentatively named the '1.5 Generation' has emerged in contemporary Australian society. They are people who are literally 'Born in Vietnam and Made in Australia' – those who had left their home country and arrived in the host country during early or middle adolescence".[87]

The exhibition was seen by others as also a way to cut across generations and move beyond the interests of the older generation only. There is now a substantial group that is a second or third generation in the new country. ("Nguyen" is now among the ten most frequent surnames in Sydney's telephone directory). Members of this group feel that they are distinctive, that they face some particular cross-generation linkages, and that they can offer something new and vibrant to both their original and their new culture.

In one expression of that view:

> "There is always a generational gap between the first and second generations, regardless of cultural and linguistic backgrounds, in the same way as the older and younger generations within 'mainstream' Australia. But for a largely refugee community like the Vietnamese, this generational gap becomes more accentuated because older Vietnamese Australians want not only to adhere to, but also to pass on their

tradition and heritage, which may not be always seen as suitable by the younger ones in a different cultural environment. Inter-generational tension exists and has been amply reflected in films and plays. It can, however, be cushioned by the 1.5 generation, because this transitional generation can and does embrace both cultures".[88]

In another:

"Their bi-lingual and bi-cultural character has positioned this so-called 1.5 generation uniquely as 'in-betweens', they cannot fully belong to either Vietnamese nor Australian mainstream culture Due to their bi-cultural position the 1.5 generation plays an important role as a 'hyphen', linking the first and second generations of the Vietnamese community, and in a wider context, linking a local and global world the identity this generation creates can be understood as being a hybrid identity which is not contained by the orthodox boundaries of race, culture and generation".[89]

It is possible, however, that Vietnamese Australians represent a special group. Vietnamese, in this exhibition's description, have a history of maintaining their sense of a special identity even in Vietnam:

"Successive foreign influences imposed in Viet Nam over long periods have forced her people into a constant fight for their identity in their own country. It was not an easy task to escape from the 'Chinese Umbrella' and to retain the indigenous culture. It was also not easy to keep distant from the French influence when Western technology proved its prevalence over Asian philosophy more than a century ago. It is, therefore ironic that, the generation 1.5 is more or less doing the same 'bloody thing' that their forefathers did: trying to search and keep their own identity while being in-between".[90]

This bridging of cultures was also at the forefront of a more recent exhibition curated by Cuong Le, utilising visual arts: *I Love Pho* (to be followed up in 2009 with a larger version called *Pho Goes Global*). Pho is a Vietnam-

ese beef rice noodle soup, central to Vietnamese cultural heritage. The dish has followed Vietnamese through their colonisation and through the diaspora. In the exhibition, Pho is used as a:

"metaphor to interpret and reveal Vietnam whose people and history are as varied and complex as the preparation and cooking of a bowl of Pho itself. Through its own global journey, Pho is unique, flexible and versatile in borrowing, adapting, modifying, ultimately creating its own culinary experiences. It challenges all notions of the hybrid, traditional and authentic where adaptation, migration and movement are common in an era of intense globalisation".[91]

The next two examples make it clear that Vietnamese Australians are not the only ones seeking to express, and to have represented in museum exhibitions, their breaking away from frozen cultural identities and their transformations of who they are and where they live.

Generate: Youth Culture and Migration Heritage in Western Sydney

This exhibition continues the theme of combining past and present. The past is a "cultural background" (predominantly Middle Eastern and Asian youth is the catalogue description). The present is life in Australia. Most of these youth have been for some time in Australia or were born in Australia. The project was developed by the Migration Heritage Centre (MHC) based at the

[83] Boi Tran Huynh (2002) "The In-Between Generation". In *The In-Between 1.5 Generation Viet-Aust* Exhibition catalogue Sydney: Casula Powerhouse Arts Centre, p.19

[84] Mundine, D. "VietPOP: a New Generation Speaks" at: www.realtimearts.net/rt50/mundine.html

[85] ibid, emphasis in the original

[86] ibid, p.16. The academic origin of the term 1.5 generation comes from Ruben G. Rumbaut (1976) "The One-and-A-Half Generation: Crisis, Commitment and Identity". Paper presented at the annual meeting of the American Society for Adolescent Psychiatry, Miami Beach, Florida May 1976

[87] Cuong Phy Le and David Cranswick (2002) "Introduction". In *The In-Between 1.5 Generation Viet-Aust* Sydney: Casula Powerhouse Arts Centre p.6

[88] Tuong Quong Luu, AO, Head of SBS Radio (2002) "Lost and Found – A New Homeland: The Roles and Characteristics of the 1.5 Generation". In *The In-Between 1.5 Generation Viet-Aust* Exhibition catalogue Sydney: Casula Powerhouse Arts Centre, p.10

[89] Cuong Phy Le and David Cranswick (2002) Op.cit., p.6

[90] Boi Tran Huynh (2002) Op.cit., p.16

[91] Pho Goes Global press release, 2006

Sydney Powerhouse Museum and the Centre for Cultural Research, University of Western Sydney (UWS).

Conceptually, the exhibition draws on views of any in-between state, and of heritage, as creative and inventive rather than static.

"What does it mean to be Australian today? What does heritage mean in a society that has changed its face so radically in the past few decades? Is it tradition, something of the past, something unchangeable? Or is it a living thing, constantly being created, adopting and adapting the past?"[92]

"The word 'heritage' made everybody feel nervous because it had been shaped by so much rhetoric about national building and national identity. And some of us felt left out. The simple fact is that 'heritage' is now more about identities on the move, shifting and transforming, fusing and traversing everyday lived practices rather than being enclosed in a stagnant and fixed notion of what it means to be young and to live in Western Sydney".[93]

Conceptually, the exhibition draws also on a view of incoming groups as not simply "enriching" some marginal parts of an established culture but also as changing that culture:

"*Generate* focuses on the *generative* contribution of young people to changing notions of Australian culture and the place of migration heritage in its formation".[94]

"These young people often express a sense of *being in-between* as they negotiate life between their cultural backgrounds, friends and the wider Australian society. Rather than simply harking back to homeland traditions, ritual and ceremony, memory and ancestry, migrant youth *actively create* new linkages, attachments and affinities between and across different cultures. This suggests that these young people may be the first generation to move away from explicitly ethnically-defined cultural identities, embracing other categories such as region, religion, occupation or gender to define their place in Australian society. Their involvement in different cultural worlds *requires real engagement with diversity* and provides

rich resources for invigorating the multicultural fabric of the nation".[95]

"Engagement with diversity", however, needs to take account of the social categories or identities that are already present within established groups. That presents a particular problem in Western Sydney. The area is large, densely populated (1.7 million), and economically vibrant. In the eyes of much of Sydney, it has long been seen as "a cultural wasteland".[96] In the eyes of those who live there, that description is meaningless.

Youth from families with migration history behind them may then turn to a regional identity as their new status. This regional identity, however (e.g., being a "Westie") may in itself be limiting. That sense of a limited external image is certainly part of the emphasis in the Casula museum on its being a "vibrant and innovative" arts centre. It is also part of *Generate*'s focus on altering the image of "Western Sydney" as separate from other parts of the city and of "Westies" as essentially bound to the region, only occasionally "visiting" places outside it.

How then to counter that image? The book associated with the exhibition *Generate* describes moves toward "breaking myths":

"This book is concerned with the way that popular images of Sydney's west as a cultural ghetto on the suburban fringe continue to marginalise, stereotype and impact on how young people living in Western Sydney relate to their own sense of identity, home and belonging. This book is about breaking, altering and rewriting such dominant myths and narratives by calling attention to the continuities and discontinuities of cultural spatial practices that constitute the living heritage of young people's lives. Much of the young students' concerns here is formed by their acute awareness of being looked at, judged, and found inferior by the dominating gaze of the self-proclaimed 'inner city' cosmopolitans. As such, their work is a way of 'talking back', a response to the experience of 'Othering' by asserting the reality and legitimacy of their own experience of home and place".[97]

The exhibition itself focuses on representing the youth of

the region as "both very localised and highly mobile".[98] In their daily life they often travel back and forth between their suburbs and the inner-city. The project was then geared toward bringing out their sense of movement and of journeys within the city (the "experience of migration, of moving around, is increasingly a universal one").[99] More concretely, each participant starts from a particular spatial point.

"Each story is a response to an individual site and space, as a study of people and their specific history and understanding of place and culture. The students used a variety of visual approaches to communication, linking signs and sequential imagery, in a layering and building up of visual information. Some used statistics as a starting point, which became focus points for linking within the narratives. Most of the students began with the railway station in their selected suburb as a starting point, and then the journey opened out to include other streets, landmarks, and individuals who inhabit and add colour and life to the particular Australian vernacular which is found in the works".[100]

Emerging then is a different view of "journeys", of travel and movement:

"The language of youth, home, identity and belonging follows their journeys through a cultural mapping of Western Sydney. Each suburb acts as a transit stop. Each stop acts as a temporary, dynamic identity. The movement of their lives comes from the turnings and hesitations of their crossings: full of breaks, deferrals and postponements. The result is a series of visual reflections on space and place which go beyond the conventional dimensions of youth culture".[101]

That particular change from "conventional dimensions", however, may still be limiting. The picture presented is, for example, a very serious one. Here are youth earnestly travelling, altering myths, and changing Australian society for the better. Are there alternatives?

Bodgies, Westies and Homies

The last exhibition I single out is one that opened at the end of 2006, created by a new young curator at the Fairfield City Museum and Gallery, Kim Tao. Like *Generate*, the emphasis in this exhibition is on change over generations rather than any static "cultural maintenance";

"The exhibition aims to document the history of being young and to encourage people to think about how society has changed and how their experience of youth is different to that of other generations".[102]

The focus is on "the social history of youth and growing up in Western Sydney, exploring the concept of 'Being Young in 2006' (aged 16–25) with comparisons from past generations who grew up in the 1940s – 1960s".[103]

As in *Generate*, the content emphasised is creative work:

"The interactive and collaborative nature of the project encourages local youth to use art and film to express themselves creatively and address both the stereotypes and realities of growing up in Western Sydney".[104]

Unlike *Generate*, however, the images emphasised are both "new" and "fun". The exhibition is structured around four main themes:

1. *Having Fun* – leisure, games, clubs, sport, social events, friends

92 Ang, I. and Shumack, K. (2002) "Introduction". In *Generate: Mapping Youth Culture and Migration Heritage in Western Sydney*. Sydney: Migration Heritage Centre and Centre for Cultural Research, University of Western Sydney, p.10
93 Karaminas, V. (2002) "Migrations of Identity and Home: Mapping Western Sydney". In *Generate: Mapping Youth Culture and Migration Heritage in Western Sydney*. Sydney: Migration Heritage Centre and Centre for Cultural Research, University of Western Sydney, p.19
94 Ang, I. and Shumack, K. (2002) Op.cit., p.10, emphasis in original
95 ibid, pp.10-11, emphasis in original
96 ibid, p.11
97 Karaminas, V. (2002) Op.cit., p.22
98 Ang, I. and Shumack, K. (2002) Op.cit., p.11
99 ibid, p.12
100 ibid, pp.12-13
101 Karaminas, V. (2002) Op.cit., p.22
102 Exhibition synopsis provided by The Fairfield City Museum and Gallery, February 2006
103 ibid
104 ibid

2. *Being Cool* – fashion, hairstyles, trends, music, computers, language
3. *On the Street* – cars, street racing, crime, vandalism, drugs, alcohol
4. *My Home* – family, houses, quality of life, rules

To convey those themes, the exhibition includes "objects and photographs from museums, local studies and private collections, and oral histories and home movies". Included also is a "series of workshops facilitated by an established young artist and filmmaker … where local young artists will be able to create artworks and a short film for display … during the exhibition period".[105]

In short, the aim is to bring out a vision of identity as transcending orthodox cultural and generation boundaries, with the embracing and the creating of a new regional identity as a vibrant alternative.

Final Comments

This chapter has focused on exhibitions that serve as examples of four moves away from traditional representations of immigrant and refugee narratives. All four aim at accounts and images that immigrants and refugees will feel represent the reality of their experience, and that, in others, will generate a richer understanding, a greater empathy, a sharper awareness of others' experiences and the policies that shaped them, and a loosening of the usual categories and assumptions that we bring to the lives of those we see as "others". All four aim also at describing challenges that other museums may find familiar and changes they may see as possible to adapt or best avoided.

The first move consisted of staying with the standard metaphor of a "journey" but adding complexity to one or more of its phases: bringing out, for example, the sadness of departures, the plight of those left behind, the nature of the journey, the shock or joy of arrival, and the multiple progressions that occur before feeling that there is an end to "being a refugee". The title *Walk With Me* is evocative.

The second took the form of adding more of the "negative" or "grittier" side to points of departure, transit, arrival or settlement. The conventional narrative is one of happy arrivals, welcoming crowds, and the pub-

lic recognition of differences as enriching the country now entered. The reality often has more to do with moments of exclusion as well as inclusion, of rejection as well as acceptance, based on criteria that varied from one time to another. The titles *Passports* and *Getting In* are evocative.

The third and fourth are still concerned with changes over time but go well beyond the point of arrival as either an immigrant or a refugee. Instead, the focus in the third kind of move is on the landscape as a measure of change. The shift is away from the concept of separate identities and separate spaces, bringing out instead shared landscapes and shared suburban style that co-exist with a sense of different histories. *Buddhism in Suburbia* is an evocative title.

The focus in the fourth kind of move is on going beyond "frozen" identities. Instead the emphasis is on identities that combine past and present, old and new. Titles such as *The 1.5 Generation* are now evocative. The title *Bodgies, Homies, and Westies* takes the move still further. The emphasis now falls on taking over identities based on the particular regions in which one lives: identities that highlight a shift in generations and a shift in practices ranging from games to dress.

All four moves, I have noted, present museums with challenges related not only to content but also to method: challenges that vary from the availability of objects that might convey meanings to the reluctance of people to offer personal stories that might identify them too closely, might seem "unappreciative", or might stir up memories felt to be best left undisturbed.

The account is deliberately selective. It is selective in its focus on two particular countries. Even within these two, New Zealand has been given far less space than that given to Australia. New Zealand, however, deserves – and will be given – its own space in a later review. It is selective also in the museums and exhibitions covered. I have aimed not at covering everything possible but at pulling out examples that are illustrative and that can usually be supplemented by direct comments from curators, bringing out their intentions and their sense of challenges and possible steps.

Do those illustrations of change mean that all the challenges have been met? There are still missing stories. At an earlier point, I mentioned briefly that in museums

globally there is a shortage of stories about the people *who did not make it or were left behind*. These may be the stories of refugees denied family reunions as governments worldwide move towards making this more difficult for refugees and migrants (e.g. the recent moves by France). This lack is also notable in Australian museums despite their prominence in other media. In the Australian context, for example, the denial of family reunions for refugees granted Temporary Asylum Visas (TPVs) led to desperate attempts by family members to reach Australia by boat (attempts described in later chapters). These stories of tortuous journeys and often tragic endings (e.g. the journey of the boat known as SIEV X) are not yet present in museums. References to boat travel remains firmly located in the 19th and mid-20th centuries.

Largely missing are also the stories of the majority of global refugees and the internally *displaced in overcrowded refugee camps*. (The exhibition *Walk With Me* was one exception). The concentration on those who make it downplays the fact that there is a much larger population of those still needing to be moved to safety or supported where they are. The link between the arrived and those still in waiting is seldom made. In the Australian context also, the creation of offshore detention camps in places like Nauru is not yet dealt with by museums. Missing, finally, are the stories of those *who are forced to return.* These several stories are being dealt with in other media – in theatre, in new media works, in film and in literature. They are also prominent in sections of the print media and television. We need now to watch how and when they begin to appear in museum representations.

[105] ibid

Top: The opening of the *Candombe Yauguru* exhibition at the Fairfield Gallery and Museum, Sydney.

Left: (Boy in costume) Adrian Sanchez at the opening of the *Candombe Yauguru* exhibition.

It's more family friendly in Western Sydney

MARGARET PHAM

MODERN HOMES
MODERN FAMILIES

Bodgies, Westies and Homies at the Fairfield Gallery and Museum, Sydney.

The "push" and "the pull". From the *Passports* exhibition at Te Papa Tongarewa, Museum of New Zealand.

Shipping trunks at the *Passports* exhibition at Te Papa Tongarewa, Museum of New Zealand.

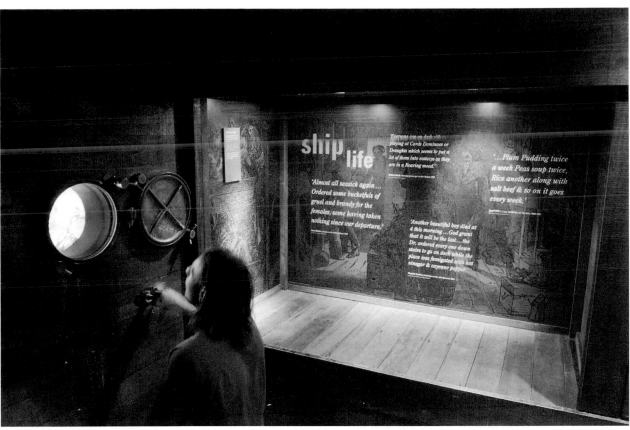

19th century migration. The *Passports* exhibition at Te Papa Tongarewa, Museum of New Zealand.

The entrance to the *Passports* exhibition.

Survivors: Students, 'refugees from Oldland', in the Woop-Woop
Detention Centre.

Survivors: A refugee education programme at the Migration Museum, Adelaide, South Australia. Protest between two groups of Newlanders. Some who want the refugees to stay, others who want them to go home.

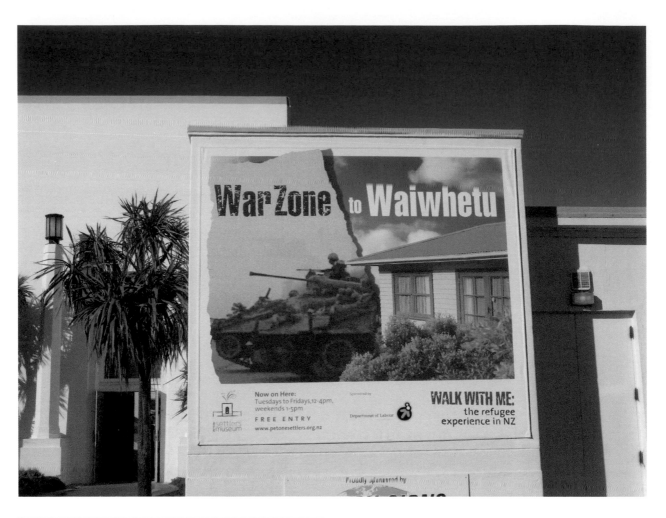

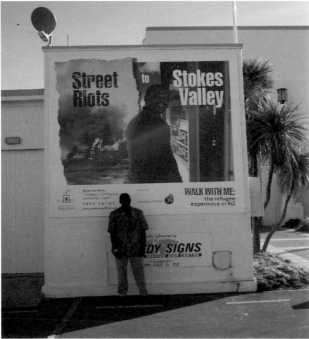

Walk With Me: The Refugee Experience in New Zealand at the Petone Settlers' Museum in Hutt City, New Zealand.

Walk With Me: The Refugee Experience in New Zealand.

CHAPTER 1
Introduction and Overview

Katherine Goodnow

Across countries and across time, asylum-seekers and refugees have been represented in a variety of ways. In some of these they appear as dangers, threatening to "over-run" a country or a region with "floods" of incompatible strangers. Closing the gates, "securing the borders", then becomes the action that should necessarily follow. In other representations, the same people are pictured as desperately in need of assistance, as "homeless, tempest-tossed" and "yearning to be free".[1] If a country is to maintain its sense of humanity and compassion, and its reputation, opening the gates at least to some extent becomes the action that should necessarily follow.

Competing frames mark each step of the way when it comes to situations that involve refugees. Countries may vary in the extent to which their governments and their people favour one representation, one kind of frame, over another. Any single country may also vary from time to time in the extent to which its policies are oriented toward exclusion or toward entry, presented to the public as reflecting "a crisis of control" or "a humanitarian crisis". At times, these policies may even be presented in ways that attempt to combine both orientations: to reflect – to use one description – both "hard heads and soft hearts".[2]

Understanding such variations and shifts is important for two inter-related reasons. One of these is their social and political significance. These representations go to the heart of perceptions and policies related to refugees, human rights, international agreements, and the possibility of cultural diversity. Any attempt to "manage the media" or to influence opinions needs to start from an understanding of how representations are established, maintained, or changed.

The other reason is the opportunity offered to add to what we know about the nature of representations in general. Central to analyses of representations are questions about how representations compete with one another for credibility, how disagreements or dissent are managed, the nature of "news", how representations change over time, and how a variety of circumstances – from the interplay between sources and media to the nature of audiences – influence the way representations are shaped and received. The way asylum seekers, refugees and population moves are represented allows us to pursue those questions. We can then note how the pursuit of the general questions adds to the depth of our understanding of any specific event. We can also note how various proposals about the general questions work out in practice and may be expanded.

It is possible, however, to pursue the general questions by way of a variety of content areas. News reports, novels, film and television, for example, have all been analysed with an eye to the ways in which they represent diversity (people varying, for example, in skin colour, country of origin, class, gender, speech, or age) especially when they differ from the group that most perceive as "us".

Representations of diversity, however, are likely to vary with whether those "others" are already present within a region or are outside it. "Others" already within a region, for example, may be made as invisible as possible, seldom featuring in representations of the "mainstream" or "the essence" of that society. In contrast, when "others" are at our gates, and when that arrival is dramatic in its style, it is often more difficult to make them invisible: to have them simply fall outside the usual "news". Shutting the gates and ignoring the pleas for entry, opening the gates to a selected few, opening them only to allow entry into another restricted space with a new set of barriers: These actions are more likely to be "news", to evoke some comment or reflection, and to call for representations that justify them and make them part of "common sense". In effect, when diversity is accompanied by refugee status, old questions about the representations of "others" and of appropriate actions now take a new form.

How then shall we proceed? The analysis of many representations, especially over time, often turns to some specific events, using them as an anchoring base for examining possibilities that can apply beyond them. For refugees, there is no shortage of such events. At an earlier point, for example, I turned to representations – in the Norwegian press – of Bosnian refugees in Norway during the election period of 1993 and 1995. Some of those representations emphasised the need for limits of several kinds: limits to the total number, to the length of stay ("asylum" should be temporary), and to where – within the country – refugees could live. Other representations emphasised the need for compassion, the impossibility of return to the country of origin, the moral unacceptability of forced return, and respect for the traditional meaning of "asylum". The election in 1995 was strongly marked by that contrast in representations, with the larger percentage of votes going to those who had expressed the need for compassion and concerns for the country's reputation as "humane".[3]

This takes as an anchoring base a different set of events: a different place, a different set of refugees, and a longer period of time. The period covered is 2001 to 2006. The events in question begin in 2001 when a ship on its way from the west coast of Australia to Singapore (the Norwegian freighter – *Tampa*), rescued 400-odd people from their sinking boat. Most of the rescued were originally from the Middle East, but they had boarded in Indonesia with the hope of reaching Australia and being accepted there as refugees.

The asylum seekers wished to move toward Australia. The Australian government insisted that the ship return the refugees to Indonesia. Conditions on board led the captain to issue an international distress call and to sail toward the nearest port. This was Christmas Island: an island controlled by Australia. Against the expressed wishes of the Australian government, it entered Australian territorial waters, anchoring off Christmas Island. The Australian government then refused permission to land. Neither crew nor passengers could leave the ship.

That beginning promptly led to a flurry of competing representations. Was this "a maritime rescue" and "a response to distress", covered by the conventions of the sea, international agreements, and humanitarian principles? Or was it "illegal entry", violating "the sovereign right" of a country to refuse entry at will? That clash of representations was far from minor or local. Still being debated, at international levels, are definitions of responsibility and possible consequences. If all countries exercised their "right to refuse", for example, what would happen to any rescued group? Would ships now become less willing to engage in rescue?

That beginning was marked also by major attempts to control the representation of these asylum seekers and their situation. The Australian government allowed no contact by Australian news media with anyone on board the *Tampa*. All announcements and all news were to come through government sources. The definition of "distress" could then be managed, to the point of being declared either non-existent or at least below the level needed to warrant "rescue". As it turned out, some of the attempted management was reduced by their being another source of news already on board. One of the

1 Phrases engraved on the Statue of Liberty (New York), from a poem (*The New Colossus*) by Elaine Lazarus.

2 *Sydney Morning Herald*, 01/06/05

3 Goodnow, K (1998) *Refugee Policies, Media Representations* Bergen: Department of Media Studies; Goodnow, K. (1999) "Norway: Refugee Policies, Media Representations". In O. Tveiten *Bosniske Krigsflyktninger i Mediebildet – Nordiske Perspektiver*. Copenhagen: Nordisk Ministerråd. Chapter 9, however, notes that the dominant voices in 2005 are more in favour of restricted entry and the maintenance of homogeneity rather than the tolerance of diversity.

crew sent, to Europe, photographs of the rescued 400 plus, huddled on the decks of a ship intended to carry at most 50. That breach in control, however, was far less than full media contact would have yielded. It also allowed the government to claim that no legal request for asylum had been made. A legal request requires contact with a civilian resident and setting foot on Australian soil (an asylum request to someone in the Defence services does not count).

Highlighted from the start by those actions was the extent to which law had been observed. Representing oneself as acting "legally", whatever its costs to others, is clearly part of the representation game when it comes to refugees, often complicated by the presence of both local law and international agreements. The *Tampa* event concretises that concern in dramatic fashion. The Australian government took two steps that made it possible to represent the *Tampa's* asylum seekers as "never actually arriving". It redrew Australia's borders, so that the island in question was "excised" from the "migration zone" that had served in the past as an area from which applications for refugees status could be made and considered. In an "outsourcing" move that has since become attractive to many other countries[4], it also financed a detention centre in another country (the impoverished state of Nauru) and imposed there its own internal policy of mandatory and indefinite detention and its exclusion of the media. (The first journalist allowed entry, after a change in government in Nauru, was in 2005).

In the face of criticism from both national and international quarters, the government also had to invent ways of presenting itself as simultaneously both firmly in control and compassionate. In a move designed to delete any question of compassion, it reframed the dilemma as one of determining who decides "who will come into the country and under what circumstances". "We will decide" became the slogan for the election campaign. Its appeal, several have noted, allowed the government – the Coalition led by John Howard – to win, at the end of 2001, an election is was expected to lose.[5]

Those several moves illustrate in dramatic fashion the ways in which a government can manipulate representations. It can define its borders as in such desperate need of "protection" that a variety of reinterpretations

and exclusions are called for. The moves provide as well the opportunity to ask what makes some particular representations attractive or feasible to particular groups of people at particular times. In theory, the persuasiveness of any representation has been described as influenced by factors such as the relationship between government and media, the nature of audiences, and in particular, the categories, narratives and history that audiences bring to bear on events and expect to find in any news report or any account of events.[6] The events that began with the *Tampa* provide the opportunity to observe and examine such factors and the related concepts that have been offered.

The events that began to unroll in 2001 illustrate also how shifts in representations and actions can occur. The established procedure was one of mandatory and indefinite detention for all who entered without prior screening: a policy that has been labelled as entry "by invitation only".[7] Shifts away from that policy came only in 2005. They were only to parts of the policy. They came also in response to some particular expressions of dissent: expressions that also juggled images of control and compassion, but with an emphasis on the latter, and that came not from "the opposition" but from within Howard's own party.

Here then we have the opportunity to observe and analyse what several have seen as the classic fate of all representations that seek to be "persuasive". An initial definition or interpretation is asserted. It is challenged. Over time, to maintain its dominance, it needs to keep those challenges off-stage, to discount them, or to co-opt them (to "domesticate" them).[8] The Australian events offer also the opportunity to ask what makes dissent effective and to observe how the lack of a clear focus or of coordination among dissenting voices can produce little change to a firmly maintained black-and-white stance.

The Order of Chapters

To allow readers to sample according to their varying interests, this overview provides a broad advance map. Readers may, for example, start with the background material in Chapters 2 and 3: material covering concepts drawn from studies of representations in general

(Chapter 2) or from analyses of contexts – features characterising contexts in general and the Australian scene in particular (Chapter 3). They may instead skip directly to a set of chapters covering a rapidly unfolding series of events that began with the *Tampa* in 2001 and continued with other "maritime incidents" (incidents such as the "children overboard" affair and SIEV X). That series of events prompted a flurry of actions and justifying representations on the part of the Australian government, and were met with a mix of approval and criticism (Chapters 4, 5 and 6).

Those chapters bring out the continued interplay of competing frames, the nature of attempts to manage representations, the impact of what makes some events "newsworthy" and others not, and the nature of dissent and moves to deflect the impact of dissent. Dissent becomes a more dominant theme in the analysis of next events: events that take us up to the end of 2006. Dissent emerges as having several bases. It may stem from concern with issues of law and false representations, from compassion sparked by the visible distress of individuals ("women and children" especially, and "people just like us"), from dismay over the procedures followed in the course of implementing policies and the departures from a country's core values. This trio of chapters (7, 8 and 9) looks at the relative effectiveness of these bases for dissent, and at why dissent is sometimes successful and sometimes not. It asks also whether changes are made for individuals or for groups, alter procedures or the policies themselves, and are reversed or sustained over time.

The final chapter considers two ways of extending what has been learned from the double strands of analysis: strands focused on proposals about the nature of representations in general, and on the way these proposals are concretised in the course of working through a specific series of events. One extensions consists of asking whether the same proposals fit a different series of events (Norwegian in this case) and of bringing out some unfinished questions about representations: questions relevant to all representations and, in particular, to those of asylum seekers or refugees.

More specifically:

Chapter 2 outlines four conceptual proposals. These are the conceptual hooks on which hang the analyses of particular events. Each states a position and each raises questions that then become the focal points for analysis.

The first proposal takes the form: *All events can be described in more than one way and each interested party seeks to make its "definition" or "frame" persuasive or credible.* The critical questions then have to do with how some particular "definitions" or "frames" come to be established and sustained, and how dissent or competing frames are managed.

The second takes the form: *Sources and media both play active parts.* Sources "negotiate" rather than simply "pass on" information. One party may seek to restrict news in the name of official secrets, operational decisions, or the "need to know". The other may begin to look for alternative sources or to claim the legitimacy of access, the "right to know". The critical questions then have to do with the nature of tensions and selective alliances, the opportunities that various media provide, and the uses made of this variety.

The third proposal takes the form: *Accounts build on, and work with, the understandings, preferences, and sensitivities of anticipated audiences.* The critical questions then have to do with the nature of audiences: what they understand, what they expect, their patterns of language and thought, their ready-made categories and narratives, and, in particular, the ways in which they approach any issues involving "us", "them", and the differences or borders between the two. As both social scientists and semiologists such as Kristeva have pointed out, our perceptions of what is safe, intriguing, alien or dangerous rest on underlying meanings and understandings related to "us" and "them" and the

4 UNHCR (2006) *The State of the World's Refugees* Geneva: UNHCR

5 See, for example, David Marr and Marion Wilkinson (2003, 2004) *Dark Victory*. Sydney: Allen & Unwin

6 See, for example, Allan, S. (1999) *News Culture*. Birmingham: Open University Press; Hall et al. (1978) *Policing the Crisis: Mugging, the State, and Law and Order*. London: Macmillan; Schlesinger, P. and Tumber, H. (1994) *Reporting Crime: The Media Politics of Criminal Justice*. Oxford: Clarendon; Tuchman, G. (1978) *Making News: A Study in the Construction of Reality* New York: The Free Press

7 Human Rights Watch (2002) *"By Invitation Only": Australian Asylum Policy*. Vol.14, No.10 (C) – December 2002

8 The term "domesticate" comes from Hallin, D. (1987) "Hegemony: The American News Media from Vietnam to El Salvador, A Study of Ideological Change and its Limits". In D. Paletz (Ed.) *Political Communication Research*. Norwood, NJ: Ablex. The general argument about hegemony and dissent over time is to be found in several sources: cf. Gramsci 1971, Rose 1999

lines that separate them.[9]

The fourth and last proposal takes the form: *All representations change over time*. The critical questions then have to do with the possible forms of change (e.g., at the core or on the edges of an initial representation?) and with how change comes about. Of particular importance is the occurrence, the nature, and the fate of dissenting voices: the occasions both when they are fragmented and less effective and the occasions when they succeed in producing change.

Chapter 3 turns to a more specific background question. It is often said that representations – both their production and the ways in which they are read – depend on the nature of "contexts" or "settings". That statement, however, calls for some specification of the features of contexts that make a difference. That specification helps to make more understandable the context and the initial acceptance, by the Australia public, of its government's representations. The specification also brings out features that are relevant to the description of any context. The chapter accordingly draws examples from both the Norwegian and the Australian scene.

The other purpose is to bring out aspects of the Australian scene that make more understandable the representations and the actions that form a major part of the events to be described in later chapters.

The chapter focuses on three features of contexts. They have to do with aspects of geography, history, and social structures. More specifically, the selected aspects of *geography* have to do with the way a country's area is perceived, the ease of access to borders, and the nature of international agreements. The selected aspects of *history* have to do with past representations and policies toward immigration (a country's external borders) and toward detention (the borders within, exemplified in restrictions to detention centres or camps, to non-citizen status, or to non-participation in the life of a community). The selected aspects of *social structure* have to do with those that allow the presence of dissenting voices (e.g., the existence of more than one political party or one media voice), and that specify the nature of dissent (e.g., topics where open debate is feasible or topics – "racism", for example – best avoided).

Chapters 4, 5, and 6 cover the first phases in the series of events that provide the anchoring base for examining how asylum-seekers and refugees are represented. Those events followed one another in quick succession. They began (*Chapter 4*) with the *Tampa*'s rescue action, the Australian government's refusal of permission to land, its restrictions on media access, and its insistence that the rescued were not in any way Australia's responsibility. They were not, in the government's representation of them, legitimately in Australian waters and not in any "serious distress" (they were not, in some accounts, "genuine refugees"). That denial of responsibility was a major source of dissent, expressed especially by other countries and by international agencies. It became even more a source of dissent and criticism once images and reports began to come from the *Tampa* itself and from Norwegian sources. The interpretation of "distress" now became contested. The image of Australia as a compassionate country became hard to sustain.

Chapter 5 outlines some degree of shift in actions and representations. The Australian government moved in two directions, both presented as necessary moves toward "border protection". One of those moves was the legislative step of "excising" several islands from Australia's "migration zone": points where, once people arrive, they can present an asylum request to anyone who could be counted as a "migration agent" (any civilian citizen or legal resident). With all contact restricted to members of the Defence Forces, and no foot being set on what might count as "Australian" soil, the government worked at sustaining its representation of these asylum seekers as people who "never really arrived" and were "not our responsibility".

The other step taken was "the Pacific solution". Those on board the *Tampa* would be transferred to an Australian Navy vessel. Some would be taken to New Zealand, which had volunteered to take a number, families especially. Most would be taken to the island of Nauru, with Australia building and financing a detention centre there: a centre where movement (and media access) was restricted but applications for refugee status could be processed. (Nauru, and a further site in Papua New Guinea, turned out to become as well the "removal" site for others in later intercepted boats).

Chapter 6 expands the analysis of these moves and their representation, and the emergence of dissent. Over the next few months of 2001, events pulled possible

representations in two directions. September 11 intervened, prompting an even stronger emphasis on "border protection". The election slogan for the year became: "*We* will decide who comes to this country, and the circumstances under which they come".

At the same time, boats continued to arrive. Two of these became part of Australia's everyday vocabulary. They also provoked questions about the government's representation of "boat people" and cemented the image of these often being children and families: people who warranted compassion. The events attracting such interest came to be known as the "children overboard affair" and the "SIEV X incident". In the first, the government represented children as being "thrown overboard" by "unacceptable people" attempting to "intimidate" the government into altering its policies. (They were, in fact, being rescued from a sinking ship by members of the Australian Navy but this took time to come out). In the other, 353 people drowned when a ship sank as it attempted to sail from Indonesia to Australia. Many of these were children and the fate of children became compelling "news". The need for compassion in the face of distress and desperation now began to be voiced more often. Their strength, however, was undermined both by the lack of a coordinated voice and no clear focus for dissent. The concerns that had begun to gain steam, however, did not go away and, over time, dissent and alternative representations became stronger. Chapters 7, 8 and 9 outline those shifts.

Chapter 7 picks up a particular basis for dissent: a basis that now comes to the fore. It had to do with issues of law and of "truth". The effectiveness of exercising control over representations – treating them in this case as a government monopoly – is undercut when the accuracy or the truthfulness of the controlling source comes to be doubted. Australia's version of its "sovereign right" to set aside more conventional interpretations of maritime law (the saving of those lost at sea and their being landed at the nearest port) came under attack. So also did misrepresentations in the "children overboard affair". From the media, the opposition parties and – finally – from a source once within government and in a direct "position to know" – came accounts of how the government had converted actions based on concerns for the safety of children into the portrayal of "boat people" as willing to use their children as pawns in an intimidating game. This unravelling of a misrepresentation, and the contradictions it presented to the government's initial account, prompt questions about the effectiveness of this form of dissent, the relevance of timing, the lies that matter in the public eye, and the ways in which the evidence of lies or doubtful legal status may be pursued and turn out to be varyingly effective.

Chapter 8 takes a second basis for dissent, together with evidence of some particular points of changes in its wake. Over the years 2003 to 2005, dissent began to be more focussed on conditions within detention centres became a common concern for many, with debate about the policy of mandatory detention in the first place set more to the side. Some particular groups of people in detention centres also came to be a coordinating focus. Initially, these were "women and children" (children especially), and their newsworthy stories led to their being moved into community detention sites, with "fences" rather than "barbed wire". Fire was then added to dissent by the well publicised stories of two children and two Australians who were, by error, treated as "illegals": one kept in prison and detention for over 8 months, one actually deported to her country of origin (the Philippines). The names and stories of both became part of everyday knowledge. The outcome was a government-initiated inquiry, the admission of the need for change in implementation procedures and in departmental "culture". Remaining intact, however, were the policies of mandatory and indefinite detention and of decisions in the hand of a government department rather than the courts. Continuing also were cases of marked departmental "error", still making news in the years that followed.

Chapter 9 presents a more positive picture of change. In the first of these, all families on Nauru were transferred to Australia and given temporary visas. That change was in response to the media finally gaining access (permission granted by the new government in Nauru), and to the visibility once more of individuals who were facing an indefinite stay and had surely

9 Kristeva, J. (1982) *Powers of Horror: An Essay on Abjection.* New York: Columbia University Press; Kristeva, J. (1991) *Strangers To Ourselves.* New York: Columbia University Press

"suffered enough". Nauru, however, was not completely closed and, in 2006, became a detention centre for a new group of Burmese asylum-seekers. In a second change, the government – after much resistance – drafted new legislation. No children were to be held in locked detention centres. (They could be in secure community detention). All cases where detention was over two years in length were to be reviewed by the Ombudsman: a move designed to avoid indefinite detention. (The Ombudsman, however, unlike the courts, has no legal power and, critics added, two years is a long period before any external review.) Changes in the kinds of visas issued would reduce the uncertainty of futures (many on temporary visas were to be given permanent residency). Those changes still left Australia taking a different approach to detention than is the case in many countries. Detention in closed centres, under guard, remained mandatory for most. Nonetheless, changes were made. The chapter brings out the importance of the specific nature of changes, together with the need to monitor later attempts to reverse them. Brought out also is the significance of a particular source of dissent. In this case dissent came by way of voices within Prime Minister John Howard's own political party, leading to strong media interest in the "battle" between him and a small group of "rebels": a group that also remained in a position to monitor later attempts at reversal.

Chapter 10 looks at two extensions to the analysis offered up to this point. One is to other places, other series of events. Events in Norway over the same time period (2001 to 2005) are taken as a base. The two countries do not follow identical paths. Both illustrate, however, swings in the balance between "control" and "compassion", together with the power of personalised images, media pressure, and coordinated dissent. Common also is the occurrence of times marked by a political scramble for "tough stands" (e.g., election periods), and the importance of observing events over time.

The other extension returns to the general proposals about representations that were outlined in Chapter 2. Those proposals then serve as a base for underlining what may be watched for in the course of analysing or monitoring events in any place and at any time. We have learned, for example, to watch for varying kinds of competing frames, the ways in which these are justified or challenged, the ways in which some events become "newsworthy", the part that the various forms of media play, the forms that change takes and the circumstances that prompt changes. The proposals serve also as the base for identifying gaps in the analyses of representations: unfinished and continuing questions that would deepen still further our understanding of representations of refugees and of representations in general.

The overall aim in this final chapter is to avoid offering only a summary of previous chapters. The advance map offered in this chapter essentially serves that purpose. With this broad advance map in hand, we may now turn to the first of the two chapters that focus on general proposals about the nature of representations: the literature that has highlighted the presence of competing frames, the place of the media, the nature of audiences, and the forms and fate of dissent.

CHAPTER 2

Conceptual Proposals and Analytic Steps

THE ANALYSIS OF ANY series of events needs some guiding concepts. Ideally, they should be guiding concepts that apply to more than any particular series or any particular kind of content. The concepts brought to bear on the series that starts chronologically with the *Tampa*, for example, should apply also to representations of asylum-seekers, refugees and borders in other places or other times. More broadly still, we should be able to place the representations of asylum-seekers, refugees and borders within general theories about the nature of representations. That broader placement makes the specific representations – the ways in which they are produced or read – more understandable. It also offers them a "conceptual home" that can itself be expanded by those specific representations.

The guiding concepts to be used were briefly mentioned in the Chapter 1 overview. In this chapter, they are considered more fully. Noted also are several of the observational and analytic steps that these proposals suggest: steps followed through in the later chapters.

The central proposals all start from the position that representations are not simple "reflections of reality". Instead, they are shaped by agendas, assumptions, patterns of thinking, patterns of language, and what audiences are expected to want, understand, need to know, find interesting or find threatening. This general position is the starting point for many analyses of the media and representations in general. Given the extent to which the representation of asylum-seekers, refugees and borders in the Australian events took the form of news reports, (press, radio, television), however, I shall focus mainly on representations within analyses of what Allan has termed "news culture".[1]

More fully, the four proposals that stem from this general view of representation, and the analytic steps they suggest, are these:

Proposal 1. Any event can be represented in more than one way, with each seeking to be more persuasive, credible, or apparently objective than others. That proposal prompts questions about what it is that makes some representations have greater appeal than others, and how those who wish to have their representation be dominant – be "hegemonic" or "the primary definition" – move toward making it so and toward diminishing the strength of any competing representation. All sources, the argument runs, seek to make their representation the most credible, the most like common sense. How governments, media, and other interested parties seek to do so in relation to borders and refugees then become steps to observe and examine in practice.

Proposal 2. Management or shaping is not one-way. Both sources and media play active parts. Representations typically attract more than one interested party, with each actively involved. The two that have received most attention are sources and media. The essential point is that the media are not simply passive puppets

1 Allan, S. (1999) *News Culture*. Birmingham: Open University Press

of some controlling interests. Instead, both parties play active parts. Each has an agenda. Each uses a variety of techniques to promote that agenda or to meet particular needs. Each sometimes advances the other's position and sometimes questions, probes, or rejects it. In any set of events then, we need to look at the specific techniques that are used and the circumstances that influence whether "the dance" displays one pattern rather than another.

Proposal 3. Audiences always matter: Their preferences, interests and sensitivities affect what is attended to and found credible or reassuring. On any occasion, sources and reporters need to consider an audience's preferences for particular ways of conveying information. People expect "news", for example, to follow particular formats. They prefer particular kinds of stories and particular forms of language. Preferred also are representations that confirm, or at least do not unduly upset, the views that people hold about themselves, others, and the world they live in. These second kinds of preference are particularly relevant to accounts of "us" and "them", especially when those categorised as "them" are also "strangers", potentially shaking the lines of separation seen as upholding the stability of one's own society. Special attention then needs to be given to the shape and the feelings prompted by representations that are about "foreigners" (representations that range from "asylum seekers" and "refugees" to "boat people", "queue jumpers", "illegal immigrants", possible "terrorists"), about "us" (how can we be called "illegal", "inhumane", "lacking in compassion", "racist", or "barbaric"?), or about orderly lines of separation between "us" and "them" ("border protection").

Proposal 4. Accounts and interpretations change over time. That proposal seems intuitively obvious. It challenges us, however, to spell out the nature of change, together with its sources and consequences. Of particular interest are proposals to the effect that dissent is inherently liable to fragmentation and, in a more positive fashion, that over time dissent from an initial representation can gather force, prompting either some shift in the initial representation or moves toward maintaining it. Those proposals call for analyses and observation of the forms that dissent takes in practice. Those forms may cover, for example, arguments that the original representation and the actions related to it violate the law, are based on errors or untruths, or run counter to what is humane or in keeping with a country's values and image. Called for also is attention to the changing effectiveness of those arguments over time.

For each of these proposals, I shall outline the form that arguments take and what those arguments prompt us to be alert to when we turn to a specific series of representations. The aim in each case is a double one. One is to develop a "thick description" of the way asylum-seekers, refugees and borders are represented and to observe how well these general proposals fit a particular series of events.[2] In the process, both the accounts offered by the several interested parties, and the level of their acceptance, should become more understandable. The other aim is to see how the proposals in themselves can also be expanded to cover other events.

Proposal 1. Representations as Multiple and Contested

This type of proposal has been offered within analyses both of government positions and of media representations. For both, however, a major starting point is an argument[3] offered in relation to governing, in the 1930s and often carried over to analyses of news reports.[4]

In essence, Gramsci's argument is that government control can be exercised by force. Even more effective, however, is control exercised by persuading people to accept an ideology – a representation of what is necessary or should happen – that supports the government's agenda and its actions and diminishes the likelihood or the strength of questioning and dissent. That likelihood is especially diminished, Gramsci argues, when the dominant group's representation of events becomes part of daily life and of what is seen as "common sense": shaping perceptions of ourselves and our world and our sense of the rules and norms that should govern practical conduct and moral behaviour. The impact of "lived hegemony" on the demarcation of the "limits of common sense", Allan argues, is an aspect of Gramsci's position that has particular relevance to the analysis of news reports.[5]

A similar type of argument is often phrased in terms of various parties – government or media – seeking to

set down "the primary definition or primary interpretation of a … topic … the terms of reference within which all further coverage (as well as any subsequent 'debate') takes place".[6]

Common to concepts of both hegemony and primary definers is certainly the argument that no one interpretation of events will occur without competition. Hegemony, in Gramsci's account, is always "contested". It can never be taken completely for granted. There will always be some resistance, some opposing voices. Compromises with opposing positions will also need to be made, ideally affecting only the fringes of one's position rather than its core. Primary definitions, Deacon and Golding especially point out, also need work if they are to remain dominant: work that entails "battles" or "debates" with dissenting and critical voices.[7]

Gramsci's analysis was directed mainly toward the interpretations and positions offered by dominant political groups. The media, however, have been described in similar terms. In their own ways, for instance, the media may all "strive to *naturalize* the social world", to "make the world beyond direct experience look natural".[8] They may all strive to make their accounts or their positions "appropriate, legitimate, or inevitable".[9] They may all seek as well to present themselves as offering an authoritative, balanced and comprehensive account of events.

Hallin offers a finer specification of what may be sought.[10] The specification in this case comes from analyses of what journalists do, but applies equally to government statements. Hallin distinguishes among three regions or spheres of understanding that may be part of moves toward "naturalisation".

The sphere of "motherhood and apple pie" is one of Hallin's three:

"Within this region journalists do not feel compelled either to present opposing views or to remain disinterested observers. On the contrary, the journalist's role is to serve as an advocate or celebrant of consensus values".[11]

The sphere of "legitimate controversy" is the second. It covers a "range of social issues which are framed by journalists as being the appropriate subject of partisan dispute. The typical types of controversies which unfold during electoral contests or legislative debates, for example, are situated here".[12]

The "sphere of deviance" is the third. Here are the voices of "political actors and views which the journalists and the political mainstream of the society reject as unworthy of being heard".[13] Journalism then "plays the role of exposing, condemning, or excluding from the public agenda those who violate or challenge the political consensus. It marks out and defends the limits of acceptable political conflict".[14]

The very presence of more than one sphere of understanding then makes it unlikely that there will be only one interpretation offered or accepted. As long as there is any content area where "healthy debate", "legitimate controversy", or even "tolerable eccentricity" is accepted, there will be more than one point of view in the market. The critical questions then have to do with the ways in which one comes to be more persuasive or more credible than another.

It would be limiting, however, if we saw the competition for credibility or for "the initial definition" as existing only between government sources and the media. That competition often does occur. It is also often marked within governments and within parts of the media. *Neither governments nor media are monolithic.* That point has been well made in relation to the media. The "news media … are far from monolithic in

2 The term "thick description" is from Clifford Geertz (1973) *The Interpretation of Culture*, New York: Basic Books

3 Gramsci, A. (1971) *Selections from the Prison Notebooks*. New York: International

4 Allan (1999) Op.cit.; Hall, S., Critcher, C., Jefferson, T., Clarke, J. and Roberts, B. (1978) *Policing the Crisis: Mugging, the State, and Law and Order*. London: Macmillan; Williams, R. (1989) "Hegemony and the Selective Tradition". In S. de Castell, A. Luke and C. Luke (Eds.) *Language, Authority and Criticism*. London: Falmer

5 Allan (1999). Op.cit.: 86

6 ibid: 71. The term "primary definer" comes from Hall, Critcher, Jefferson and Roberts (1978) Op.cit.

7 Deacon, D. and Golding, P. (1994) *Taxation and Representation: The Media, Political Communication and the Poll Tax*. London: John Libbey: 202

8 Gitlin, T. (1980) *The Whole World Is Watching: Mass Media In the Making and Unmaking of the New Left*. Berkeley: University of California Press: 6, cited by Allan (1999) Op.cit.: 63, emphasis in original.

9 Allan (1999) ibid: 49

10 Hallin, D.C. (1986) *The 'Uncensored War': The Media and Vietnam*. New York: Oxford University Press

11 ibid: 116-117

12 ibid: 116

13 ibid: 117

14 ibid: 117

their reporting".[15] They are also far from monolithic in their views of how sources should be treated, and of the extent to which the goals of "reflecting public opinion", "moving on", or "advancing the story" should be paramount. Talkback radio, for example, is more likely to provide opinion than the analysis expected of programs designed to look closely at a small number of topics.

Sources are also far from monolithic. They may be united by the goal of being regarded as the most credible of all sources. They may also, however, compete with one another or dispute with one another. They may seek to establish that theirs, if not the only source, is the most authoritative, the one that should be listened to. Differences and contests among sources have overall received less explicit attention than that given to those that occur among media. Any analysis, however, needs to consider the nature of "the contested dynamics within and between source organizations as they struggle to 'get their message out'"[16]: advice I shall aim to follow.

Some Specific Steps Stemming from Proposal 1

The outlining of this proposal has already suggested many of the aspects to government and media sources that we should be alert to when we turn to any particular set of events. To pull out some specific steps, we should certainly be alert to all forms of contest or competition among representations. We need to note the ways in which government or media sources attempt to establish any hegemonic account or primary definition, with particular attention to the ways in which "common sense" is claimed, the nature of dissenting views, and the ways in which those voices are dealt with (e.g. discounted as "deviant" or "absurd").

We should also expect to observe news reporters actively placing stories and people within various spheres of understanding. In related fashion, we should expect sources that seek control – politicians, for example – to try to place their accounts or their positions in the first sphere, making it seem unimaginable that anyone would look at events in any other way. When they play the "statesman" role, they may acknowledge that others may hold a legitimately different view. In full electoral mode, however, we should expect to find them seeking to banish any opposition or questioning voices to "the sphere of deviance": "unworthy to be heard". We should as well expect to see them keeping a careful eye on consensus values and making efforts to always align themselves with those values. Strong, compassionate, moral, proud of one's country, undeterred by overseas criticism is the image to be constructed when the consensus is that those qualities are needed, or when a consensus supporting one's position needs to be created.

Proposal 2. Both Sources and Media Play Active Parts

It is tempting to see sources – government sources especially – as very much in control of what the media report and how they report it. Control can certainly be sought, often successful. Sources can become, to use a term from Hall et al., "the primary definers" of controversial subjects.[17]

The media, however, are far from being simple conduits for whatever material is passed to them. They may pass on material as simple "fact". They may exaggerate it. They may, for example, "take the smallest snippets selectively leaked to them and blow them up into an open-and-shut case".[18] They may question what they are given, push for more information, or look for sources that offer a different view.

What kinds of moves occur on either side? What circumstances prompt the making of particular kinds of moves?

Both sources and media have a repertoire of moves they may make. That repertoire has been spelled out especially within analyses of access, with particular attention to the moves that source managers may make. We shall see many of these moves exemplified in John Howard's approach to the Australian events, making them an appropriate base for examining the forms they may take.

Sources and Their Moves toward Management

To pull together points made in several analyses[19], *sources may seek to:*

Become the only source. A site (e.g., a ship or detention centre), for example, may be declared physically

off-limits, with no visiting or interviewing allowed. The hope is then that one source – the official source – will be all that the media has to work with.

Restrict the availability of other sources. The existence of other information sources may be admitted. They are now, however, placed at one remove. The advice passed on comes, for example, from expert, legal, or confidential sources that are difficult to check. Those other possible sources may also be advised to be silent, on a variety of grounds (from respect for the government to the nature of their position as public servants or as holders of contracts that need not be renewed).

Establish themselves as the authoritative or most credible source. For all sources, it has been argued, there is a "hierarchy of credibility".[20] Reporters and readers, it has been pointed out, may hold "the view that those 'at the top' will have access to a more complete picture of the bureaucratic organization's workings than members of lower groups whose definition of reality, because of this subordinate status, can be only partial and distorted".[21] The aim of any source is then to take advantage of this assumption. Accounts will seem more credible if the person speaking is seen as "at the top", "at the front" or, in general, "in a position to know".

Restrict the likelihood of inquiry. Questions may be deflected by representing them as an attack on the integrity or expertise of some "motherhood" groups: "our Navy", for example, or "our boys at the front". More formally, an opposition's proposal for an official inquiry may be voted down in Parliament. If accepted, its terms of reference may be restricted. To take an example from events in 2005 that involved an Australian citizen with a psychiatric disorder (Cornelia Rau) being held in a detention centre for illegal immigrants, an inquiry may be declared as private rather than public.

Provide favoured access to some. Preference goes, for example, to those who provide "soft entries" for the material they are given. Preference goes, for example, to those who do not "qualify their statements or test the credibility of … evidence … they give political operators who cultivate them a free rein all the way to the goal line".[22]

Choose the media format that best suits their purposes. Various formats are differentially difficult for government sources to control, often prompting a preference for doorstop interviews, press conferences and "hard news" media, for formats "which have less space and time and are less likely to do investigative reports".[23] Howard, for example, emerges as having a strong preference for talkback radio. This format tends to pick up ongoing stories, particularly from other sources – last night's news, this morning's newspapers. The person interviewed can then be prepared for the questions to be posed, and offer a prepared answer. Talkback radio also often provides the opportunity to repeat an earlier message rather than explain one's position or cope with a deepening series of questions.

Media Moves toward Access and Credibility

What moves on the part of the media are related to such access-controlling moves on the part of sources? Analyses of "news culture" point to several.

The media position themselves so that they gain preferential or probable access. They may do so by becoming known as "soft entries". More subtly, they may work at placing themselves in the probable path of news, occupying "a position of convenience"[24] "where news is most likely to take place".[25]

The media reinforce the status of authoritative sources. They may "participate in upholding a normative order of authorized knowers in society".[26] That may be because they share the same ideological views. It may also be because the everyday pattern for gathering news reinforces the status of some groups. Journalists tend to specialize. They may specialize in particular geographic

15 Schlesinger, P. and Tumber, H. (1994) *Reporting Crime: The Media Politics of Criminal Justice.* Oxford: Clarendon: 20

16 Allan (1999) Op.cit.: 74 citing Schlesinger and Tumble (1994) Op.cit.: 20

17 Hall et.al (1978). Op.cit.

18 McEnvoy cited by Soloman, D. (2002) *Howard's Race: Winning the Unwinnable Election.* Sydney: Harper Collins: 226

19 Allan (1999). Op.cit; Becker, K. (1967) "Whose Side Are We On?" In *Social Problems*, 14 (3), 239 – 247; Fishman, M. (1980) *Manufacturing the News.* Austin: University of Texas Press; Solomon (2002) ibid.

20 Becker, K. (1967) Op.cit.

21 Cited by Allan (1999) Op.cit.: 68; Becker (1967) Op.cit.: 241

22 McEnvoy cited by Solomon (2002) Op.cit.: 226

23 Miller, D. (1994) *Don't Mention the War: Northern Ireland, Propaganda and the Media.* London: Pluto: 109-110

24 Fishman, M. (1980) *Manufacturing the News.* Austin: University of Texas Press

25 Allan 1996) Op.cit.: 66

26 Fishman (1980) Op.cit.: 96

areas or particular topics. They may attach themselves to particular organizations. The end result, in each case, is one of placing oneself in a position where intended or unintended access to sources becomes probable.

Once given material, or faced with restrictions, news reporters may stop with one source or seek others. The source they seek may be another authoritative voice (another expert, for example). It may be someone closer to the action (even if that someone is not "at the top"). It may be someone with an interest in providing alternative information, leaking what is restricted, or offering a way round access barriers. Sought often are people who will be both equally credible and interested in presenting an alternative account. Sought also are ways to protect the insiders willing to go round official barriers or, if they are "low status", to make their accounts more credible (they are, for example, the people "on the spot" or "at the face of the action").

Reporters may actively probe or question what they have been given. This is the kind of move that Allan sees a particular need to explore.[27] In any analysis of events, he argues, we "need to account for ways in which journalists challenge official sources, even to the point of pursuing campaigns". Given the central position that government sources occupy, that challenge may need to be carried out with some delicacy or some ability to claim that questioning is justified and expected. Challenge may also be influenced by some particular circumstances. Journalists may choose to probe, for example, if the account offered seems too favourable, too blatantly one-sided, or tied to unreasonable conditions: e.g., indefinite limits to the access they need in order to provide news. All told, one of the intriguing facts to any news story – certainly to the Australian events – is the set of circumstances under which questions arise and are sustained.

Some Specific Steps Stemming from Proposal 2

The possible moves on the part of sources or of reporters suggest especially the need to be alert to their appearance in the Australian series of events, noting both their occurrence and the circumstances that prompt some being made rather than others. We need to note, for example, the scope that various parts of the media offer for government control, the uses that various sources make of particular media formats, and the kinds of alliance or support that various media offer. Of particular importance are likely to be the circumstances that make questioning and investigation less likely to occur: circumstances that may range from the inclination of the media to "advance the story", "moving on", to the occurrence of a rapidly unfolding series of dramatic events that allows little scope for any in-depth analysis of issues.

Proposal 3. Audiences Always Matter

This section takes up two questions. The first – dealt with briefly – asks why audiences matter and notes that some matter more than others. The second asks what it is about audiences that sources or media take into account or need to consider. It takes up audience expectations of two kinds. One of those has to do with what "news" is about and how it should be conveyed. The emphasis is on the "informational" features of any statement or representation. The other has more to do with the kinds of feelings that audiences are likely to experience. Those feelings are often linked to the kinds of narratives embedded in various accounts of events. Narratives evoking "us" and "them" are of particular relevance.

Why Audiences Matter

On the media side, people need to be persuaded into some optional forms of action: to buy your newspaper rather than others (assuming there is more than one), to boost ratings by listening to your radio program or watching your television reports rather than others. From one place to another, the options may vary. The only alternative, for example, may be only word-of-mouth information. Even then, however, the hope is always that your voice and your account will be listened to rather than those of others.

Some of the same hopes apply to people in political places. People need to be persuaded to vote for you, preferably on clear ideological grounds (you are seen as a "good", "promising", or "moral" choice), at least on the grounds of being comparatively less of a disaster or a threat than the alternative. Again, from one place to another, the options may vary. In the United States and

Norway, for example, people may choose not to vote at all. In Australia, in contrast, voting is compulsory, so the choice becomes always one of who to vote for (or to take the seldom-used route of casting an invalid vote). The critical task then is to persuade people into some recorded approval of your position. Even when governments exercise strong control, recorded approval matters. Governments will often go to some lengths to demonstrate that they are the peoples' choice in any election or referendum, with this endorsement then regarded as legitimizing their position on grounds other than force or the lack of alternatives.

"Audiences", however, may sound as if they are single blocs. In practice both sources and media operate with "target audiences" in mind. For politicians in electoral mode, for example, it will be the "swinging voters" in marginal seats. For television or radio programmers, it will be the large section of the population that quickly changes what it listens to or watches.

Audience Expectations: The Informational Forms that Accounts Should Take

Informational expectations have been given particular attention within analyses of what is expected in relation to "news". To take some examples, audiences have been described as expecting that:

News stories will fit their assumptions. They will be in keeping with "little tacit theories about what exists, what happens, and what matters".[28]

News stories will cover some topics but not others. The topics of interest will have to do, for example, with some places but not others, some organisations or groups but not others.[29] More broadly, the expectation of journalists and audiences is that:

"news concerns the *event*, not the underlying condition; the *person*, not the group; *conflict*, not consensus; the fact that *'advances the story'*, not the one that explains it".[30]

Events will be made quickly understandable. This expectation, Gitlin argues, helps account for the way journalists "frame" events both for themselves and their audiences.[31] "Frame" is a term first offered by Goffman to describe the way events are made meaningful by being placed under various recognizable headings.[32] This is helpfulness, this is intrusion. This is assault, this is defence. This is legal, this is crime. This is a security matter, this is not. This is typical, this is weird:

"Frames enable journalists to process large amounts of information quickly and routinely; to recognise it as information, to assign it to cognitive categories, and to package it for efficient relay to their audiences".[33]

In turn, audiences are likely to take a negative view of accounts that are not quickly understandable. Certainly one Australian politician – Kim Beazley, the head of the Labor Party at the time of the *Tampa* and again in 2005 – lost popularity by being, in his own description, "prolix".

Audience Expectations: Feelings and Stories about "Us" and "Them"

Over and above simple informational preferences, audiences expect accounts of events to take account of their feelings. News accounts, for example, will not cover "all the gory details" of events. They should cover enough of them to have an event qualify as "newsworthy" but not so much as to evoke the feeling "not fit to print". Accounts by journalists or governments should as well not damage an audience's view of itself. To be told that voting for a particular political party (Howard's Coalition Party) represents a victory for "fear and greed" or for "the dark side" of Australian character, for example, is not endearing to the large audience that did in fact vote that way. The ideal is more one of accounts or representations that give rise to a manageable charge of shock, horror, amusement or excitement and that leave one feeling ultimately good about oneself.

How does this kind of ideal come about? What gives rise to various kinds and degrees of feelings? For those

27 Allan (1999) Op.cit.: 73
28 Gitlin (1980) Op.cit.: 6, cited by Allen (1999) Op.cit.: 63
29 Tuchman, G. (1978) *Making News: A Study in the Construction of Reality.* New York: The Free Press
30 Gitlin (1980) Op.cit.: 28, emphases in the original
31 ibid
32 Goffman, E. (1974) *Frame Analysis.* New York: Harper and Row
33 Gitlin (1980) Op.cit.: 7

questions, I shall turn to sources other than the analyses of "news culture" that have been prominent up to this point. I shall instead draw from several parts of the social sciences. I shall also focus specifically on representations that have to do with feelings about "us" and "them". Those feelings, it has been pointed out, may take a variety of forms, ranging from uncertainty and a sense of "difference" to hostility or compassion toward the other, from a sense of satisfaction to a sense of shame toward oneself and one's people.

Why and when events and accounts of events evoke particular feelings has been of interest within analyses of prejudice, public opinion, group relationships, and history. From these several analyses, I single out two that are especially relevant to the feelings that narratives about asylum-seekers, refugees and borders can evoke. Those two come from social psychology and – more extensively – from work by Julia Kristeva.

Some Proposals from Social Psychology

The proposals of particular interest centre on people's sense of "ingroups" and "outgroups".[34] Brought out especially are four aspects:

One's own group will always be considered in a more positive light than members of the outgroup. They will possess a greater share of all good qualities: They will see themselves, for example, as more developed, humane, rational, sensitive, balanced, tolerant, relaxed, spiritual etc. Whatever counts as "good", we will have more of it.

Our interests will of course come first. That placement may have to be justified on the grounds of our greater virtues or our greater needs, but the sense will always be there that, in any competitive situation, we should have priority.

The explanations for any actions of "ours" that are less than optimal are likely to be found in unfortunate circumstances. Less-than-optimal actions on "their" part are likely to be attributed to their nature, to traits ranging from laziness to greed, violence, or barbarianism.

"Outgroup homogeneity": "You" are all alike, "we" are individuals, recognizably different from one another. The outgroup – "them" – is seen as a bloc, as made up of relatively faceless people who are alike and can be thought of in purely categorical terms. They are, for example, non-believers, Muslims, Catholics, foreigners, "boat people", "illegals". They are people "from the city" or "from the country", "the chardonnay set" rather than "the real people".

Whatever the category, the assumption is that the people within it will be all more or less alike. For political purposes, obviously, it is often advantageous to have them remain so. They can, for example, all then be tarred with the same brush. They do not become individuals – "real people" – with particular histories that may tug at our heartstrings or make them seem similar to "us".

Some Proposals from Julia Kristeva

Two books are especially relevant. One of these, *Strangers to Ourselves*, focuses both on the way foreigners have been treated in the past and on the experience and options of the stranger; options that include the refusal of speech or conformity.[35] The focus covers far more than the foreign national. The stranger is the person "who does not belong to the group, who is one of them, the 'other'".[36] He or she may then be "the Moroccan living in France, the intellectual who stands apart from the bourgeoisie, the woman who works in a world where men are 'us' and women 'other'".[37]

The second book, *Nations Without Nationalism*, is more specifically concerned with the stranger who is a foreign national.[38] It was prompted especially by the rise of tensions between national groups both within and outside of France, and by the clash of two ideologies: equality and racism.

Both books start with the assumption that there is always some separation between self and other, and some tension between them. That is the same assumption just described in the work of social psychologists. Kristeva brings to that assumption, however, the use of different lines of evidence, an emphasis on the importance of the codes or procedures that regulate contact and conduct, and a particular concern with what gives rise to the several kinds of emotions that foreigners evoke.

History as a source of evidence is of particular importance in Kristeva's analyses. The evidence that social

psychologists turn to is typically quantitative, often experimental (e.g., the deliberate division of people into competing groups), and occasionally historical. The evidence Kristeva turns to is far more experiential and historical. For the analysis of strangers and foreigners, she turns especially to history. She recognises that turning to history may seem strange:

> "People will object, however, that when an overflow of immigrant workers humiliates French suburbs, when the odor of North African barbecues offends noses that are used to other festivities, and the number of young colored delinquents leads some to identify criminality with foreignness – there is no point in poring over the archives of thought and art in order to find the answers to a problem that is, when all is said and done, very practical".[39]

Kristeva herself, however, hopes that history will help move discussion forward:

> "The difficulty inherent in thinking and living with *foreigners* ... runs through the history of our civilization and it is from a historical standpoint that I take it up in my work, hoping that confronting the different solutions offered by our predecessors would make our present day debates about immigration more lucid, more tolerant, and perhaps more effective".[40]

That application of history may readily be seen in one of Kristeva's first points: Self and other are expected to be separate, with their contact regulated by accepted procedures. As a particular instance, she recounts the story of the Danaïdes, the fifty daughters of Danaüs who asked for asylum among the Argive. The Argive King objects to their failure to follow proper procedures:

> "So outlandishly arrayed in the barbaric luxury of roles and crowns, and not in Argive fashion/ Nor in Greek? But at this I wonder how without a herald, without a guide, without patron you have yet dared to come".[41]

And Danaüs himself alerts his daughters to the kind of approach expected by those who ask for asylum:

> "Let no boldness come from respectful eye and modest features. Nor talkative nor a laggard be in speech/ Either would offend them. Remember to yield/ You are an exile, a needy stranger/ And rashness never suits the weaker".[42]

Small wonder, to anticipate, that one of the objections to "boat people" is that they have approached without herald, guide or patron, without seeking the visas they should have from the proper officials (regardless of the fact that there may have been no official channels to which people could apply).

Small wonder, to anticipate again, that any appearance of threat, of being anything other than a supplicant, would be responded to negatively or that the image of boat people being threatening or rash could be used to make refusal seem all the more reasonable.

Greek history, in Kristeva's hands, is the source of several other parallels, including Plato's recommendation that certain kinds of arrivals – those whose genuine interests one might be dubious about – be "received ... outside the city".[43]

Kristeva's goal, however, is not simply to provide reminders that "foreigners" and "refugees" are not new issues. More specifically, she uses the large sweep of history, together with current events, to ask about the nature and bases of the several emotions that may arise: the tension and uncertainty, the fear, suspicion or hatred, the sense of compassion, or the sense of attraction.

The sources of various emotions provide the second strong theme in Kristeva's analyses.

To start with the more positive emotions, she sees the

34 Cf. Tajfel, H. (1981) *Human Groups and Social Categories: Studies in Social Psychology*. Cambridge: Cambridge University Press; Tajfel, H. & Turner, J. C. (1986) "The Social Identity Theory of Intergroup Behaviour". In S. G. Worchel & W. Austin (Eds.), *Psychology of Intergroup Relations* (2nd edition: 7-24), Chicago: Nelson-Hall

35 Kristeva, J. (1991) *Strangers To Ourselves*. New York: Columbia University Press

36 ibid: 5

37 Goodnow, K. (1994) *Kristeva in Focus: From Theory to Film Analysis*. Bergen. Department of Media Studies: 90-91

38 Kristeva, J. (1993) *Nations Without Nationalism*. New York. Columbia University Press

39 Kristeva (1991) Op.cit.: 50

40 Kristeva (1993) Op.cit.: 16, emphasis in original

41 Aeschylus, *The Suppliants* cited by Kristeva (1991) Op.cit.: 47

42 Cited by Kristeva (1991): 47

43 Plato cited by Kristeva (1991): 55

attractiveness of what is foreign as sparked by the sense that one's own safe and predictable society has become boring and sterile. Hoped for then may be an infusion of something new. Settled for may be occasional forays into less known regions, protected by a guaranteed safe return.

The sense of *compassion* Kristeva sees as dependent on the extent to which we can put ourselves in the foreigner's place:

> "It is not simply – humanistically – a matter of our being able to accept the other, but of being in his place, and this means to imagine and make oneself other for oneself".[44]

As a means of control then, the effective measures will be those that make unlikely any sense that this could be one's own fate or the fate of those one sees as part of one's own group. In contrast, compassion will be harder to deny when it is possible to think that "there but for the grace of God go I", when we are reminded of past errors in failing to be compassionate (e.g., refusal in the case of boats carrying Jews attempting to escape from Germany), or when the person treated harshly is "one of us".

The sense of *tension and uncertainty* Kristeva sees as stemming in large part from the clash of two ideological codes. One calls for keeping the foreigners at a distance, both physically and psychologically. Rousseau, to use an example from Kristeva, describes "the patriot" as properly "hard on the foreigner".[45]

The other code calls for some degree of open-ness and reasonable treatment. Guests should be treated in certain ways. The refusal to receive all others runs the risk of attracting a harsh reputation among others. Plato's arguments on this score, Kristeva notes, are still relevant (they may well brought to mind also when Australia was widely condemned for its refusal to receive the "boat people"). In Plato's terms:

> "The intercourse of cities with one another is apt to create a confusion of manners; strangers are always suggesting novelties to citizens ... On the other hand, the refusal of states to receive others, and for their own citizens never to go to other places, is an utter impossibility and to the rest of the world is

likely to appear ruthless and uncivilized; it is a practice adopted by people who use harsh words, such as xenelesia or banishment of strangers, and who have harsh and morose ways, as men think".[46]

When does such tension shade into or become the more negative feelings of *fear, suspicion, and hatred*? Critical for those feelings, Kristeva argues, is the presence of a perceived threat to what people see as effective separations or safe borders: essential bases for a sense of safety, security and stability. Negative reactions, for example, become stronger whenever there is the perceived threat of a splintered country, numbers that may become unmanageable, breaks in the codes that regulate how both parties should act, or challenges to the vested interests people have in maintaining the usual borders or in keeping the costs of action – both psychological and financial – at a level regarded as reasonable.

Control of public opinion, those proposals imply, will often move toward creating precisely those concerns, precisely that sense of "threat". Prompted then is a return to safe alternatives, established codes and procedures, and clear lines of demarcation between "us" and "them"

Some Specific Steps Stemming from Proposal 3

Some of these are prompted by accounts of the way information is expected to be packaged. We clearly need to be alert to the way news or policies are "framed", with frames often indicated by the descriptive and categorical terms used: terms such as "floods", "boat people", "illegals" rather than "refugees" or "asylum seekers". When information is in the form of news, we clearly need to be alert also to the ways in which the presentation of "new developments", "advancing the story", acts against a closer and longer look at issues. Especially when events follow one another in quick succession, each prompting reporters and audiences to "move on", we should expect the analysis of issues and the probing of accounts to suffer. The events in 2001 were certainly of that kind.

Some further analytic steps are prompted by accounts of how certain ways of packaging or presentation give rise to a variety of emotions and are often designed to do so. Narratives that have to do with "us"

and "them" call for particular attention. Of interest are the ways in which a sense of "us" is constructed. So also will be the ways in which "others" are represented, especially when those representations emphasise their difference from "us" and the threats they present.

Kristeva's analyses underline especially the need to examine how various emotions come into play or come to be played on. Tension and uncertainty are certainly an effective basis for arguments that a country needs firm control – an unswerving, resolute stance. More positively, we need to examine the conditions under which emotions such as compassion can arise. The first occasion of a senior Coalition politician saying "sorry" for Australian detention procedures, for example, occurred in 2005 in relation to an Australian held for some months in a detention centre because, in the course of a psychotic episode, she claimed to be German and the authorities could not establish her identity (Chapter 8). The outpouring of public concern was major. Even the conservative tabloid *The Daily Telegraph* ran an article on her participation in surf life saving and work as a Qantas stewardess under the heading "as Aussie as you get".[47] Outrage and compassion, in effect, appear to depend on the sense that the person involved is "one of us" or, at least, "like us".

Proposal 4. Representations Always Change over Time

Refugee stories are likely to be continuing news stories. There is then always the possibility that a particular interpretation may unravel. What makes it likely to do so or, in contrast, be sustained?

Several analysts of news culture and media control have taken up this issue in relation to all continuing news. Most start from the position that no interpretation of a politically loaded issue lasts without effort:

"Not only does primary definition have to be won, it must also be sustained interpretatively and evaluatively through a series of battles, in which its political vulnerability may progressively increase".[48]

"A social group can, and indeed must, already exercise 'leadership' before winning governmental power (this indeed is one of the principal conditions for the

winning of such power); it subsequently becomes dominant when it exercises power, but even if it holds it firmly in its grasp, it must continue to 'lead' as well".[49]

Over time, several kinds of change may occur. The contesting/resisting voices may gather strength. Access may change as new sources emerge.[50] There may occur "an accumulation of contradictions", making an original interpretation less credible, or prompting the build-up of resentment at continuing control over access to all but one source.[51] Those who were originally "faceless" may begin to emerge as "real people". Public consensus may itself shift, making a shift from an original account necessary. In short, for several reasons, we need to ask about how any original account comes to last.

Promoting the Lasting Power of an Account

Influencing the lasting power of any interpretation are circumstances and moves that increase its strength or diminish the impact of any dissent. I begin with those that may promote a sustained dominance. They include:

The use of repetition. The same message may be repeated over and over again: "We will decide who comes to our shores and no one else", for example, was asserted over and over again by John Howard and became, together with "Putting Australia's Interests First", the electoral slogan of his party. The repetition need not, however, be limited to one source. The nature of news is that stories are often picked up from one source and recycled by another. The format then may change, but the message or the interpretation does not. To take one example:

"The ABC's *AM* program often feeds out of that morning's newspapers. Talkback radio announcers rely

44 Kristeva (1991) Op.cit.: 13
45 Rousseau cited by Kristeva (1991) Op.cit.: 143
46 Plato cited by Kristeva (1991) Op.cit.: 55–56
47 *The Daily Telegraph*, 13/02/05
48 Deacon and Golding (1994) Op.cit.: 202
49 Gramsci (1971) Op.cit.: 57–58
50 Schlesinger and Tumber (1994) Op.cit.
51 Hall et al. (1978) Op.cit.: 217

on newspapers for much of their news and, in some cases, their views as well".[52]

Maintaining a sense of crisis. Allan has considered this aspect especially in relation to crime.[53] His description, however, applies just as well to the creation of a sense of crisis or "panic", of being "swamped" by countless numbers of refugees who will, by their very nature, not uphold the values of the society they move into and will threaten both its cohesion and its safety:

"The subsequent creation of a 'moral panic' across the field of the news media, in particular the daily press, contributed to a reconfiguration of 'the public consensus about crime' along far more authoritarian, and explicitly racist, lines. A recurrent feature of the news reports examined is that 'mugging' is unquestionably identified with black youth living in 'crime prone' urban 'trouble spots', and that this is a 'new problem' requiring 'proper policing'".[54]

Locating problems within the unchangeable nature of the "enemy". In the areas of crime, immigration, and war, it helps to divert attention away from the possible impact of conditions that might be changed: conditions ranging from living conditions to despair over any possible future. The aim is not to "contextualise" the problem but to justify the isolation or removal of an irredeemable or unassimilable "other".[55]

Preparing an advance strategy for repair and flexibility. This is part of Schlesinger and Tumber's list of requirements for the continuing success of one source's accounts. Shaping media agendas, they comment, calls for a number of conditions to be present, with one of these being the means to monitor impact and to adjust action accordingly.[56]

Weakening the strength of any dissenting voices. Here several moves may be called upon. Access may be made contingent on submitting prepared questions and programmes, avoiding anything unexpected.[57] Dissenting voices may be discredited, trivialised or written off as inevitably "biased" (the voices of refugees or of refugee action groups easily fall into the "biased" category). More negatively, dissent may be labelled as promoting divisions at a time when firm and consistent purpose

is needed. Dissent may in addition be made less visible. During Howard's electoral campaign, for example, notice to journalists of where he would be appearing was often given late on the night before and in vague terms.[58] The appearance of journalists and of dissenters who might make critical television coverage then became less likely.

More broadly, dissent may be taken over, incorporated into the dominant account. Take-over, it has been argued, is in fact essential for an account to remain dominant. In Gitlin's terms, building on Gramsci:

"only after absorbing and domesticating conflicting values, definitions of reality, and demands on it, in fact, does it remain hegemonic".[59]

Conditions Diminishing the Effects of Dissenting Voices

I shall divide these factors into three sets. The first has to do with control over timing, the second with the nature of news and the news industry, the third with some features of dissenters e.g. their "fragmentation".

A lesser degree of control over timing. Government sources, by virtue of their more privileged position, can control the timing of announcements and "alternative stories" to a greater degree than can the opposition.[60] The events unfolded in Chapters 4 to 6 will bring out the use made of this advantage. To it, we may add the greater likelihood of ill fortune for the voices of dissent. The Labor Party in Australia had no control over September 11 being both the day of events in New York that dominated all news sources and the day of the official launch to their electoral campaign. Events of that swamping kind, however, are often easier to recover from or to build on if you have the more controlling hand over access to sources, and already occupy a centre stage position.

Features of "the news". One of the difficulties for dissenting voices is that they often seek to raise an issue. Issues, however, are not news events. They do not "tell a story" or "advance a story". The dissent may also come from parts of the news production industry that start from a "less listened to" position. Day, for example, sees editorials as being largely ignored (he has been the

editor on several Australian newspapers):

> "They're probably the least read part of the paper, and those who read them don't take any notice anyway. If they did, we'd be a republic by now, because while the great majority of Australian papers editorialised in favour of a Yes vote in 1999, the public remained relatively unpersuaded".[61]

Masters adds some further features in his opening comments for a 2003 workshop on "The Death of Investigative Journalism".[62] The decline of investigative journalism, in his experience, reflected its expensiveness in a climate of cutting costs and increasing profits, the rise of defamation suits, and the growth of a "can't do" public relations industry. From within commercial television stations came the increasingly frequent advice to "avoid all the information that will be found to be disturbing, complicated and threatening to a perceived median of the audience's values and beliefs".[63] From without came officials and advisors who "tell you what you can't report and who you can't interview". "One journalist", Masters comments, "up against ten flacks from the Department of Immigration and Multicultural Affairs is not an even contest".

Features of the dissenting voices. The feature most widely discussed has to do with *fragmentation*. This is one of the features noted by Herman and Chomsky in their analysis of how the media can become agents of government propaganda rather than reporters of news events or probing questioners of established positions.[64]

The presence of multiple sources of dissent to refugee policies is certainly easy to observe. Dissent may come from opposing political parties, religious groups, refugee action groups, news presenters whose audiences are faithful to them because they do probe or who are becoming increasingly restless over restrictions on access or the expectation that they should believe "almost anything". It may come as well from citizens who find a government action's shameful and embarrassing. Tony Kevin, for example, describes his devotion to detailing the story of one particular disaster, the SIEV X, where 353 drowned, in the following terms:

> "If I had walked away from this issue, once I had real-ised how serious it was, I could not have lived with myself. I want my children to live in a society that has the guts to confront its dark side. There was never any choice, although there were times of deep gloom along the way".[65]

Finally, the voices of dissent may be those of "ordinary people" who keep "investigative reporters fuelled and fed":

> "Ordinary people need us to tell their stories and no matter how many minders Canberra and Washington can put in the way, intelligence does have a way of sneaking through. Good citizens know that stories and news are shared rather than owned".[66]

All told, however, coordination among dissenting voices is expected to be fragile, making it unlikely that they can by themselves create the kind of united "democratic claim" sometimes seen as a possible bulwark against the power of established systems.[67]

This possibility of inherent separateness among dissenting voices appears in several analyses of competing representations. In Herman and Chomsky's analysis of political voices, for example, "the Left" is more likely to be marked not only by factions that do not agree but also by a readiness to make a public display of its internal differences.[68]

More broadly, several analysts have argued that

52 Solomon (2002) Op.cit.: 226-227

53 Allan (1999) Op.cit.

54 ibid: 170

55 ibid: 170

56 Schlesinger and Tumber (1994): 39

57 Miller (1994) Op.cit.

58 Solomon (2002) Op.cit.: 208

59 Gitlin (1980) Op.cit.: 256

60 Schlesinger and Tumber (1994) Op.cit.: 39

61 Day, cited in Solomon (2002) Op.cit.: 30

62 Master, C. (2003) "The Death of Investigative Journalism". Available at: http://evatt.labor.net.au/news/186.html

63 ibid: 5

64 Hermann, E.S. and Chomsky, N. (1988) *Manufacturing Consent: The Political Economy of the Mass Media.* New York: Pantheon

65 Kevin, T. (2004) *A Certain Maritime Incident: The Sinking of SIEV X.* Melbourne: Scribe

66 Master (2003) Op.cit.: 5

67 Habermas, J. (1992) "Further Reflections on the Public Sphere". In C. Calhoun (Ed.) *Habermas and the Public Sphere.* Cambridge, Mass: MIT Press

68 Hermann and Chomsky (1988) Op.cit.

dissent in any society not dominated by a single controlling group will inevitably reflect a variety of concerns. Its ethos is likely to be one that favours diversity rather than a single uniform conception of what is good, informal arrangements rather than regulated agreements, a free and open exchange of opinion rather than a negotiated or coerced agreement behind doors.[69] The co-ordinations that do occur are inevitably likely to be fleeting, matters of choice rather than tradition.[70] The challenge arising is one of how to allow a sense both of freedom and of some degree of order or shared values.[71]

Dissent may also be felt to be at odds with the need for a common set of values. Diversity in opinions or accounts might theoretically promote richness. It can also bring a reduction of power unless the several voices manage to create the sense that they represent a consensus. That construction of consensus, it is argued, is necessary because the sense of being part of a society depends on it. We may hold a belief in the value of "healthy debate" and at least a 2-party system, but the sense of some common values is critical:

"We exist as members of one society *because* – it is assumed – we share a common stock of knowledge with our fellow men: we have access to the same 'maps of meanings'. Not only are we able to manipulate these 'maps of meaning' to understand events, but we have fundamental interests, values and concerns in common, which these maps embody or reflect".[72]

Diverse voices of dissent may often not fit with that need for a sense of consensus, especially at times of uncertainty or when the call is made for everyone to "pull together".

Some Specific Steps Stemming from Proposal 4

The general implication of this proposal is that the events used as an anchoring base for examining representations should cover a period of time that allows one to observe changes in representations and the interplay of moves toward dissent and moves toward diminishing the power of dissent. Over that time, we can then be alert to the nature of dissent: to aspects of fragmentation. We can also watch for whether dissent focuses on the contradic-

tions between an initial representation and what is legal or true, or between a representation and what is human, decent, or compassionate. We can also watch for the ways in which dissent is treated. It may, for example, be written off as "inevitably biased" (the fate of comments from groups such as "friends of the refugees" or church organisations), or as "a joke". Caught out in a lie and faced with the possibility of an inquiry Senate, for example, Howard laughs at the suggestion that he – the Prime Minister – might take a lie detector test ("the public are my lie detectors") and presents the notion of a trial as a farce in which "the usual gang" will, of course, find him "guilty, as charged", a trial as meaningless and laughable as that in any Gilbert and Sullivan opera (Chapter 7).

On a more positive note, we can observe the occasions when dissenting voices do find a common focus. Children in detention centres, as we shall see in Chapter 8, became such a focus for many who were unhappy with a variety of conditions in detention centres and for the smaller number who are unhappy with the very policy of mandatory and potentially indefinite detention. We can examine the occasions when an initial representation does show clear changes, allowing us to ask what actually changes (are the changes, for example, at the core or at the edges?) and how change is related to various kinds and sources of dissent.

A Final Comment:
The Nature of "Contexts"

Implicit in the four selected proposals is the view that the effectiveness of any particular representation is influenced by the particular "context" in which it is produced and read. The likelihood of one account being dominant, the presence and strength of various dissenting voices, the preferences, fears and values of particular audiences, the presence of time and the possibilities of review – all of these help to put into practice the proposal that "the fluidly complex conditions under which the account is produced and consumed or 'read' … need to be accounted for".[73]

In effect, understanding how people described and "read" the events that unrolled during the time of the *Tampa*, and after it, calls for understanding some specific features of context both within Australia and

outside it. We need to understand, for example, how it could be that, within Australia, the reaction to the government's representations and actions after the *Tampa* was one of acceptance or approval. In contrast, the international reaction was predominantly one of condemnation. We need to understand also how it is that Australia in 2005 showed a rise of concern with conditions in detention centres and some changes in detention policies, driven largely by calls for compassion and decency. In contrast, Norway provides an example of a move in 2005 toward less supportive measures toward detainees than in the past, reigniting a debate about responsibilities and obligations.

We need then to consider features such as the nature of the political scene, the population mix, the geographic position and the immigration/detention history of any country. The nature of those features as they apply to Australia is unlikely to be well known outside Australia, or to all Australians. I spell them out in Chapter 3, with the double aim of illuminating the Australian setting and at the same time bringing out the features that make a difference to the shape and the fate of representations in any place or at any time.

69 Young, I.M. (2000) *Inclusion and Democracy.* Oxford: Oxford University Press

70 Rose, N. (1999) *Powers of Freedom: Reframing Political Thought.* Cambridge: Cambridge University Press

71 Laclau, E. and Mouffe, C. (1985) *Hegemony and Socialist Strategy.* London: Verso

72 Hall et al. (1978) Op.cit.: 54–55, emphasis in the original

73 Allan (1999) Op.cit.: 4

CHAPTER 3
Specifying Contexts: Significant Features

THE WAY ANY representation is produced, responded to, or changed depends on its particular context or setting, in time or in place. What is it about contexts that make a difference? What marks the difference between one setting and another? Without a specification of features, references to the significance of settings or contexts have little value.

With that general task in mind, this chapter has two aims. One is to provide a backdrop that adds meaning to the events described in the chapters to come. These are the events selected as an anchoring base for examining how representations of borders and border-related events compete for credibility, emerge as "news", and are sustained or changed over time.

The other is to outline a set of features that can be brought to bear on any setting. Toward that end, each section offers examples from both an Australian and a non-Australian context. The non-Australian context is most often Norway: chosen in part because it offers both similarity and contrast in relation to Australia and because the incident of the *Tampa* brought into prominence Norway's criticisms of Australian actions and its views of responsibility.

Between one context and another, however, there can be many differences. This chapter focuses on features that have particular relevance to the representation of asylum-seekers, refugees and borders. In broad terms, these features have to do with aspects of geography, history, and social structure.

The selected aspects of geography have to do with how an area is perceived (e.g., as "empty" or "open"), the ease of physical access from various places, and the political or economic ties to other countries. Regardless of its physical position, no country exists in isolation.

The selected aspects of history have to do with past immigration and detention policies. This history shapes the categories and the narratives that people bring to events involving entry or exclusion: the positions they have come to see as "common sense", the views they take of "diversity", "race" or "social cohesion", and the extent to which they are likely to see asylum-seekers and refugees as warranting compassion or as "aggressive illegals". The section is divided into two parts: one dealing with the history of immigration, the other with detention.

The selected aspects of social structure have to do with those that allow internal dissent, that provide room for more than one voice. Among these is the presence of official political voices (the main parties), a possible chorus (e.g., the media), and connections between the two. The presence and strength of those voices shape the occurrence, nature, and effectiveness of dissent or criticism.

Cutting across all sections is the need to keep in mind both national and regional borders. Immigration and most refugee situations involve national borders: the lines between countries. Detention situations have more to do with internal borders. Once within a country,

for example, what should happen to people while their right to stay is being considered? Should they be kept in locked centres (mandatory detention), restricted to particular parts of the country, or allowed to move freely until their cases are decided? How long should detention or an indefinite status last? The features that mark the differences between one setting and another – geography, history, and room for dissent – are relevant to decisions and viewpoints about both kinds of demarcation lines.

Geographical Features

The selected aspects have to do with perceptions of a region, ease of access, and ties to other countries.

Regional Perceptions

Physical features certainly make a difference to the representations of a region. Critical also, however, are the ways a region is perceived, both by people outside it and those already within it. Physically, for example, Australia is a large country with a small population. In size, it is close to the area of the USA. Its population is around 20 million.[1]

For many of those viewing the country from outside, that feature can encourage the perception of the country as relatively "empty". In the words of a refugee on board the *Tampa*: "Australia is a big country: we thought there would be a place for us".[2]

That kind of perception is far from new. To the country's first "boat people" (English arrivals in the late 1700s), the land certainly appeared to be "empty", to be owned by no one in particular. There were no town walls, fences, or bridges: no markers of ownership. Signs of occupation could be made meaningless by the perception of people as, at best, "nomadic". In fact, Aboriginal groups had a strong sense of place, of respect for others' ownership of significant places, and of the procedures to be followed in requesting permission to pass through another's area.[3] Those borders and expected procedures, however, were invisible to the new arrivals, and are still not highly visible to many who are no longer "new".

That same apparent open-ness also has an influence on what are seen as potential sources of threat. In Australian discussions about borders, references are often made to Australia's "large, unprotected coastline". There is indeed far more coastline than the existing surveillance system can easily cover, but landing in many places could be unrewarding. Coupled with that perception of the coastline is often the sense of "danger from the north". To the south lies only Antarctica. To the north, however, lie the densely populated countries of Indonesia, China and Japan, and for one of those countries – Japan – there is a memory of the 1940s when it occupied parts of New Guinea and bombed the nearest northern city (Darwin). Adding still further to the sense of being "unprotected" is the feeling of distance from the countries seen by many as the closest to Australia in spirit and cooperative ties: Great Britain and the United States. From time to time, Australian governments describe Australia as an "Asian" country. This is the region to which it belongs geographically and where its economic ties should be strongest. The description as "Asian" does not sit well, however, with many Australians, nor with some other "Asian" countries, leaving unchanged the perception of the coastline as "unsecured".

Geography in Relation to Access

People rarely seek entry into countries that offer little and are difficult to reach, especially at times when there are few incentives to leave their own areas. Some countries are also easier to reach than others and offer more than one way to arrive.

In many countries, for example, there are two *routes to an illegal stay*. One is to apply for a tourist visa or a working permit and then "overstay", disappearing into the local community. In effect: legal entry, illegal stay. The other is to enter without advance permission, asking after arrival for permission to stay. Australia's "boat people" are in the second category. The ease of both

1 The Australian Bureau of Statistics projected the population to be 20 399 836 on Sept. 11, 2005. http://www.abs.gov.au/ausstats/
2 "Ali" cited by *Tv2.no*, 28/08/01
3 Myers, F. (1986) *Pintupi Country, Pintupi Self: Sentiment, Place and Politics Among Western Desert Aborigines.* Washington D.C.: Smithsonian Institute Press and Canberra: AIAS

routes varies from one country to another. "Overstaying", for example, is affected by conditions such as the likelihood of standing out as "different" and by state or regional control over identification, work registration or medical care. Australia's current population mix means that few people stand out as obvious strangers, and many can melt into existing groups. The number of "overstayers" is then difficult to determine. It is certainly estimated to be far larger than the number arriving by small boats from Indonesia, prompting again the question: What makes this smaller set the centre of such a storm?

Adding to differences in attractiveness of access is the presence of agreements about what represents a "country of first entry". Signatories to the Refugee Convention of 1951 may send asylum seekers back to the first signatory country the asylum seeker passed through. All countries are not equally affected by the agreement. "First entry", for example, has less impact on Norway than it does to countries like Italy or Spain. (For most refugees, Norway is not the first on any route to another place).

"First entry" would not seem to apply easily to Australia, especially to people coming from countries such as Afghanistan, Iran or Iraq. Many of the countries that are first reached, however – countries such as Indonesia and Malaysia – are not signatories to the Refugee Convention. They are not required to receive refugees for whom they may represent "first entry". Refugees who arrive there or are returned there may also be sent back to the countries from which they fled (*refoulement*). Signatories to the Convention are bound by the agreement not to send asylum seekers to countries where there is a possibility of such forced return. In effect, geography by itself may affect the ease of physical access. Geography combined with international agreements, however, may affect the likelihood of being able to stay.

International Ties

The countries that are closest need not be the countries whose opinions or cooperation matter most. In the midst of criticism from countries such as Norway and international bodies such as the UNCHR, for example, the Australian government could assert that it was receiving little negative comment from the USA or from England: countries, it implied, that "really mattered" (Chapter 5). The criticism from other sources could sting but it could be offset by the sense that "primary" ties were not being affected.

Simple geographical proximity may also not mean easy cooperation. The reverse may in fact be true. To take an example from Australian events involving "boat people" sailing from Indonesia, Indonesian cooperation when it came to "people smuggling" would have been an asset to Australia. Cooperation, however, was hindered by a lack of political closeness between the two countries, and by Indonesia's suspicion of Australian actions in both East Timor and Indonesia. The Australian government in fact found itself in the embarrassing position of Indonesia's President refusing to receive phone calls from Australia's Prime Minister (Chapter 4). Here then was a time when that Prime Minister was readily granted time and photo opportunities with the leader of a distant country – George Bush – but was being snubbed by a neighbour whose immediate cooperation was hoped for. Physical proximity is clearly not always positive in its effects.

Variations in History: Earlier Experiences with New Groups

History shapes a country's sense of "self" and "others" and of the extent to which diversity within a country or a region is possible. It shapes also the categories that are used to distinguish among people and the actions toward them that seem reasonable or outrageous.

I shall divide the relevant history into two parts: one dealing with external or national borders, the other with borders or barriers within a country. A country may, for example, be reluctant to open its borders for all but a small number of people who meet particular criteria. Once in, however, they may be allowed free movement and the opportunity to become part of local communities. In contrast, a country may place major restrictions both on initial entry and on movements within: restricting its new arrivals to particular areas, placing them in closed detention centres, offering no assistance toward employment or toward learning a new language, and making uncertain the possible timing of any move

toward overcoming those internal barriers.

The history of immigration and external borders provides the starting point. All countries have an immigration history. Where they vary is in the nature of that history, in their perceptions of its place in the images of themselves and their regions, the people they prefer, the distinctions they draw among them, the provisions they make for new arrivals, how they expect people to apply and, if successful, to act after they enter. Where they differ also is in the extent to which the problems they face lie predominantly with those who seek to enter or with those who, once in the country, turn out to be "non-returnable".

To start with some non-Australian contexts, some European countries see themselves in a special light:

"Unlike the USA, Canada or Australia, no Western European country sees itself as an immigrant society …. Most Europeans still consider mass migration to be the historical exception. Residing in the same place throughout one's life is considered to be normal".[4]

Some countries may also have a history of people leaving but not of people moving in, at least in any large numbers. Greece, Ireland, Italy – even Norway – for example, have seen people emigrate but have not seen, in remembered times, large numbers of people coming in and wishing to stay.

That kind of history can readily make it difficult to regard as "normal" any large-scale movement into one's own region. It could also diminish the likelihood of regarding, as part of one's strengths or virtues, the readiness to bring in large numbers of people and to maintain nonetheless the sense of a cohesive society. To take Norway as a specific example, the main new arrivals since the end of World War II have come from countries racked by civil war and have been officially classed as in need of asylum: parts of Africa, for example, and – to a larger extent – Bosnia. Intake was then more a sign of the country's acceptance of a moral obligation than a concern with the size of its population or its economic needs for people with particular skills: skills in the fields, the factories, or the hospitals.

Economic needs have by no means been completely absent. The need for staff in Norway's hospitals, for example, has brought some special arrangements for entry by nurses trained outside Norway. Norway voted twice against being a member of the European Union but did join the European Economic Area that allows for the movement of labour.

Australia offers a contrasting pattern. Most of the non-Indigenous population has an immigrant history, beginning in 1778 (usually referred to as a "settler" history). The influx was almost entirely "white", with the English, Irish and Scots predominating. The discovery of gold in the 1800s brought in a greater variety of people, including many from China. Some of the Chinese stayed. Some returned when prospecting was not successful. Many were returned during a push toward a less "mixed" society. Some further mixture came with the need for labour on the sugar cane fields, with "Kanaka" workers brought in from neighbouring islands: again with many returned after a fixed stay, and a smaller number staying, usually seen by many "whites" as part of the "Aboriginal" population.

By the time of the White Australia Policy then (1890 – 1950), the dominant internal image was of a country that had a large enough population and that could afford to be very selective about any new arrivals. The very name "White Australia Policy" is itself an indication of attitudes toward "colour" and of some particular distinctions among people.

The big shift came after 1945. This is the shift that Human Rights Watch has called a move toward entry "By Invitation Only".[5] The party then in power (Labor) recognized both the need for a larger population and for people who could advance the country's economic growth. The construction of roads and houses, the production of goods that were not classed as "essential" for a war effort, the development of export idustries that went beyond the traditional wool, wheat and iron ore: All of these had been delayed by six years of war.

The government then began a selective immigration program. The original selection was biased toward English and Europeans. Many of the latter had been

4 European Observatory on the Social Situation, Demography and Family cited by Sheila Barter, posted on the BBC-website, June 2002

5 Human Rights Watch (2002) "By Invitation Only": Australian Asylum Policy. Vol.14, No.10 (C) – December 2002

displaced by the recently ended war (e.g., Estonians, Lithuanians, Poles, Sudeten-Deutsch, Ukrainian). Others were attracted by the economic opportunities offered by a booming construction industry. To this day, for example, many of the firms involved in the production and laying of cement carry Italian names. To this day also, Melbourne remains – after Athens – the city with the largest proportion of residents with a Greek background.

Over time, upheavals in immigrants' home countries (e.g. Chile, Cyprus, Czechoslovakia, Hungary, Latvia, Pakistan, Vietnam) increased the mix. Over time also, the proportion of immigrants from Asia increased, again assisted by criteria geared toward the labour market and an absence of demands on social services. Criteria such as an existing level of English-speaking skill, education, and technical skills, for example, currently make immigration from Hong Kong or Singapore easier than from countries such as Turkey.

Over time, to take a last form of change, Australia began to receive immigrants who fell into the Australian category popularly known as "Muslim". They were perceived, however, as less interested in assimilation than previous waves had been. They often dressed differently. They publicly kept and observed their religion. They were suspected of harbouring deplorable views of women. And some appeared to others to be over-represented in reports of rapes and street crimes.

The end-result was a "mixed" population and a mix of views. Australians often like to perceive the country as having become successfully "multicultural". The French insistence that girls not wear veils or headscarves in school, for example, has no parallel in Australia. At the same time, there were and are major tensions. By 2001, the mix was volatile and a great deal of fear and prejudice lay ready to surface. With an election drawing closer, distinctions among those seeking entry and concerns about their potential were often taking some particular forms. To take a comment from Atkins' 2002 review:

"They went like this – boatpeople, illegals, queue jumpers, street gangs, raping white girls. It was ugly. And that race card sits there ready to be played at any time. It's like the south of the USA when Reagan broke off the old blue dog Democrats and took them for his own. The Republicans still own them and the Democrats are on the outside because of it. Howard and (campaign director Lynton) Crosby have worked out how to unlock these voters and they will again and again".[6]

Charlton's comments are similar:

"The divisions over refugees in the community were clear. The opinion polls and the focus groups were showing privately what callers to John Laws and Alan Jones were saying publicly – a substantial majority of Australians were opposed to 'unauthorised asylum seekers' attempting to come to the country. The reasons seemed to vary. They included concern about the so-called 'queue jumpers' …. and a deep-seated suspicion of foreigners, particularly Muslims, exacerbated in New South Wales by the ramped up issue of ethnic – read Lebanese – gangs and violent crimes".[7]

Area Variations

That minimal history may make it seem as if all parts of the country were alike. In fact, however, issues of intake and routes for intake were more salient in some regions than in others. Some of the Western suburbs in Sydney provide a specific example. Atkins' analysis of the election and its results is again informative:

"The asylum-seeker issue was given greater potency in Western Sydney because of the intense immigrant mix – about 40 per cent of all migrants settle in this part of the country, giving many electorates an overseas-born quota of about 70 per cent, as against an average in most other parts of Australia of little more than 20 per cent".[8]

Migrant groups were particularly sensitive to questions of "illegal queue-jumping". Most often, they themselves had come to Australia legally as economic migrants or – the hard way – through refugee camps. They were also concerned about issues of family reunion, and were likely to see the acceptance of uninvited refugees as a disadvantage for their own cases.

A Contributed Image: The Right to Choose

A history of selection to meet economic needs, with a smaller infusion of people who have passed the examinations set for determining whether they are "genuine refugees" or not, leaves some particular marks, especially when support for selective entry has been bipartisan. One of those marks was the category "*queue jumper*". The proper process – expected to apply also in everyday life – was one of orderly waiting in line. A second was a sensitivity to the claim that every acceptance after an illegal entry was *another acceptance denied*. When "the queue" consisted of people being sought for family reunions was long, that type of argument put acceptance in a negative light. A third – and the one I emphasise – was the appeal of an insistence on "*the right to choose*".

The right to choose, we shall see, became in 2001 the election slogan for Howard's party:

"We shall decide who comes, the circumstances under which they come, and no-one else."

It was a phrase that Howard repeated ad infinitum, as if any alternative to his policies was a loss not only of "sovereignty" but also of any control. The appeal, it should be noted, is not uniquely Australian. To take again a Norwegian example (an editorial comment from a conservative newspaper):

"If we accept relatively well-resourced Bosnians who have enough money to buy airplane tickets to come to Norway, we lose out on the right to choose those that need it most".[9]

Australia, however, stands out for the extent of use and the apparent appeal of this particular frame.

Variations in History: Detention and Internal Borders

People seeking entry to an area present less of a problem if they go through a selection process and can then be consigned to particular areas. Many of those who came out to Australia on "assisted passages", in the 1940s and 1950s, for example – especially if they came from the "displaced people camps" in Europe – signed agreements to work wherever they were assigned for a 2-year period.

What happens if people arrive without going through any selection process for skills or economic needs? Where should they live – and how should they live – while processing takes place to determine whether they should be allowed to stay? Should they, for example, be locked in detention centres or allowed to live and work in the community? What happens if that process takes a long time or the conclusion is drawn that they cannot stay? Is mandatory detention to be indefinite? Can they be returned to the country they came from? What if return is not possible or if the criteria for "safe to return" are debateable?

Again, those are issues that have been faced by many countries, with the shape and salience of concerns, and the approaches adopted, varying from one place to another and from one time to another. Over time, for example, issues of entry may become overshadowed by issues of detention. The "flood" of refugees may dry up, but there remain, potentially visible and potentially a new site for concerns about rights and compassion, people waiting for years for a decision about their status. There remain also people who have been judged not to be "genuine refugees" but are – to use a commodity-style term that has become frequently used – "not returnable".

I start again with some non-Australian contexts, with particular attention to Norway. That country, as I noted earlier, provides not only an example of changes over time in the decisions faced and the actions taken, but also a contrast to Australia. Norway was as well the country most immediately caught up in the *Tampa* event.

Detention in a Norwegian Context

The years 1993, 1996, and 2001 provide a first picture of variations in context, with each of those years presenting a changing demand for decisions: decisions influenced at each time by some particular circumstances. The year

6 Atkins, D. (2002). In D. Soloman (Ed.) *Howard's Race: Winning the Unwinnable Election*, Sydney: Harper Collins

7 Charlton, P. (2002) "Tampa: The Triumph of Politics". In D. Solomon (Ed.) *Howard's Race: Winning the Unwinnable Election*. Sydney: Harper Collins

8 Atkins (2002) Op.cit.: 151-152

9 *Aftenposten*, 17/7/93. All translations from the Norwegian are done by the author.

1991, for example, saw an influx of refugees that led to visas being required for those still seeking entry and, for those already in the country, decisions about the location of asylum centres and some debate about whether these should be "locked" (they were not, but crossing internal borders was nonetheless made difficult). In contrast, the year *1996* saw a major rise in the salience of decisions about the length of stays. Stays were originally intended to last no more than 3 to 4 years (the period of "asylum", after which the right to residency should be granted). The year *2001* saw a shift in entry-seekers from people seeking asylum to people more readily categorised as seeking work (should they all be simply turned away?). Detention, however, was still an issue in relation to "unreturnables" (where should they live?) and in relation to immigrants who had committed crimes (where should they serve out their time? Should they be deported?).

In slightly more detail: In the course of a civil war, large numbers of Bosnian refugees needed to be moved out of their country. Approximately 12 000 came to Norway, almost 50 000 to Sweden and 18 000 to Denmark. Some of these came directly from UNCHR camps while others arrived by their own accord.

With the aim of not having the same or a larger number continuing to arrive, the government's decision in October 1993 was to introduce visa requirements. (The decision came 3 weeks after an election in which the Labor Party was returned but with a reduced majority). Airlines would now no longer accept people without a visa, and land transport through Denmark was already closed. One justification offered was in terms of cost (e.g., "continued open borders … is too expensive for us when it stops us keeping up the work for refugees in and around Bosnia".[10]) Another was in terms of housing. The refugees were allocated to areas where buildings were available (e.g., army camps or hospitals no longer in demand) and where local councils were willing to accept newcomers and interested in the local jobs that they generated. There was, however, not an indefinite supply of such possibilities.

These asylum centres were not "locked" or fenced in (a contrast to Denmark and to Australia). They were, however, in areas often well away from the main cities: areas where "strangers" tend to stand out. Norway has as well a strong regulatory system for anyone (citizen or non-citizen) moving from one area to another, with each person required to register a move with a national registry. All need also to provide their social security number to any employer, and wherever they seek medical care (a national system), or any form of assistance. In effect, refugees might (and did) express concern about the places they were sent to and the conditions of their stay (and be thought "ungrateful"). In one centre, for example, a number went on a hunger strike. In another, the local mayor – after publicly describing the centre as effectively "a prison" – asked for the refugees to be transferred.[11] Nor could the Bosnian refugees anticipate any integration into the life of the communities they were now in. Their acceptance was not accompanied by the right to work or by assistance in learning Norwegian. In effect, the centres might not be physically locked but internal borders and boundaries were very much present. Sweden, in contrast, granted permanent residency from the start and took steps – language provision was one – to promote positive integration.

The year 1996 saw a new round of decisions to be made. Permanent residency was expected to be granted after 4 years. That date come up in 1996 for those who had arrived in 1992. Repatriation now became an issue. Return was a possibility strongly endorsed by the Progress Party ("Bosnians" should return to "build up their country") but opposed by the UNCHR and by others who saw forced repatriation, particularly at that time, as unreasonable and lacking in compassion. Now there appeared in the media special attention to the plight of children who were effectively in "closed detention sites". These children, predominantly Kosovo-Albanians, were in churches protected on the grounds of "church asylum". Their applications to the government had failed, and they sought protection in the churches to avoid deportation and to file a request that their applications be re-evaluated.

In a move that we shall see again in Australia, parts of the press ran a series of portraits of children in these restricted spaces:

"Faremo (the Minister for Justice) can save him: Samim is 5 years old. For 316 days he has sat as a prisoner in God's house. The Norwegian Association for Asylum Seekers (NOAS) has started a national signa-

ture campaign: Let the children in church asylum go free!"[12]

A new minister for Justice (Anne Holt) announced the decision. Bosnian refugees would be granted permanent residency: "The news took all the steam out of the asylum debate at the Labour Convention".[13]

A third phase appears in 2001. Norway's Progress Party had moved toward distancing itself from positions that could be regarded as racist. Immigration and immigrants, however, still remained a volatile issue. The increase in the voters that the Progress Party attracted enabled it to influence the choice of Prime Minister and to promote several legislative moves: entry more open for work-related immigrants, the removal of legislation that provided permanent residency if processing was not completed in 15 months, a reduction in financial support to asylum seekers whose applications had been denied (this support was later removed completely), and the goal of a "more effective deportation policy".[14] The rise in popularity provided also more media access for concerns about "ethnic tension and conflict", "ethnic" contributions to crime, and a new aspect of detention: Where should people with a refugee or immigrant background serve out their time? Carl I. Hagen, Leader of the Progress Party, argued that immigrants should carry out their jail sentences outside Norway, with Norway covering the cost:

> "We should pay for them to do their time in countries on their own continent …. That means that Africans would, paid by us, do their time in an African jail, Asians in jails in an Asian country and Russians in a Russian jail. Then we could avoid the hopeless situation where people have to stand in a queue to do their time in Norway. Otherwise we have suggested closed detention centres for those that show unacceptable behaviour when they are in centres like they do in Denmark. All the other parties say no".[15]

Such extreme moves were not widely endorsed. The general political move, however, was one of all parties endorsing the "tightening" of restrictions. Newspaper headlines also expressed concern about "criminals in Oslo's streets" with the criminals being "those who are deported and are awaiting transport … walking freely in the meantime".[16]

Concern was also increasingly expressed about asylum seekers who were granted residency at the end of the 15 month period, simply because their applications could not be processed during that time, and about poor screening "letting in potential terrorists".[17]

That acceptance of "tightening" was then part of the contextual climate that Norway brought to the events that the *Tampa* began to unroll.

Detention in the Australian Context

In contrast to Norway, "mandatory detention" had been a part of the Australian scene – with bipartisan political support – since 1992. The variations had been in who was placed in detention centres, where the centres were sited, the length of time people could be detained, the possibilities of review by outside groups or agencies, who ran the centres, and the conditions that were maintained within them. Each of those features is worth a brief note. Each of those aspects became a focus for concern, dissent, and change.

Who and how many. Prior to 1992, Australian law permitted the detention of people ("non citizens") without a valid visa, but did not require it. The 1992 legislation *required* detention for certain "designated persons". 1994 legislation made it mandatory for all persons who arrived without a visa, stayed beyond the time their visas allowed ("overstayed"), or had their visas cancelled. Detention, in current official terms, "reflects Australia's sovereign right … to determine which non-citizens are admitted or permitted to remain … and the conditions under which they may be removed" (another form of the "right to choose"

10 Gunnar Berge, Minister for Local Government, *Aftenposten* 1/10/93
11 Goodnow, K. (1999) "Norway: Refugee Policies, Media Representations". In O. Tveiten *Bosniske Krigsflyktninger i Mediebildet –Nordiske Perspektiver*. Copenhagen: Nordisk Ministerråd, provides a more detailed account
12 *Dagbladet*, 04/07/96
13 *Dagbladet*, 08/11/96
14 Norwegian Prime Minister Kjell Magne Bondevik "Norway in Renewal", *Aftenposten* 18/04/02
15 *Dagbladet.no*, 04/08/01
16 *Dagbladet*, 01/03/02
17 *Aftenposten*, October 2001 and Progress Party legal-political spokesperson, Jan Arid Ellingson, to VG 30/10/01

argument). It also "ensures that unauthorized arrivals do not enter the Australian community until their identity and status have been properly assessed ... are available during processing ... and, if their visa applications are unsuccessful, ... are available for removal from Australia, and ... are immediately available for health checks".[18]

The numbers of people detained have varied from one year to another. Between 1997 and 2001, however, the numbers by year rose from 2713 to 3757, 8205, 7881, and 7808. (A decline began in 2002 with 6196 still in detention in June 2006). Those numbers cover both men and women, and both adults and children (children of all ages). Their countries of origin also varied. The 1992 legislation, for example, was prompted by an influx of asylum seekers from Vietnam, China, and Cambodia. In later years, the countries of origin were – in alphabetical order – most often Afghanistan, Iran, Iraq and Pakistan.[19]

Where. The oldest centres were in the larger cities: Sydney (Villawood, established in 1976), Melbourne (Maribyrnong, 1960), and Perth (1981). Later centres were in more remote areas, with some opened specifically in response to an increase in "boat people". Among those, Woomera, in a remote part of South Australia, received particular media notice. It was difficult to reach and pictures of it, surrounded by razor-wire fencing and by flat, dry, empty land, carried an instant "prison" image. (It was closed in 2004, and Baxter – only slightly more accessible and still forbidding – opened in its place).

Length of stay. The legislation in 1992 imposed a 273 day limit. The 1994 legislation removed that limit. Detention could now be *indefinite*:

"This ... laid the foundation for the most controversial aspect of mandatory detention – *indefinite detention* in purpose-built 'detention centres' run by correctional services, without charge or trial".[20]

The possibilities of review. Who might possibly be involved in reviewing the decisions made? The 1992 legislation disallowed judicial review of decisions, leaving the Immigration Department and the Minister as sole arbitrators. (A change in June 2005 brought the Ombudsman into the picture, to receive reports on all cases in detention for more than 2 years, investigate individual cases, and recommend release). The Human Rights Commission at one point could send letters informing detainees of their right to legal assistance, but that avenue for revue was closed by legislation in 1999, leaving various groups of less official "friends of asylum seekers" the main source of information.

Restrictions after release from detention. Release from detention might seem at first to be equivalent to the end of internal borders. That, however, is not (and has not been) the case. Individuals without documentation papers may, for example, be released from a centre on a "Temporary Protection Visa" (TPV). They must then re-apply for permanent status after 3 years. In the meantime, they do not have the right to family reunification, have limited access to social security, and no right to financial assistance for tertiary study. They are, however, in a better position than those given Bridging Visas. These have no right to work, no access to the national health care system, and no right to the Assistance Scheme for Asylum Seekers in the Community.[21] The allocation of Temporary and Bridging Visas, and their restrictions, has again consistently been decided only by the Department of Immigration and by the Minister.

Conditions within detention centres. Locked centres are in themselves problematic, especially when they are not easily visited by others, there are few facilities for schooling, sport, or health care (mental health especially), and any attempt to leave is categorized as an attempt at "escape" that in itself opens the possibility of official imprisonment. Any sense that one is now "safely within Australia", or seen as a probable part of the community, is likely to be further eroded by the centres being run not by staff who are part of a government department, but by staff hired by a private company: Global Correction Services based in London. The Howard government "outsourced" management to this group in 2003.[22]

In all, Australia's external borders might well be easy to overcome. The internal borders that kept those who had arrived from contact or membership in Australia communities, however, were major. For a long time, those borders were either not highly visible to the public

or not strongly objected to. They became, however – like the "children in churches" in Norway – a focus for dissent even among people who did not find tight national borders objectionable.

That shift provides a bridge to the third and last feature of contexts: the presence and nature of dissenting voices.

Aspects of Dissent

Dissent was noted in Chapter 2 as a major part of how any representation comes to be accepted, sustained or change. Conceptually, the likelihood and the possible effectiveness of dissent have been core issues within analyses of hegemony, primary definers, or competing representations.

For the analysis of contexts, dissent is also a central topic. At issue especially are the opportunities for dissenting voices to be heard, the extent to which these are split or have a common focus, the topics they tend to address and the topics they avoid.

Dissent over the nature of conditions in detention centres provides a useful starting point, illustrating especially the extent to which dissent comes to focus on particular content.

The Content Attracting Dissent

As in Norway, Australian dissent took people as its focus: reflecting once more the adage that "news" is about "people", not "issues". Charlton's description of events in August 2001, shortly before the *Tampa* events hit the press, provides details. At the time, the Minister for Immigration and Multicultural Affairs was Philip Ruddock:

"Ruddock had to endure the political fallout of a damaging parliamentary inquiry into detention centres, in which the government's policies and practices were severely criticised. On August 13, about the time the *Tampa* refugees were preparing to leave Indonesia, the ABC's *Four Corners* program was broadcasting 'The Inside Story', a splendid piece of television journalism that went inside Sydney's Villawood detention centre for the very first time. Included in the broadcast was an interview

with Sydney clinical psychiatrist Dr. Zachary Steel. According to Steel, three separate studies had shown that Australia's 'so-called illegal refugees' were more traumatised than those who had come here through official refugee programs. 'Almost everybody within that detention environment is presenting with signs of clinical depression', Dr Steel told *Four Corners*. As well, Steel and three of his colleagues had had their findings published in the British medical journal *The Lancet*".[23]

"Perhaps the most poignant feature of the *Four Corners* program was the plight of a young boy, Shayan Bedraie, so traumatised by his experiences that he had to be drip-fed and rehydrated. Doctors at Sydney's Westmead Hospital said he would benefit from a more normal environment than a detention centre. The Department of Immigration said he should go back to Iran. The following day Ruddock ... the man who proudly sports an Amnesty International badge in his lapel, kept referring to the boy as 'it'. The controversy that followed the program raged for days Ruddock took the unusual step of rebutting the program by issuing a six-page statement, compiled after obvious perusal of departmental files not available to the program makers at the time".[24]

The media, however, were again divided in the extent to which they took part in the criticism:

"For months, Ruddock had been taking a fearful

18 www.immi.gov.au/detention/facilities.htm
19 ibid
20 From *Wikipedia*, online encyclopedia, section on Mandatory Detention, emphasis added
21 The National Children's and Youth Law Centre and Defence for Children International (Australia) (2005) *Rights of the Child in Australia*: The Non-Government Report on the Implementation of the United Nations Convention on the Rights of the Child
22 From the Auditor-General's (2005) Audit Report: *Management of the Detention Centre Contracts*: "Since November 1997, the provision of detention services at the immigration detention facilities has been outsourced to private organisations. For the period between November 1997 to February 2004 detention services were provided at all mainland immigration detention facilities by Australasian Correctional Services (ACS). ACS provided these services through its operational arm, Australasian Correctional Management (ACM) ACS/ACM are now known as GEO Australia Pty Ltd. Between 1 December 2003 and 29 February 2004 the provision of detention services at Australia's immigration detention centres was progressively transitioned from GEO to GSL The cost of providing detention services through the Contract is approximately $90 million annually, not including the cost of overheads and contract administration."
23 Charlton (2002) Op.cit.: 90
24 ibid: 91

pounding in the broadsheet newspapers and on the ABC over the Government's treatment of people in detention centres. But not, it should be added, in the tabloid newspapers, where prominent commentators such as *The Daily Telegraph*'s Piers Akerman and *The Herald Sun*'s Andrew Bolt were becoming increasingly strident in their support of the government".[25]

In effect, at the time of the *Tampa* the conditions within detention centres – but not their presence or their use – were of increasing concern, but not to all. There was for some time little dissent to the view that, if they landed, the asylum seekers on ships such as the *Tampa* would be allocated to closed detention centres while their applications for asylum were processed, with detention potentially indefinite.

A Topic Avoided

The comments on content up to this point have focused on where dissent is likely to be expressed. Of interest also are the topics where dissent is known to exist but acknowledgement of its presence is publicly avoided.

Especially relevant to issues of borders and immigrants is acknowledgement of racism and the avoidance of dissent that could be labelled as "racist".

"Racist", in one description, has become "the most scalding expletive in the news business today".[26] It makes "reporters bite their tongues" and politicians insist that, regardless of how others may perceive their actions, neither they as individuals, nor the countries they represent, are "racist" and any suggestion that they are is offensive.[27]

Most analysts of language, however – whether news reports or everyday speech – see racism as a built-in frame of most discourse. What is avoided, to take a distinction from Hall, is "overt racism", leaving "influential racism" as the "naturalized" norm.[28] Needed then, Hall continues, are analyses of how this discourse proceeds: its "vocabulary", "syntax" and "grammar" in particular places and at particular times, the distinctions drawn between what can and cannot be said.

What can occur with little or no challenge, for example, is the identification of people by racial categories (Libyan, Pakistani, Afghani etc.) or by religious cat-

egories (e.g., "Muslim"). The specific category terms may shift from time to time (e.g., from "Negro" to "black" or "African-American") but the identification is usually routine. What can also usually occur with little or no challenge is the use of "marked" forms that indicate the qualities that go with various racial identities. Marked forms have attracted most attention in analyses of gendered speech (e.g., terms such as a lady judge or a woman jockey indicate that the norm – requiring no mark – is male). Designating someone as a Christian Lebanese has a similar quality. So also does the term "ethnic". "Whites" or "locals" are never "ethnically" defined.

What should nowadays be avoided, however, is the open denigration of people already identified by racial category. To take an example from 2001, a member of Howard's Coalition Party described people "who would throw their children overboard" as "repulsive". Howard was promptly asked for a comment. Senator Ross Lightfoot, he said, was at liberty to express his opinion but he, Howard, would not use "those terms". A statement by the leader of Norway's Progress Party (FrP) follows a similar pattern. France's Le Pen had expressed approval of Hagen's anti-immigration stand:

"TV2 broadcast on the 14th of September an interview with LePen who indirectly gave their support to FrP. 'Vote Norwegian! Vote for Norway, first of all. Vote for those that prioritise Norway. That is normal, correct and responsible'".[29]

Hagen promptly distanced himself:

"Carl I. Hagen became unusually furious and came forward with his crying wife and said that 'LePen is a horrible and base racist, from whom I strongly distance myself from ... In the Norwegian election campaign neither I nor my colleagues have at any time attacked immigrants ... It is the immigration policies that we have spoken out against and that is a major difference'".[30]

Those avoidances mark the current scene. They are not, however, unchanging forms of language. The constant goal may be one of maintaining "a racial hierarchy",

accepted as "common sense". Over time, however, the ways of achieving this may vary, Wilson and Guitiérrez' analysis of phases is especially relevant.[31] The anchoring material had to do with the changing representation of people of colour in U.S. white news accounts. It is, however, equally relevant to accounts of refugees.

The first phase, Wilson and Gutiérrez argue, is one of exclusion, of invisibility. People of colour are simply not visible members of "mainstream" society.[32] In the second, they emerge as objects of fear, as threats to an established social order. In the third phase, there is an open confrontation between "us" and "them", expressed by military action or by legislated action (e.g., segregation laws, immigration laws). At this point, the language of crisis justifies the actions taken. In the fourth, fears are diminished by reassurances that the "outgroup" knows its place or has adopted the roles and ambitions of the dominant group: they have become "like us". The last is a visionary future, in which "we" covers all groups, represented on equal terms.

News accounts, and political rhetoric, several analysts have noted, may actively reiterate the language of confrontation when it suits their purposes.[33] They may also, as we shall see especially in Howard's rhetoric, split "ethnic" groups, designating some as not to be feared (they have been here for a while and "want the same things that we do"), and others (the new "boat people") as to be feared, as presenting a crisis that calls for military-style confrontation and tightened legislative exclusion: with offence taken throughout at any suggestion of "racism" (see especially Chapters 4 and 5). Those moves, however, stem in themselves from their occurrence in a context where some forms of language are accepted as "not to be said" but others – often with the same implications – appear "rational" and meet with little or no challenge.

Possible Dissenting Voices:
Political Parties and Media

Mentioned already have been the opportunities for expressed dissent that can arise when there is more than one political party or one media format. This section outlines more explicitly the nature of political and media divisions, again with borders and immigrants/refugees as

the content area.

Political Parties

To begin with *Norway* as an example, the main parties have traditionally been the Labour Party (Arbeiderpartiet) and the Conservatives (Høyre). A third party – the Progress Party – has gathered increasing power over the last ten years. Its leader, Carl I. Hagen, has been explicit about the need for severe limits on entry, the absurdity of his opponents' thinking and the need to consider costs and priorities:

- "Norway is driven by exaggerated niceness. The Left think with their hearts. The brain is better used in this connection." (They) "think Norway should eventually take on a million refugees and asylum seekers".[34]
- (In Norway) "patients are waiting for treatment …. The elderly are not getting sufficient care. And still we commit funds on demand when it comes to asylum seekers and refugees".[35]
- "the suggestion of a deportation centre is pointless if it should simply be another asylum centre totally without restrictions …. 3 – 4 000 asylum seekers disappear from centres in Norway. In addition the police in Oslo say that there are up to 20 000 illegal immigrants in Oslo. That is a reason in itself for locked centres".[36]
- "Imams must speak Norwegian in the mosques … It is the Norwegian language which is the language of use here amongst us …. Many immigrants tell shocking stories about the contents of the imams' speeches …. When freedom of choice collides with the goal of

25 ibid: 90
26 Gissler, S. (1997) "Newspapers' Quest For Racial Candor". In E.E. Dennis and E.C. Pease (Eds.) *The Media in Black and White.* New Brunswick, NJ and London: Transaction: 111
27 ibid: 111
28 Hall, S. (1990) "The Whites Of Their Eyes: Racist Ideologies and the Media". In M. Alvarado and J.O. Thompson (Eds.) *The Media Reader.* London: British Film Institute
29 Reported by Anti-rasistisksenter http://www.antirasistisk-senter.no/infobanken/dokumenter/artikler/xt97.html Also cited in *Aftenposten,* 15/09/97
30 ibid
31 Wilson and Gutiérrez, Op.cit. (1995)
32 ibid
33 E.g., Hall, S., Critcher, C., Jefferson, T., Clarke, J. and Roberts, B. (1978) *Policing the Crisis: Mugging, the State, and Law and Order.* London: Macmillan
34 Hagen cited in *Aftenposten,* 02/09/93
35 ibid
36 Hagen in *Nettavisen,* 18/04/05

integrating immigrants, freedom of choice must go. That is why FrP (The Progress Party) says no also to Muslim schools in Norway …. Not all Muslims are terrorists, but many terrorists are Islamists".[37]

Within *Australia*, there are again two main parties. One is currently called the Liberal Party, or the Coalition (a combination of the Liberal Party and the Country or National Party). It is traditionally on the "right" or conservative side of political issues. The other is known as the Labor Party. It is traditionally on the "left" or less conservative side of political issues. There are, in addition, several smaller groups: primarily the Greens and the Democrats (usually more liberal). Making a more erratic appearance is a party known as One Nation, or Pauline Hanson's Party. It was formed in 1997, with its first member elected to Federal Parliament in 1998. In the Queensland state election in 1998 the Party won 22.7% of the vote and 11 of the 89 seats. Its primary plank was an open and strong concern with the "high" level of immigration into Australia ("Asian" immigration especially), and the strength of Hanson's support – both before the election and after its results were known – took many by surprise. It also led the two main parties – the Coalition especially – to take a second look at their immigration statements and policies, and at how to recover the voters who had drifted into support for Hanson.

Part of that second look was prompted by the extent to which power had long lain with the two main parties, with one and then the other leading in Federal or State elections. At the Federal or Commonwealth level, for example, Labor was in power from 1972 to 1975, the Liberals in power from 1975 to 1983 (predominantly with Fraser as Prime Minister), Labor from 1983 to 1996 (with Hawke and then Keating as Prime Ministers), and the Liberals from 1996 to the 2007 (with John Howard as Prime Minister and Kim Beazley as the Opposition leader for most of that time). Labour from 2007.

Even with a majority, however, dominance may be shaky. The party that governs the Lower House, for example, does not always dominate the Senate (2005 in fact marked the first year that the Liberals acquired a majority – slim but nonetheless a majority – in both). Dominance at the State level is also varied, with – in 2005 and 2006 – Labor governments in place in all

seven states.

In effect, small gains or losses in seats can tip the balance of power: a circumstance that gave a particular interest to marginal seats and to the rise of a new voice that could alter the balance in any election that was about to take place. It was also a voice that expressed a definition of Australia's needs that had been for some time avoided by the main parties. Especially when Malcolm Fraser (Coalition Party) had been Prime Minister, there had been an attempt to present an image close to that presented by Sweden:

"In contrast to Norway and Denmark, Sweden does not have a large party in Parliament who plays on xenophobia …. It is a dangerous debate to start. We may then begin to discuss what the handicapped, or the elderly cost".[38]

Between the two main parties in Australia, there was an agreement that "race" would not be an issue in immigration debates. "Race" almost raised its head when a decision needed to be made about entry for Vietnamese refugees during and after the Vietnam War. The Prime Minister at that time, however (Malcolm Fraser), took a pro-entry stand:

"As PM (Prime Minister) … Fraser hadn't hesitated to authorise their entry and got the nod from the Opposition. Fraser says that only one of his MPs disapproved. Guess who".[39]

The MP referred to was John Howard. Howard's later position, however, was that he simply reflected community views:

"I do believe that if in the eyes of some in the community (Asian migration is) too great, it would be in our immediate-term interest and supportive of social cohesion if it were slowed down a little, so that the capacity of the community to absorb was greater".[40]

At that time, this attitude met some strongly negative comments:

"I see fundamental Liberal values being questioned in

ways that would seriously alter the complexion of the party ... the issues of race and multiculturalism have been important, indeed fundamental to me, in many years of active politics. Those concerns are not new. I believe it tragic that the Liberal Party runs the prospect of being divided on these issues".[41]

The Labor Party also saw multiculturalism in positive terms. Race or nationality as a criterion for immigration-selection was not seen, at least in public, as an acceptable political tool. The discredited post-WWII White Australia policy was clearly kept in mind by members of both parties as an error:

"When ... Bob Hawke" (the Australian Prime Minister for Labor over the years of 1982 to 1992) "brought the issue to a head in Parliament with a motion that no Australian government would use race or ethnic origin as a criterion, four Liberals crossed the floor to vote with the Government: Ian Macphee, a former Immigration Minister in the Fraser government; Steele Hall, the former South Australian premier, Peter Baume and a former shadow minister, Phillip Ruddock. The very same Phillip Ruddock who, as Howard's Immigration Minister 13 years later, would implement John Howard's divisive, racially suspect, fear-based campaign against desperate refugees".[42]

What then could prompt the open expression of concern with "undesirable" immigrants, with threats to the country's borders, cohesion, and safety? In the eyes of some commentators, the answer lies in Howard's own values. His orientation has always been toward an Australia that is essentially a "British" country. His views on restrictions to entry then are now new. They were simply not a political asset in earlier times.

In the eyes of others, the political appeal of various positions was sufficient in itself to account for Howard's change of voice. In 2001, during the pre-*Tampa* months leading up to the election date of November 10, three features marked the political balance:

The Coalition was widely expected to lose. The bases for voters' disaffection were local. The Coalition was unpopular both because of local tax issues and because of questions regarding the integrity of their Ministers.

In the election year, the Coalition had introduced a value-added tax (the GST) of 10%. Those most affected by this were typical Coalition voters. Added to that were several scandals involving the Small Business Minister, Ian MacFarlane, who was seen to have himself avoided paying the recently introduced value-added tax:

"All Howard's policy reversals – on petrol, beer, the business activity statement, contractors and caravan parks – will be for nought if MacFarlane becomes a symbol for a government prepared to try and cheat the same tax which it has denied sending many businesses to the wall".[43]

Labor was expected to keep the seats already held and to add others. Among those seats, however, were several in the Western part of Sydney and along the NSW coast. Political commentator Dennis Atkins argued that it was "mathematically impossible for Labor to win power without winning seats in Sydney and along the NSW coast".[44] Those seats, however, were known to swing between parties, and attracting votes in those places was important to both parties. They were also seats marked by strong concentrations of recent immigrants who were eager to see more room for family reunion and could be expected to be sensitive to any suggestions of others "queue-jumping".

Diversity in Media Voices

The last point to be made in this outline of dissenting voices has to do with the media. I shall restrict comment to the Australian context.

Australian media take several forms: press, television, radio (including talkback radio). Some are openly affiliated with particular political positions. In 2001, that affiliation was especially explicit for the

37 Hagen in *Bergens Tidende*, 21/05/05
38 Integration Minister Mona Sahlin, *NTB*, 14/05/02)
39 Phillip Adams in *The Australian* cited by Charlton (2002) Op.cit. 80
40 Howard in 1988 on the ABC's *PM* program to broadcaster Paul Murphy, shortly after he became the Opposition leader. Cited by Charlton (2002) 82
41 Fraser cited in Charlton (2002) Op.cit.: 82
42 Charlton (2002) Op.cit.: 82-82
43 Milne in *The Australian*, 26/08/01
44 Atkins, D. (2002) In D. Soloman (Ed.) *Howard's Race: Winning the Unwinnable Election.* Sydney: Harper Collins: 155

Coalition and in areas such as Sydney:

"Australia's biggest city is now a very hostile media market for Labor, with an almost daily dose of criticism and worse from *The Daily Telegraph*'s Piers Akerman, backed up with the often angry voice of Alan Jones at breakfast and the serious tones of John Laws into the morning. Labor's message not only does not get through, it is trashed before it raises its head. Beazley was neither heard nor seen".[45]

Taking a more independent stance – but often seen by the Coalition as "anti-Coalition" – were newspapers such as *The Age* (Melbourne) and the *Sydney Morning Herald*, and the non-commercial radio station, the ABC (a national radio that depends on government funding but is nonetheless often critical of the party in power).

Those voices – and those of other sources of agreement and dissent – provide the last of the contextual features I have singled out as relevant to the way representations of refugees are produced and read in various places and at various times. The nature and the implications of these features are relevant to all refugee situations. They are made especially clear and concrete, however, when turn to the specific events that began with the *Tampa*'s rescue and were followed by some further dramatic "maritime incidents", and the emergence of dissent.

45 ibid: 154

CHAPTER 4

The *Tampa* and Initial Framing

THE PREVIOUS CHAPTERS have outlined some core proposals about the dynamic aspects to any account of events (Chapter 2) and some of the contextual features that influence the way an account is shaped or read at particular places and in particular times (Chapter 3). These proposals and features could be brought to bear on any set of events.

This chapter starts a series of three that looks at a particular set of events. Those events provide an anchoring base in which we can see how far the general proposals help interpret what happened and where they may be made concrete or expanded. The chapter covers the first days of the *Tampa* "incident", offering both a description of events and an analysis of how events were given competing frames, media control exercised, and dissent managed.

First Frames: Competing for the Primary Definition

On August 26, 2001, the Norwegian freighter the *Tampa*, on its way from Perth to Singapore, responded to a call from the Australian Seek and Rescue authorities to assist a boat in distress.

The events that then unfolded could be framed in at least two contrasting ways. In one, what occurs is a maritime rescue, with decisions to be made by the ship's captain, and distress and the security of lives as the prime consideration. In the other, what occurs is an attempt at illegal entry into another country's territory, with decisions to be made by the local government, and firm control over one's borders the prime consideration.

The ship's captain, the Norwegian government, and people concerned with "the law of the sea" adopted the first frame. The Australian government adopted the second, held to it in the face of criticism as "inhumane", and began a series of moves – including tight media control – designed to have its definition accepted, at least by the majority of Australians and for a period that would last through the November election.

What makes two competing frames possible? Most situations involving refugees contain some ambiguity, with each party then highlighting the features that support their frame.

Maritime Rescue: Distress

In favour of the *Tampa* being defined as a "maritime rescue" were these features:
- The *Palapa 1* was sinking, in international waters.
- The *Tampa* was responding to a call for vessels to assist, with help in reaching the *Palapa 1* provided by an Australian Coast Watch aircraft. Responded to also was a direction, from the Indonesian authority (BASARNAS) designated as responsible for search and rescue operations in these waters, to head for the nearest Indonesian port (Merak).
- Conditions on board the *Tampa* were a further form

of distress. From a small ferry (the *Palapa 1*), there emerged a staggering number of people (438), all to be found place somehow on a ship designed to carry 50 people, including a crew of 27. Food, water, medical supplies, blankets, places to sit, lie down and sleep were all in short supply. In addition, after an hours sailing toward Indonesia, five of the asylum seekers advised Captain Rinnan that continuing to Indonesia would result in action ranging from jumping overboard to the taking of hostages. The crew could also now be in jeopardy.

The advice given to Captain Rinnan, when he contacted the Australian rescue team (AusSAR) for advice was that the decision was his: "You're the master. The decision is yours".[1] Rinnan turned toward Australia's Christmas Island (85 nautical miles away rather than the 246 to the Indonesian port – Merak) and was directed by AusSAR to hold a position offshore and wait for customs officials before any landing.[2]

How then could another source – in this case, the Australian government – argue for a frame other than "maritime rescue" and have it largely accepted within Australia? Helping to make feasible the claims of "illegal entry" and "not our responsibility" were these features:

- The *Palapa 1* was sinking in international waters, in a region where research and rescue was an Indonesian impossibility. The *Palapa 1* had also set sail from Indonesia.
- The Australian government, after AusSAR's advice to proceed to Christmas Island, directed the *Tampa* to turn once more and proceed to Indonesia. It was then an explicit statement to the effect: "don't head here". The *Tampa* did not have "permission to enter Australian territorial waters" or "to land in Australia or any Australian territories".[3] Captain Rinnan was also advised that, if he proceeded, he himself would be breaking Australia's migration law (another "illegal entry") and be open to prosecution and a heavy fine.[4]
- Few Australians were aware of exactly where Christmas Island was and what "the nearest port" might be (the "far north" of Australia is unknown territory to most). The nature of international maritime law was also largely unknown, making it seem reasonable for

Australia's Prime Minister (John Howard) to claim that "as a matter of international law this matter is something that must be resolved between the Government of Indonesia and the Government of Norway".[5] In effect, this is 'in no way our problem'.

Sustaining a Definition: Media Control

Outlined in Chapter 2 as a general feature of representations was the need for steps that maintain any initial definition and to head off dissent. The *Tampa* incident concretises and expands that general proposal.

At this point, the government's *Tampa* narrative has all the marks of a classic Western (*High Noon*) confrontation between sheriffs and outlaws. A line has been drawn and the command issued: Stop! Go no further! This kind of story clearly has popular appeal, but takes some particular forms of management if it is to be sustained.

The government moved toward two main forms of media control: news blackouts and the release of "fuzzy information".

News blackouts: The Federal Government moved to establish a monopoly on the news. To start with, access to the boat was cut off. In the morning of the 27th:

> "a directive was sent to the administrator of Christmas Island, Bill Taylor, to 'take all steps necessary' to ensure no boats could go out to the Norwegian ship. Flying Fish Cove, the island's only port, was closed indefinitely".[6]

In addition, all information was channelled through Canberra rather than through local sources or the Search and Rescue Centre – a limit justified, in part, by describing all decisions as "operational decisions" that are not open to scrutiny:

> "the Government muzzled every agency involved, from the Australian Search and Rescue Centre and Coastwatch to the island's government employees, enabling John Howard and his ministers to audit the facts, selectively release information and obfuscate the truth".[7]

The closing of access, it needs to be noted, had two functions. It blocked the media from developing an alternative picture. It also meant that asylum seekers could not apply for asylum. If the asylum-seekers had reached Christmas Island or an Australian civilian had boarded the ship, "this would have triggered the provisions of the Migration Act, which then meant that Australia had to determine the status of the people on board".[8]

Fuzzy information: News blackouts, combined with rapidly unfolding and rather dramatic events, allowed government statements to be less thoroughly interrogated by the media than might otherwise have occurred. Uninterrogated, that is, until they were later no longer "newsworthy". Australian authorities, in the form of political adviser Moore-Wilton, for example, was able to make the claim, without question in Australian media, that it was illegal for the *Tampa* to enter Australian waters – a claim was later seen as a "bluff".[9]

"Fuzzy" also were statements about the position of the boat and "feasible ports of disembarkation". The latter phrase appeared early in government statements:

> "There was a clear obligation under international law for those people to be taken to the nearest feasible port of disembarkation which we are informed was an Indonesian port called, I think, Merak".[10]

Merak, in those first descriptions, and in later descriptions, was presented as feasible by virtue of its proximity: "The Indonesian port was as close if not closer than Christmas Island"[11] – a statement hard to combine with a difference between 85 and 246 nautical miles.

That kind of claim, it should be noted, is all the easier to make if the geographical area is not well known. These events were occurring in the north-western tip of Australia, in an area that many Australians would regard as "remote". Exactly where Merak and Christmas Island are is not part of everyday knowledge and many Australians are still under the impression that the *Tampa* was closer to the port of Merak than to Christmas Island. Feasible given the lack of general knowledge was also a description of conditions on Christmas Island:

> "Christmas Island doesn't lend itself to receiving a container vessel. The vessel cannot come close to the island or any of the points at which its food or other material sustenance are received …. we made it clear all night that Christmas Island was quite an unsuitable destination for this vessel … (There was) inherent danger to people if they were taken off the vessel …. Enormous difficulty in the high seas … coupled with the fact that the vessel cannot approach Christmas Island at all".[12]

This was contradicted later by both the harbourmaster and a union official: Information that was not at first available to the media as the harbourmaster had received instructions not to talk to the media.

Sustaining a definition as "not our problem" is helped also by pointing to others who can be described as responsible. Indonesia was raised as one possibility. The Prime Minister's advice to a press conference that the boat had to turn around and return to Indonesia and that Australia would help cover Indonesia's costs.[13]

Indonesia, however, was not interested, and Foreign Minister Downer later admitted that "Indonesia's view was that the *Tampa* passengers were illegal in Indonesia, too" and were therefore never going to be accepted there.[14] The Indonesian President simply did not respond to Howard's calls. Indonesia and Norway, however, still continued to be mentioned by the Australian governments as having more legal – if not moral – responsibility than Australia:

> "At this stage the Indonesians are disinclined to take the people back and we continue to talk to them. We continue to convey our position to the Norwegian authorities. Our position is that it is not Australia's

1 Cited by Cornford and Crichton, *Sydney Morning Herald*, 01/09/01

2 ibid

3 Howard, 27/08/01, at: www.pm.gov.au/news/interviews/2001/interview1187.htm

4 Charlton, P. (2002) "Tampa: The Triumph of Politics". In D. Solomon (Ed.) *Howard's Race: Winning the Unwinnable Election.* Sydney: Harper Collins: 88-89

5 Howard, 27/08/01, at: www.pm.gov.au/news/interviews/2001/interview1187.htm

6 Marr, D. and Wilkinson, M. (2004) *Dark Victory.* Sydney: Allen & Unwin: 63

7 Cornford and Crichton, *Sydney Morning Herald*, 01/09/01

8 ibid: 93

9 Marr and Wilkinson (2004) Op.cit.: 32

10 Howard, 27/08/01, at: www.pm.gov.au/news/interviews/2001/interview1187.htm

11 Ruddock, Minister for Immigration, 27/08/01, at: www.pm.gov.au/news/interviews/2001/interview1187.htm

12 Ruddock, 27/08/01, www.pm.gov.au/news/interviews/2001/interview1187.htm

13 Howard, 27/08/01, www.pm.gov.au/news/interviews/2001/interview1187.htm

14 Downer, cited by Charlton (2002) Op.cit.

responsibility to take these people. They were picked up in a search and rescue zone for which Indonesia is responsible. The vessel does not have any Australian citizens on board. The port of *nearest feasible disembarkation* was Merak, an Indonesian port. It is just simply not possible to berth this vessel at Christmas Island, quite apart from any diplomatic or other considerations and I think that point has to be emphasised again and again. It is not a question of what is the nearest port, sailing time wise, it's a question of where is the nearest place *of feasible disembarkation*."[15]

Stalemate and a Breach in Media Control

Part of the proposals in Chapter 2 had to do with the probability that alternative sources of information will emerge prompting a competing definition. The *Tampa* incident again concretises and expands that argument. The government's approach was one of denying all direct media access, making itself the only source:

"Christmas Island looked very much like a military operation But inquiries to defence public relations on the island were uniformly redirected to minister's offices thousands of kilometres away in Canberra. The island's port was closed, preventing even local fishermen from going out, and the island's administrator, like the military, referred inquiries to Canberra".[16]

The overall effect was then one in which "the refugees were talked about, but they remained unseen and their stories untold".[17] It was possible to present them as a mass, with individuals kept out of sight, their backgrounds and states of mind kept vague, and no available images of distress on the part of either the *Tampa*'s crew or the rescued 434.

Maintaining that degree of control, however, calls for taking extraordinary steps. It calls also for continued justification. Personal stories, the official argument ran, might have negative effects on an individual's application for asylum:

"We have had a case some years ago when a fellow's

name and photo was published in a community paper in Australia … it was argued that the paper was circulated widely in his hometown and it was claimed he would be at risk if he returned. That is the explanation. That's why we don't facilitate access. When we have allowed the media access into detention centres, it's on the basis that no faces are shown".[18]

Above all, maintaining a high level of control runs the risk that other sources of information will emerge, with that information weakening the initial frame. The *Tampa* itself turned out to be that source, with information – and photographs – released to the Norwegian press and internationally.

"As the afternoon (of the 28th) wore on with no help in sight, Rinnan put his case to the world. A press strategy had been developed by the shipping line in consultation with its P& I club, *Gard*".[19]

In this strategy, the focus was always to be on "health and safety issues".[20]

Rinnan was also able to talk to *The Australian* on the 28th. That paper then reported the deteriorating conditions on the 29th, and published photographs taken by the chief engineer of the *Tampa* and sent electronically[21]:

"But for this move by the shipping line, the Australian government might have been able to prevent the public ever seeing what was actually happening on the *Tampa*'s deck. Nordheim's photographs of four hundred people huddled under great red walls of containers would appear in newspapers and on television around the world".[22]

In effect, the people involved in this drama now began to be personalised. Reports began to appear, at least in the Norwegian press, of the crew's own concerns, of the rescue as its own drama, and of the steps taken by the crew to alleviate the distress and discomfort of those rescued. The impossibility of the refugees remaining where they were could not be questioned.

The Strengthening of a Competing Definition: Views from Norway

The *Tampa* was from the start an international story, and one of particular interest to both the Norwegian government and the Norwegian media. Both were interested in what happened to "their" people and in the allocation of responsibility among countries. Reviewing the Norwegian framing of events provides as well a reminder that one country's media control is likely to be undone by another's access, together with examples of how definitions and frames can vary from one source to another, can shift over time, and be the bases for criticism and dissent.

Norway was, of course, not the only country to comment on the *Tampa* events. It had, however, a particular history and some special interests. Historically, this is a country with long-term involvement in shipping, and a record – one in which it takes pride – of involvement in maritime rescue. That history, and its relevance to the *Tampa* events, are summarized in a statement by Jan-Erik Smilden:

"Boat refugees are becoming a more and more common sight as immigration policies are tightened the world over. In the Mediterranean, small boats with refugees are sinking in Italian, Greek and Spanish waters. Usually the refugees are taken to the nearest refugee camp on land. In Spain they are experiencing a wave of boat refugees who are coming from North Africa. The majority are economic refugees who want to come to Europe to work.

Not since the refugee streams from Vietnam in the last half of the 70s has the world experienced so many boat refugees as now. At that time, ten thousands of Vietnamese escaped from the communist regime in old hulks. Norwegian boats did their humanitarian duty and picked up refugees who were drifting in the South China Sea. The Foreign Minister of the time, Knut Frydenlund, promised that all Vietnamese who were picked up by Norwegian boats would be allowed to come to Norway and the jungle telegraph spread the happy news. It went so far that anti-communist radio stations broadcast the position of the Norwegian ships so that the people smugglers could steer their refugee hulks in the right direction.

The situation is now different than that of the 70s. The Vietnam War is over and many saw the Vietnamese with positive eyes because they fled from a communist regime. Today, Norway has a strict immigration policy. If 438 boat refugees are not a plus in an Australian election campaign, neither are they in the current Norwegian election debate".[23]

As that description implies, Norway – like Australia – brought more than one interest to the *Tampa* events. A willingness to rescue could be interpreted as bringing with it sole responsibility for the people rescued. That responsibility, however, was at odds with a tightly controlled immigration program. In a further reminder that content always matters, we need to remember that at the time of the *Tampa*, Norway was 3 weeks away from an election – an election in which one of the largest political parties (The Progress Party) was adamant that any further immigration intake would be impossible for Norway:

"It would be completely unnatural for Norway to accept refugees when the country at the moment is flooded with asylum seekers who try to sneak in front of the quota refugees from the UN's refugee camps".[24]

15 Howard interviewed by Neil Mitchell, *Radio 3AW*, 28/08/01

16 Charlton 2002: 93

17 ibid: 93

18 Spokesperson for Immigration Minister Philip Ruddock cited in *The Age*, 22/09/01

19 Marr and Wilkinson (2004) Op.cit.: 92

20 Marr and Wilkinson ibid: 93 citing *Gard News* 165, Feb./April 2002

21 For a set of these photographs, in a book by a Norwegian journalist on the *Tampa* events, see Svabø, T. (2002) *Tampa*. Lysaker: Dinamo Forlag

22 Marr and Wilkinson (2004) Op.cit.: 93

23 Jan-Erik Smilden – a journalist for one of the Norwegian national papers *Dagbladet* in the early days of the *Tampa* drama, 28/08/01

The challenge for the analyses of representation lies always in observing how shifts in frame take place. For the emergence of Norwegian perspectives, media headlines provide a starting point, with a first example offered by the banner headings for the on-line version of the news on TV2 (a relatively conservative station). These shifted rapidly from "Highjacked Norwegian Ship" on the 27th of August, to "Refugees Highjacked Norwegian Ship" on the morning of the 28th and, by the afternoon, to "The Refugees on the *Tampa*", "Hunger Strike on Norwegian Boat" and, using a statement from one of the refugees, "Fears Desperate Actions".

Conservative and liberal media – like the several political parties – were divided on whether Norway might consider taking in some of the refugees. They were united, however, in their sympathy for the position of the Captain and his crew and, increasingly, for the refugees' position. They moved quickly also from some sympathy with the Australian Government's position to negative comments on what was perceived as its inflexibility.

On the position of Captain Rinnan and his view, the Norwegian media first provided – by way of direct contact with the Captain on the 28th of August – a detailed account of the rescue itself. Those details covered the condition of the *Palapa* (sinking and falling apart), the difficulty of the rescue (rough seas), the poor condition of many of the refugees, the surprise of the crew that so many people (434) could emerge from such a small boat, and the surprise of the Captain that the *Tampa*'s straightforward action could lead to such a complicated situation: "We try to behave like good seamen and then we experience this".[25]

"The Captain cannot let people die: At least ten people are unconscious, three highly pregnant women have strong stomach pains, and a number of children are suffering from scabies, dysentery and diarrhoea. The situation on board the *Tampa* is so critical that Captain Arne Rinnan is considering sending out a 'may-day' signal. Then the Australian authorities must accept the boat at Christmas Island".[26]

On the position of the refugees, the Norwegian media began with a description of them in outlaw fashion as "aggressive Afghanis" who had "highjacked" a Norwegian boat.[27] They were seen at this point as in no immediate danger. The Australian government was refusing them permission to land but would be providing food, medicine, and any humanitarian help needed. Over the next day, however, the medical state of the refugees both before and after the rescue began to take centre stage, with the Norwegian shipping company now a prime source for this humanitarian frame:

"Everyone on board, except the children, began a hunger-strike at 14.00 hours We have asked for medical assistance ... we don't know why help has not been received ... we feel very strongly that the humanitarian aspects must clearly be put first in this situation. Many of the refugees on board will end up in a life-threatening situation if they do not receive medical treatment on land".[28]

These were as well people who were in a perilous state before the rescue:

"The ... refugees had been squeezed together in a little boat without sufficient food or water for many days before they were picked up by the *Tampa*. Many of the refugees have diarrhoea and rashes caused by scabies. Some have also fallen unconscious because of exhaustion".[29]

The photographs from the *Tampa* on the morning of the 28th, and a statement from an individual refugee, strengthened the humanitarian frame still further. Captions to the pictures described the refugees as "suffering".[30] In an interview released worldwide by Reuters, one of the refugees made their plight concrete:

"We are lying on the deck and freezing, we have little clothes and few blankets. I am afraid we will become ill ... Australia is a big country with lots of room".[31]

The same interview also undid completely the picture of "aggressive Afghanis" and of "economic refugees". Here

was a man who had been a teacher, had been dismissed, felt his life threatened when the Taliban regime enforced strict Islamic laws and – like others on the boat who had been "persecuted and imprisoned in their home country" – had "hoped for the generosity of Australia".

The view taken of the *position of the Australian government* now also shifted. The early stories were sympathetic toward Australia's difficulties. To take two statements from a relatively liberal newspaper:

"After a huge influx of refugees this summer, the Prime Minister John Howard is putting his foot down …. Last night's group of boat refugees is the largest ever that has come to Australia. In the last period of time Christmas Island has experienced a flood of refugees predominantly from Indonesia. Just in the last two weeks, many thousands of boat-refugees have arrived in Australia. The majority are from Iraq, Iran and Afghanistan and have been brought through Indonesia by people smugglers".[32]

"After about 1200 boat refugees arriving in Australia via Christmas Island during the last two weeks, the conservative government has decided that enough is enough. Christmas Island is overflowing with refugees. The same is true for many other refugee camps in other places in Australia. By refusing to allow the *Tampa* to anchor outside of Christmas Island and transfer the refugees to land, the Australian government wants to send a strong signal to people smugglers and potential refugees. The situation is not made easier for the refugees by an election looming in Australia. The country accepts 10 000 quota refugees every year through the UN-system. That should be enough, many Australians believe".[33]

In these early days also, the possibility was still entertained that Indonesia might "rescue" the refugees. As more information came into play, however, the media began to underline the plight of the refugees, and the need for some immediate action:

"In the middle of the diplomatic complications, it is important not to forget the humanitarian sides of the case. This is about poor men, women and children, many ill after a long and strenuous flight. Who

will give in first in humanity's name, Norway or Australia? And if none of them do, is the *Tampa* in danger of becoming 'the flying Dutchman'?"[34]

The likelihood of Australia "giving in", several added, was relatively low:

"Howard has used a hard hand before, and it has always been politically useful. He received strong support when he demanded radical reforms to weapon laws after a massacre in Tasmania in 1996 and when he sent Australian troops to East Timor in 1999.

Almost three quarters of callers to Australian radio programs in recent days have supported Howard's hard line towards the *Tampa* and the refugees on board the ship. People who have never heard of Jens Stoltenberg or Thorbjørn Jagland don't care about the protests from Norway. Even the large Opposition Party Labor supports the Prime Minister and there are only a few voices raised in protest – but they exist. 'Howard listens too much to radio and too little to his own conscience', says Senator Bob Brown from the environment party the Greens".[35]

Formal framing. The Norwegian shipping company kept its emphasis on the plight of the refugees, on the human impossibility of the ship moving toward Indonesia, on "the law of the sea" and on the merits of the Norwegian crew. In the words of its Information Director Hans Christian Bangsmoen:

"The Australian Coast Guard asked for assistance, the *Tampa* is anchored next to an Australian

24 Carl I. Hagen cited in VG, 30/08/01
25 Rinnan cited in *Dagbladet.no*, 28/08/01
26 *Dagbladet.no*, 29/08/01
27 *Dagbladet.no*, 27/08/01
28 Information Director Hans Christian Bangsmoen from the shipping company Wil. Wilhelmsen cited in *Tv2.no*, 27/08/01)
29 *Tv2.no*, 27/08/01
30 *Dagbladet.no*, 28/08/01
31 Ali cited by *Tv2.no*, 28/08/01
32 *Dagbladet.no*, 27/08/01
33 *Dagbladet.no*, 28/08/01
34 *Dagbladet.no*, 28/08/01
35 *Nettavisen*, 29/08/01

island, the boat may not sail further with so many people on board, and in addition are the humanitarian aspects".[36]

"Experts on human rights have made it clear ... that the Convention of the Sea from 1982 is the founding agreement which regulates movement at sea. There is as well the practice of emergency relief for refugees who have a right to be taken to the nearest port".[37]

"To create some shade, the crew has set up a few tent canvases. What there is of wool blankets have been given to the boat refugees".[38]

At the government level, the issue was more one of determining legal responsibility. The *Indonesians* made explicit, at least to the Norwegians, that the responsibility was not theirs:

"We have had experiences with these refugees who are illegal immigrants. Should we receive them? Our laws do not allow it".[39]

The *Australians* also were noted as disclaiming responsibility:

"It is absolutely not our problem. This situation arose because a boat sank in international waters, in an area where Indonesia has responsibility for rescue".[40]

The *Norwegian* Foreign Minister was equally clear on the responsibility lying elsewhere:

"Norway also won't accept the refugees It is our belief that the usual practice is that refugees are accepted in the nearest port ... the Norwegian ship was requested by the Australian authorities to help the sinking boat with refugees, and changed its course to do just that. That means that the Australians must accept the refugees as well, not the least because there is a critical humanitarian situation".[41]

As the stalemate continued, and as the local media began to focus on the lack of action, the Norwegian government's position moved more firmly to negative comments on Australia's stance. After discussions with the Australian Foreign Minister (Alexander Downer), the Foreign Minister (Thorbjørn Jagland) was forthright:

"I am completely shaken. The Australian government shows an inhumane position that I can not accept ... I have never experienced such an unacceptable behaviour from a coastal state. One can imagine that an Australian ship might have to pick up refugees off the Norwegian coast. That we should refuse to let them enter a Norwegian port would be totally incomprehensible ... There is only one solution: the boat must go to the nearest port and that is Christmas Island".[42]

Equally forthright were Jagland's comments on the lack of respect for Rinnan's position as Captain:

"The Captain was in his full right on the basis of international sea conventions in the face of an emergency and only he could make that decision He must do what he thinks is right. The most important thing now is that the humanitarian situation be dealt with".[43]

Shoring up the Definition and Deflecting Dissent

The previous section has described a generally negative reaction to the Australian government's framing of events and its decisions. That reaction argued instead for the *Tampa* to be seen as a maritime rescue, for the legal right of the Captain to make decisions, for the primary concern to be with the safety and health of those on board, and for there being no alternative to a landing on Christmas Island. The dissent was described in the form of Norwegian views. International condemnation, however, was also forthcoming, with the UN one example:

"The UN praises Norway and the *Tampa*: The UN's High Commissioner for Human Rights, Mary Robinson, praises Norway for the country's efforts in the refugee drama. Australia on the other hand is condemned. Robinson says that the UN's human rights make it clear that refugees should be able to go to the nearest port".[44]

Was there no dissent from other political parties within Australia? The initial response from the official

Opposition (the Labor Party) was of support – a "me too" response:

> "Howard announced the decision" – to refuse entry of the *Tampa* into Australian waters – "at a press conference on Monday and later repeated it, in detail, in the Parliament. Immediately … (the Opposition leader) Beazley announced to the House: 'We support the government's actions in regard to the *Tampa*. They seem to be appropriate and in conformity with international law' ".[45]

> "That is all Beazley said. That is all Labor has said. Beazley's immigration spokesman, the usually talkative Con Sciacca, has remained unusually mute. The only Labor MP to offer a dissenting public opinion has been NSW's Colin Hollis, deputy chair of the Parliament's human rights subcommittee".[46]

Colin Hollis was in fact quite damning:

> "Does anyone believe the Government would refuse to allow a ship to offload 400 European people rescued from a tourist vessel in danger of sinking? Refusing (the *Tampa*) sends a message to every captain on the high seas: they should let asylum seekers drown rather than rescue them".[47]

After Howard attempted to pass a hastily written emergency bill, the Opposition changed course (Chapter 5). For the moment, however, the Labor Party was not offering any dissent.

Within Australia, the media also were generally in support of Howard's position. Where concern was expressed, it was mainly in the form of asking whether that position had gone "too far" and was completely "in the right", both legally and morally.

Those questions, and the sting of overseas criticism, however, led to Howard offering a further set of justifications for his framing of the *Tampa*'s presence as an attempt at illegal entry, for his actions as both legal and moral, and – increasingly – for the country as in need of "strength", and for criticism as an unjustified slur on Australia's reputation.

Sustaining the Frame

Further moves now began to be added: (1) These are not "genuine refugees"; (2) Australia does respect the law; (3) the country's record is one of compassion; (4) Australia has the right to define and defend its borders.

These are not "genuine refugees" Even at the end of August and the beginning of September, Howard and Ruddock maintained descriptions of those on board the *Palapa* as "illegals", "economic migrants", or "queue jumpers". In Howard's terms:

> "People have got to have their claims to come to this country based on merit. You can't have people *pushing their way to the front of the queue*, particularly based on a *capacity to buy their passage* to this country".[48]

In those of Philip Ruddock, the Immigration Minister:

> "The people that we are seeing on boats are not the people who are immediately fleeing the Taliban and Afghanistan at the moment. They're the sons and daughters often of people who fled Afghanistan a generation ago, frequently born in Pakistan, often having worked in places like the Arab Emirates and Saudi Arabia and are under some pressure I think from some of those Middle Eastern countries at the moment to return back to Pakistan. And they're the people who have the resources to engage the people smugglers. They're the ones who are travelling and they are not necessarily those who if you were assessing

36 Bangsmoen, cited by *Tv2.no* 27/08/01

37 ibid

38 ibid

39 Indonesian Foreign Minister Hassan Wirajuda cited in *Dagbladet.no*, 28/08/01

40 Australian Minister for Immigration Ruddock, cited in *Dagbladet.no*, 28/08/01

41 Thorbjørn Jagland, cited in *Dagbladet.no*, 28/08/01

42 Jagland cited in *Dagbladet.no* 29/08/01

43 Jagland, cited in *Nettavisen*, 29/08/01

44 *Nettavisen*, 30/08/01

45 Alan Ramsey, 29/01/01, *Sydney Morning Herald*, with the headline: "Beazley is not about to rock refugee boat"

46 ibid

47 Colin Hollis, cited by Ramsey, *Sydney Morning Herald*, 29/08/01

48 Howard 31/08/01, emphasis added, www.pm.gov.au/news/interviews/2001/interview1187.htm

them in terms of priority for a resettlement place that you would be offering".[49]

In contrast are those that:

"genuinely fled Afghanistan because of the impact of the Taliban regime. The people who are fleeing at the moment and there are some hundred thousand or more of them in Pakistan ... have no money to travel, no capacity to engage people smugglers".[50]

Claiming Australia's respect for the law and for "sea-faring tradition". An example can be taken from Howard's responses to questions from Catherine McGrath in an *ABC* radio interview, asking whether Australia is doing "its duty" and noting Norway's criticisms:

"PRIME MINISTER: ... I've heard reference earlier in this programme about Australia, in some way, violating the longstanding maritime tradition of helping people in distress. Nothing could be more wrong.

MCGRATH: Well, that's part of a Norwegian ... claim at the moment ...

PRIME MINISTER: Look, let me finish. This is a very important thing because it is a very unfair reflection on Australia. Australia is a great seafaring nation too. We understand the traditions of the sea".[51]

At a later point in the same interview:

"MCGRATH: Prime Minister, as you said yourself then, it is now an impasse. You have the Norwegians throwing mud – you just referred to that a moment ago – there are obvious tensions with Indonesia ...

PRIME MINISTER: I'm sorry, I didn't use that expression...

MCGRATH: No. I'm sorry, but the Norwegians are throwing mud ...

PRIME MINISTER: I am defending the honour of this country in relation to seafaring traditions and I won't have anybody unfairly criticise our country on those grounds."

Claiming Australia's record as "compassionate" rather than "heartless". The ideal claim for status is one that combines being legally and morally in the right. Howard claimed both. An interview with Neil Mitchell of *Radio 3AW* (a commercial station) provides an illustration:

"PRIME MINISTER: Under international law we are not under an obligation and I don't think anybody can suggest that we are a heartless, insensitive, unsympathetic country.

MITCHELL: Did you weigh up any moral obligations? There is a possibility, obviously in this situation, if it drags out, that we could be looking at the deaths of some people. Are you prepared to go that far?

PRIME MINISTER: Well look, I'm just at this stage, Neil. I don't want anybody to lose their life but I would make the point that if the ship's master had been allowed to do what he originally intended to do these people would now be in Indonesia There is a point in some of these things where people, in a way, seek to intimidate us with our own decency".[52]

In the same interview, Mitchell raises questions about the need for immediate assistance to those on board the *Tampa*. The reply is that need has not yet been established:

"MITCHELL: Is there an urgent need for it (food, water, medical supplies)?

PRIME MINISTER: Well we don't know. The information we have is that the Royal Flying Doctor Service had been in touch with some of the people on board the vessel and while nobody's suggesting that there aren't some illnesses, there's always the possibility that some of the reports about those illness can be inaccurate.

MITCHELL: Okay, there were reports that two people are unconscious, you don't know if that's right.

PRIME MINISTER: Well, that has not been verified and it may not be right. It might be but it may not be. It is often the case, in a situation like this, that you do get exaggerations ...".[53]

Discounted also is the concern for the welfare of the crew of the *Tampa* and threats to their safety, prominent in the Norwegian accounts. At a press conference on August 27:

"JOURNALIST: Given the Captain was threatened by those who boarded, isn't there a concern about his safety and

the safety of his crew if he tells these people they're now going back to Indonesia?

MINISTER RUDDOCK: We're told they're not armed.

JOURNALIST: There's 400 of them and 27 …

PRIME MINISTER: We realise that. But we are told they are not armed.

JOURNALIST: Are the Norwegians armed! ….

PRIME MINISTER: I don't know … I imagine there would be a limited number of firearms available".[54]

Claiming Australia's rights to determine and defend its vulnerable borders. Australia, in Howard's increasingly "we, the country" frame, becomes a vulnerable country: vulnerable because of the size of its borders and because "others" now seek to undermine "our" rights to decide who will cross "our" borders. An interview on August 28th sets the tone of a frame that will become more and more Howard's rallying cry:

> "We are an island continent and in that way we're very different from most other countries and that is one of the great dilemmas we face. We are an island continent and we cannot allow situations to be created where we run the risk of losing control of our borders and losing control of … the implementation of our undoubted right to control who comes to this country. But we haven't violated that international seafaring tradition".[55]
>
> "Every country has the right to refuse entry to the vessel of another country of course. It's fundamental to a nation's sovereignty, a nation's control of its borders".[56]

Borders, we shall see, become the heart also of the next steps in the drama. Those steps included the armed occupation of the *Tampa* by an Australian Army unit, the drafting of legislation to change definitions of responsibility, by redrawing Australia's borders (excluding Christmas Island), and the removal of the *Tampa*'s asylum seekers well away from proximity to Australia, with the independent island of Nauru (2 946 kilometres away) to serve as a detention and processing centre that would be – apart from its financing – non-Australian. In all, here was another rapid-fire succession of events that fed the sense of a continuing drama or "crisis" and dis-

couraged both analysis and dissent. At least in the Australian government's representations, the country was now in a phase where "us" and "them" were in confrontation mode, with actions and justifications from the "us" side wrapped in terms of national pride, integrity, and honour.

49 Immigration Minister Ruddock, 01/09/01: www.pm.gov.au/news/interviews/2001/interview1187.htm

50 ibid

51 Howard interviewed by Catherine McGrath in an ABC radio interview, 28/08/01. ABC stands for The Australian Broadcasting Corporation – Australia's public broadcaster.

52 Howard interviewed by Neil Mitchell, *Radio 3AW*, 28/08/01

53 ibid

54 Howard in press conference, 27/08/01

55 Interview with McGrath, *ABC*, 28/08/01

56 Howard in an interview on Jeremy Cordeaux' talkback program on *Radio 5DN*, 29/08/01

CHAPTER 5

Hardening and Sustaining a Frame

THE *TAMPA*, WE SAW in Chapter 3, brought two compet-ing frames to the surface. The Australian government placed its emphasis on the control of borders in the face of threat. The Norwegian voices (the ship's captain, the shipping company, the government) also spoke of crisis (a "humanitarian crisis": "You can't let people die") but with an emphasis on compassion in the face of need. To sustain its frame and deflect dissent, the Australian gov ernment then moved in ways that might be regarded as illustrations of some of Gramsci's principles for main-taining "hegemony". For a while, dissent may be headed off by "starving the opposition": access to information is kept to a minimum. Alternate sources, however, are bound to appear. Then moves may be made to argue that the alternative frame does not apply ("these are not genuine refugees") and to claim for oneself the legal and moral virtues that might be thought of as belonging to the alternative ("we have a right to defend our borders; we respect the law; our record is one of 'compassion' and not 'heartlessness'"). From both sides will come an awareness of the particular audiences and of the kinds of claims that they will find feasible and persuasive, and of the kinds of events that will attract attention as "news" or pass relatively unnoticed.

The first days after the *Tampa* rescue left the two frames – control and compassion – in confrontation mode. To quote from a Norwegian newspaper article: "Who will give in first in humanity's name, Norway or Australia?"[1] The succeeding days brought major changes, both in actions and in definitions.

To provide a quick summary: On August 28 and 29, the *Tampa* issued emergency calls for medical help. On the 29th, it moved to a point 2 nautical miles away from Christmas Island: well beyond the 12 nautical mile limit the Australian had set as its limit, but still at a slight distance from the island. The move was met by a flurry of activity and a hardening of Australia's frame of "control". An Army Unit was sent to board the ship. Claims of medical emergencies aboard the *Tampa* were challenged. The possibility of towing the ship back into international waters was raised. The government pro-posed new legislation that would redefine its borders and justify almost any intervention. Nauru and New Zealand were persuaded to take the *Tampa* refugees (Australia's "Pacific Solution"), making sure that this set of asylum seekers never touched Australian soil. Taking the military frame still further, the Australian Navy was given the task of making sure that no further boats came so close.

A new dramatic event – September 11 – allowed the issue of asylum seekers and refugees to be conflated with the issues of terrorism, heightened security, and war. Dissent and alternative definitions of events were still present. They struggled to be heard, however, against the assertions of danger. In the government's representations, safety was now more at stake than ever and a clear, resolute, unequivocal stance was needed.

To take that progression apart, representations of

distress states provide a useful starting point, followed by representations of what "the law" allows or rules out. The two lines of representation and argument are in themselves an illustration of contest: contest between claims of being "right" or "wrong" because what one does respects life or fails to do so, and claims that it is within or outside the law.

Definitions: A Medical Emergency?

Claims of a need for help are clearly strengthened by people being in danger of their lives being lost if no action is taken. "You can't let people die", to use again a Norwegian description of the *Tampa* captain's dilemma. To deny that help and make it justifiable, doubt needs to be cast on the representation of need.

Distress and a serious need for medical help were a core part of Captain Rinnan's view of the situation. The situation on board was also likely to become rapidly worse. On a ship designed to carry a crew of 27, and now carrying an extra 400-odd people, latrine arrangements were a major problem. So also was the supply of food and of any protective covering. The *Tampa*'s crew also contained only one person functioning as a paramedic: the first mate (Christian Maltau) who could turn by satellite phone to his father, a physician, for backup.

In the absence of Australian help, on Tuesday afternoon, August 28, Captain Rinnan issued a serious, "pan-pan" emergency call, for medical help. He was concerned about dehydration, a high number of people unconscious, diarrhoea amongst the children, and a pregnant woman who had strong abdominal pains. He repeated his emergency call on Wednesday morning, this time issuing a MAYDAY call:

> "Still the Government refused to allow a doctor to board. The reason was simple enough. Had a doctor boarded the ship, and returned with an appeal for refugee status from one of the people on board, again the provisions of the Migration Act would have been triggered".[2]

With no assistance forthcoming, Captain Rinnan advised the harbourmaster that he was moving toward the Australian coast. At 11.30 am he breached the 12 nautical mile

limit. Howard responded by immediately ordering the boarding of the ship by 45 elite SAS troops.[3]

> "Once the SAS was on board, Canberra would decree that anything to do with the *Tampa* involved 'operational security' and declare a 'no-fly' zone around the ship. No one on board was to be allowed ashore and civilians on the island – especially doctors, lawyers and journalists – were not to be allowed out to the ship. No cameraman would get close enough to the *Tampa* to put a human face on this story".[4]

With the SAS was an army doctor, Dr. Graeme Hammond, instructed to assess the situation. According to Howard, the doctor reported that no medical assistance was needed:

> "The preliminary assessment carried out by the Australian Defence Force doctor indicates that nobody – and I repeat, nobody – has presented as being in need of urgent medical assistance as would require their removal to the Australian mainland or to Christmas Island".[5]

In Tony Wright's account, Howard was "playing with words". "In fact, the SAS doctor and medics had given treatment to a number of the refugees including attaching a drip for an individual with serious hydration".[6] The paramedic amongst the Norwegian crew was also given medical supplies to continue treatment. The description as "not so sick as to require removal", however, meant that the ban on touching Australian soil could still be upheld, without appearing completely "heartless".

Legal Moves and Dissent

One source of attack on any frame lies in claiming that it is against the law. This was in fact the Australian government's argument against those on board the

1 *Dagbladet.no*, 28/07/01
2 Charlton, P. (2002) "Tampa: The Triumph of Politics". In D. Solomon (Ed.) *Howard's Race: Winning the Unwinnable Election*. Sydney: Harper Collins: 93
3 SAS troops are a Special Air Services regiment
4 Marr, D. and Wilkinson, M. (2004) *Dark Victory*. Sydney: Allen & Unwin
5 Howard in Parliament, 29/08/01 cited in *Hansard* p.30517

Tampa – "illegal immigrants" rather than "refugees" or "asylum-seekers" – and against the decision by the *Tampa*'s captain (a "violation of Australia's territorial rights"). Sustaining the virtues of one's position then calls for making sure that it is legal. If current law is not completely supportive, then either a claimed position will need to be modified or new laws will be required.

Howard took the second option. On the afternoon of the 29th, he had lawyers draft emergency legislation that would give the government legal rights to remove the *Tampa* from Australian waters. This was the first Border Protection Bill. With the passing of this Bill:

> "the Prime Minister would have the power to direct soldiers, police, customs officials and public servants to seize 'any vessel' and use force if necessary to take the ship and everyone on board 'outside the territorial sea of Australia' …. No matter what happened – deaths, disasters and injuries – no civil or criminal proceedings could be taken against the Commonwealth or the officers carrying out these operations. And no shipping line or asylum seeker could go to the courts 'to prevent a ship, or any persons on board a ship, being removed to a place outside the territorial sea of Australia'. This new regime was to operate 'in spite of any other law'".[7]

Howard presented the Bill as making Australia "secure":

> "It is in the national interest that we have the power to prevent beyond any argument people infringing the sovereignty of this country".[8]

Dissent came promptly from the Norwegian shipping company. Any attempt to tow the *Tampa* into other waters, it was pointed out, would be treated as an act of "piracy" that would call for legal action.[9] "High-jacking" was back in the definitions again.

Dissent on the basis of law was also evident in the response of the Norwegian government to Australia's proposal that it stop the *Tampa* from proceeding. In the words of a Foreign Ministry spokesman (Karsten Klepsvik):

> "Australia asked the Norwegian authorities to stop the

boat, something that we have considered completely incomprehensible. We have absolutely no control over the boat, it is the Captain on board who has the full responsibility and we find Australia's request somewhat strange considering international law".[10]

Now, however, dissent also began to appear within Australian political circles. Some of this dissent came from within Howard's own party:

> "Petro Georgiou in the joint party room yesterday raised concerns about the new legislation and he made the point that he believes that if the current rules were in place during the Second World War that Jews fleeing Nazi Germany wouldn't have been allowed in Australia".[11]

(To anticipate, Georgiou will appear again as a dissenting voice in Chapter 8).

Stronger dissent still came from the Opposition. The Labor Party rejected the legislation, objecting, in lawyer-like fiction, especially to the exemptions it provided against "any form of civil or criminal liability" and the placement of this law above "all laws".[12]

Why did this dissent not win the day? To some observers, the position of the Labor Party's leader (Kim Beazley), was "courageous". It was also, however, seen as likely to be politically dangerous:

> "From the moment he said no to the Border Protection Bill, on the grounds that it was too draconian, Beazley was going to be offside with those who saw the decision as too soft on asylum seekers, and of failing to take a stand. Both decisions (yes to treatment of *Tampa* and no to the Bill) were defensible in their own right – indeed, the latter could be characterised as courageous, given that Beazley knew it would cost him politically – but the impression, exploited with alacrity by Howard, was that Beazley had 'flip-flopped'".[13]

Howard did in fact promptly use the shift to define the Opposition as having no clear position, reserving for himself the position of having exercised the "leadership" that Gramsci emphasised as needing to be claimed if a

political party is to sustain its initial definition.[14]

"I find their behaviour extraordinary. It is contradictory. It's flip-flopped from one side to the other and it deserves to be condemned".[15]

Some of the more extreme members of Howard's party took the condemnation further:

"Beazley and Labor showed that they are prepared to put the interests of people-smugglers and illegal aliens ahead of the interests of ordinary, decent Australians They are traitors to Australia, they are not fit to govern".[16]

In contrast, Howard presented himself and his government as decisive: "We have stood for something, we have fought for something, we've advocated something".[17]

That description of events may make it sound as if Howard's framing was minimally opposed. Consistent dissent did come from some smaller parties: the Democrats and the Green's one Senator at the time (Bob Brown).[18] Internally, the Labor Party was divided. To jump ahead a little (September 18), Labor also supported a revised Border Protection Bill. The revision met many of Labor's objections. Labor was still not united on the Bill, however, offering Howard again another opportunity to contrast Labor's mixed state with his own clear and unequivocal stance.

"The Pacific Solution" and a Change in Dissent

With the *Tampa* still resting outside of Christmas Island, both Indonesia and Norway refusing to accept the refugees, and Norway pressing issues of health and safety on board, the impasse needed to be broken. Australia moved in a way that came to be known as "The Pacific Solution". Detention and processing would occur in areas that were not Australian territory: namely, Nauru and New Zealand.

That is now no longer needed. The "outsourcing" of "processing" to a country other than one's own has become a step taken by several countries, with active rejection by several others. That current status makes is especially interesting to note that the strategy was not completely novel.

That strategy seemed unique at the time. It was not, however, completely novel. A similar solution applied to Jewish refugees sent by England to Mauritius and Cyprus pre- WWII, and Haitians sent by the USA. in 1980 and 1990 to Guantanamo Bay.[19] Of special interest also are the reasons offered at the time to make the move politically acceptable – legal, moral, and reasonable in cost.

To start with, the refugees would still have some chance of asylum (they were also not permanently in "limbo"):

"A clearly relieved Prime Minister revealed the details of the plan (on August 31). The ... asylum seekers on the *Tampa* would be sent to Nauru and New Zealand 'for assessment'. Under the deal, 150 asylum seekers, mainly women and children, were to go to New Zealand and the remainder to Nauru without setting foot on Australian soil. Australia would meet the cost of moving the asylum seekers to Nauru and keeping them there while they are assessed".[20]

If proven to be "true" refugees, some would possibly have access to Australia or other countries as part of the UNCHR quota agreement, while others would remain in New Zealand:

"Those found to be genuine refugees in New Zealand would remain there. The remainder of the rescuees will be assessed in Nauru and those assessed as having valid claims from Nauru would have access

6 Wright, *The Bulletin*, 11/09/01

7 ibid: 116-117

8 Howard, cited by Charlton (2002) Op.cit.: 95

9 *Nettavisen* 28/08/01

10 Klepsvik cited in *Nettavisen* 29/08/01

11 Catherine McGrath, *AM Programme*, ABC Radio, 29/08/01

12 Beazley to Marr and Wilkinson 2004: 117

13 Gordon, *The Age*, 08/09/01

14 Gramsci (1971) Op.cit.

15 Howard in press conference in Melbourne 03/09/01

16 Member of Parliament Peter Slipper cited by Charlton (2002) Op.cit.: 96

17 Howard at Australia-Israel Chamber of Commerce in Melbourne 07/09/01 as cited by Michael Gordon, *The Age*, 08/09/01: Gordon is the national editor of *The Age*

18 Alan Ramsey, *Sydney Morning Herald*, 29/08/01

19 Marr and Wilkinson 2004: 139

20 Charlton (2002) Op.cit.: 98–99

to Australia and other countries willing to share in the settlement of those with valid claims. Australia will bear the full cost of Nauru's involvement in this exercise … in no way will Nauru be disadvantaged by what has been offered and accepted by Australia".[21]

Nauru's willingness was a second part of the claim to moral grounds, in the face of concern about possible exploitation and of Australia "buying its way out". Nauru was – and remains – a poor South Pacific Island devastated by the effects of the mining of phosphate:

"The mines went bust but the government kept spending so that by the late 1990s the place was bankrupt. Con men had filched the islanders' patrimony. Fortunes had been wasted on an airline, a property empire, even a London musical on the life of Leonardo da Vinci …. The bottom line for the island was this: it owed millions for the fuel that ran the desalination plant on which 12 000 people relied for water. If Rene Harris felt like drawing the line at Australia's proposition, he was in a very weak position to say no".[22]

How the agreement with Nauru was reached was initially left unclear:

"JOURNALIST: Are you embarrassed Nauru and New Zealand have bailed you out of this situation?
PRIME MINISTER: I am grateful that they have offered assistance …. Good friends provide cooperation with each other if that cooperation is needed.
JOURNALIST: Did we approach Nauru or did they approach us?
PRIME MINISTER: Well, there've been discussions both ways …. Well look, I'm not going into that detail".[23]

For "that detail", the answer had to come from a question to the President of Nauru in a television interview:

"They came to me on Thursday night and after that we considered it and we agreed – they chose us, we didn't choose to be chosen. All we're supplying is the land and Australia is doing the rest".[24]

Australia's description, however, was still less a matter of economics and more a matter of friendship. At the September 1 press conference:

"We have found an alternative and I think it is fair to say that we've found an alternative with countries with which historically we have been very close. I mean New Zealand is after all in so many ways Australia's best and oldest friend … there is reciprocity and warmth in a relationship of that kind and Nauru being part of the Pacific family shares that and there's a certain symbolism in the fact that we have found a Pacific solution to this difficult issue".[25]

How far did this "solution between friends" find acceptance outside Australia? Criticism came from several quarters, related both to the choice of Nauru and to Howard's emergency legislation:

"The UNCHR was shocked by Australia's actions. Geneva had declared the Border Protection Bill incompatible with the Refugee Convention …. What worried the world body most was that Australia's new policy threatened to undermine the Refugee Convention in the region".[26]

From Norway, political commentator Jan-Erik Smilden expressed an even stronger view, couched in clearly moral terms:

"Refugees for sale: Australia has bought itself out of responsibility for the 434 refugees who were on board the *Tampa*. Shall refugees now be a growth industry for poor countries? It began with Western countries exporting polluted refuse materials to countries in the third world. The continuation was to export atomic refuse to a Russia that was desperate for hard currency. We all know that the Kyoto-agreement gives countries that pollute a lot the possibility to buy themselves CO_2 gas quotas in other countries. Now Australia is about to create precedence by 'selling' refugees to a much less wealthy country ….

For rich countries with an anti-migration movement it can of course be attractive to do as Australia has done. We here in Norway for example could

'export' our asylum seekers to our poorer neighbours in the East. Carl I. Hagen and the Progress Party have in this election campaign suggested creating asylum centres in Asia and Africa for refugees who want to come to Norway. That of course costs money but perhaps not so much as the expensive domestic asylum centres. But most important for the Progress Party is avoiding having these people here in the country. Refugees and asylum-seekers as a growth industry in poor countries. Just the thought makes sensible people queasy. There is a hope that the case in Australia will be the only case. This form of globalization we can do without".[27]

Even critical media in a live interview situation, however, had problems getting past Howard's continued framing of his position as "compassionate and humanitarian but also strong and determined", with dissent – international dissent especially – as an uncalled-for criticism of Australia as a country:

"HOWARD: This is a Pacific solution and I think that is very good.

BARRIE CASSIDY: A United Nations spokesman overnight disagreed. He said that still the most logical, the most humane thing to do is to take them to Christmas Island first. Does he miss the symbolism involved here? …. Prime Minister, how does it look in the international community for Australia to turn these people away and then a tiny country, the smallest republic in the world like Nauru, agrees to take them on?

PRIME MINISTER: Well you have to see it in the context of what we already do. Australia is a compassionate, caring nation …".[28]

Howard also worked at disproving that relations with other countries were strained in any serious way. Overseas criticism was one of the few draw cards that critical journalists had in the face of an information blackout. Even Norway, however, was presented as not offering a serious problem:

"JOURNALIST: How would you describe our relations with Norway now?

PRIME MINISTER: Oh I don't think they'll suffer any

long-term damage. I mean obviously there's a difference of view on this, but we don't retreat in any way from the position that we've taken. And our refugee record is just as good as Norway's. We don't really, easily accept criticism based on lack of burden sharing by this country. And some of the criticism that has been made of Australia by other countries, some of it has been quite ludicrous given the long and meritorious humanitarian record this country has and we've taken enormous number of refugees per capita, far more than a country like Norway".[29]

Howard's assessment, to look ahead, was realistic. In 2005, the Norwegian Prime Minister, Kjell Magne Bondevik, visited Australia and both Prime Ministers agreed to put the affair behind them.

More Dissent: A New Legal Challenge

The argument that the *Tampa* refugees could not claim the right to be considered for asylum in Australia, and their transfer to an Australian naval boat for the trip to Nauru, did not sit easily with everyone. A group of concerned Australians initiated a Federal Court Action that could bring the *Tampa* refugees under the Migration Act, with Australia then required to hear their applications:

"Julian Burnside QC for the Council of Civil Liberties told the Court yesterday that the SAS troops on board the *Tampa* were acting as migration agents and were bound by law to bring the boat people ashore".[30]

21 Howard press release, 01/09/01

22 Marr and Wilkinson 2004) Op.cit.: 138

23 Unnamed journalist in joint press conference Howard/Ruddock, 01/09/01

24 President Rene Harris on the television program *60 minutes*, 02/09/01

25 Howard in joint press conference with Ruddock, 01/09/01

26 Marr and Wilkinson (2004) Op.cit.: 140

27 *Dagbladet*, 04/09/01

28 Howard in interview with Barrie Cassidy, *insiders*, 02/09/01. Cassidy is an interviewer with the *ABC*, known – like the ABC's Kerry O'Brien – for his probing rather than accepting style

29 Howard in press conference in Melbourne, 03/09/01. Ranking countries by intake of quota refugees through resettlement programmes (e.g. directly from refugee camps) does give Australia a relatively high ranking (1 of the 9 best countries) – a statistic referred to often by John Howard. By head of population, however, Australia is relatively low e.g., in 2001 1: 281 compared to "top" countries such as Armenia 1: 13, Guinea 1:42, Iran 1: 27, or Switzerland 1: 27. The U.K. accepted 1: 317.

30 Alan Jones, *Radio 2UE*, 3/09/01

For Howard, a legal overturning of his decision would be unfavourable. At the same time, he had to tread carefully so as not to show disrespect to the law. His initial response was not to speak directly about it:

"HOWARD: Well I don't want to talk about the court proceedings. We have a very strong view about the action that's being brought but that view is being put in the Federal Court by the Commonwealth counsel and it's not appropriate that I add to it".[31]

In a reminder that relationships between sources and media may take a variety of forms, however, Howard could count on several pro-Government media sources. Alan Jones (a radio interviewer with a popular talkback program) provides an example par excellence. An interview with John Howard by Alan Jones provides a specific instance:

"JONES: Many people would, of course, say that the Prime Minister of Australia, whomever he or she is, should be the person determining our destiny and our foreign policy position not the Federal Court".[32]

Jones was not contradicted. He later added negative views of the dissent exemplified by the court action and the Labor Party's contribution to "the problem":

"JONES: It was the same Mr Justice North though, who as a barrister acted for the waterfront workers in 1986. He advised a seaman union in relation to massive strike action in Robe River. He represented the unions in the Mudginberri dispute. He represented the pilots when they were fighting the Hawke Government Had your legislation been supported in the Parliament last week by the Labor Party this action couldn't have been brought.
PRIME MINISTER: No The answer to that is undeniably it could not have been brought because the legislation would have said that once an instruction had been given by an authorised officer that instruction was not reviewable before the courts."

In a later interview Howard, with a decision still pending in the Federal Court, Jones again criticised the court system 'on behalf of his listeners':

"Can you understand the public concern that the plaintiffs in this matter before the Federal Court can't name anyone who's represented? Now, you're a lawyer, my listeners want to know how does this matter get before the court? There are people who are waiting 18 months for a worker's compensation case, if you're injured in a car accident it takes until you're in your grave to get into court. This mob just walk up and walk in".[33]

The interview then digresses to "piracy" and to the *Tampa* captain as "defying" Australia's directives and maritime law. Jones then returns to the court issue and "the people's" opinion:

"*The Daily Telegraph* ends an editorial today by saying the broader issue is the right of the court ... to act against the best wishes of the elected Government. In the eyes of the public, it's the role of Governments to determine policy, not an unelected judiciary. Under our constitutional system, the powers of the state and the judiciary are separate. This is the way they should remain without the lines being blurred by the legal profession. Both parties should withdraw and the case be abandoned. 90% of Australians I think would agree with that.

PRIME MINISTER: I'm sure a lot of people would agree with that."

Small wonder that some dissenters from Howard's representations – with regard both to refugees and other issues – argue that his core agenda is a reduction in the power of all but the executive parts of government: a reduction in power for courts, international agencies, or unions.[34]

In the end, the Federal Court turned down the case, allowing the transfer to take place. On September 3, the asylum-seekers were taken off the *Tampa* and transferred to the HMAS *Manoora*. The *Manoora*, to jump ahead slightly, on its voyage to Nauru also scooped up asylum seekers on the *Aceng* as part of the Navy's assignment to turn boats back. Howard, adopting a "humanitarian" definition, argued that the transfer would be of

benefit to the asylum-seekers. The *Manoora* "has 2-3 operating theatres. It's frequently at sea for weeks on end with hundreds of troops so the conditions on it are much better than the conditions on the *Tampa*".[35]

The conditions on board offered to the asylum seekers were in fact quite basic. The asylum seekers were also kept in the dark as to where they were heading. Arrival at Nauru weeks later, and attempts at off-loading the asylum seekers, prompted further conflict. Some of the asylum seekers were forcibly brought ashore (though this was denied by the Minister of Defence Peter Reith). Stories of a "riot" on board were leaked to the press:

> "Lurid accounts of the riot would appear in the press during the election campaign: stories of women threatening to hang their children, a mother deliberately breaking her child's arm by throwing her to the floor, of bunks torn apart and used as weapons, of shit smeared on the walls and thrown at the soldiers".[36]

The press, however, were moved back from the scene:

> "The press watched the landings on the last day through very long lenses, for they had been forced back about 80 metres from the landing stage".[37]

Nauru now ceased to be "news", at least in Australia. That disappearance was attributed in part to the nature of the drama:

> "Nauru now almost completely disappeared from the (Australian) news. Most of the journalists flew home. Events had moved on and they had to follow. It was the same to the very end: each new sensation in the story obliterated the last".[38]

That "disappearance from the news", it should be added, was assisted by no visa being granted by Nauru to any journalist who wished to inspect the camps or interview internees. The first such visa was issued in 2005 after a change of government in Nauru. Then Nauru became once more a major story (Chapter 8). Until then, however, reminders of the *Tampa* and Nauru came mainly in the form of news again directed toward a person: news,

for example, reporting that Australia's "toughest" military unit (the SAS) had awarded Captain Rinnan a mounted crest bearing the regiment's fabled "winged dagger", or flaming sword Excalibur, with the words, "Who Dares Wins".[39] Rinnan also briefly appeared in the news when the UNHCR also awarded Captain Rinnan their highest award (The Nansen Award) in 2002.

Maintaining the Crisis:
Conversion to a Broader Military Action

Assigning a military group (SAS officers) to board the *Tampa* was a first step toward adding a "national defence" air to refugee exclusion. That air was quickly echoed in the headlines of the *Daily Telegraph*: e.g., "Iron Fist" (August 30), "Warning Shot", "Boarding Story" (September 1).

A more extensive involvement of the defence forces came with the decision to deploy the Navy to patrol Australia's territorial waters, turning back vessels suspected of carrying "illegal immigrants". It was the beginning of what was to be called Operation Relex. The deployment ensured that the media's attention (particularly front-pages, television news broadcasts and the all-important talk-back radio) continued to focus on the day-to-day unfolding of events rather than on analysis or criticism. It also now framed the blockade and interception of "boat people" as a "military" action:

> "The Australian Defence Force will conduct enhanced surveillance, patrol and response operations in international waters between the Indonesian archipelago and Australia. This will involve five naval vessels and four P3 Orion aircraft".[40]

The Royal Australian Navy was to stop boats from

31 Howard in press conference in Sydney, 02/09/01
32 Interview with Howard by Alan Jones, *Radio 2UE*, 03/09/01
33 Jones, *Radio 2UE*, 07/09/01
34 See, for example, Senator Linda Kirk's First Speech in the Senate 28/02/02 at www.aph.gov.au/senate/senators/homepages
35 Howard in press conference in Melbourne, 03/09/01
36 Marr and Wilkinson (2004) Op.cit.: 225-226
37 ibid: 227
38 ibid: 228
39 Wright, *The Bulletin*, 22/02/02
40 Howard in joint press conference with Ruddock, 01/09/01

entering into the Migration Zone by a variety of means – including force. The Navy itself was concerned about how this might run counter to the maritime principle of saving the lives of people in trouble at sea but this criticism became public only later and even then came from people not on active Navy duty (the Navy Reserve, a past Navy Chief: Chapter 7). Information was again channelled through Canberra, and all releases to the media came from Canberra. That placed the government sources in the kind of position described by Marr and Wilkinson as "a unique position to know what was going on in the Indian Ocean – and put it to use – almost as it was happening".[41]

Media then had to develop some forms of access, bypassing others they might have turned to and been familiar with:

> "The expensive Defence public relations machine and its 100 or more civilian employees were disempowered. Some military men candidly called this what it was: censorship".[42]

The control exercised, however, made it possible to keep the media focus on the day-to-day drama of arrivals and interceptions, in a style similar to that of war coverage:

> "Well ladies and gentlemen, late last night another vessel was spotted by Australian Coast Watch believed to be carrying illegal immigrants to Australia. That vessel was intercepted by *HMAS Warramunga* …. people were taken off the Indonesian vessel and placed on *HMAS Manoora* which is the vessel carrying the other people who were taken off the *Tampa* …. At no stage did this latest vessel reach Australian territorial waters … and as a result questions of application for asylum status do not arise".[43]

The description by now of the people on board the boats was no longer even "queue jumpers" or "refugees". They were simply "illegal immigrants", attempting to enter Australian territorial waters.

That emphasis on "illegals" matters for two reasons. One is that they convey to the public the presence of danger and one more reason for exclusion. The other is the less visible but still sensitive observation of international agreements:

At a Senate hearing in February 2000, for example, a government officer answered a query about the relevance of "criminal offences" to the application for a visa in these terms:

> "The benefits of protection 'cannot be claimed by a refugee when there are reasonable grounds for regarding (them) as a danger to the sensitivity of the country or who, having been convicted of a particularly serious crime, constitutes a danger to the community of that country' …. Then one of the criteria for grant of a protection visa is a character criticism. If they do not meet that criterion, they can also be refused a protection visa".[44]

To be ruled out are also people who might orchestrate illegal entries. Attempting to enter Australia, an officer from the Immigration Department explained, is "no offence in the sense that there is the capacity to prosecute, detain, imprison or fine the person for that act, unless they are somehow involved in organising the unlawful entry into Australia of others".[45]

"Illegal" and possibly "criminal", a potential danger to the community and lacking in "character": These then come to be the promoted descriptions. For all such special phrasing and the control of media access, however, questions still surfaced. This was, after all, not an "ordinary war". It also brought with it questions about limits to the use of force against unarmed people. Those areas of questioning were again met by the need to avoid releasing "operational instructions", and by claiming once more a definition of one's position as one of both firm control and compassionate respect for others:

> "JOURNALIST: What instructions will be given to the captains of warships should they encounter people …
> PRIME MINISTER: I don't normally try and detail what operational instructions will be given. All I can say to you, Geoff, is that, as always the Australian Defence Personnel will act in accordance with the law and in a humane fashion …. Geoff, don't think for a moment that we're talking about acts of belligerence, but we're certainly talking about acts which are designed to deter and encourage deterrence".[46]

"We don't, in this nation, sink boats".[47]

The question, however, did not go away. Queries about what the warships would actually do continued to surface:

"CASSIDY: How does it work? Do these people actually board these vessels when they find them and then turn them around and send them back?

PRIME MINISTER: Well, there are a variety of things they can do. I mean, I am not going to go into the detail of that. I don't think that's appropriate. All I can say is that as always Australia will behave both lawfully and decently".[48]

"WOOLEY: Natural decency, as you say, does dictate that our naval skippers will stop and pick people up out of the water.

PRIME MINISTER: Of course, we are Australian. We don't behave barbarically. We don't shoot people, we don't sink ships, but our generosity should not be abused.

WOOLEY: Well with the increased naval patrols what are we going to do? I mean, create the scenario for me – there's the ship, there are the …

PRIME MINISTER: No, I'm not going to, for very good operational reasons, I'm not going to try and hypothesise about what our ships will do except to say that they will behave within the rules of international law and proper cannons of decency.

WOOLEY: But you can tell me, they would try and turn them back I take it.

PRIME MINISTER: Well they would certainly encourage them within those constraints to go back, yes.

WOOLEY: And if they refuse?

PRIME MINISTER: That creates challenges and that's why I can't give blanket guarantees and I don't think people would expect me to because, on the one hand, they don't want the boats to come and they want us to do everything we can to deter them but they don't want us to behave other than in a decent, Australian fashion.

WOOLEY: But if any of these people do end up legally in Australia … what kind of message does that send to the smugglers?

PRIME MINISTER: No, no, well it means, it sends, more importantly, a message to other would-be illegal immigrants: it's far better to go in through the front door and that is exactly what we want".[49]

September 11: Adding Terrorism to the Need for Border Control

Even before September 11, the spectre of terrorists infiltrating Australia was raised, amongst others by the Minister for Immigration, Ruddock. This further demonised the asylum-seekers. It was also an angle to the story that played into the drama of the situation and was picked up by some journalists – not yet as a critical element but simply as another angle.

September 11, however, brought a major change of scale to concerns about terrorism: a change sustained by its rapid sequel – the declaration of war against Afghanistan (September 20) and the immediate promise of support by Howard. The hapless Labor Party was again sidelined. On this day, the Labor Party was to launch its new campaign – Beazley's "definition tour" with an emphasis on issues of health, education and families. In contrast, the timing for Howard could not have been more perfect. He was in Washington having his photograph taken shoulder-to-shoulder with George Bush. He was at the heart of events and any other issue was pushed far back from the front pages of all media.

Initially, radio and television interviews with Howard focused on his safety and reactions in Washington:

"And you were actually at the Pentagon less than 24 hours before. True?"[50]

40 Howard in joint press conference with Ruddock, 01/09/01
41 Marr and Wilkinson (2004) Op.cit.: 178
42 ibid: 179
43 Howard in doorstop statement, 08/09/01
44 Australian Senate, Legal and Constitutional Committee, *Hansard*, February 10, 2001: 217, statement made by Ms. Bedlington, Manager of the then existing Port Hedland Detention Centre and a member of DIMIA – The Department of Immigration, Multiculturalism and Indigenous Affairs
45 ibid: 216. Statement by DIMIA officer Peter Metcalfe, who became in 2005 DIMIA's new Head of Department after what was announced as an overhaul of the department
46 Howard in joint press conference with Ruddock, 01/09/01
47 ibid
48 *Insiders*, ABC, 02/09/01
49 Howard in interview with Charles Woolley, *60 minutes*, Channel 9, 02/09/01
50 Mike Munro, *A Current Affair*, Channel 9, 12/09/01

It did not take long, however, for the media – and not only the right-wing media – to tie together the two issues of border control and terrorism. Howard was careful to let the media push the link themselves while he remained more cautious in direct allegations. He did, however, take the opportunity to push his arguments for increasing border control still further. The theme became one of a government and a people reluctantly but rationally cutting back on freedoms that were once part of its everyday practices and its national pride. An interview with Ray Martin (Channel 9 – television) provides an example:

"RAY MARTIN: As Aussies we are so used to freedom …

PRIME MINISTER: We are.

RAY MARTIN: Not used to controlling airports.

PRIME MINISTER: I think we'll have to put up with more inconvenience. I think we'll have to accept that. It won't be easy, but I think it will be necessary. Checking on people who come to Australia …. It will mean that we live in a higher state of alert. It's sad, it's the last thing we want in carefree, lovely Australia, but we are a global village now and we have to accept this.

RAY MARTIN: We now know, in fact, this attack against New York and against Washington was planned over a long period of time. We have about 5 000 refugees or people in our camps around Australia. Do you have evidence at all that any of these people have a terrorist or heavy criminal background?

PRIME MINISTER: Well we have evidence that some of them have a criminal background.

RAY MARTIN: But not terrorism?

PRIME MINISTER: Well we're not sure about that. Of course, there are a lot of others … border surveillance and border protection and greater scrutiny of who comes to this country is clearly one of the things we have to do as a consequence of what's occurred".[51]

More direct allegations that terrorists were likely to be found among "illegal immigrants" were made, however, by other members of Howard's party and allowed to stand. An interview by Mark Willacy on *ABC radio* (19/09/01) provides an example:

"WILLACY: Yesterday one of your MP's Peter Slipper claimed in Parliament that there was an undeniable link between asylum seekers and terrorists. Do you agree with that analysis?

PRIME MINISTER: Well I haven't seen what he said. I've been asked about this before. My view is that every country has a right to fully protect its borders. The question of the character background and so forth of the people that have sought to come to this country illegally, the evidence on that one is mixed. Some of them have criminal records. Many of them don't. Not all of them have fled tyrannical regimes as is almost universally suggested by the Government's critics.

WILLACY: But does Mr Slipper's language here – does that do anything to bring calm to this whole debate in the wake of the attacks especially in the US?

PRIME MINISTER: Well what I …. I haven't seen precisely what he said but look, speaking for the Government – and Mr Ruddock's speaking for the Government on this – we are not trying to exaggerate links between terrorism and illegal immigration. However, every country has a redoubled obligation in the light of what has happened to scrutinise very carefully who is coming into this country. And I argued for what we have done in relation to illegal immigration before the tragic events of last week. The tragic events of last week have not altered our policy on illegal immigration. Our policy on illegal immigration is not a product of the tragic events of last week".[52]

Howard could, however, again rely on some aligned media sources to be less restrained. In a radio interview, Alan Jones begins by linking "terrorist" concerns, and the exclusion of refugees, to popular opinions, with the judgement of courts set aside as deviant:

ALLAN JONES: The *Daily Telegraph* today in Sydney editorialises in part and says with the threat of terrorist counter attacks against any nation that aids the United States, Australia must be vigilant, particularly in maintaining the sovereignty of its borders. It is for this reason Mr Howard should reintroduce the Border Protection Bill this week when Parliament resumes, regardless of the outcome of the appeal to the full bench of the Federal Court today.[53] What is your reaction to that?

PRIME MINISTER: I can assure your listeners, Alan, that we will be taking all the steps that are available to us legally to fully protect our borders.

JONES: So to strengthen the laws to enable you to turn away illegal boat arrivals.

PRIME MINISTER: We should have the right to have, we should assert the right to give ourselves a legal position that fully protects us.

JONES: And you'll be ensuring one way or another that occurs?

PRIME MINISTER: Absolutely".[54]

A Revised Bill: Borders Redrawn, Control and "Leadership" Reaffirmed

The Bill previously rejected by Labor was revised, resubmitted to Parliament and, this time, accepted. Its significance lay in three features. First, it *redrew Australia's "migration zone"*: in effect, its border as far as asylum seekers were concerned. Several places between Indonesia and Australia – Christmas Island, Ashmore Reef, the Cartier Islands and the Cocos Islands – were "excised" from the areas that, if reached by asylum seekers, would allow them to apply for entry to Australia. They were still close to the Australian mainland coastline and they remained Australian territory. People who were intercepted at sea or who landed on any of these "excised offshore places", however, could be transferred to processing centres on Nauru or (a further addition by then) Manus Island in Papua New Guinea.[55]

Small wonder that the UN saw the Bill as running counter to agreements, and that one member of Howard's party (Petro Georgiou) saw it as being "the first time a Western national had moved to tighten the definition of refugee statutes", at least in this fashion.[56]

Second, the Bill *reaffirmed the power of people acting on behalf of the government*. That power was less sweeping than before. The Bill, however, still diminished the power of the courts and the ease with which legal redress could be sought for government action. As Beazley pointed out in the course of an election debate with Howard, the revised Bill "was *Tampa* specific, ... put reasonable restraint on Commonwealth officers, ... protected the position of Australian citizens" (the original Bill allowed exemption from liability for actions

taken against all people: entry seekers or citizens) ... (and) recognised that there are judicial processes involved with this".[57]

Third, the differences between the first and the second form of the Bill *were more obvious to the courts, politicians, and bureaucrats than they were to the public*. The bases to Labor's acceptance of the revision – however logical – were not presented in readily grasped terms.

Those grounds were made clearest in Beazley's statements during a later election debate:

"Now on your Border Protection Bill, after I offered you bipartisan support you swung across the table at me a piece of extraordinary legislation which would have allowed a Commonwealth official exemption from all civil and criminal liability. Not simply just dealing with foreigners coming into this country but with Australian citizens. It was a poorly thought out bill. And what did I offer you? I offered you at that time a Tampa specific Bill which would have covered the Commonwealth officers in whatever it was that they were doing with the Tampa to take them to a safe haven.

Now when you came back with a bill that did these things; 1 – it was Tampa specific; 2 – it put reasonable constraints on Commonwealth officers; 3 – it protected the position of Australian citizens; 4 – it recognised that there are judicial processes engaged with this; what did we do? We passed it because everyone of those points we made in the debate. Now if you had sat down with me that day and talked that through you would have had that legislation through the Parliament the day you introduced it Now the person who flipped flopped on this, Prime Minister, if you want to use those insulting terms if you don't

51 Interview with Ray Martin, *Current Affair*, Network Nine, 16/09/01

52 Interview by Mark Willacy on *ABC radio*, 19/09/01

53 The appeal was related to the High Court in relation to the transfer of the asylum seekers off the *Tampa*. The appeal was not successful.

54 Jones, *Radio 2UE*, 17/09/01

55 Human Rights Watch (2002c) *World Report 2002: Refugees, Asylum Seekers, Migrants, and Internally Displaced Persons*. At: www.hrw.org/wi2k2/refugees.html

56 Petro Georgiou cited in Marr and Wilkinson (2004) Op.cit.: 203-204

57 *Channel 9*, 14/10/01. Nonetheless, the first legal claims for compensation after government actions in relation to exclusion (detention or deportation) came when those actions were taken against people who turned out to be citizens rather than "non-citizens" (Chapter 7).

mind my saying, was you. You came back with a bill that worked and a bill that we could support ….

My challenge to you is this – put up on your Liberal Partly website the original bill and along side it the new bill and let people themselves see the fact that, and you can put my speech up as well, and let them see the way in which you changed in that second bill to produce something that was acceptable to us. And if you haven't done it in the next couple of days I'll do it on my website."

Howard responded by rejecting any alignment of Beazley with principle:

"HOWARD: The reality is that you went from one side of the street to the other and then back to the other side. And the only reason in the end you passed that legislation was because of your perception of political pressure from the electorate. It had nothing to do with principle. You have gone from one side of the street to the other on this issue for months and months.
BEAZLEY: The only reason why we passed it John is it was in the national interest. That's all."

"National interest", however, was far less colourful than Howard's description of his position, and the alignment of himself with what "we" are and what "we" face:

"The terrorists will be defeated if we hang onto our essential Australian mateship. We treat each other decently and we work with our friends and our allies around the world to make certain that we work this out. Look, we are an optimistic people. Australians have great capacity to pull together in adversity. It is one of the greatest things we have. Our egalitarian sense of mateship gives us that character, almost above all other people, that capacity to pull together in adversity so if there is one nation on earth that is better equipped than most to handle this adversity it is the Australian nation".[58]

This congratulatory message is clearly more in line with the way most people wish to see themselves: an alternative much preferred to descriptions such as "inhumane" or "shameful". Did everyone buy this rosy picture and this repeated contrast between Howard's "strength" and Beazley's "weakness"? Dissent was strongly present in an interview by Kerry O'Brien: the main presenter on the ABC's 7.30 television program (an analytic news program). O'Brien is widely respected as a thorough and aggressive questioner, a person whose requests for interviews are usually accepted even by people who can expect some incisive probing. The program's appeal lies partly in its wide audience and partly in that audience containing people who might well have been turned off by Howard's simplified stances.

In the course of this interview, Howard described Beazley as having "flipflopped" on illegal immigration, as having been "weak and vacillating", O'Brien challenged:

"Well, who really did flip and flop on the Border Protection Bill? What Kim Beazley objected to about your original Border Protection Bill was that it was too … important to try and take on board and decide on with the short time frame that you gave him. He wanted that bill to be reconsidered. Now wasn't it you who substantially changed the Border Protection Bill which he then supported? And isn't that the only thing on which he has disagreed with you on illegal immigration?"

Howard side-stepped the question: "Kerry, that's a very difficult question. I'll leave the punditry to you and others."

O'Brien continued with a recital of the Liberal Party's "backflips" on domestic issues related to petrol and taxes, with Howard now pushed to say that these were changes "in response to community concerns".[59] Once more, he claimed an alignment with "the people", assigning any critics to an outer circle playing with words.

The electoral campaign continued in the same populist vein. The election, it was argued, was a choice, at a time of national crisis, as one between firm, decisive leadership and a "flipflopping" alternative. The position of refugees had become part of an electoral campaign against an opposition whose general stand on the importance of "border control" and the exclusion of "illegals" was the same as that of the government,

but who could hopefully be portrayed as "weak" rather than "strong" and as falling short of what a country could expect in times increasingly portrayed as presenting constant insecurity and danger. The conditions that prompted asylum seekers to attempt risky entry to Australia, the reasonableness of "outsourcing" to countries such as Nauru, the conditions in detention centres within Australia or in Nauru: these were pushed into "minor themes" status in the orchestration of the country as in danger and one party as "strong". Australians were not the first or the only audience to find that framing persuasive.

58 ibid
59 O'Brien, *7.30 Report*, ABC, 05/10/01

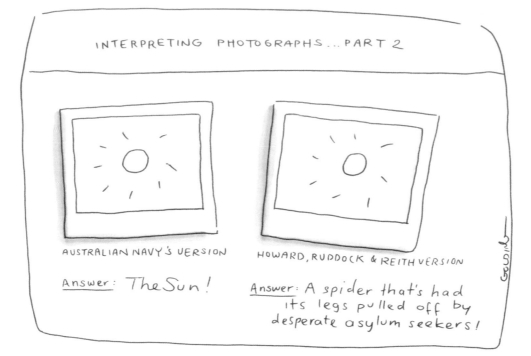

"Interpreting photographs" by Matt Golding. From the exhibition, *Cartoons 2002: Life, Love, Politics* at the National Museum of Australia. Reproduced also in *The Melbourne Times*, February 20, 2002.

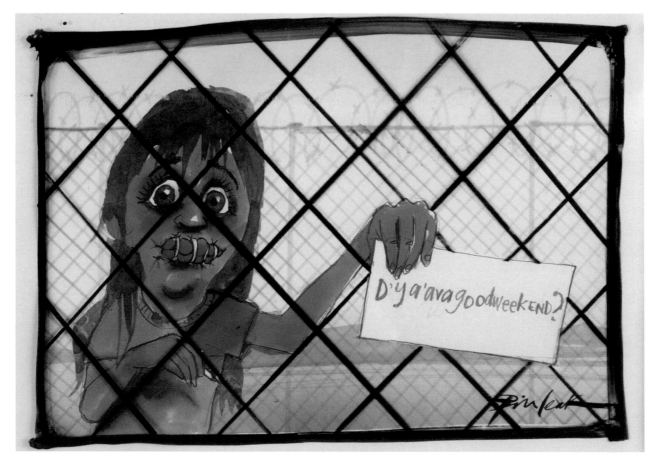

"D'javagoodweekend?" by Bill Leak. From the exhibition, *Cartoons 2002: Life, Love, Politics* at the National Museum of Australia. Reproduced also in *The Australian*, January 27, 2002.

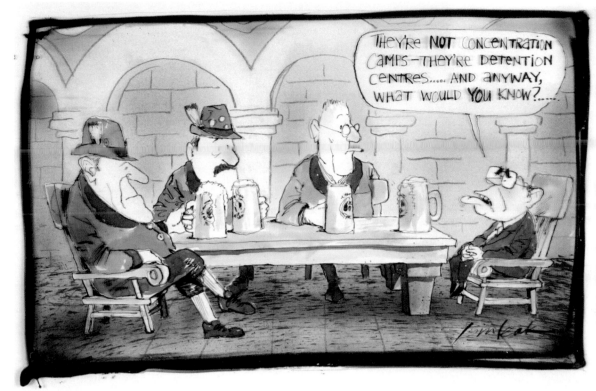

"PM in bierhalle" by Bill Leak. From the exhibition, *Cartoons 2002: Life, Love, Politics*. Reproduced also in *The Australian*, July 3, 2002.

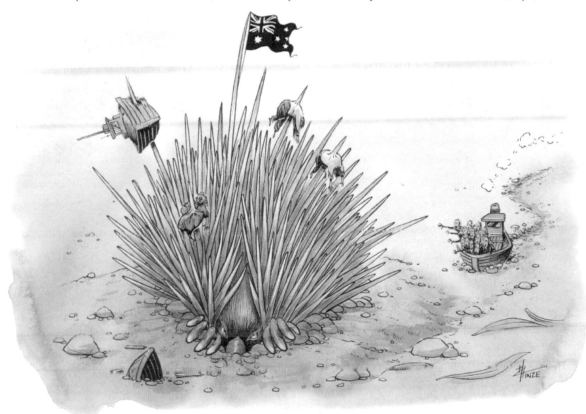

"Digging in" by David Pope. From the exhibition, *Cartoons 2002: Life, Love, Politics*. Reproduced also in *Chain Reaction*, Spring 2001.

CHAPTER 6

One Represention Unravelled, Another Sustained

To be successful in sustaining an initial representation, it has been argued, any source needs to meet several conditions. It must have a clear and "newsworthy" message, attractive to the audiences it wishes to persuade. It must anticipate the strategies of others and have on hand ways of deflecting dissent or making competing representations less credible than its own. It must also anticipate the need to moderate an original account and prepare the ground for doing so without losing its own credibility.[1]

To compete or to push for change, to take a second line of argument, dissent needs to have an equally clear, newsworthy and attractive message. It also needs to overcome its inherent tendency to be fragmented. Some coordination or common cause needs to emerge. Needed also is some continuing concern with changing the core of a competing agenda or ideology, resisting the temptation to be satisfied with change in a localised area of discontent or a partial solution.[2]

Those arguments have been outlined in Chapters 2 and 3. Aspects of both have also come up in the chapters covering the first phases of the series of events that began with the *Tampa*'s rescue. The next phase of those events provides the opportunity to give them an additional anchoring base and to take them further, especially in relation to the representations of people who flee their own country and seek to cross a nation's borders.

Chapters 4 and 5 have brought the events that began

with the *Tampa* to a point where the threat of an unlimited number of "boat people" arriving by way of Indonesia was represented as calling for what was essentially a blockade. The Navy was to stop and return to international waters any boat seeking illegal entry from Indonesia. If the nearest landfalls (Christmas Island, Ashmore Reef) were reached, that would no longer count as having reached Australia: no claim for asylum processing could be made. Anyone who needed to be rescued, and could not be returned, would be taken to one of the "Pacific" processing centres.

Without the Navy's interception, the Prime Minister argued, the future was bleak:

> "But if we threw up our hands and stop this …. That would be a recipe for the shores of this country to be … thick with asylum seeker boats".[3]

Like all representations of deterrence, however, this one ran several risks. Waiting in the wings were already several questions:

- Are these people really such a threat?
- Is this what the Navy should be doing?
- How long can this be sustained?
- Are we inviting a new set of moral dilemmas? What if the Navy has to use force? What if people are hurt?
- Where is compassion in this response? "Realism", maybe, but compassion?
- What does this say about us as a people?

For the government at this stage, it was very difficult to change either its policy or the definitions on which it was based. There was no alternative policy readily at hand and the government had staked its reputation on this one. Even any "softening" or moderation at this point would run the risk of the government appearing to be "weak" or to "flip flop": precisely the qualities it was attributing to the not-to-be-trusted Opposition.

The ideal scenarios for the government would now take several forms. At least until after the election on November 10:

- The boats would stop coming.
- Fewer boats would come.
- If boats did come, the people on board would "behave badly".
- If boats did come, there would be no disasters, or at least none for which the government could be held directly responsible. Any fault would lie elsewhere (e.g., with the Indonesians, or the "people smugglers").
- The Navy would accept its role without complaint and stay silent, leaving the government information sources in media control.
- The government's message would remain credible, and the government would be seen as truthful.
- The media, for one reason or another, would not probe too deeply and attention would rapidly shift to another topic. New events, for example, would quickly push the beginnings of any probe off the front page.

Those ideal scenarios did not occur. What arose were opportunities for questions and expressions of dissent to appear, and the need to work hard at maintaining the original definition. Both are brought out by turning to two "incidents": two occasions on which boats did come and did not simply return to Indonesia.

There were more than two such incidents, prompting at one point naming the boats by their number e.g. SIEV 4 or SIEV 5 (SIEV standing for Suspected Illegal Entry Vehicle). Many of the incidents involved were also far from easy or peaceful interceptions.[4]

The two that provide the focus for this chapter, however, had several distinctive qualities. They were, to start with, highly visible to the public eye. They came to be known as "The Children Overboard Affair" and "The SIEV X Incident" with both phrases entering everyday language. They also remained memorable, staying newsworthy – at least in some quarters – long after their first blaze in the news.

Both incidents also bring out some particular aspects to issues that affect the fate of all representations. One of these is the availability of information, of access. The other has to do with the ways in which some immediate concerns – with what is news, with the people "responsible" for an event – deflect attention away from core issues.

The two incidents, however, are not identical in the form they took, or in the issues they raised. The first, for example, the "Children Overboard Affair" (more officially, SIEV 4), raised questions about direct misrepresentation: Who lied about children being thrown overboard? Who knew but was silent? How could "error" be acknowledged without losing all credibility? The second (SIEV X) was more distinctly a human tragedy. A boat leaving Indonesia sank and 353 people on board it drowned. Many of those were children and women. Their images removed any trace of "facelessness". They also brought issues of compassion strongly to the fore, underlying questions about when these issues can become dominant and when they can be deflected by focusing on questions of direct "fault" and "responsibility".

For both events, there are now detailed chronologies available with an emphasis on what happened when, who knew what and who was responsible for various representations.[5] The focus here, however, will be on the way a frame may be weakened but its core sustained, on the emergence and management of dissent, and on the particular role of the media.

1 Schlesinger, P. and Tumber, H. (1994) *Reporting Crime: The Media Politics of Criminal Justice*. Oxford: Clarendon

2 E.g., Herman and Chomsky 1994; Laclau and Mouffe, 1985

3 John Howard on *Radio 2GB*, 31/10/01, cited by Marr and Wilkinson (2004) *Dark Victory*. Sydney: Allen & Unwin: 328

4 See Human Rights Watch (2002a) "Not For Export": *Why the International Community Should Reject Australia's Refugee Policies*. A Human Rights Watch Briefing Paper, September 2002; Human Rights Watch (2002b) "By Invitation Only": *Australian Asylum Policy*. Vol. 14, No. 10 (C) – December 2002

5 For the "Children Overboard Affair" see, for example, Marr and Wilkinson (2003) Op. cit. For the "SIEV X Incident" see Kevin, T. (2004) *A Certain Maritime Incident: The Sinking of SIEV X*. Melbourne: Scribe

Children Overboard: SIEV 4

First Frame: "Moral Blackmail" by "Unacceptable People"

On October 7, the Federal Government, through a spokesman for Defence Minister Peter Reith, claimed "a group of asylum seekers trying to reach Australia had thrown children overboard In a premeditated attempt to force their way into the country".[6] (There was at this point no indication of the boat sinking. It was, however, noted as having been intercepted by a Navy vessel).

A similar statement was made by Immigration Minister Ruddock:

> "Immigration Minister Philip Ruddock said sailors from *HMAS Adelaide* boarded the vessel in Australian waters at 8am yesterday and gave an order for it to turn back. After the order was resisted and a second group from the navy ship boarded the vessel, adults began jumping overboard and pulling children with them".[7]

> "Disturbingly a number of children have been thrown overboard, again with the intention of putting *us* under duress … I regard these as some of the most disturbing practices I've come across in public life … People would not come wearing life jackets unless they planned action of this sort".[8]

Howard was also not slow to comment, using the incident to raise again questions about the extent to which the boat people were "genuine refugees". The actions, he said, were "an attempt to morally blackmail Australia … I can't comprehend how genuine refugees would throw their children overboard …. Quite frankly, I don't want in this country people who are prepared … to throw their own children overboard".[9]

At this point, all information was again channelled through Canberra – through the offices of Prime Minister Howard, Immigration Minister Philip Ruddock and Defence Minister Peter Reith. No direct or official information from the Navy was available.

No questions?

Dissent could take two forms. One was to query the general policy of blockade that Howard had adopted. Boats were apparently still arriving. The other was to query the portrayal of this particular action: Were children actually thrown overboard? Could this be an act of desperation on the part of asylum seekers rather than an attempt at "blackmail" and "intimidation"?

The political queries initially focused on the effectiveness of the policy. The Opposition Leader let the story stand. He "condemned the tactic" (he later termed it an "outrageous act") but said the arrival of yet another boat proved that the government's deterrence measures "were not working".[10]

The response from the Australian Democrats was also a query about the general policy:

> "Australian Democrats leader Natasha Stott Despoja said the forcible removal of boats carrying asylum seekers was the most expensive option and would do nothing to solve the problem in the longer term".[11]

Media response covered both the general policy of blockade and the accuracy of the government's story. Sparking both was a particular interest in gaining access to material that would be newsworthy (photographs and videos). Access to these useable kinds of information had been radically restricted in the case of the *Tampa*. To be once more deprived of what was felt to be an essential part of a story, as media's reasonable entitlement, and then to be offered only pieces, now appeared to be unjustified and, after a while, suspicious.

On the first day after the government's report was released, the media promptly reflected its framing of events. The *Herald Sun*, for example, carried the headline "Overboard: Boat people throw children into ocean". The front page also included a 'voteline' box on their front page: "Should boat people who throw children into the sea be accepted into Australia as refugees?"[12]

Other parts of the media offered Howard the opportunity to respond on the implied character of people who would act in such a fashion and to discount the possibility that it might express "desperation". A radio interview on *2GB* by Philip Clark provides an example:

> "CLARK: Mr. Howard, can we talk about a few domestic

issues? I mean, clearly the election's going to be conducted against this background …. of events which are of global importance, and … matters like health and education and so on. No doubt they'll be important, but can we turn to the refugee issue for a start? I mean, I was horrified, I think every parent would have been about the image you had at the weekend of boat people throwing their children overboard. I mean it says two things I suppose, one is the desperation of the people involved. *It may say something else about them*. Well, what was your reaction?

PRIME MINISTER: Well, my reaction was I don't want in Australia people who would throw their own children into the sea. I don't and I don't think any Australian does ….

CLARK (inaudible)

PRIME MINISTER: Well that's one view. Another view is that this is an attempt to morally blackmail Australia. I think it is. Genuine refugees don't put their own children at risk, they become refugees in the name of the preservation of the safety of their children. There's something to me incompatible between someone who claims to be a refugee and somebody who would throw their own child into the sea. It offends the natural instinct of protection and delivering security and safety to your children. So I don't accept that it's a measure of the desperation. I think it's more a mark of the determination of those who've taken advantage of people, of using the services of people smugglers. It's the people smugglers that are taking advantage of them. But it's a determined attempt to intimidate us and we have to understand that. They'll be treated humanely and they have been and they will be and I want to thank the men and women of the Australian Navy for doing this very difficult, very disagreeable thing, it's not easy for them …. It's very stressful for them and I'm very conscious of the impact on a lot of young sailors and we're endeavouring to implement a policy that protects the integrity of our Immigration system … and we're not going to be pushed around by this kind of intimidatory behaviour".[13]

An interview with Neil Mitchell repeats the moral theme:

"MITCHELL: You always seem genuinely angry about

the situation with the refugees and the children being put overboard.

PRIME MINISTER: Well I was and am, Neil. Refugees' motivation is often the protection of their children. And trying to provide their children with a better life for the future. It's not within my frame of comprehension that people who are genuine refugees would throw their children into the seas".[14]

An interview with Alan Jones on his talkback program (*Radio 2UE*) brings out again the extent to which this story pushed aside other events (Labor's policies on health and education were among these) and gave Howard the opportunity both to claim the high moral ground and to demonstrate sympathy (again for "the sailors" rather than the asylum seekers). This interview marked also the emergence of some first minimal words of caution about the reports. The interview moved quickly from the "war on terrorism" to spending money on refugees in camps in other countries (e.g., Pakistan), and then to the drama at sea:

"JONES: Back to the refugee issue, 120 kilometres off Christmas Island. We've all seen the stories and the headlines, children being thrown overboard. What do you say about how this matter ought to be addressed?

PRIME MINISTER: Well it's our firm resolve that these people will not come to the Australian mainland. We believe that they should go back to Indonesia. We're in communication with the Indonesian Government. Quite frankly, Alan, I don't want in this country people who are prepared, *if those reports are true*, to throw their own children overboard. And that kind of emotional blackmail is very distressing, it must be very distressing for the sailors on the vessel, I feel for them, many of them young men and women. Confronting this kind of situation is very difficult and I thank

6 Cited by Douez and Forbes, *The Age*, 08/10/01
7 ibid
8 Ruddock in press conference, 07/10/01, emphasis added
9 Cited by Taylor, *The Age*, 08/10/01
10 Douez and Forbes, *The Age*, 08/10/01
11 ibid
12 Marr and Wilkinson 2004: 251
13 Howard in interview with Philip Clark, *Radio 2GB*, 08/10/01
14 Howard in interview with Neil Mitchell, *Radio 3AW*, 08/10/01

them warmly for the job that they're doing on behalf of Australia. But we cannot let ourselves be intimidated by this".[15]

A later part of the interview contains a further first qualification:

"PRIME MINISTER: ... I think what is happening at the moment is that our resolve is being tested. It is a very difficult issue because you are dealing with highly emotional behaviour, you're dealing with people, *I don't know their backgrounds* but I do know this, it's a matter of common humanity. Genuine refugees don't throw their children overboard into the sea".[16]

Why these first qualifications? And why the concern with "the sailors" but not with *these* asylum seekers? To take the first – the expressed concern for "the sailors" – these comments came at a time when, out of the public eye, Navy discontent at the role they were playing was growing. Turning around overladen boats, with poor or no navigation systems, that might well sink on a return journey, was hardly in line with the Navy's definition of war or its ethos of saving lives of those in need at sea (cf. Chapter 4). Being part of a refugee blockade was also cutting across being formally at war. The *Adelaide* was preparing to return to base and then to the Middle East when it was detailed to stop SIEV 4.[17]

The qualifications mark a strategy that would appear over and over again. Government spokespeople made strong statements but at the same time defended themselves against later scrutiny ("If these reports are true"; "reports made to me"; "I just acted on the advice given"; "I don't know their backgrounds"). As the "overboard" story continued, Howard, Ruddock and Reith were to increasingly distance themselves from challenge by the use of such phrases.

The pressure to do so came from the media beginning to access a new set of sources. One of those was a news reporter for Channel 10 – Elizabeth Bowdler. Her important source came from the Navy itself – from the Commander of the ship that had intercepted SIEV 4. Bowdler had phoned the *Adelaide* and talked to Commander Banks. He had described the rescue of the 200-odd people from the *Olong* as the ship broke

up, spoken warmly of the children now on board the *Adelaide* (including a 3-week old baby), and said that there were photographs to go with the story. He had emailed to Canberra two of these, showing 2 of the *Adelaide*'s sailors who had jumped into the water to rescue women and children from the sea. Bowdler then phoned Defence public relations asking for the photographs.[18] In addition, some of the sailors from the *Adelaide* had spoken to civilians on Christmas Island, saying that no children had been thrown overboard. Many in the Navy line of command were by this time also aware that the story was being misrepresented. They may have assumed that their corrections to the story would be passed on to the relevant Ministers and accepted by them. They seemed also to accept reminders that all enquiries to them should be referred to Canberra. The number of "leaks", however – and a lack of trust in statements from Reith, the Minister for Defence – kept media interest alive.

On October 10, the Minister for Defence (Reith) was asked about photographic evidence. He claimed no knowledge: "I don't know whether there are photographs ... what I do know is the reports that were made to me, and I don't doubt their authenticity or credibility".[19] Claimed also was the impossibility of releasing video footage described as showing a child being pushed into the water by asylum seekers. This footage, he said, was "on board the *Adelaide*, so it is not physically available, I have not seen it …. It shows a child being pushed into the water".[20]

At fault once more were the "undesirable" refugees: "those on board had disabled the vessel, were 'extremely aggressive' and had probably caused it to sink, forcing sailors to mount another rescue".[21]

Pro-government sources promptly moved to the description of sceptics as ridiculous:

"The strange thing about the 'debate' over our treatment of asylum seekers is that so many 'good' people are so keen to think we're monsters. Earlier this week, Immigration Minister Philip Ruddock said Iraqi boatpeople had thrown their children overboard when *HMAS Adelaide* tried to turn their boat back to Indonesia. He said our sailors had to jump into the sea to rescue some 14 children and adults. Only a fool

could think Ruddock would make this up, given the incident was witnessed by dozens of sailors and officers Add this scare campaign to those about our 'concentration camps', our racism and so on".[22]

Critical voices, however, continued to be heard. They also began to cover more than the validity of a news-worthy story. Expressed as well was concern for the plight of the asylum seekers, the way the actions were affecting Australia's self-image as compassionate, and the effectiveness of the government's "stop the boats" strategy.

An interview with Jon Faine provides an example. The interview illustrates in its order what was regarded as newsworthy at the time. That order went – War in Afghanistan, Howard's visit to a mosque, and then the asylum seekers. Domestic issues such as the collapse of a national airline (Ansett) came only later:

"FAINE: Asylum seekers, if we can move on to that topic you still have boat after boat heading towards Australia with hundreds of asylum seekers. Where are they going to go?

PRIME MINISTER: Well, whether it is boat after boat with hundreds ...

FAINE: Well, 187 here and a couple of hundred the other day Nauru is full as we understand it It hasn't stopped the flow of people, you can't legislate against desperation The Melbourne Anglican Synod is calling on the Federal Government to convene a Royal Commission into its treatment of asylum seekers and the entire refugee intake policy. Is there any merit in that?

PRIME MINISTER: Well, with great respect to the Anglican Synod, I would ask the ... Synod to remember that this country has a very generous refugee policy. I heard one of the spokesmen on early morning ABC Radio this morning ... expressing the hope that Australia would once again be seen as a compassionate country. Now I reject that very strongly. This country remains very compassionate towards refugees but we are determined that we are going to preserve the integrity of that refugee policy and we cannot allow a situation to arise where people choose, and not Australians choose, who comes to this country. That is essentially the mantra of many people, that it is for others to decide whether they come to Australia not for us to decide".[23]

A Representation Begins to Fall Apart

Dissent at this point took several forms, with little coordination among these. Where coordination did emerge was among sections of the media, united by the sense that they were being denied access to material they were told existed, and by the suspicion that they were being treated as gullible. At first, the questions took the soft form of whether the photographs in fact proved anything conclusive:

"TRIOLI: It's a reasonably tight shot They are all wearing life suits. Mr Reith, there's nothing in this photo that indicates these people either jumped or were thrown?"[24]

The response was an attack on Trioli's morality (this is questioning the veracity of the "Royal Australian Navy") and a mention of further proof – a film:

"REITH: No, well you are now questioning the veracity of what has been said. Those photos are produced as evidence of the fact that there were people in the water. You're questioning whether it even happened. That's the first point and I just want to answer that by saying these photos show absolutely without question whatsoever that there were children in the water Now, you may want to question the veracity of reports of the Royal Australian Navy. I don't and I didn't either but I have subsequently been told that they have also got film I have not seen it myself ... but I am told that someone has looked at it and it is an absolute fact, children were thrown into the water. So do you still question it?

15 Emphasis added: these are the first words of caution.
16 Interview with Alan Jones, *Radio 2UE*, 08/10/01; emphasis added
17 Marr and Wilkinson (2004) Op.cit.: 252
18 Marr and Wilkinson (2001) Op.cit.: 258
19 *The Age*, 10/10/01
20 ibid
21 Forbes and Taylor, *The Age*, 11/10/01
22 Andrew Bolt, "So Keen to Find Evil-Doers" in the *Herald Sun*, 11/10/01.
23 *Radio 3LO*, Melbourne, 09/10/01
24 Virginia Trioli, *ABC radio*, 10/10/01

TRIOLI: I'll question anything until I get the proof.

REITH: Well, I've given you the evidence.

TRIOLI: No. You've given me images.

REITH: Well, quite frankly if you don't accept that, you don't accept anything I say".[25]

In a more coordinated fashion than usual, other journalists also began to push Howard, Ruddock and Reith to prove their claims. Howard worked hard to stall the issue – a tactic that usually works as the news agenda moves on to new issues. In the doorstop interview below, for example, he promises to "make enquiries" and to go back to his sources. Like Reith, he also tries to throw off questions by suggesting that they are inappropriate and cast doubt on the integrity of institutions such as the Navy, rather than on his own integrity. "The Navy" remains silent. An example is a doorstop interview by the Prime Minister with questions from a number of journalists. The string of questions from the journalists stayed with the one topic, rather than "moving on". The media clearly felt it was "on to something".

To focus only on the questions:

"JOURNALIST: Can you tell us how many children were thrown overboard, were they wearing life jackets, what evidence is there (inaudible) children were thrown overboard and can we have access to that evidence? ….

JOURNALIST: Are you still confident Mr. Howard of this information because you did make a lot of it at the time it got ….

JOURNALIST: Have you any problem with the (inaudible) reporting the incident and any photographic ….

JOURNALIST: Given that it's become a public issue though and both yourself and Mr. Ruddock have talked about events of the people going overboard, would it be helpful if people could see the videotape? ….

JOURNALIST: Prime Minister do you see it any differently in the situation of people going overboard if it happened just after shots were fired in their direction?

JOURNALIST: Mr. Howard, have you asked for a full report of this incident with the *Adelaide* and if not why not?"[26]

The Prime Minister's response in each case was along the line that:

"*I have no reason to disbelieve the information I've been given*. I still haven't been given any information that would cause me to disbelieve what I was told by the Immigration Minister".[27]

There were, he said, "photographs and other evidence" but the photographs were "a matter you have to discuss with Defence. Mr. Reith's office is handling that".[28]

"The evidence", however, continued to be the point of attack: attack that was in some cases hard-hitting. Michael Gordon, in the *Sydney Morning Herald*, for example, pulled no punches:

"The pictures released yesterday will be widely hailed as justification for all that John Howard and Philip Howard and Alexander Downer and Peter Reith have said about the latest boatload of would-be refugees. But are they? …. Even yesterday the Prime Minister and his ministers were unable to say how many of the 14 (out of some 220) who ended up in the water were children – and how many of them had been tossed overboard. Those who sought some detail and context were dismissed by Mr. Ruddock as trying to make 'heroes' of boat people, while Mr. Reith complained that 'people who weren't there are making exaggerated and unfair claims'".[29]

Pictures and their interpretation provided as well a point of entry into the debate for refugee groups in Australia. The Refugee Council of Australia President David Bitel, for example, objected to the description of the children as small and "readily lifted and tossed without objection".[30] He described the government as "demonising and scaremongering" and "deliberately inflating the issue for political ends … It is appalling for the Minister to make these sorts of statements without having the facts to substantiate them".[31]

The News Moves On

In the midst of all the debate over photographs and video footage, the fate of those who were on the boat received

little attention. The boat itself sank. It was clearly "not returnable". Those on board, however, were still not to land on Australian soil. While the incident was being played out, and the refugees were held on board the *Adelaide*, the "Pacific Solution" continued to expand. A deal to set up a new "processing centre" in Papua New Guinea was made on October 8 and, on October 10, Howard announced that this would be the destination of this latest group of boat people. They were then taken off the *Adelaide* and ashore to Christmas Island (now no longer part of the "migration zone"). From there, they were to be flown to Papua New Guinea.

The PNG Prime Minister Mekere Morauta was reported as saying that his country stood "ready to cooperate with Pacific Forum states" in finding a haven for the asylum seekers.[32] The cooperation would again be financed by Australia, with the cost estimated as "contributing to a bill of more than $100 million for the government's hardline stance against illegal immigration".[33]

Once again cost and the "outsourcing" of refugees to other countries was a point of dissent:

"And in the meantime, another less fortunate country, Papua New Guinea, is prevailed upon to process this boatload at an undisclosed cost to Australia and with many logistical details either under wraps or still evolving. There is no compelling evidence that the policy is working and a strong prospect that it will become unsustainable – but not before November 10".[34]

The policy of deterrence and detention, however, remained intact and widely supported. Two interviews illustrate the support offered the majority of the media and Howard's moves to reduce the impact of a further source of dissent: concern with the implicit racism of his position and the likelihood of its promoting racial tension and conflict within the community.

Public support is a strong part of an interview with Jeremy Cordeaux:

"CORDEAUX: Does it surprise you, the overwhelming support? I guess this program and programs like it all over the country have never had the kind of phone traffic on an issue like this.

HOWARD: Perhaps the extent of it did. I think what it does indicate is that people want, just as they want control over their own lives, they want this country to have control over its own borders. I think it's very important and that's what it's about, it is not about being unsympathetic to people who are persecuted, it is about giving ourselves the capacity to control our borders".[35]

The translation of any racist implications into a concern with "harmony" and "tension" is illustrated by an interview with Philip Satchell and David Bevan.[36] It begins by considering Howard's planned release of a program to promote "racial harmony":

"BEVAN: Prime Minister, I think it's fair to say those tensions that you're talking about, talking about racial harmony and the tensions that we're feeling in our community at the moment, that they've been … well, if they haven't been complicated, they've certainly been intensified by the problem of asylum seekers. How long can we keep sending asylum seekers to nearby nations?"

Howard discounts any increase in tension or tolerance:

"PRIME MINISTER: Could I just sound a word of caution about the question of the level of tension? It's, we shouldn't make the mistake of saying there's a lot of tension. There is some, but most Australians are responding, I believe, quite magnificently. *They're being open and tolerant and not seeing people of Islamic faith as being in any way associated with terrorism.*"

25 Peter Reith interviewed by Virginia Trioli, *ABC Radio*, 10/10/01
26 Doorstop interview, 10/10/01, emphasis added.
27 ibid, emphasis added
28 Doorstop interview on a flight between Melbourne and Brisbane, 10/10/01
29 Michael Gordon, *Sydney Morning Herald*, "Do the pictures really tell the story?"
30 Cited by Forbes and Taylor, *The Age*, 11/10/01
31 Cited by Forbes and Taylor, *The Age*, 11/10/01
32 ibid
33 ibid
34 Michael Gordon, *Sydney Morning Herald*, 11/10/01
35 *Radio 5DN*, 16/10/01
36 *Radio 5AN*, 16/10/01

What a previous leader of the Liberal Party (Malcolm Fraser) described as "the dark underside" of Australian sentiment toward "others" who are seen as "different" emerges, in Howard's glowing description, as either not provoked or not even present.

Maintaining the policy of blockade and the frame of necessary deterrence to boats that would "keep coming" was helped especially by the appearance of some further boats and the opportunities they provided for both political positions and public concerns.

Nonetheless, over October and November, the questions continued. They returned in force, for example, after *The Australian*, on November 7, flew a reporter to Christmas Island to check local knowledge (information from sailors) of what had happened. It then ran a story querying the government's "children overboard" interpretation. The government at this point could have corrected its version, especially since by that time the Acting Defence Force Chief – Air Marshall Houston – had directly told Peter Reith that, as he testified at a later Senate inquiry, "there was no documentary evidence to support the statement that children had been thrown overboard".[37] Reith instead announced that he would release the video. Howard faced a series of questions at a major meeting at the National Press Club in the course of interviews on television and radio, but stuck to his position. The Defence Minister had been acting on the basis of advice from Defence. He himself relied on their advice and also on "written advice" from the Office of National Assessments to the effect that "people on the vessel had jumped into the water and that children had been thrown into the water" (advice that turned out to have added to it a warning that the statement was written after the Ministers' statements and so was "flawed").[38]

At the same time, however, reporters were addressing direct questions to the Chief of the Navy (David Shackleton), who had been out of the country for a few weeks but had flown back to farewell the *Adelaide* and the *Kanimbla* as they left for the Gulf. He was then briefed by Commander Banks (the captain of the ship that had picked up the "children overboard"). When "asked directly if the video showed children being thrown into the sea, he replied 'it doesn't look as if they were thrown in' ".[39] On the next day:

"The front pages were not kind to the Prime Minister that morning. (November 9) 'NAVY SCUTTLES PM'S STORY' was the headline in the *Australian*, 'HOWARD IN HOT WATER OVER OVERBOARD CLAIM' said the *Sydney Morning Herald*, while the *Courier-Mail*'s verdict across page one was, 'PHOTO SINKS HOWARD'S CLAIM'.[40]

Nonetheless, Marr and Wilkinson add: "the editorials of nearly every major newspaper endorsed Howard's re-election. 'Australians' …. concluded the *Daily Telegraph* …. 'want energy and calculated daring' ".[41] They were also apparently willing to accept Howard's assurance that such "errors" would not occur again. A new boat had hit the public news (SIEV 10), and this time, Howard advised, he had instructed the Defence Minister (Peter Reith) to present the "unvarnished" Navy report "and people can then make their own judgements …. I do not want people … saying well 'Howard and Reith are making this up".[42] He then returned to the themes of praise for the Navy for its actions (particularly the rescuing of children), condemnation of "illegal immigrants", and the interception of refugees as part of a broader defence effort against "people who would seek to come to this country illegally …. endeavouring to break the law of this country".[43] Reserved for the government was still the claim of a position that was both legal and, for those who could represent themselves, as not well informed by their subordinates, moral.

SIEV X

SIEV 4 generated a phrase that became part of Australian vocabulary. "Children Overboard" became a summary term for government exaggeration and misrepresentation. No one, however, died and the asylum seekers themselves remained faceless. Attention could then easily stay framed on government history and evasion. The boat that became known as the SIEV X presented a different picture. It became for Australia "part of our folk history".[44] It became the topic of a Senate inquiry in 2002, plus repeated newspaper articles and television programs.

What made SIEV X so widely known about and so memorable? The story is first of all an example of how

media access can undermine attempts of government control. It is also an example of the importance of personalizing refugees: a personalization that taps into a fear that all can feel – drowning at sea.

The 44 survivors were promptly interviewed by journalists and representatives of The International Organisation for Migration (IOM) who were already in Indonesia. Many of the 44 survivors were in fact already known to IOM, (they had spent time in centres managed by IOM) and had refused to land until IOM representatives were present.

Within Australia, there were also relatives waiting, with many of these fathers who had been separated from their wives and children and could not have legal reunion for at least several years. It was their wives and children who had attempted entry by way of SIEV X. Both sources could provide photographs and stories of the people they had lost and of the SIEV X's journey.

The narrative begins with reports from both within and outside Australia. The boat started out from Indonesia with at least 300 people on board. It sank in Indonesian waters. The 44 survivors were picked up after 19 hours in the water by Indonesian fishing boats and taken back to Indonesia.

The questions most prominent in the first reports are in themselves indicative of what makes events attract both attention and more than one kind of representation. Cutting across reports were these queries:
- How many dead? The size of the disaster clearly matters.
- Why so many? How did they die?
- Who were they? Whole families were wiped out or almost so. Many of those lost were children – the youngest just 3 months old.
- Why do they take this risk?
- Is anyone going to do something?
- Who is responsible? Where should we "direct our anger"?

How many died? The first UNCHR briefing, at the Palais des Nations in Geneva, gave as a first estimate 360 people – 300 of them women and children – as drowned, with 44 of those on board surviving.[45] The number surviving was also the leading point in reports issued by CBS and CNN on October 22.[46] The location in the reports was indefinite: "in the Java Sea" (UNCHR), "off the island of Sumatra" (CNN, CBS). The extent of the loss, however, was the first point to be made. There had been other drownings. In the words of IOM's local director, Richard Danzigar, "four or five boats have foundered near the coast with one or two drowned but not a tragedy on this scale. As far as I know, it's the worst".[47] For days, however, the concern persisted with "just basic numbers. Is it now clear exactly how many people did die and how many did drown?"[48]

Why so many? How did they die? The details fit the worst narratives of death at sea. The ship – described as 19 metres long – was overcrowded. It sank quickly (probably within 10 minutes of beginning to founder). To take some details from the CBS report: "Within minutes, it broke up and sank, spilling dazed survivors and thousands of gallons of fuel into the ocean".[49]

Many people – perhaps as many as 200 – were trapped under the hull. There were few life jackets and the survivors reported most of these as defective. Surrounded by the bodies of others, "people were trying to hold on to pieces of wood but they were not strong enough or the wood sank and then they died. We were all exhausted and waiting to die".[50] In rough seas, and through hours of that afternoon and night, many died, perhaps as many as 160. The few who did survive hung on, eventually being picked up after 20 hours by an Indonesian fishing boat. In the words of one survivor, "the conditions were unlike anything you could image, worse than anything you've seen in the movie *Titanic*".[51] A Sydney headline brings together both aspects of number and of time: "Asylum seekers' boat sinks in 10

37 Marr and Wilkinson (2004) Op.cit.: 334
38 ibid: 341
39 ibid: 344
40 ibid: 358
41 ibid: 339
42 Howard interviewed by John Laws, *Radio 2UE*
43 Doorstop interview, 19/10/01
44 Kevin, T. (2004) *A Certain Maritime Incident: The Sinking of SIEV X*. Melbourne: Scribe: 250
45 UNCHR spokesperson Kris Janoski, 23/10/01 at: http://www.unchr.ch/
46 CBS and CNN, 22/10/01
47 *Sydney Morning Herald*, 23/10/01
48 Question from Mark Covin, based in Australia to Ginny Stein, ABC representative in Indonesia. *ABC PM*, 23/10/01
49 *CBS*, 22/10/01: http://www.cbsnews.com/stories/2001/10/22/world/main315415.shtml
50 *CBS*, 22/10/01: http://www.cbsnews.com/stories/2001/10/22/world/main315415.shtml

minutes, killing 350".[52]

Who were they? One feature stood out in all accounts. These were "families", with the women and children – those trapped in the hull – suffering the greatest loss: a major departure from any picture of aggressive single men seeking their fortune or forcing their way on to Australian soil. Prominent in UNCHR and IOM accounts was also the fact that a number of those who had died had already been through a major stage in relocation. They had been officially recognized as refugees and might well expect, in time, acceptance in one country or another.

The extent to which those who died were the people normally thought of as deserving sympathy and help – the young, the wives or mothers struggling by themselves – comes through over and over again. It was part of the survivors' own accounts. The tragedy, for one survivor, lay in watching die those who normally would not: "Beautiful girls, beautiful girls, quickly, quickly die".[53]

The tragedy for others lay in the way entire families were wiped out or almost completely so. In the words of a mother who had hoped to join her husband and had lost their three daughters (8, 6, and 5). "I feel now empty. I have lost everything." Her husband's sense of loss compounded the grief: "When she telephoned him on Monday night to tell him his daughters were dead, she says he pleaded: 'Not one left? What did you do? What did you do'?"[54]

Observers felt the same sense of familial and personal loss. Here was a man who had lost his wife, 3 daughters, and 1 of his 2 sons. Only he and one son survived.[55] Among those to survive was an eight-year-old child who had lost 21 family members.[56] Especially touching were the few cases where the youngest had survived: a father with his 2-year old "the baby" he had held "on the back of my neck. Four or five times she went down. I got her out and held her on my shoulder".[57]

"'It has touched each one of us,' said IOM counsellor Maha Bodemar. 'I see one little girl maybe eight years old who survived while her parents and siblings died. There's a doctor we all knew, very articulate, who spoke excellent English and helped us a great deal. He died with his wife and five children. We're all just

devastated by it'".[58]

The demarcation of "the young" or those "who do not deserve to die" is one way of breaking an all-absorbing category – "illegals" – into more differentiated parts: a major step in the overcoming of prejudice and in the undoing of a black-and-white frame. A further demarcation appeared in the first UNHCR reports: "UNHCR's preliminary findings indicate that asylum seekers and even refugees recognised by UNHCR were among passengers of the ship".[59]

Distinctions of that kind appear more fully in comments by Raymond Hall from the offices of the High Commissioner for Refugees in Jakarta, in the course of an interview with Ginny Stein (a journalist within Indonesia):

"Well on the boat of course, is a mixed bunch of people. It includes people who have been rejected, rightly rejected for refugee status. It includes people who've never applied for refugee status. So it's a mixed group of people, some of whom are possibly recognised refugees, some of whom had their cases been concluded, would have been recognised, and people who would have been, and had been rejected. So it's a very mixed group and I think you'd have to break that group down".[60]

The group of people "who are recognized as refugees", however, is especially underlined. This group might have grounds for waiting in Indonesia rather than taking desperate measures. As "genuine refugees", the people in the also can make some special call on international responsibilities.

Especially prominent in Australia was still a third differentiation. Within the group were people who already had ties that linked them to Australia. The individual who exemplified this plight for the Australian public was the mother who had set sail with her three daughters – 8, 6, and 5 – and lost all three. She hoped to join her husband in Sydney. He had been granted a temporary visa in Australia but that gave him no certainty of being able to stay in Australia and no rights to family reunion. For her, the alternatives of being accepted to go elsewhere or of possibly staying in Indo-

nesia under the protection of IOM were not attractive alternatives. For the first time, the nature of restrictions even after being allowed to enter became clearly visible to the Australian public.

Why did they take the risk? The survivor's reports and those of IOM make it clear that the risk was known. The boats were not always sea-worthy. Other boats had been known to founder but not with this extent of loss.[61] Some of the survivors themselves had been on boats that had been unable to proceed, and counsellors with the IOM had explained the risks.[62]

Against that knowledge of risks were two circumstances that the first reports underlined. One of these was *armed force at the time of embarkation*. The heading for Ginny Stein's report on October 24 reads: "Shipwreck survivors claim they were boarded at gunpoint". They realized the boat was low in the water and "overcrowded and some did not want to get on board but they were forced at gunpoint to do so".[63] The armed enforcers included "the people smugglers" and a group described as "about 30 police". The survivors' reports, and comments from Raymond Hall, were to the effect that this aspect of "no choice" was not unique to SIEV X.

The other underlined circumstance was *the sense of "no choice" in terms of possible futures*. Clear in the reports by survivors and UN observers is the awareness of risk. Some had gone on other boats attempting to make the journey to Australia, but their vessels had sunk.[64] They knew about Australian policy, that Nauru might be where they were sent. An ABC interviewer, speaking to Ginny Stein, pushes the point:

"COLVIN: So it's not a question of ignorance? These are people who've either read or seen on television or heard on the radio some of the message that the Australian Government's been trying to put across?"

Stein replies that "they know very well But they say their lives are so desperate, they have no future, that they cannot go back". Stein then moves to part of an interview with a survivor:

"SURVIVOR: I want to live in Australia and Australia's the place I want to go. Yes. I don't have a place. I left Afghanistan because my life was in danger. I cannot

go back. Even the Taliban has said I cannot go back and this is the only way I can go.

STEIN: So many people have died. People you know. Would you still be prepared to make that journey today?

SURVIVOR: Yeah. I sat by myself with my eyes while the boat sank in the ocean. Here no one is helping us. United Nations Organisation should help people. Needy people. But they are doing nothing, just giving two times food. That's not a life. Everyone wants education, life and work. They cannot give us".[65]

The UNCHR itself recognised the limits of what they could offer or arrange. Its members felt a particular responsibility to those already recognized as refugees. At the time of the SIEV X, however, there were 450 such people in Indonesia. Of those "we've had a total of 31 who've been able to get to the departure stage this year. So 31 have left, out of 450".[66]

Is anyone going to do something? That question appeared with regard to the 44 who survived, the 400 "recognized refugees" who were waiting to be accepted somewhere, and the large number – possibly 5 000 – of "irregular immigrants" temporarily in Indonesia and hoping to move. The media's immediate concern was with the survivors:

"COLVIN: And in the absolutely short term, what will happen to these people now? Will they be taken in by the UNHCR, the International Organisation for Migration? Is anybody going to do anything about them or do they just stay in this hotel until they can

51 ibid

52 *Sydney Morning Herald*, 23/10/01

53 Survivor's comment to Don Greenlees, *The Australian*, 23/10/01

54 Greenlees, ibid

55 ibid

56 *AAP*, 23/10/01

57 Survivor account to Ginny Stein, *ABC PM*, 23/10/01

58 *CBS*, 22/10/01

59 UNCHR Briefing Notes, 23/10/01, Op.cit.

60 *ABC PM*, 24/10/01

61 *Sydney Morning Herald*, 23/10/01

62 Reported on *CBS*, 22/10/01, Op.cit.

63 *ABC PM*, 24/10/01

64 Ginny Stein, *ABC PM*, 23/10/01

65 ibid

66 Raymond Hall in an interview with Ginny Stein, *ABC PM*, 24/10/01.

find another boat to bring them towards Australia?

STEIN: The various representatives are saying quite simply we're here to offer emergency assistance. We will give food and clothing. We will give counselling" (the IOM also flew in a medical team). "But they're saying nothing else at this stage. With the group that went back, there are you know, there were scores of other people who have been waiting many, many months. Some people say up to two years that are in the same position. So it's not just this group of survivors that is the case at hand".[67]

For the smaller group, their immediate state – their physical injuries, their trauma – was the person-oriented representation that dominated the news. The larger problems were, however, recognised by those living with them for longer periods of time. The UNCHR, for example, saw the problem in terms of the need for international cooperation. Unless countries agree to take refugees, for instance, meeting the criteria to be a "recognized refugee" can be a very slow step forward. In Raymond Hall's terms:

"We really do need a better international effort to address this problem. And maybe if one good thing comes out of this terrible tragedy, it will be to mobilise governments in that respect and really to highlight the need to address this problem".[68]

That larger need, however, seemed swamped in the press reports, and government statements, by a much more immediate focus on the question: Who is responsible for this?

Who is responsible for this? One of the striking features to the representation of any disaster is the attribution of responsibility. There are times when that attribution is linked to an equal concern with taking steps toward solving a problem or reducing the likelihood of further disasters. There are times also when that attribution is linked with the more specific goal of deterrence: this person, or people like this person, will – if the first is punished – be less likely to commit this act again. There are times as well when the main concern seems to be with a more immediate expression of anger on the one hand and denial ("not me") on the other.

A focus on anger is present in a question from Mark Colvin to Ginny Stein after reports began to emerge of people having been forced at gunpoint to board SIEV X.

"Colvin: Ginny, a lot of people who hear this story are going to be very, very, angry, particularly about the conduct of the Indonesian police. To whom, should the anger be directed?"[69]

Among the survivors, and those waiting still in Indonesia, there was no indication of doubt about the blame lying at Australia's door. Australia's policies were the problem. Their anger was then directed toward the Australian government, and that anger made news. The father of the "three little girls" who drowned (the mother and the children were hoping to reach the father, at the time on a temporary visa in Australia) "blamed the Australian government":

"I heard that Australia was very compassionate toward dolphins but what about human beings? Is this what you do to them? …. I hope Mr. Ruddock can take some satisfaction from viewing the floating corpses of my children".[70]

The same kind of position was taken by Australia's Refugee Action Collective:

"The Refugee Action Collective today said Australia's hardline approach was to blame for the deaths because it forced asylum seekers to take desperate measures. 'They are forced to use leaking boats, dangerous methods and use unreliable, criminal organisations to escape persecution,' said spokesman Simon O'Neill".[71]

Even Philip Ruddock's offer of an additional 40 refugee places did not dispel anger. In a further report from Ginny Stein:

"Colvin: How are these survivors responding to Philip Ruddock's offer today to offer 40 extra places for the recognised refugees?

STEIN: In some respects they saw it as a good move, some people did. They said that, you know, maybe

this is the beginning of a shift in the stance by the Australian Government in their attitude towards asylum seekers, that perhaps they are now being seen as human beings, and the Government may be responding in that way as a result of this disaster. But at the same time, there was a very angry response, as this religious leader showed when he asked for a right to be able to tell people in Australia what he thought.

RELIGIOUS LEADER: (Translation) Does this mean we have to shut up our mouth about 375 victims, just for the sake of only 40 people?"[72]

Responsibility, however, was never part of the representations offered by the Australian government. The loss of life was acknowledged as a "terrible tragedy" but the major theme was the need to sustain strict control over one's borders and the lack of connection between the policy of "control" and the SIEV X loss. The blame lay with Indonesia:

"Now I am saddened by the loss of life, it is a huge human tragedy We had nothing to do with it, it sank, I repeat, sank in Indonesian waters, not in Australian waters".[73]

A statement from Defence Minister Reith was equally blunt:

"Reith said he had no official information from the Australian Defence Force 'because we've not been involved'. He told Channel Seven the government's tough tactics with asylum seekers could not be blamed for the tragedy. 'Our tougher tactics don't go to the safety of vessels in any way. As to the safety of vessels, that really is a matter for Indonesian port authorities and safety authorities We are tough when it comes to saying that people are not coming to the Australian mainland but we've been very compassionate in dealing with any boats that have come into our jurisdiction in terms of ensuring that they were seaworthy, that people have medical attention Look, we have bent over backwards to do the right thing by people but we are not in favour of people jumping the queue' ".[74]

Both statements derived much of their colour from their being also an attack on a comment by Labor's leader – Kim Beazley. Beazley had issued a very short comment – accurate but inept: "If that has occurred it's a major human tragedy. It is a very sad thing indeed." He also remarked that what it "points to is the failure of policy" and the lack of the "agreement we need with Indonesia in order to be able to ensure that those who put themselves in such danger are not encouraged to do so".[75] Howard promptly labelled the reference to "a failure of policy" as "a slur" on both himself and the government.[76]

Beazley's restrained comments were less person-oriented than those of Neville Wran (a previous Premier of New South Wales), speaking at a Labor support meeting. Wran cut straight to the images that had concretised the loss in many newspaper reports and for the public: "three little girls", "sisters in their best dresses, smiling for a family photograph".[77] They had not seen their father in 2 years and the photograph was for him. In Wran's words:

"When I saw those three little girls, something told me Mr. Ruddock was wrong. We're not dealing with a problem here, we're dealing with people".[78]

Howard's response was to deny any responsibility and to attack both Beazley and Wran: Wran as "playing politics" and both men as "besmirching" the reputation of the government and himself. His comments to a sceptical interviewer (Liam Bartlett, *Radio 6WF*) provide an example of a much-repeated representation:

"HOWARD: That boat sank in Indonesian waters, it sank in Indonesian waters. It had nothing to do with

67 Mark Colvin to Ginny Stein *ABC PM*, 23/10/01
68 Interview with Ginny Stein, *ABC PM*, 24/10/01
69 *ABC PM*, 24/10/01
70 Interviewed by Don Greenlees and Vanessa Walker, *The Australian*, 25/10/01
71 *Sydney Morning Herald*, 23/10/01
72 *ABC PM*, 24/10/01
73 Howard on *Radio 6PR*, cited by Marr and Wilkinson (2004) Op.cit.: 316
74 *AAP* report, 23/01/01
75 ibid
76 Marr and Wilkinson (2004) Op.cit.: 316
77 Don Greenlees, *The Australian*, 25/10/01
78 Neville Wran at the Labor Party Fundraiser, Sydney, 25/10/01 cited by Marr and Wilkinson (2004) Op.cit.: 319

the actions of the Australian Government and he sought quite contemptibly to link that with the policy of the Government …. I am not going to stand by silent and allow people to besmirch the good name of this Government. I don't care what the circumstances are. I'm not going to have the good name of this Government besmirched ….

BARTLETT: He said it pointed to a failure of policy.

PRIME MINISTER: Well who's in power though.

BARTLETT: Are you twisting his words?

PRIME MINISTER: No I'm not. I mean what does a failure of policy mean if it doesn't mean that in some way we are responsible for this tragedy ….

BARTLETT: Can I ask you that question again – do you honestly think Kim Beazley blames you for the deaths of 370 people?

PRIME MINISTER: I honestly believe that is what he was inferring yesterday.

BARTLETT: Do you honestly think that?

PRIME MINISTER: I do believe that. Well what else can it mean? Can I read you the words again? 'But it's a major human tragedy if that has occurred and that is a very sad thing indeed. What it points to is the failure of policy'. In other words he was directly linking the two. The policy he's talking about is the policy of the Government. We're the Government. That's the only possible policy that he was referring to and that is the impression that he wanted to create …. Mr. Beazley endeavoured to besmirch the name of the Government, he endeavoured to leave an impression in the minds of the Australian public that in some way the Government was to blame for this tragedy. Now that was contemptible and ….

BARTLETT: You've made it clear so let's move on."

Where is the Power of Dissent?

Two incidents have been outlined. One – the "Children Overboard Affair" – cast major doubts on the credibility of government accounts and on the likelihood that any checks and balances to those accounts would stem from a public service that appeared to be increasingly cowed or politicized. The Prime Minister's own credibility survived only by his being able to assert that he was not well informed. With every reason to do so, he argued, he had assumed the information given him was correct but it was not. What appeared at first to be a serious undercutting of the government's insistence on the need for control – the "beastly" nature of these would-be immigrants – seemed to be effectively written off as a "mistake", to be rectified by a future change in style – "unvarnished" reporting and a specification of the sources used as a base.

For the second incident – SIEV X – the immediate effect was one of a boost in the need for compassion. If this loss of life was the result of a hardline policy toward the control of one's borders, was the policy so worthwhile? Was the threat so great? The policy and the representation of a need for control, however, remained intact. The tragedy was undeniable. The policy, however, was "not the cause" and so did not need to be changed. Where change should occur was within Indonesia (or perhaps in the hearts and minds of those entry seekers who had still not understood Australia's "message").

Neither of those incidents seems to support a picture of initial or hegemony-seeking representations being effectively challenged. Contradictions to the accuracy of a representation seem to be bouncing off a protected surface. A major competitor to representations emphasizing the need for control – representations emphasizing the need for compassion – seems to be no match for "the hard line". Sympathy may be expressed, but – especially with the supporting stance of "not responsible" – "control" wins out, and the policies based on the representations of that need remain unchanged.

If the events covered were to end at this point, dissent would appear to have little power. Both incidents, however – like the *Tampa* narrative – turned out to have a long life. They continued to be the sources of inquiries. Both, for example, were part of a widely-read, prize-winning analysis of Howard's "Dark Victory", by David Marr and Marion Wilkinson. SIEV X became the basis for another book (Tony Kevin's "A Certain Maritime Incident"), a web-site that continued to be updated (Marg Hutton's website sievx.com), and a Senate inquiry.

All three incidents (*Tampa*, Children Overboard, SIEV X) contributed as well to a residue of dissent that, over time, did continue to work for change and to

achieve change. That dissent had two planks to it. One focused on questions of "law" and "truth". The primary aims were to pin down what really happened (to establish "the truth" and pin down who had misrepresented it or hidden it), and to clarify areas of grey (especially grey areas of law). The other focused on the need for compassion: on the innocence and deservingness of the many of the people involved, and on the necessity for some changes either in border or detention policies and in the way these were administered.

The forms that these lines of dissent took, and their impact, are the subject of the next two chapters.

CHAPTER 7

Dissent: Challenges Focused on Truth and Law

Aʟʟ ʀᴇᴘʀᴇsᴇɴᴛᴀᴛɪᴏɴs ɪɴᴠɪᴛᴇ dissent. The questions to be explored then are the forms it takes, its timing, its sources, and its effectiveness: aspects influenced by the initial framing and the actions taken in its name.

That general proposal applies to all representations. The Australian case presents again the opportunity to see how it works out in practice and in relation to the representations of refugees, and how it may be expanded.

In the Australian case, the government represented asylum-seekers and refugees as bringing a degree of threat that called for extreme measures: refusing a ship permission to land a group rescued at sea, redrawing its borders, enacting legislation that increased its "sovereign right" to turn back boats suspected of carrying irregular immigrants, directing the Navy to intercept and turn back such vessels, transferring to other countries those who could not be turned back to their source, placing all detainees (within the country or after "outsourcing") in mandatory and potentially indefinite detention and, for those recognised as "genuine refugees", moving only slowly toward any status other than temporary residence.

What happens over time to such representations? This chapter, and the one that follows, take up the continued occurrence of challenges and their impact (or relative lack of impact). Those challenges take further the narratives begun in the previous chapters. They also add to our understanding of how dissent is presented and deflected, how an initial representation is sustained, when challenges are effective, and the points of change that are most and least likely to occur.

The division of chapters is partly one of time. Most of the events covered in Chapter 7 occurred in 2002-2003. Most of those covered in Chapter 8 occurred in 2004-2006. More importantly, the division is in terms of two kinds of challenge. Chapter 7 takes up challenges focused on issues of "truth" and "law". Chapter 8 takes up challenges focused on "compassion" and "accountability". That division is not hard and fast. The events that evoked in many a sense of shame and a sense of compassion as the proper course, for example (Chapter 8), involved both a concern with distress and hardship on the part of individuals and a concern with whether government officials had failed to meet their "duty of care" and were in this sense legally culpable.

Nonetheless, the general division holds between an emphasis, in Chapter 7, on the government's claims to an officially correct moral ground (we acted legally and we told the truth) and, in Chapter 8, on the need to move to a moral ground marked more by some "quality of mercy" and by signs of "heart" or "compassion".

This chapter is itself in two parts. In the first, the challenges revolve around issues of "truth". What happens when an account turns out to be a "misrepresentation"? At what point can these contradictions be called "lies" as against "errors" or "mistakes"? How can

they be defended? When do they matter?

In the second part, the challenges revolve around issues of law and of international agreements. Some of the actions involved raise questions about "truth", in the sense that an action may be presented as "within the law" when the reality is far more vague. Of particular interest, however, are areas of ambiguity (together with the ways in which people move to clarify these or keep them ambiguous), and moves directed toward having the very definitions of what is legal kept away from the courts and reserved to the government itself.

Each of the two parts begins by asking about the general significance of challenges involving questions of truth or law. Our double concern is again one of using proposals from general analyses of representations to make a particular series of events more understandable, and of using those events as an anchoring base that allows us to see how those proposals work out in practice and to extend them. Each part then proceeds to examine the forms that challenges took and the counter-moves they met in the series of events for which the *Tampa* was taken as the start.

Dissent Focused on "Lies", "Errors", "Mistakes", or "Omissions"

The events that began with the *Tampa* brought up several occasions when questions arose about the "truthfulness" of the accounts offered by the government. The *Tampa* incident itself, for example, brought up questions about the validity of accounts that denied the presence of medical distress on board the ship. Questions about "truth" were even more prominent in the "Children Overboard Affair", and in the SIEV X narrative. Both of these incidents prompted questions – media questions and questions at an official inquiry – as to who knew the truth, who withheld it, and who distorted it.

In principle, the theoretical argument runs, any primary definition is likely to encounter "contradictions". As they accumulate, the primary definition may be weakened. It may also need to be altered to accommodate or diminish the force of "contradictions" (Chapter 2).

"Contradictions", however, are likely to vary. Some may bounce off the "Teflon surface" of a primary definition. Others may cripple it. We need to start then with some consideration of how contradictions may vary: vary in their original shape, in the counter-moves they attract, and in the extent to which they are seen as making a minor or a serious dent in an original representation.

The General Significance of "Lies", "Errors", "Mistakes", "Omissions"

To be noted first is the presence of an interesting set of categories, each with implications.

A "misleading" statement, for example, may stem from a "deliberate lie" or from "being poorly informed", with the latter possibly resulting from "information withheld" by others, my sources being inadequate or not recognizing the need to pass on information, or my communicating to others "don't tell me".

Evidence of a "deliberate lie" or a "deliberate shading of the truth" can have serious consequences. It may incur reprimands or the loss of a position. A leader, for example, may be judged "not fit to govern" by virtue of the poor character he or she has demonstrated, face a role of "no confidence", or be expected to resign. Less drastically, what may be called for is the retraction of an earlier statement or the amendment of a policy.

Being "poorly informed" is a smaller charge and a better defence. "The account given to me was in error"/"I didn't know"/"Nobody told me": that certainly was Howard's constant response as parts of the "children overboard" frame fell apart. It is not always an ideal response. It may imply, for example, that the people who should pass on information were misleading their seniors in order to suit their own agenda, were careless or ill-informed, were simply too busy to pass on the information they had, or mis-judged its significance. Poor subordinates, however, are a reflection on one's own competence. If attacked, they may also say more than one wishes them to say. The Opposition may seek to demonstrate "fault" of some kind or incompetence on the part of the subordinates one has fired. The safer defence is to say that one is actually well-served. It is instead "the pressure of the job" or "the demands of other matters" that give rise to misjudgment. Peter Reith, for example, was the Minister who emerged in 2002 as the one most directly informed that the original

statements about "children overboard" were wrong. He was, however, consistently praised by Howard as "honourable".[1] Some things simply did not come up because conversations between Reith and himself "moved on to other matters".

Where then do "mistakes" lie? Here again there are distinctions or sub-categories, each with implications. Mistakes may come about because of some "dereliction of duty" or a limited definition of one's duty. Was the failure to search for a boat known to be "overdue" (SIEV X), for example, a "dereliction of duty", or a limited definition of duty: duty seen as an obligation to search only under certain circumstances, to cope with tragedy but not to seek to avoid its occurring?

"Mistakes" can also come about because the people who implement one's policies are not up to the job. They may be overworked, poorly trained, or poorly supervised. The 2005 Palmer Inquiry into detention centres, for example (Chapter 8), found that all 3 such circumstances applied to the "mistakes" of detaining two Australian citizens and deporting one of these. Under those circumstances, heads may be expected to roll. More seriously, the policy being implemented may need to be changed or – the harsher judgement – found to be "unworkable" and best discarded. A policy with a high likelihood of "mistakes", it can be argued, should never have been attempted in the first place.

To say "I've never been given any such information"/"I didn't know", however, is certainly not the only defence that can be offered when evidence of "lies" or "mistakes" is brought forward. Potentially available also is an attack on those seeking or providing the evidence. The Senate Inquiry, as we are about to see, brought out many statements of that kind. This Labor-dominated inquiry, Howard claimed, was "a political stunt", a joke, the sad expression of complaint after "losing a fair and square election". In effect, nothing it came up with should be taken seriously.

With those general points in hand, let us turn to some specific challenges and counter-moves, as they occurred in practice.

Media Analyses of "Truth Overboard"

In the wake of the election, several media sources turned to asking why the clear indications of false statements about "children overboard" had not turned voters strongly against Howard. They asked also about the implications of that success – and the ways in which it was achieved – for the future of Australian society. They were concerned especially with the extent to which a government could frighten or over-ride the balances expected to keep it back from excess: namely, a free press with reasonable access to sources, and an independent public service.

Those analyses help make clear the ways in which "lies" and "errors" are perceived, and the ways which a government's framing of events and its acceptability to the general public can emerge relatively unscathed from contradictions to its original narrative.

One aspect to the mis-representation soon emerged as being beyond doubt. Over December 2001 and January 2002, the photographs and video footage presented as evidence of "children thrown overboard" were recognized as, at best, inconclusive and – more of a contradiction – as evidence of something quite different. In one description:

> "It all seemed so simple then. We now know that the government perpetrated outstanding lies to prop up its position. The government's portrayal of asylum seekers as the sort of people who would throw their children to the sharks turned out to be, in fact, photographs of sailors from the HMAS *Adelaide* rescuing children from a sinking boat. The sailors were robbed by their own government of the right to be hailed as heroes".[2]

What amazed some journalists, however, was that the government's stories had been believed in the first place. Richard Ackland, for example, saw one reason as lying in the gullibility of listeners:

> "As is now all too painfully obvious, most of the citizens swallowed this emotive beat-up, as did a fair hunk of the media. It just confirms the adage that we get the governments we deserve".[3]

Another journalist – Laurie Oakes – took a darker view. For him:

"Howard's false claim that asylum seekers ... tossed their children into the sea ... is a significant matter and will not be forgotten for a long time It must be clear to even the most one eyed Howard backer – and to Howard himself – that a change of leader before the next poll is imperative".[4]

A third journalist – Catherine Lumby – took the more incisive step of asking what lies the voting public was likely to feel strongly about:

"(I)n politics there are lies and there are lies. The lies that interest the public are not always the lies that have the greatest impact on public interest If a politician is caught using a government car to transport a friend (or a dog, as recently happened in NSW) the talkback lines run hot for days Perhaps the reason we set the bar so high on these smaller matters is that we can all relate to the temptation to pocket the office stationary or fiddle our tax returns. Catching politicians with their fingers in the public purse is, for many of us, our one opportunity to play boss and occupy some moral high ground. The big public interest issues are just too abstract to get excited about".[5]

What matters also, Lumby argues, is the extent to which the original presenters can "obfuscate" an issue:

"The children overboard saga is a classic example. Astute journalists picked up the whiff of something rotten about the claim right away. But, like sewage seeping out of an underground pipe, the truth took its time to come to the surface. Now John Howard and Philip Ruddock have moved into the obfuscating phase Anyone who has bothered to read the details of the government's own report into the children overboard affair will be left in little doubt that the public weren't told the truth. And common sense dictates that senior government members should have known the truth well before the election. But they're now betting that if they can just keep blowing smoke and striking defiant poses long enough, the issue will go away. Politicians know that the public is far more likely to get incensed if their elected representatives fudge travel expenses".[6]

A longer-term concern: The "muzzling" of sources. The fewer the sources of information, and the greater the power of the source, the easier it is for one framing of events to be sustained and for mis-statements to stand uncorrected. One way to achieve that position is to allow the media no physical access to various sources. Media representatives were not allowed on the *Tampa*, for example. They were also kept at a distance from the disembarkation point at Nauru. Less obviously, people can be told not to speak to the media. Doing so may also incur penalties for those who do it or, in some proposals, for those they speak to.

These less physical restrictions on sources came to be of increasing concern to many in the media. Part of that concern began with the extent to which the public service had gone along with the government's misleading statements. Howard's main defence at this point was that "he wasn't told":

"Howard is furious over all the newspaper headlines calling him a liar. 'People are playing fast and loose with my reputation' he complains. He and his Ministers were not lying, he argues, because they were never informed that what they told voters was false. But really, the answer to the 'what did they know?' question is pretty obvious. Howard and co. knew enough to know they did not want to know. And that would have been clear to key bureaucrats. If Ministers *were* kept in the dark, treated like mushrooms, it is because that is the way they wanted it. Knowing the truth would have created too many political difficulties in an election campaign".[7]

1 Howard in interview with Paul Murray cited by Marr, D. and Wilkinson, M. (2004) *Dark Victory.* Sydney: Allen & Unwin: 381
2 Tony Wright, *The Bulletin*, 26/02/02
3 Richard Ackland, *Sydney Morning Herald*, 22/02/02
4 Laurie Oakes, *The Bulletin*, 26/02/02
5 Catherine Lumby, *The Bulletin*, 26/02/02
6 ibid
7 Laurie Oakes, *The Bulletin*, 26/02/02

An even more lasting concern, Ackland argued, was the extent to which the government could control the sources from which some independent account might emerge (and that the media might normally hope to access). Here was a direct threat to the media and its access routes:

"As this scabby little lie gradually gets unpicked we can glimpse how chunks of the Public Service were simply cowed or, worse, gleefully did the Government's bidding. The navy was threatened by the Government to not reveal any details of the offshore operations involving boat people. The people at the euphemistically named Australasian Correctional Management are under strict orders to say nothing about what goes on inside the detention centres. A reporter from the *ABC* has already been charged for failing to retreat more than one kilometre from the Woomera detention centre. And the Public Service is not allowed to utter a squeak about the awful porkies being peddled by pollies".[8]

That situation, as Ackland and a Herald editorial pointed out, could become worse if a new Bill put forward by the Howard government was passed. That Bill – an amendment to legislation already in place with regard to "Espionage and Related Offences" – would make it an offence to communicate or receive "official information" unless its release was "authorised". In effect, "all official information would effectively be treated as if it was an official secret". The Bill, if passed, "could be used not only to catch spies but also against whistleblowers who expose government blunders or trickery, and against journalists and politicians who publish such unauthorised information in the public interest …. It … would have a truly chilling effect on democratic debate".[9]

Now dissent came from more than individual analysts. Representatives of the media met with the Attorney-General's Department. The Press Council wrote to express its view that the scope of the Bill needed to be limited to "matters of national security and defence". More allowance also needed to be made for actions undertaken in the public interest where "the greater good may be served by the release of information, say, malfeasance, illegality

or impropriety." The danger lay in clauses that would "criminalise … both whistleblowers and those who receive information from whistleblowers". This dissent was successful. Several clauses were then redrafted.[10]

Similar concerns arose again, however, in a later amendment to legislation related to terrorism. The concern again was with the breadth of the amendment. It would, for example, provide a lengthy jail return for refusing to name a source. Journalists would "be detained on the mere suspicion that they hold information that may relate to terrorist activity and … may be held incommunicado and questioned, without legal representation, for 48 hours".[11] Journalists would also have to prove that they did not have any requested record. The media again objected. The Bill was debated in Parliament in December 2002 and again in May 2003. It was passed in an amended form in June 2003; a form regarded by the Press Council as improved but still placing restrictions on "journalists in their role as gatherers, holders, and providers of information".[12]

The overall impact of both Bills, it is clear, would be to make government actions more opaque than ever, and informed criticism of any action or any account all the less likely to arise. Small wonder then that on this score the press dissented in more concerted fashion.

A Second Source of Dissent: The Senate Inquiry

The media were not alone in questioning the truth of government accounts of "children thrown overboard". The Senate (where up to 2005 the Coalition did not have a majority) also took an active part, initiating an official inquiry.

Far from being dull, this inquiry was extremely "newsworthy". Its drama lay in the people who now came forward (the Navy now emerged as possessing at least one "frank and fearless" character), the aggressive questioning from some Senators, and the air – especially in the slices of interviews that appeared regularly on television and the press – of a courtroom trial that had to end with someone being found guilty. Here was "a compelling political thriller".[13] This time, some amendment to the original framing and to the credibility of any future government representation seemed inevitable.

The committee's initial brief was to address the "children overboard" episode. That brief guided its title: "A Certain Maritime Incident" (CMI). The government itself, however, broadened that brief to cover 12 SIEV interceptions during the period September – October 2001, and then broadened it further to cover all "operational procedures observed by the RAN and by relevant Commonwealth agencies to ensure the safety of asylum seekers on vessels entering, or attempting to enter, Australian waters". That broadening, as Labor Senator Faulkner observed in the October conclusions, meant that the CMI could consider as well government actions taken within Indonesia (not only at sea).[14]

The dissenting power of any committee lies partly in its inclusion of more than one voice. It lay partly also in its membership. This came from Labor, the Democrats, and the government's Coalition Party. The Coalition members, however, were a minority. Power lies also in its brief. This committee could request information previously classed as "secret" (it was often still censored) and ask for witnesses to appear. No one, however, could be forced to appear.

An early part of the drama then lay in who would or would not appear. Several people declined requests to do so. Among those were Reith and his advisor Scrafton (Scrafton would emerge in 2004 to state that he had himself directly told the Prime Minister that the videotape of the "children overboard" was inconclusive). Those who did appear were often evasive. Their evasiveness made especially significant the appearance of two Navy officers: Air Marshal Angus Houston and Brigadier Gary Bornholt (the military's representative on the Defence public relations team). Bornholt – troubled from the start about the interpretations of the "overboard" photographs – had been present when Houston spoke directly to Reith (November 7) and told him the "thrown overboard" narrative was in error. In contrast, Admiral Barrie's testimony started with a "may have been thrown" and was then amended in a second statement to "there being no evidence" a sad contrast to the position of Houston and Bornholt:

"The Air Marshal blew Admiral Barrie, Peter Reith and both internal investigations" (these had been within government departments and Houston had not been called) "out of the water. Houston would not be budged. He said, 'I stand completely behind my testimony. My job is to offer frank and fearless advice to government'".[15]

A hero had finally emerged from the shambles. So also had a pin-pointable villain, Peter Reith. Howard, however, could still claim that he was "never told", and he continued to do so. On the occasions when Reith might have told him, "the conversation just moved on".[16]

Far less clear were events related to SIEV X. The areas of ambiguity here were several. They are noteworthy because they suggested some other contradictions, some further possible dramas that could have made "news", but did not. They point also to the ways in which some weaknesses in a frame may be saved from attack. Some areas of ambiguity may not be possible to clarify. Others may be left undisturbed because of possible backlash.

Where the boat had sunk. Howard offered one statement (Indonesian waters). Ruddock offered another (off West Java). Indonesia offered a third (near Christmas Island). The position affects the attribution of responsibility. The ambiguity, however, persisted throughout the inquiry and was still being discussed at the end of 2003.[17] The Senate committee could not resolve these differences, and the exact position remained undetermined.

How official Australian information could be so precise. From an early date, Australian officials in Indonesia could supply the media with details on the port from which the boat had left, the number of people on board, the dimensions of the boat and the date when it left. How did these officials come to have such detailed and immediately available information? How close a watch did they keep on boat departures and conditions? What made this aspect of surveillance possible? This area of

8 Ackland, *The Sydney Morning Herald*, 22/02/02
9 *Sydney Morning Herald*, Editorial, 06/02/02
10 Australian Press Council: *2001-2002 Report on Free Speech Issues*
11 ibid
12 Australian Press Council: *2002-2002 Report on Free Speech Issues*
13 Margo Kingston, *The Sydney Morning Herald*, 26/02/02
14 Kevin, T. (2004) *A Certain Maritime Incident: The Sinking of SIEV X*. Melbourne: Scribe: 120
15 Marr and Wilkinson (2004) Op.cit.: 383
16 ibid
17 Cf. Kevin (2004) Op.cit.: Chapter 7

ambiguity was not one the Senate inquiry wished to pursue with any vigour. It seemed willing to avoid any further probing into Australia's "smuggling disruption" activities in Indonesia: probing that could make "secret" involvements public, and leave Senators open to attack as unpatriotic or even subversive.

How Australian surveillance failed to sight the boat. The boat had left on October 18 and did not sink until October 19. Survivors were in the water for 19 hours before 2 fishing boats reached them. The Navy, however, reported no sighting of the boat. Given the investment in surveillance by sea and by air, how could this be possible? If they knew the boat was "overdue" in the waters they normally surveyed, why was no check carried out? The Senate inquiry concluded that the Defence Forces had not committed any "dereliction of duty" in its surveillance. Any funding of "dereliction" would certainly have been unsettling and unpopular.

From Senator Bartlett (Democrat and so not one of the two main parties), however, came the incisive comment:

"I believe that the SIEV X incident, like the 'children overboard' affair, is symptomatic of flaws inherent in the new border-protection regime policy, and that it exposes major failures in the implementation of that policy. Fundamental to the new border-protection regime is an underlying lack of respect for the value of human life and human rights the response of Australian officials to the SIEV X intelligence reveals the inherent bias ... towards 'detecting, deterring and denying' asylum seekers rather than reacting to warnings of the danger to people attempting the passage to Australia in unseaworthy vessels. It does not require 20-20 vision in hindsight to recognize that 400 passengers on a vessel belonging to a people smuggler, well known to Australian officials as using smaller than normal vessels, was a tragedy in the making".[18]

Senator Bartlett followed up that concern in October 2003 with a motion urging the immigration department to grant permanent visas to the survivors and to set up an independent inquiry.

In media reports of any next steps, however, following up those possibilities ran second to a more person-oriented interest in locating villains in Indonesia. These were the "people-smugglers". Locating them, and bringing them to trial, became the next "news": a story that continued through to 2005, when the Egyptian-born Abu Quassey — considered to be the main organizer for SIEV X and other boats — was convicted, in an Egyptian court, of people smuggling. Once again, news emerges as about persons, not issues.

Counter-Moves

In the face of these several contradictions to his initial framing, how could Howard respond? On "Children Overboard", he could continue to insist that he was never told directly that his initial account was in error. Reith did not contradict this position and, as noted earlier, a direct contradiction by Reith's advisor — Michael Scrafton — did not come until 2004.

On SIEV X, Howard could continue to claim that "the boat sank in Indonesian waters ... it's not our fault". An editorial in *The Australian* indicates a general acceptance of no direct fault: "But whatever the failings of the Australian government, it has not tricked desperate people into risking their lives on the high seas on desperate vessels of doubtful safety".[19]

In relation to all episodes, Howard was also careful to make good use of rewards rather than reprimands, lowering the likelihood of whistle-blowing. The Navy was always noted as doing a "fantastic" job in the face of great difficulties. No-one in his government, he said, would be made a "scapegoat". After a year's decent interval, Reith was in fact appointed, by Howard, to a top-salary post as a director of the European Bank of Reconstruction and Development, based in London, with the commendation that "I have always found Peter Reith an honest person I think he's well qualified". Reith, as Marr and Wilkinson note, "has never been a banker".[20] Max Moore-Wilton, who had coordinated many of the interception operations and had come to be known as Max the Axe for his approach to the public service, was appointed in December 2002 to be chief executive officer of Sydney Airport after its sale by the Commonwealth to private investors. He went with a commendation from Howard for his success in making the public service "responsive to the wishes and

the goals of the elected government".[21] Secrets are not likely to surface from such praised and well-rewarded sources.

The only direct claim that Howard himself was told came, in fact, from a public servant (an advisor to Reith) after he had left the public service. This was Mike Scrafton and the challenge did not emerge until 2004. It is an excellent example of how a contradiction can come "too late" and how it may be written off as irrelevant, of interest only to political opponents seeking ammunition.

Scrafton was unequivocal in his report that he had spoken directly to the Prime Minister:

"SCRAFTON: I'd been asked to go to the Maritime headquarters and have a look at the video. I did. I went ... I had spoken to Peter Reith earlier that afternoon, who had said he'd been speaking to the Prime Minister and the Prime Minister had said he wanted somebody they could trust to go and have a look at the video.

I did that The Prime Minister rang me that evening. I explained to him that the video was inconclusive, it certainly didn't provide any evidence supporting the claim that children were thrown over board He rang me back seeking some clarification. I spoke to him again, telling him that we didn't believe the event had actually happened and that the photos that had been relied on certainly were well known not to be of the event, but of the sinking afterwards.

He asked me specifically about the ONA report and how it was that he had this advice And I said that my understanding, from talking to people around the place, was that they were just simply picking up the Minister's comments and that he really should check with ONA as to the veracity of it.

McGRATH: So up until now, there's been no ability for the Opposition to prove that the Prime Minister was ever told that the incident didn't happen But you're confirming now that the Prime Minister was told by you the event didn't happen?

SCRAFTON: That's right

McGRATH: But from what you're indicating, the Government hasn't been honest about this.

SCRAFTON: They certainly weren't ... What the Prime Minister said in my view was certainly not qualified enough based on the information that he had".[22]

And the reasons for Scrafton's 2004 appearance? He was no longer in the public service. He was as well concerned with "correcting the record" and stung by the government's derogation of 43 public servants who, in a letter to the press, expressed their reservations about the validity of the government's representations for involvement in the war with Iraq:

"Almost every book that's come out has ... been inaccurate as to what my role in the office was. But I suppose the trigger was the disrespect with which the 43 signatories of the open letter were treated and how the issue was moved away from truth in government onto them personally. I think (that) triggered me to correct the record".[23]

The media gave Scrafton's emergence prominent attention and the Senate threatened a further inquiry. It was, however, now 2004. No one else came forward. It was also Scrafton's word against that of the Prime Minister, and many people already felt that of course Howard had lied. It had simply been politically useful to do so at the time. As for the Senate, Howard's position was that any inquiry was laughable. In a talkback radio interview with a constant and fervent supporter – John Laws – he reduced the possible further inquiry to a Gilbert-and-Sullivan type farce:

"PRIME MINISTER: They will find me guilty.

LAWS: Well why wouldn't you then allow your ministerial staff to appear before that inquiry? Wouldn't that be to your benefit?

Prime Minister: They will find me guilty no matter what happens, you know that John. I mean this is a political game, this is not a court of law, this is not a serious impartial inquiry where we carefully weigh

18 Cited by Kevin (2004) Op.cit.: 245-246
19 The Australian, 10/12/03
20 Marr and Wilkinson (2004) Op.cit.: 381
21 ibid: 382
22 The World Today, ABC, Reporter: Catherine McGrath, 16/08/04
23 ibid

the evidence and you know Chief Justice Faulkner comes to a very objective conclusion that the Prime Minister is guilty. I mean really, I mean what are we on about, I mean let's get a little bit of perspective about it. The Senate is being used by the anti-government parties to score political points against me. Now we have been over this before, but they will want to go over it again and they will want to play their political game …. We'll have grave deliberations and they'll objectively come to the conclusion that I'm guilty.

LAWS: As charged.

PRIME MINISTER: As charged, and you know slap him in irons".[24]

Ultimately, the matter lapsed. Howard's description as "Honest John" might be used with still more bite than before, but his leadership of the party was unchallenged. Voters seemed pre-occupied with matters of tax, bank interest, and war and there was still no effective challenge from the Opposition. Howard won the 2004 election. "Lies" clearly do not always matter, at least not to everyone and not to the exclusion of other interests. When, we need to ask, can dissent based on these grounds, be effective?

Issues of Legality

I start again with the general significance of legal issues.

General Significance

"Acting legally" is clearly a useful prop for any representation. Claims that actions are against the law, or against agreed-upon principles, are also potential challenges to any action and its justification. That double relevance gives a particular significance to areas of ambiguity: both their exploitation and efforts to clarify them. It gives a particular significance also to the presence of established conventions and agreements to observe some international principles, to claims that these have not been respected, and to the insistence – in response to criticism – that a country's "sovereign rights" over-ride all other considerations and that determining what is "legal" is a matter for governments rather than courts to decide.

Where the Australian government's actions stood in relation to law and agreements has been the topic of several analyses.[25] For my present purposes – bringing out forms of challenge and their impact – I single out two particular lines of challenge. One came from the Norwegian government, seeking agreements that would clarify the "rules of the sea" and modify a country's right to refuse the landing of those rescued at sea. The other came from international agencies, concerned with the violation of agreed-upon rights.

The Law of the Sea

This aspect of the law arose especially in response to Australia's actions in relation to the *Tampa* and its claims of the legal right to refuse entry and to transfer those rescued to some "second country". (I set aside the issue of its rights to board a ship or to return a ship to its source, without clear agreements on acceptability to the country of origin or careful attention to the waters in which the ship was found).

The Australian and the Norwegian governments clearly had different views of what was legal with regard to actions involving "rescue at sea". The Norwegian government was also concerned with future incidents: "What will happen if situations like those the *Tampa* experienced re-emerged?":

"The Captain has a requirement to help – but then what? The SOLAS-Convention is completely clear as far as the Captain's requirement to offer assistance to other ships in need. But SOLAS says little about what can happen after the shipwrecked have been picked up. It doesn't state clearly in either SOLAS or SAR that any country is required to let a ship that has saved people from shipwrecks, to be allowed to land those that are saved. The incident with the *Tampa* showed that the lack of clear international regulations can create uncertainty. It would of course cause totally unacceptable consequences for a trade ship to have to sail around with saved people over a long period of time".[26]

That kind of threat, the Norwegian Maritime Directorate pointed out, could also lead to "individual captains – perhaps under pressure from others – choosing to 'look

the other way' if another ship is in distress."

The Norwegian authorities sought, in conjunction with the International Maritime Organisation, a series of meetings among interested parties with the gaol of working out new regulations that would clarify what should happen. They drew a clear distinction between the need to rescue and the steps to be taken after that. What they sought was a clear agreement on what the Captain could not be expected to do:

"The Captain should not be required to try to find out the 'status' of the person who has been saved: e.g., if they are refugees/asylum seekers; what nationality they have; which country the boat in distress sailed from etc".[27]

Sought also was a clear agreement on what should happen in cases where "no country gives permission to accept the people who are saved". In that event:

"The Captain must be given the right to decide to take these people either to the closest coastal state, or … to the closest port if the ship continues its planned route, or to a proximal coastal state along the planned sailing route if the conditions on board makes this necessary. In the attempt to get acceptance from the majority of countries, we have in addition suggested that the country that the Captain has chosen as the 'receiving country' in a particular case, must not necessarily let the shipwrecked come directly on land but can alternatively make an appropriate secure ship available and secure that the saved can be transferred to it".[28]

Norway encountered no difficulty when it came to agreeing that the meetings should be held and the issues discussed. Its general principles were also agreed to. The specific requirements proposed, however, were opposed, with Australia and the USA offering the main objections. The proposal supported took a vaguer form:

"Contracting governments shall coordinate and cooperate to ensure that masters of ships providing assistance by embarking on board persons in distress at sea are released from obligations with minimum further deviation from the ship's intended passage".[29]

Norway continued to urge that further regulations were needed. "After difficult discussions", however, it accepted a "compromise solution which was not based on the Norwegian text but which incorporated the principles that Norway suggested. This solution was supported by a number of central countries, amongst them USA, Australia and Norway. The suggested solution will be formally approved by the IMO in May 2004".[30]

International Agreements and the "Right to Decide"

Underlying discussions about where a rescued group might be taken or should be taken is a still larger issue. Within the events chosen as an anchoring base, this issue surfaces particularly in the Australian government's "mantra" during the election period took the form: "We decide who comes to this country and under what circumstances". The government was determined that those decisions could not be made by a ship's captain, regardless of circumstances and regardless of traditional laws of the sea or of any particular country's legal definition of a captain's areas of responsibility.

At the same time, a country's rights to decide can never be unlimited, especially if it wishes to see itself – and to be seen – as part of some "family of nations" and has signed agreements that lay out the principles that the signatories should follow. The options than may be of two kinds:

- To abide by the letter of the law or of any agreements it has signed
- To demonstrate or claim "good faith" in relation to those agreements, even where there are some areas of legal ambiguity

24 Interview with John Laws, *Radio 2UE*, 18/08/04

25 One useful source is Mathew, P. (2003) "Legal Issues Concerning Interception". In the *Georgetown Immigration Law Journal*, 17 Geo Immigr L J: 221 – 249

26 Scheel, T. (2003) "Internasjonalt Etterspill etter *Tampa-saken*: Hvem har Ansvar for de Skipsbrudne?" In *Navigare*, 2-200310. Oslo: The Norwegian Maritime Directorate.

27 ibid

28 ibid

29 Marr and Wilkinson (2004) Op.cit.: 387

30 From the Norwegian Maritime Directorate's 2003 *Annual Report*

The ideal justification for one's actions is to meet both expectations. The lesser ideal is to argue that the first has been met. One may then meet criticisms from bodies such as the UNCHR, but one can still claim that one has acted legally. Some amendments to existing law may be made to add support to one's case (e.g., a new Border Protection Bill) but, as log as there has been no clear breach, the claim of acting "legally" and "properly" can still be made and, if necessary, defended in court.

The general public can also be counted on to be uninterested in fine legal detail. They can be expected to be interested in clear violations of a law, and to be unhappy with government officials or elected representatives who show little or no respect for the law or "the truth". The size and the nature of a violation, however, and the evidence for it, need to be readily understandable.

For public consumption then, it is useful to find areas where there is some ambiguity of interpretation and where a claim of having met international expectations can be made, in terms that the general public would readily understand. One such area is the agreement in principle to "burden share" in relation to refugees. Howard, for example, assured the country several times that Australia took "more than its share". Other countries might disagree, but the image of some "burden sharing" could be claimed.

Easily defended also was the obligation not to have refugees forever "in orbit". They should go somewhere, and that they did. Moreover, Australia accepted the costs of them going there and being kept there while their status as refugees was considered. Where they went was simply not to Australia.

Less readily understood, yet at the core of debates over obligations, were several other areas. Setting aside for the moment the special place of children, these had to do with:

The nature of ultimate responsibility. Once categorised as a refugee or not, where were people to go?

Appropriate lengths of time. Was indefinite detention in keeping with human rights? Was it in keeping, for example, with the concept of "effective protection"?

The concept of a "safe third country". If people could be transferred from one place to another, but only to "a safe third country", how would this be defined?

The principle of non-refoulement. This is a principle that came up in the Senate inquiry. It is not, however, a familiar term and needs to be defined:

> "No Contracting State shall expel or return ('refouler') a refugee in any manner whatsoever to the frontiers of territories where his life or freedom would be threatened on account of his race, religion, nationality, membership of a social group or political opinion".[31]

"Chain refoulement" is also to be avoided: that is, sending refugees to a country which has not signed the Convention and sees it as feasible to send the refugees on without regard for the risk to them. Indonesia is not a signatory to the Convention.

The extent to which obligations apply only to refugees who have entered one's territory or at the border. If people never actually set foot on your soil – if they are turned away at the border or at sea – do any of your obligations to consider them, or to give them "effective protection", apply?

It is on the last two issues that legal questions were especially raised in 2002-2003. Nauru and Indonesia, for example, are not signatories to the Convention on the Status of Refugees. Is there then a risk of refoulement? Two interpretations may also be offered for the point at which obligations really apply.

In one of these interpretations, the principles apply only once refugees are within your territory. If people seeking entry never touch foot on you soil (e.g., if they are turned back at sea), it can be argued, "the principles do not apply". The U.S. has successfully argued this point in a 1993 case where an 8-1 majority of Supreme Court judges accepted the interception of Haitians at sea and their "return".[32]

In a different interpretation, the principles apply both within a country's territory and at its border: in effect "no rejection at frontiers without access to fair and effective procedures for determining status and protection needs".[33] This interpretation, Mathew notes, may be argued as "soft law". At the least, however, it argues for a country being expected to take some steps to protect refugees from chain refoulement.

Where then did Australia stand? For the most part, the government took the first interpretation. It would stay within what it saw as the letter of agreements it had

signed. It would take extraordinary steps to operate on that interpretation: altering what would count as its "Migration Zone" – its effective borders for asylum seekers, restricting all contact with anyone who could be regarded as legitimately receiving a request for asylum, changing its legislation (the Border Protection Bills) so that it assigned itself the right both to refuse entry and to transfer asylum seekers to "some other place". Even in 2005, moves toward "excision" continued.[34] Those moves could, and did, upset lawyers and people concerned with human rights. As long as the legal manoeuvres were not highly publicized or made readily understandable, however, the government's interpretation of its obligations could be claimed – and accepted by the general public – as not only legal but also as both morally right and "common sense".

A Summary Comment

In all, issues of "truth" and of "law" were clearly the bases for lively challenges and countermoves. Issues of "truth" were also readily understood by the general public. The question was more one of which departures from the truth were significant to them, especially at the time of their being revealed. Some Ministers and some governments may fall on the basis of having been found to lie but clearly all lies are not of equal value.

Issues of law clearly matter as bases for dissent. They need to be responded to by assurances to the effect that the government always acted within the law. No legal responsibility could be attributed to it. Issues of law, however, may readily become remote from public interest, especially if the law involved is international law or a principle based on international agreement. Telling a lie under oath is easily understood as an act against the law: one widely regarded as especially unacceptable when the person involved is a public figure. Failing to respect an international agreement or "the customs of the sea" is a much vaguer area. It can, however, prompt a sense of being exposed to criticism by other countries. "Image" is then at stake. In Howard's counter-move, this sensitivity was largely finessed by assurances to the Australian public and in response to critics overseas that the country was certainly "taking its share" of what could reasonably be expected or was agreed to, with

comparative figures presented to show that this was so. We were, he said over and over again, not only a country that should have "the right to decide". We also exercised that right with due concern for the distress of others.

Compassion and empathy, it appears, had at best a small place in this set of challenges and counter-moves. A larger place for them, and their effectiveness, is brought out more by the events described in the next chapter. Now attention turns to specific people – people with faces, with narratives that became known and evoked concern, already caught up in the country's detention procedures and suffering by virtue of them. These became the focus and the source of some changes in the government's representations of what could now be done.

31 *Convention Relating to the Status of Refugees*, 1954, article 33
32 Cf. Mathew (2003) Op.cit.: 96
33 UNHCR definition of non-refoulement: cited by Mathew, ibid: 98
34 Report in *The Guardian Weekly*, July 2005

Points of Change: From Concerns for Individuals to Concerns for Groups

W HAT CAN COMPETE with a framing of refugee and asylum issues in terms of crisis and control, with both external and internal borders presented as necessities? If the index of challenge and change is a shift in the way people vote, then little competition seemed to occur. Howard proceeded to win the election not only in 2001 but also in 2004. In 2004, his party even succeeded in winning for the first time a majority in the Senate, removing a major check on the conversion of his policies into approved practice.[1] For markers of change toward refugee-related events, we need then to look outside large changes in voting patterns.

Did dissent then occur? Did it bring about changes? Changes in policy did occur. Howard presented them as shifts in the implementation of his policies and not the policies themselves. They were nonetheless changes that he fought against and made only grudgingly. Dissent also occurred. The shape it took, and the features that contributed to its effectiveness, add still further to our general understanding of dissent.

In broad terms, the challenges noted in the preceding chapter focused mainly on issues of law and of truth in the presentation of events. The challenges now to be noted were marked by more personalised narratives and emphasised on compassion, the recognition of distress and vulnerability and the need to act "humanely".

Four events bring out the more specific nature of the changes and the circumstances that shaped them. They are described over the course of this chapter and the next. This chapter takes up the first pair, marked especially by the significance of *personalisation and humanisation*. The stories that were judged newsworthy and that stayed in the news were about people. Names like Virginia and Naomi Leong, Ian Hwang, Vivian Alvarez Solon and Cornelia Rau became part of the Australian vocabulary. They were "women and children" or women who were wrongfully deported: people who were not only far from being dangerous but also deserving of compassion and protection.

The chapter that follows then takes up the second pair of events. These combined personalisation, dissent from within the governing party, and concerns with both compassion and accountability. Both chapters chart the nature of dissent (noting especially how they differed from earlier criticisms). Both also describe the forms of change that occurred, and the extent to which those changes were sustained or chipped away once the initial heat of dissent wore off.

We begin with changes involving "women and children", usually slanted toward those more readily perceived as innocent and in need of protection: children.

Change 1. New Provisions for "Women and Children"

The UN Convention on the Rights of the Child describes

the placement of children in detention as "a last resort". A review by HREOC (Human Rights and Equal Opportunity Commission) made it very clear that this was not occurring in Australia.[2] That review made news. So also did the expressed concerns of organizations such as CHILOUT (Children Out of Detention).

Children are not likely to fare well, however, when they and their families are placed in locked detention centres that are often in isolated places, when these centres offer little in the way of education or recreation, and when they are surrounded by people in various states of depression and anger. When those conditions stretch over time – in some cases, for years – the likelihood of ill effects becomes even higher. Here then is a situation where penalties are being incurred by those who would appear to be both the most vulnerable and the least responsible for where they find themselves.

Small wonder then that children often become the focus of calls for compassion and change. One of the first sustained news story about conditions in Australian detention centres, in fact, had to do with the heavy impact of detention on the mental health of a 5-year old boy (Shayan Badraie) hospitalised after psychiatric assessment of his extreme withdrawal symptoms (Chapter 4). A focus on children is not, however, unique to Australia. In Norway, for example, even the conservative Minister for Local Government, Erna Solberg, describing further restrictions on asylum seekers and "non-returnables", emphasised that "children will not suffer".[3]

Considering children by themselves, however, runs counter to another everyday category: one expressed as "women and children". To take one example, the Australian Navy, in the words of a retired Admiral, is "trained to fight wars" not to "handle women and children refugees".[4] This everyday combination of "women and children" – almost as if it were a single word – implies that the two should stay together and that both should be given special treatment: should be recognized as the weak and vulnerable who warrant our care. Ideally, this unit is part of one still larger: that of "family". In a pinch, "fathers" may be detached from that unit. "Women and children", however, seem more strongly glued together.

In general, then, actions that separate women and children from each other or that treat them with a lack of care – as no different from adult males – are likely to be felt as actions to avoid and, if they occur, as needing some special justification.

The state, however, does at times separate mothers and their children, legally or physically. That separation applies when mothers are in prison. It has often applied also when mothers and children are asylum seekers or refugees.

Often with reference to where people are born, for example, the state may be prepared to let children enter a country, or stay in a country, but not their parents (or the parents but not the children). Distinctions of this kind come up in every country. Inevitably, they present problems for all concerned. For the public, they also provide examples of "heartlessness" and prompt calls for more compassion and more "common-sense". In effect, the contradictions between firm legal control and human sympathy now become more visible than usual.

A contradiction that attracted Australian attention in 2005 was exemplified by the story of *Naomi Leong*. Her mother, Virginia Leong, had been in detention (Villawood) since December 2001, after attempting to leave Australia on a false passport. She was then 2 months pregnant. Naomi was born in the detention centre and was categorized as "stateless". The mother could return to Malaysia. The child, however, belonged to neither country. (The mother's insistence on staying in Australia, even if Malaysia accepted her daughter, stemmed also from there being an older son, born in Australia

1 The platform in the 2004 election was not the same as in 2001. In 2001, the core issue was the strengthening of borders. The electoral slogan was "we shall decide who comes to our borders and under what circumstances". Howard could – and did – claim that "the boats have stopped coming". The key emphasis in 2004, however, was the capacity of this party to manage the economy, combined with his capacity to "take a stand", to be "resolute". The economy was in fact doing well. Labor was successfully painted as likely to raise interest rates (in fact a decision for the Reserve Bank). Any rise in interest rates was a major anxiety, however, in a country marked by low interest rates and high consumer debt. Labor had also changed to a relatively unknown new leader (Mark Latham), allowing Howard to contrast his known "resoluteness" with the probable unpredictability of a younger and more volatile leader. At the State level, Labor was still highly successful. The Premiers in all seven states were now Labor. At the Federal level, however, Labor never seemed to gather the steam in 2004. Labor won, however, the 2007 election needed to alter Howard's progress

2 Human Rights and Equal Opportunity Commission (HREOC) (2004) A *Last Resort: The Report of a National Inquiry into Children in Immigration Detention*. Available at: www.humanrights.gov.au/human_rights/children_detention_report

3 *Aftenposten*, 24/01/02

4 Sir Richard Peek on *ABC Lateline*, 09/11/01

and being brought up by his father).

By 2005, Naomi Leong was a 3-year old who had never been out of Villawood detention centre and was becoming increasingly disturbed. She was seen by a psychiatrist (Michael Dudley) who described her as "mute", "listless", and beginning to bang her head against the wall. The Department then granted Naomi three hours a week at a play centre. She was overjoyed and reluctant to go back to Villawood. Her joy and her reluctance made instant news, helped by the photographs that could be taken once the child was away from Villawood. The story made the front page of the *Sydney Morning Herald*. After that, "letters poured in from the Australian public. People were simply appalled".[5]

That outpouring, combined with international attention, spurred changes for this family. A report in *The Guardian* (England) provides one example of that attention. Under the headline "Act now against draconian laws", it noted the interest of Malaysian media and the Malaysian government's offer for Naomi to apply for citizenship on humanitarian grounds (grounds that the Australian government could also act on at the Minister's discretion). Noted as well was the dilemma this would present for Virginia Leong. She would have less access to her 7-year-old son, living with his father in Sydney.[6]

DIMIA's solution was now to release this mother and daughter from Villawood, providing them with the type of visa known as a "bridging visa". Naomi was described by her mother as "jumping for joy".[7] As several critics immediately noted, however, this visa meant that Ms. Leong could not work or have access to medical aid. What she really needed was to be granted residency. Even if that action were taken, they noted also, the change would have been for that one mother-and-child only. There were 68 other children still in detention, and a case-by-case resolution was not the way forward.[8]

The Naomi Leong story, however, did not stand alone for long.

The *Sydney Morning Herald* by this time was featuring the presence of young children in detention centres. Later in the month the front page presented 7 photographs of young children (2 were infants): photographs that were their Villawood identity cards. The headlines

ran: "Meet the barcode kids in detention", and "there are 45 more pictured inside". "These", the front page caption said, "are the faces that the government doesn't want you to see lest they become human in the face of the public. There are the people we were so scared of. They are but children".[9]

The Department now adopted a "softening" move. The solution proposed was to build special detention centres for women and children. One such centre had been trialled at Port Augusta in South Australia. Similar centres were proposed for Sydney and Perth (to be ready in 2006). The centres would still be guarded by security cameras and alarms. Fathers or partners would have "frequent access" but not live on site. The children could go to schools. Families could go shopping. And "inconspicuous fences would replace razor wire".[10] All told, the Minister stated, as she turned the first sod for the planned Sydney centre, the new centres would "uphold Australia's commitment to 'border protection' but 'soften the impact' on women and children".

The proposed new centres, however, met with criticism from groups such as CHILOUT. They pointed out that the children were still in detention. Unappreciated also was the Minister's repetition of an "old statement" about deterrence. The new arrangements, she said, still "sent a message" to people smugglers. They "should realise that there was no point taking children on boats to smooth the passage into Australian society. The children also would be detained".[11] The concern is still on the status of children as bargaining pieces, and not on any duty of care or concern for their welfare.

Weakening still further the picture of changes made on the basis of compassion were other human-interest stories in the press and on television. Children who had been in the country for most of their lives were being deported to countries that were for them "foreign". Their tearful presence on television, and their reluctance to return, made a powerful impact. Attracting particular attention was the account of 2 children taken from a public school and moved to Villawood (Ian and Janie Hwang). That narrative again had unusual features that made it newsworthy.

"Softening" blown apart: Ian and Janie Hwang. These two children and their mother made news in both March and July of 2005. Ian was 11, born in Korea. Janie

was 6, born in Australia. Their mother was arrested on March 8 for a visa violation and sent to Villawood detention centre. On that day, the children were called out from their classrooms and also taken to Villawood. They were scheduled to be deported to Korea on March 22. That action was stopped by a court injunction. The children and their mother, however, stayed in Villawood for 4 months, until their release. The children, it turned out, had never been "illegal".

Making their stories memorable (they made for striking television) were several circumstances. One was that this was a story not only of heartless practices that were hard to justify but also of gross departmental error. Another was the involvement of several people, objecting on several grounds. A third was an appealing cast of characters. To the children themselves were added the school principal, an articulate schoolmate of Ian's, an immigration lawyer (Michaela Byers), and a representative of the Teachers Federation (Angelo Gavrialatos).

The removal from school also brought out several extra objections and negative images. "Snatched" was Andrew Fowler's description on ABC TV.[12] "It was very disturbing …. It's not something I've ever come across before in my entire service", said the school principal (Fran Larkins). "He didn't even get a chance to say goodbye," said his friend.[13] It makes other children "anxious because they saw their friends removed and they didn't know what was going on", commented the Minister for Education, Carmel Tebbutt.[14] And it's not an isolated instance, the Teachers Federation added. The Federation "alleged at the time" (March) that "up to nine children had been removed from schools by immigration officers and put into detention".[15]

The prompted image of "storm troopers" seizing and removing children was bad enough. It turned out also that the scheduled deportation was "an error". A court injunction sought by the Refugee Action Coalition of NSW had stopped deportation happening on the planned date (2 weeks after the children were removed from school). The children and their mother were then held at Villawood for 4 months. Michaela Byers (a representing lawyer) began a review of their case. So also did the Department. Those reviews yielded the recognition of an "administrative error".[16] The family had held bridging visas since 1998 and were not "illegals". Legal

action against the Department was now a possibility. In the meantime, Ian Hwang cemented his appeal as a person to care about by coming across as an "all-Australian" boy. "Yes", he said when asked directly, he had "had to face bad things, like when someone tried to commit suicide". The main thing, however, was that he could go back to school:

"Inside it's really boring and there's no friends and no education, not much, but outside there's a lot of education and there'll be a better life. I feel great, I feel happy. I would like to thank all the people who helped me out".[17]

The Immigration Department, the *Daily Telegraph* report added, "has denied it made a mistake in detaining the two Whang (sic) children". Their detention was at the request of the mother who wished to have them with her. (The children had been staying with relatives while the mother was overseas). The Department's image, however, was now at best one of a total lack of sympathy where children or women-and-children were concerned. That it was often unsympathetic, grossly incompetent, and operating without regard for others' rights or feelings then grabbed the front pages.

Earlier Appearances of Concerns for "Women and Children"

Were all these concerns new? If not, what made them now more newsworthy and more effective in producing some changes in action? We have in fact seen at an earlier time concern for the position of women and children.

5 Senator Kerry Nettle, the Greens, in Parliament, 11/05/05

6 Anna Pha, *The Guardian*, 25/05/05

7 Jano Gibson, *Sydney Morning Herald*, 24/05/05

8 *The Age*, 25/05/05. For a description of these events see also www.sydneyanglicans.net/socialissues

9 *Sydney Morning Herald*, 31/05/05

10 Malcolm Brown, reporting a description by the Minister for Immigration, *Sydney Morning Herald*, 10/06/05

11 ibid

12 *ABC TV*, 20/03/05

13 *ABC TV*, 08/03/05

14 news.com.au, *AAP*, 20/07/05

15 ibid

16 Byers' description in *The Daily Telegraph*, 20/07/05

17 *ABC Online News*, 21/07/05

The boat SIEV X was a prime example. Among the close to 400 drowned, the majority were women and children. Some of those children had also been at the centre of personalised media narratives: notably the "three little girls" dressed in their best clothes in a photograph sent to the father they hoped to join in Australia.

That personalisation had also been accompanied by a call for compassion. The "three little girls" could no longer be helped. Would the Prime Minister, however, show some particular sympathy for other survivors or for the girls' father? Would he allow the father (Al-Salimi) to meet with his wife: a survivor now back in Indonesia? Under the restrictions of the temporary visas assigned to so many who had been granted refugee status, the father could not return if he once left the country. In an ABC television interview, Tony Jones asked:

"You're a father yourself …. Do you not think that Australian voters would have forgiven you for allowing that man to go back to his wife and then come back to Australia? …. It's not too late before the election to change your mind on this issue".[18]

Howard stood his ground. The decision, he replied, was not his: "Tony, the decision is in the hands of the Immigration Minister. Under law, it's not in my hands." Moreover: "If the policy is altered in one case, questions are going to be asked as to why it should not be altered in other cases".

What then is different between that compassion-arousing event and the events just cited? To be noted first is a difference in effectiveness. The 2005 events did prompt the same government to make some visa changes (the action taken for Naomi Leung's mother), to stop a deportation action and admit a departmental error (taken in relation to Ian and Jamie Hwang), and to make some changes in detention conditions (special centres for women and children, with "inconspicuous fences" rather than "barbed wire").

Differences in the nature of dissent and the reasons offered for compassion are more varied. They were related to the nature of the people described and also to the context – the conditions at particular times. Relevant, and worth considering on any compassion-arousing

occasion are these circumstances:

Where people are: These events were on one's own soil, in one's "own back yard". They could not then be thought of as "remote" and those responsible could not be thought of as "foreign others" over whom one has no control (e.g., soldiers who force people on to boats or "people smugglers"). That "right here" feature had also been present in the case of Shayan Badraie (Chapter 4): the boy brought to public attention by a visiting psychiatrist (Zachary Steele) after he developed clear signs of traumatised behaviour (mute and refusing to eat or drink). That particular case, however, did not generate any general concern or any general change in policy or procedure. Further conditions, then, need to be added.

Who expresses concern and when: The expressions of concern were now more broadly-based and maintained. Shayan Badraie's trauma drew wide attention, especially in medical circles. Events related to him remained newsworthy, continuing through to the 2006 outcome of a legal action claiming compensation for lasting psychological harm. (The family accepted an out-of-court settlement, described as $400,000, offered by the Department of Immigration. They were also granted permanent residency visas.[19]) Now, however, attention came from an organization with a focus on *all* children in detention (the organization named CHILOUT). The *Sydney Morning Herald*'s series of stories also emphasised the total set of infants and young children in a Sydney detention centre. There need not be medical proof of psychological damage. Children should simply not be in detention centres. At issue then was no longer a single child who might be "saved" by removal from conditions with which he could not cope, and whose distress needed to be "proved" rather than assumed as inevitable in the face of detention, especially prolonged detention.

How concern is expressed. Concern could now be expressed by a short, easily visualised message. Children did not belong behind "barbed wire" or "razor wire". Here in an effective sound-bite was the sense of a general heartlessness, a general incompatibility between the actions taken and the way one should act.

The extent to which concern is maintained. Concern in this case did not disappear after a first "softening" move from those taking the "hard" position. In response

to the rising criticism, especially as it appeared in the *Sydney Morning Herald*, the responsible government department had made some changes. It moved toward building special detention centres for women and children. The proposed new centres, however, still met with criticism from groups such as CHILOUT. The children were still in detention and pressure was maintained for further changes.

In all, these are the features to watch for in any series of events where calls are made for compassion.

Change 2. Public Awareness of Wrongful Actions: Solon and Rau

For this move toward change, it again makes sense to start with the iconic narratives, especially since a government-sponsored inquiry was triggered by the public concern that one of these narratives raised (the story of Cornelia Rau). That inquiry was soon expanded to cover also Vivian Alvarez Solon. It was Cornelia Rau's "odyssey", however, that attracted the major and the more sustained news narrative. I shall accordingly describe briefly the Immigration Department's treatment of Vivian Alvarez Solon and then, more fully, that of Cornelia Rau.

Vivian Alvarez Solon: The Human Face of "Removal"/ "Deportation"[20]

Vivian Alvarez Solon came to the attention of the Department of Immigration after a hospital (in a country town in New South Wales – Lismore) could not establish her identity. She had been admitted with head, neck and spinal injuries (July 2001). Those injuries were severe, to the extent of her having been diagnosed as suffering "an incomplete paraplegia".

Alvarez Solon identified herself as Vivian Alvarez (Alvarez is her pre-marriage name), as born in the Philippines, and as in Australia on a spouse visa. The later government inquiry notes that while she consistently said she had a visa, "departmental officers invented another story about her".[21] That story described her as having been "smuggled into Australia as a sex slave" and as wanting to return to the Philippines. She was checked in Australian listings only under the name Alvarez, not under the name Solon, Young (the name of her previous husband) or, the report notes, the name "Vivian". The only barrier that the deciding departmental officers saw to her being deported lay in her physical condition. The Philippines Embassy needed to be persuaded of this before issuing a travel visa and the Department needed to meet its own requirement that she be "physically fit to travel". Once the judgement of "physically fit" was made, and the travel visa issued, Alvarez Solon was quickly deported and the Department saw its obligations as met.

By April 2005, the Department – in recognition of its error – had asked Australian Federal Police to look for her. The actual identification was made by an Australian priest who recognised her from a set of photographs of missing persons presented on an ABC satellite television program. She was living – and had been since her arrival – in a convent run as a hospice for the dying.

Despite that late search, however, the Palmer Report (and news stories before the report appeared) made it clear that some departmental officers had known in 2003 and 2004 – possibly close to and perhaps even at the time of deportation – that Alvarez Solon was an Australian citizen.

All told, she was – in one journalist's description – a "crippled, disturbed Australian citizen who was dumped in the Philippines in 2001, leaving behind her children" and "left to rot".[22]

Were there then changes in policy after this event? And what was the outcome for Vivian Alvarez Solon? In 2005 the Department of Immigration and Multicultural Affairs began making provisions for her support if she returned to Australia. It also made the way she had been treated an addition to the inquiry it had initiated in response to Cornelia Rau's story. An additional report was then compiled by former police commissioner Neil Comrie – who had worked also on the Palmer report. The report was, according to the Ombudsman, John

18 *ABC Television*, 08/11/01

19 *Sydney Morning Herald*, 03/03/06

20 "Removal" is the term now preferred by the Department of Immigration, used as an alternative – at least in their own reports – to the more negatively perceived "deportation".

21 Palmer, M.J. (2005) *Inquiry into the Circumstances of the Immigration Detention of Cornelia Rau*. Canberra: Commonwealth of Australia

22 Mike Seccombe, *Sydney Morning Herald*, 15/07/05

McMillan, "critical of the actions of some officers in the department".[23] That report certainly contributed to the outcome of negotiations regarding compensation. A confidential arbitration hearing began in March 2006 to determine compensation and provisions of support. This resulted in an undisclosed financial agreement in June of that year.

Financial compensation, however, was clearly not regarded by all as ending the issue. George Newhouse (Alvarez Solon's lawyer) pointed out that the officers responsible remained nameless. Their identity was never disclosed. "Until DIMIA officers are held accountable for their callous, inhumane and unlawful actions", he argued, "history will be doomed to repeat itself".[24] With compensation now accepted, however, media interest in the Alvarez Solon narrative – barring some new dramatic event – is likely to have come to an end. New deported faces will be needed for continued action.

Cornelia Rau: The Human Face of "Detention"

Cornelia Rau's story was significant not only because it was so "newsworthy" but also because it was the immediate spur for an official inquiry into the Department's procedures.

What made Cornelia Rau so newsworthy? One factor was her appearance. She has been described (and her family provided photographs to that effect) as a "strikingly beautiful, fit young woman": easily recognised and identified if proper steps had been taken to circulate a photograph.[25] In her 30s, however, there had been some psychotic episodes and in March 2004 she went missing from a psychiatric unit in Sydney. Concerned for her safety and her need for care, her parents listed her as a "missing person" and supplied a photograph. Rau, however, had travelled to another state (Queensland), wandered from one place to another, and was finally picked up by Queensland police as a "vagrant" and a suspected illegal immigrant.

Cornelia Rau at this time identified herself as German, using the name Anna Brotmeyer (sometimes Anna Schmidt). (Her parents were from Germany, but moved to Australia when Cornelia was 4 years old.) She was, she said, a backpacker who had overstayed her visa. With no identifying papers, she was transferred to

a Brisbane jail and spent 4 months there while checks were made on her possible identity. (Within Australia, there is no national list of "missing persons", and her details and photograph were not sent to any other state.) During this period, some assessments of her mental state were also undertaken, with varying results ("personality problem" or "psychosis"?). Rau was then transferred to the Baxter detention centre. Baxter is in itself not a welcoming sight. It "sits in the scrub 10 kilometres outside Port Augusta …. A hostile, distant setting".[26] By the time of her arrival, Cornelia Rau was in a confused and disturbed state. Within a week of her arrival, that disturbance was highly visible, and on October 15 (she had arrived on October 6) she was moved to a special part of Baxter: a "behaviour modification" unit known as Red One. It took 4 months before she was identified, not by the Department, but by way of a newspaper story of an unusual detainee at Baxter, prompting action by her parents.

What made Cornelia Rau's story such major and sustained news? What gave it such status that an inquiry was begun, headed by someone outside the Department (the Palmer inquiry)? One important circumstance was the continuing nature of the story. Helping that continuity was the fact that a sister (Christine Rau) was a journalist. Helping it also was the concern of the Rau family not only with what had happened to Cornelia Rau. The family was visibly shaken not only by what had happened to Cornelia Rau but also for what this indicated about how people were treated in Baxter. Their search for what was happening in detention centres such as Baxter brought to public attention and public concern conditions that affected her and others in positions like her.

That general importance was underlined also by others. Julian Burnside's comments provide an example:

"Why did it take Cornelia Rau's case to provoke widespread public concern about immigration detention? The treatment received by Rau" (Burnside was particularly concerned with the amount of time she spent in solitary confinement) "is commonplace in Australia's detention centres. The only novel feature of the Rau case is that she is uncomfortably like us. She looks like a typical Aussie girl. We are shocked

at her treatment, but she received the same careless, cruel indifference that most asylum seekers receive. Why is it acceptable to treat asylum seekers this way, but shocking when it is done to one of us?"[27]

That general concern might still not have grabbed public attention. Helping that outcome, however, were details that made all aware of how deficient, and how distant from what might be assumed, conditions in places like Baxter actually were. Among these aspects were:

- The general lack of medical care for people in Baxter, under conditions likely to prompt a need for care.
- The plausibility now given to descriptions of detention centres as "prisons" or even "concentration camps".
- The almost accidental way in which Cornelia Rau's identity was determined.
- The number of people who had described "Anna" as disturbed, but had been disregarded.
- The several indications that she was not a German national: indications also disregarded.

More fully:

Detention conditions in the "Management Unit". Slow identification is one difficulty. Treatment that is "humiliating and degrading" during that period is another, especially when the treatment is directly under Australian control, and clearly out of line with what Australians generally regard as part of "Australian values".

Cornelia Rau spent most of her 4 months in Baxter in one "management" section or another. Those units are based on the interpretation of unusual behaviour as something to be "rectified": to be punished when it occurs and rewarded by the return of "privileges" when it ceases. That interpretation and those decisions are made by personnel at Baxter, often by people appointed as guards. The contrasting interpretation is that unusual behaviour calls for medical assessment and care. That interpretation, however, can readily be ignored unless it comes from clinicians. Clinicians at Baxter, however, were consultants who visited irregularly and needed to wait to be asked to assess a detainee or for official permission to do so.

The picture of "management" that emerged reduced Christine Rau to public tears. Detainees gave close descriptions. An Englishman who had over-stayed and spent time in Baxter while Cornelia Rau was there, and was now safely back in England, went public. Red One, it emerged, allowed detainees to be placed in several stages of isolation. Cornelia Rau spent much of her time at Baxter in Red One. For much of that time, she was also in a cell without privacy, observable by male guards whenever she showered or went to the toilet. Several reports described her as being spied on in this way, as treated roughly by guards, and as often screaming for long periods.

Her behaviour, however, was usually regarded by guards as "putting it on", as attempting to "get away with something". She was undoubtedly "difficult" for them to handle: often angry and breaking "rules". The problem lay in their regarding her attitude as something to be "broken" and in their treatment of her as somehow less than "human".

Medical care in Baxter. On call at Baxter are one psychologist, a GP clinic, and six nurses. Detainees, however, cannot go to the medical centre without appointment. Psychiatric consultants visit irregularly. The psychologist on duty attributed "Anna's" behaviour to a "personality disorder" (not in itself a "mental illness"). A visiting psychologist saw her once. In the light of her "posturings, bizarre behaviour, and guardedness", he considered "schizophrenia" the most probable diagnosis.[28] He also recommended further assessment at Glenside Psychiatric Unit in Adelaide (the nearest large city for Baxter). Glenside, however, was already under pressure and was reluctant to take in more than 1 or 2 referrals from Baxter at a time. At this point, they already had as many as they could handle.

Adding to the general unease about the quality of care was its "outsourcing". In Christine Rau's description:

"The Department's detention service at Baxter is Global Solutions (Australia) Limited the company subcontracts its general medical services to

23 Cited by Jewel Topsfield, *The Age*, 02/09/05
24 *Sydney Morning Herald*, 15/07/05
25 David Marr, *The Age*, 18/07/05
26 ibid
27 Burnside is a Melbourne barrister, actively concerned with human rights issues. *The Age*, 07/07/05, after the release of the Palmer Inquiry report.
28 David Marr, citing part of the Palmer Inquiry Report: *Sydney Morning Herald*, 18/07/05

International Mental Health Services, which employs the nurses. International Mental Health Services subcontracts its GPs at Baxter. Psychological care is provided to Global Solutions by Professional Support Services".[29]

In effect, care has no direct line of organization and is not an intrinsic part of the Department of Immigration or of the Department of Health.

The disregarding of reports of "Anna" as disturbed and of indications that "Anna" was not German. Reports of "Anna" as disturbed rather than deliberately "difficult" came from a variety of sources. Detainees spoke to visiting refugee advocates. They also spoke to two independent psychiatrists (Drs. Newman and Dudley) when these psychiatrists came to assess other detainees. They were not allowed access. "Anna" was not on their list. Two chaplains who had direct contact with her spoke on her behalf. One (Michael Hillier) wrote to the Minister (Amanda Vanstone). He described "Anna" as "clearly mentally deranged in a very serious way" and as needing to be placed in Glenside, not at Baxter: "What is being allowed to happen is unprofessional".[30]

Emerging also were early doubts about whether "Anna" was "German" or "an Australian of German parents". There was little support for her claim to be German:

"She had no documents, several dates of birth, no names for her parents, no coherent account of her upbringing or how she arrived in Australia and not a single soul in Germany who could vouch for her Anna ... was not fluent in German ... the grammar" (in a letter sent by her to the German Consulate asking for help toward spending Christmas in Germany) "was not correct ... The German Consulate wanted fingerprints. Anna refused After a phone call from Anna to the consulate, the vice-consul rang her case officer to say: 'Anna might be an Australian citizen of German parents".[31]

The Consulate placed a copy of Anna's photograph in the lobby of the Consulate, but saw itself as having "no authority any more to continue activities".[32]

The Sydney Morning Herald and *The Age* (Melbourne) ran a short story, based on comments from refugee advocates, about a "mad German" at Baxter.[33] "Anna's" parents saw the *Herald* article and alerted NSW police. (February 3). On February 4, Cornelia Rau (still identifying herself as Anna Schmidt) was transferred to Glenside hospital, with a 3-month hospitalisation order. In late February, during a visit by her parents, she acknowledged herself as Cornelia Rau, but her overall prognosis remained unclear. Without doubt, however, her lawyer – Claire O'Connor – noted: "This whole thing has made her sicker, and that's the sad part".[34]

In all, what happened to Cornelia Rau brought home an awareness that this kind of treatment could come to "any of us".

Outcomes to Events Involving Cornelia Rau

As in the section on Alvarez Solon, I start again with some personal outcomes and then move to governmental response: response documented in the form of what is known as the Palmer Report.

Changes for Cornelia Rau

In June 2005, Cornelia Rau was released from hospital in June 2005, but conditionally: she must take medication or be readmitted. Cornelia Rau disagreed with that requirement: "she insists she is well and (asks) why is everyone forcing her to take medication".[35]

As of July 18, 2005, however, Rau was able to give a television interview, to offer an explanation of why she identified herself as Anna Brockmeyer (a cult group she had been involved with "would have known where I was"), and to emphasise that the most important outcome for her was the recognition of injustice: "Well, ... it's important for me that I get truth in this matter. That people understand that I'm a person who has been unjustly treated and that I'd like to have people respect that".[36] Throughout the year, she was able to stay out of hospital and out of the public eye: "According to her sister, Christine Rau, Cornelia Rau was as of February 2006 living in a flat on her own by the beach in South Australia and studying".[37]

In the meantime, the state-appointed guardian instructed solicitors to prepare a case for compensation.

Cornelia Rau's own comments point to an emphasis on a lack of justice. The comments from her lawyer (Clair O'Connor) singled out as particular "grounds for compensation" that "the mentally ill Ms Rau was ignored ... that she was detained in jail without having committed a crime (and) that she was monitored at Baxter detention centre by male staff and subjected to detention without review". In all, it had "failed in its duty of care towards her".[38]

Howard apologised to both Solon and Rau in July 2005 but "refused to promise compensation".[39] Solon, as described previously, has received compensation through legal action. So far, Rau has not.[40] Senator Kerry Nettle (The Greens) did put forward a Senate motion in September 2006, proposing that Cornelia Rau be compensated for her ordeal rather than forcing her to take the compensation claim through the courts. The motion was not passed.[41]

Points of Official Change
In response to dissent and criticism, the presenters of a particular frame for events may make changes on the margins of their position or move to some central changes. Moving to the margins is the preferred option. In the language of representation analyses, dissent is then "domesticated". It has been fully noted and can even be described as now accepted and absorbed.

Favoured often by governments as a move toward controlling dissent and demonstrating an apparent willingness to listen are inquiries that it establishes, with specific terms of reference and headed by people whom they appoint. Favoured also is a selective take-up of recommendations, if any should emerge that are unpalatable.

The inquiry generated in the wake of public awareness of what had happened to Cornelia Rau provides an informative example. I give it closest attention both because it illustrates how dissent can gather and sustain force and because the report emerged as a statement not only of details that should be changed but also of principles that can be applied to all occasions of detention, in any country.

The inquiry that came to be known as the Palmer Inquiry appeared at first to be destined to follow that kind of path. Its brief came from the Minister for Immigration (Vanstone). On February 8, 2005, she announced that an inquiry would "investigate, examine and report on matters related to the case of Cornelia Rau, including in particular the actions of DIMIA and relevant state agencies, during the period March 2004 and February 2005". The inquiry would be headed by a former Federal Police Commissioner (Mick Palmer). It would be private ("protecting the privacy of Ms. Rau"), and would be completed quickly. The expected date was March 24. The draft report was completed by June, and it was publicly released in July.

That highly specific brief was then extended to cover an additional individual case (Alvarez Solon) and, opening the box more fully, a suspected 200 similar cases. The second expansion was prompted especially by a television interview with a person identified as a DIMIA employee ("Jamie", voice and face disguised). "Jamie" appeared on television:

"because people can say there's only one or two cases and on the whole we're very efficient. That's not the case at all. There's only one or two that have come to the media. Things have gone wrong in every case load, particularly in the refugee and compliance area".[42]

His disguise, he continued, was because the Inquiry had no power to protect witnesses and because he saw the Department as quickly punitive toward anyone taking a critical or "too sympathetic" position.

In effect, the brief for the Palmer Inquiry was limited. So also were the Inquiry's powers. It could not compel witnesses to appear. (A Royal Commission inquiry

29 Christine Rau, *Sydney Morning Herald*, 04/05/05
30 ibid
31 Marr, *Sydney Morning Herald*, 18/07/05
32 ibid
33 *The Sydney Morning Herald* and *The Age*, 31/01/05
34 Christine Rau, *Sydney Morning Herald*, 04/05/05
35 Topsfield and Grattan, *The Age*, 07/07/05
36 Channel 9, *60 Minutes*, 18/07/05
37 *The Age*, 06/02/06
38 Penelope Debelle, *Sydney Morning Herald*, 15/07/05
39 Michelle Grattan and Jewel Topsfield, *The Age*, 15/07/05
40 greens.org.au/mediacentre/mediareleases/senatornettle/301106a
41 A similar motion was presented to the Senate earlier in the year. www.kerrynettle.org.au/500_parliament_sub.php?deptItemID=304
42 *ABC TV*, 14/06/05

– the type many argued for – can do so). It would focus on the Department's own records of events and judgements. It would also report to the Minister. The Minister and the Prime Minister could then decide if and when to make the report public. They could also act or not on the recommendations made.

Nonetheless, the report made judgements and recommendations about the Department's general "culture" rather than only specific cases. Its title may have been "Inquiry into the Circumstances of the Immigration Detention of Cornelia Rau". It was, however, highly critical of the Department and saw its procedures and management as urgently in need of major overhaul. It was quickly made public and some recommendations were immediately acted upon ("heads must roll" was one television headline).[43]

The Palmer Report: Newsworthy Pieces and Highlighted Principles

The report is in itself a prime example of how the news focuses on people and expected narratives, with issues left to the side or expected to be taken up only by some particular parts of the media. It is as well a prime example of how interest can be maintained by continuing to raise points of drama.

Before the report appeared, for example, the concern often expressed was that the report would be a "whitewash", possibly presenting Alvarez Solon and Rau as isolated cases. As the likelihood of that became less, reports began to circulate that the report would be a "hair-raiser". Dramatic interest then turned to the date of its release: Who has a copy of the draft, making delay less likely? (The Queensland Premier – Beattie – was reported to have a copy. Christine Rau said she did not.) Will the Minister (Vanstone) sit on it? Will it then be "leaked"? If the report is truly negative, who will be found to be "the villain"? Whose head will roll? Will the Minister be the one to go or some relatively faceless bureaucrat? (Shortly before the report was tabled, the Head of Department resigned, prompting *The Age* to comment that he had "fallen on his sword" but in a way that was "well short of disembowelment".[44](He was to be proposed as the next Ambassador to Indonesia. The Minister, *The Age* continued, would be "lucky to keep

her head".[45]

Neglected in the media accounts, however, was the Report's careful analysis of principles and its emphasis on rights. I highlight these features for several reasons. One is that the Palmer analysis could well serve as a model for all expressions of principles and all inquiries into obligations and failures to meet them. A second is that these features were especially notable within the context in which it appeared. Principles and rights have not been frequently used terms within Australian Government statements during the Coalition Party's years of control (a country's "sovereign rights" were an exception). They were then unexpected terms within a report stemming from an inquiry initiated by the government and headed by a government-appointed individual (an ex-Federal Commissioner of Police). A third is that the response of others to the Report – the concerns expressed in response to what it revealed – often focused on the specifics of the actions taken. The Report itself, however, regarded as central the Department's operating on "assumptions" that were at odds with respect for the significance of depriving an individual of liberty, for law, and for the Department's own regulations. Central also was a highlighted opposition between two frames. In one, the protection of liberty is paramount. In the other, placing barriers between the community and "suspected illegals" is paramount. Errors in the name of "security" or "suspicions" then become tolerable. Detention comes to be an end in itself.

This opposition between "security" and "civil rights" is a pervasive concern in the Palmer Report. Page 1, for example, starts with the heading "Principles". The starting principle is "individual liberty":

"When there exist powers that have the capacity to interfere with individual liberty, they should be accompanied by checks and balances sufficient to engender public confidence that these powers are being exercised with integrity".[46]

In keeping with that principle, the "intention of … Government" is that:
- "every reasonable effort be made to ensure the right people are detained as being 'reasonably suspected of being an unlawful non-citizen'

- expeditious and comprehensive inquiries be made to establish the identities of detainees whose identity is in doubt
- the overall duty of care – including, in particular, medical care – owed to detainees be consistently and effectively applied
- detainees be held in detention only for as long as is necessary and justifiable".[47]

These are the principles that the report saw as not having been met. The ways in which they were not met, and the recommendations, may be grouped according to those breaches.

1. *"Every reasonable effort" was not made.* Judgements were often made on the basis of insufficient and unchecked "suspicion".
2. *"Expeditious and comprehensive inquiries were not made".* They were instead, often piecemeal, made "on the run", and slow.

The general quality of decisions and inquiries, the report noted, called for changes at the level of training and supervision. Needed also were limits to the "extraordinary powers" of low-level officers who lacked understanding or training with regard to the meaning of the Migration Act or of what in legal terms, constitutes "reasonable suspicion".[48] At a deeper level, the Report disagreed with the view put forward by DIMIA that "the power to detain on reasonable suspicion … once exercised … remained lawful until an event occurred that resulted in "release of that person".[49] "In the Inquiry's opinion … (this view) is erroneous and has led to flawed practice" and has weakened the individual's "only protection against indefinite arbitrary detention".[50] The Inquiry's "opinion" was noted as supported also by legal discussions about the meanings of "reasonable suspicion".

3. *Duty of care was not observed.* That lack of duty was especially apparent in the arrangements for detainees to be held in prisons (Cornelia Rau's first 4 months) and in the arrangements for mental health assessment and care both there and at Baxter.

On the first score, the Inquiry found "unsatisfactory"

the lack of any formal agreement between Corrective Services and DIMIA about responsibilities and arrangements.[51] Moves for a new agreement had begun in 1999-2000 but had not been completed.[52] It regarded as "of serious concern" the "lack of understanding – and, indeed, the attitude that would underpin it" – contained in the view expressed by a DIMIA executive that DIMIA paid the Queensland Corrective Service "$95 a day for each detainee and that therefore the Queensland Corrective Service had total responsibility for … care".[53] The result was that Ms. Rau was detained in a jail that did not have separate facilities for women detainees for 6 months, though she "was not a prisoner, had done nothing wrong, and was put there simply for administrative convenience" rather than the "last resort" reason that DIMIA's own instructions specify – and kept there for months.

The Inquiry was even more critical of the level of provisions for mental health assessment and care, both during the prison period and at Baxter. A first general comment was that:

"the standard of health care offered to Anna … was inadequate …. At issue are the prevailing culture, lack of assertive leadership, uncertainty about roles and responsibilities, lack of training, lack of arrangements for effective communication, poor co-ordination and consultation, and a failure of management responsibility and oversight".[54]

Many of the particular criticisms and recommendations were specific to the sites where Cornelia Rau was held. More general, however, was the discrepancy noted between the circumstances of detainees and an assumption made about their needs. The *assumption* within the Department is that the services offered to detainees

43 *Channel 7 News*, 29/06/05 referring to the demands of the Labor Party
44 Michelle Grattan, *The Age*, 14/07/05
45 ibid
46 Palmer (2005) Op.cit.: i
47 ibid: i
48 ibid: 24
49 ibid: 22
50 ibid: 22
51 ibid: 30
52 ibid: 30
53 ibid: 32
54 ibid: 119–120

should be like those offered to the general population. The reality is that the detainee "population in ... any detention facility ... is *not* similar to the general population".[55] "Detainees suffer the additional burden of trauma, being arrivals in a new country, often having experienced abuse and deprivation, and having their immediate desire for migration status frustrated It requires a much higher level of mental health care than that provided to the ... community as a whole".[56]

The assumption of equivalence, the Inquiry noted, was one major reason for care being inadequate. So also was the "assumption on the part of some staff ... openly shared with the Inquiry ... that transfer to Glenside (the psychiatric hospital) was a 'back door out of detention'".[57] Both "assumptions contributed to the general environment within ... which decisions about priorities for assessment and referral needed to be made".[58]

4. *The length of time in detention went beyond what was "necessary and justifiable".* Here again, the Inquiry noted the lack of understanding and training with regard to the Department's own instructions and the Migration Act. More serious still – and more relevant to all detention situations – was an "assumption culture": "there appeared to be a general lack of understanding on the part of officers of their legislative responsibilities under the Act ... a belief that the follow up investigation ...was a matter of process, with no limitation of time and no need to execute the process as a matter of urgency ... the fact that a person's liberty had been taken seemed to be accepted simply as 'a matter of fact' and as a result of a person's own doing".[59]

That belief, the report notes, reflects a culture in which "detention" is in itself seen as the primary goal. Given a different attitude, "effective management and oversight practices would have led to identification of the problems and remedial action within a matter of weeks".[60]

In this and other aspects of the principles that should be applied, the actions and attitudes of the Department – especially given the lack of review and of checks and balances – were found to be "of great concern". Individual officers might act with integrity but the problems were more "systemic".[61]

Responses to the Report and its Recommendations

How did the media and people concerned with the position of asylum-seekers respond to the Palmer Report? I shall focus on responses that had to do with the general issues. Widely expressed was *regret that the Inquiry was limited in its brief and its powers.* These limitations meant that the inquiry could not address with any closeness the general policies that promoted the kind of "culture" that the Department had developed.

Expressed by many also was *agreement that "reform will need to come from the top",* with questions raised about whether this would actually occur. The report itself was noted as forthright in its view that "the current ... executive management team is unlikely – without significant independent leadership and support – to have the perspective or capacity to lead and bring about the major changes in mindset and practice that are required".[62]

Doubt was expressed, however, about the likelihood that Howard's changes in personnel would meet this need. The new Head, for example, was to be Andrew Metcalfe, who had grown up in the Departmental culture. There were also no serious consequences for the previous Head (Bill Farmer: proposed by Howard as the next Ambassador to Indonesia). "His fate appears to be more of a case of reward than of punishment".[63]

In a further expression of doubt, there was *regret that provisions for review would remain within the Department, however well-reformed its procedures might be.* The preference expressed by several (Christine Rau was one of these) was that the decisions to detain and deport or "remove" should be made by the *courts* rather than by bureaucrats. As Glenn Nicholls pointed out, many of the decisions that were now "departmental" once needed to be judicial. "Deportation", for example, used to require court approval. "Removal" to another country no longer does so.[64]

The same kind of reservation was expressed with regard to medical care. In contrast to the centre-run nature of arrangements such as those at Baxter, state-run medical services would be "accountable, expert, not answerable to detention centre management, and governed by patient rights-based legislation and policy".[65]

Medical care was also at the core of *concern that the report did not address what happens to mentally-distressed detainees after they have been "removed"*: "the only medical consideration at the time of removal is 'physically fit to travel' capacity to survive upon repatriation is considered irrelevant to the decision to deport".[66] (The removal of Vivian Alvarez Solon was a prime example.) Allied to that concern was the need to consider not only the circumstances before detention that undermine the mental health of many detainees, but the "harmful effects of long-term detention". If those effects were taken into account, questions of responsibility and of the justifiability of long-term detention in itself would become paramount.

Cutting across reservations about immediate procedural changes was *concern that changes outlined by Howard would focus only on the short term.* Reservations about whether the changes in personnel would really result in a change in Departmental "culture" have already been noted. Christine Rau felt as well that the apology made by Howard would be overvalued: "An apology is quickly made and quickly forgotten".[67] Also of concern was the degree of focus in the government's announcements on the details of what the government would immediately offer (e.g., down to the value of the phone calls that would be offered to Vivian Alvarez Solon). Lawyers for both Alvarez and Rau reserved judgement about compensation amounts, but were concerned that details of compensation detracted from the need to take steps that would prevent "history repeating itself". Those steps, the lawyer for Alvarez Solon argued, would need to include the identification of the particular Departmental officers who had made the deportation decision or had known of the "error" but not acted on that knowledge: steps the Department and the Palmer report had avoided.

Reservations about the short-term were also at the core of *concern that one problem was being replaced by another*: "In the Rau fallout, besieged Immigration Minister Amanda Vanstone promised a departmental overhaul. Children and families were released. Numbers in detention centres dropped dramatically as the issuing of temporary protection visas expanded. This time last year there were 1445 detainees in Australia; now there are 768".[68] The policies of mandatory detention and of temporary visas that left people in uncertain situations with very limited support – these, however, remained unchanged. In many ways, the softening on one part of the existing policies was offset by an increased use of another controlling part. Detention conditions might improve for some people. Outside detention centres, however, the problems remained untouched.

Overall, those several responses to the Palmer report offer a set of criteria that we could well use as a basis for judging any proposals for change.

They also make it clear that the story of administrative and political change had by no means come to a complete end at this point. Those changes may be prompted by personalised, widely publicised, narratives, and the reactions those narratives give rise to. What happens after those narratives dominate less media space is another matter. Change might be sustained. It might increase in pace. Decisions and representations might also revert back to their previous level of emphasis on the need for tight control and closed gates, either to entry into the country or into any full participation in life within it.

Those possibilities point to the need, in all cases of dissent and response, to monitor what happens beyond the short-term. They point also to the need to ask what provisions are made for monitoring and what independent organisations might be available to take on that task.

One such source is the Human Rights and Equal Opportunity Commission (HREOC). Released at the start of 2007 was a report on detention conditions in centres within mainland Australia (that is, excluding

55 ibid: 149
56 ibid: 149
57 ibid: 150
58 ibid: 150
59 ibid: 25
60 ibid: 193
61 ibid: 168
62 ibid: xi – Main Finding #20
63 Editorial, *The Age*, 15/07/05
64 Nichols, G. (2005) "Deportation: How Australia Reversed the Burden of Proof". In *Australia Policy Online*, Melbourne: Institute for Social Research, Swinburne University of Technology. At: www.apo.org.au/webboard/results.chtml?filename_num=12135
65 Coffey and Clutterbuck, *The Age*, 18/07/05
66 ibid
67 Christine Rau cited by Topsfield and Grattan, *The Age*, 07/07/05
68 *The Age*, 06/02/06

Christmas Island and Nauru). Noted overall was an "improvement in the approach and attitude of … staff running immigration detention centres. There have clearly been substantial efforts to improve the physical environment, reduce the tension levels, enhance the programs and activities available … and improve the mental health services".[69] The report went on to specify a number of further changes.

Recommended as well, however, was the need to repeal the mandatory detention laws and, in the absence of that, the need "to promptly (within three months) release or transfer people out of detention centres".[70] Recommended also was a wider use of bridging visas, more generous financial support to accompany them, and free legal aid and immigration assistance. Overall, the report commented, if the burden of time in detention and in waiting for uncertain decisions was not reduced, improving conditions in detention centres could go only so far toward improving outcomes.

Similar comments have been offered by a second group interested in sustained monitoring – this consists of Members of Parliament. Green Senator Kerry Nettle provides one example. Senator Vanstone (the Immigration Minister) announced at one point the spending of "several million dollars" on improving conditions at Baxter (the centre where Cornelia Rau had spent considerable time). The money went toward improving "sports facilities … a new visitor centre, better facilities …. we are making it friendlier".[71] Perfect happiness and the complete absence of actions such as attempts at self-harm could not be expected, and Senator Vanstone maintained an interpretation of such actions as attempts to intimidate or pressure a resolute government:

"People who want to stay in Australia will always resort to, some will try and resort to, a very unattractive type of protest in order to pressure the government through the media to give them the outcome they want. But Australia has a very good record of not giving in to such protests".[72]

Senator Kettle's response was that "the revamp amounted to little more than 'beautifying the cage' while detainees are driven mad inside".[73]

The media provide a third potential minority group, alert especially to signs of gross government attempts at "spin" and to stories about people that can be "newsworthy". *The Age* (04/09/05), for example, was happy to quote the defence offered by the new Head of Department (appointed after the Palmer report was completed) for the continued building and renovation of detention centres:

"Despite the declining detention numbers, and Mr Metcalfe's declaration that detention is a last resort, building of a new 800-bed \$336 million facility at Christmas Island is continuing. 'Frankly you hope that it's built and never gets used', Mr Metcalfe told *The Sunday Age*. 'People smugglers do not ring up two years ahead and tell you that a whole lot of people are going to come to the country'".[74]

Happily reported also have been stories of people deported in circumstances that echo those that applied to Cornelia Rau or Alvarez Solon. *The Sydney Morning Herald*, for example, happily summarised the Ombudsman's report of how "Mr T." had been treated. Ethnic Chinese but from Vietnam, Mr T. was sponsored by his sister (resident in Australia) and became a citizen in 1989. Over the next 22 years, he was "admitted to psychiatric wards at least six times. The Immigration Department wrongly incarcerated him three times (one of these occasions was for 8 months).

"Each detention was precipitated by … police apprehending the homeless, disoriented Mr T. Identification was impeded by Mr T.'s confusion, varied explanations, language difficulties, language difficulties and wrong names".

The "sorry mess", the *Herald* commented, "can be distilled into one chilling equation – flawed laws delivered excessive authority in the hands of under-trained, ill-equipped and unfocused immigration officers".[75]

Over and above a written apology from Senator Vanstone (received), the next step expected for Mr T. was again financial compensation.[76]

Mr T. came to media attention because his circumstances had been reviewed by the Ombudsman

and the Ombudsman's report was public information. Stefan Nystrom's story was picked up by non-governmental routes, with one of those being a protesting family after a High Court decision allowing his resident's visa to be cancelled. At the age of thirty-two, after living in Australia for all but three weeks of his life, Nystrom was deported to Sweden, where he had been born. (His Swedish-born mother had been living in Australia for eight years but was visiting in Sweden at the time of Stefan Nystrom's birth). The grounds for cancelling his resident's visa and for his deportation were his convictions for several criminal offences (8 prison terms, mostly for offences against property and drug offences but also including armed robbery and aggravated rape). The objections to the action were (1) his lack of any real relationship to Sweden (he speaks no Swedish, and his family is in Australia), (2) his current involvement in living differently (in his mother's words "he's stopped it all and just give us a break"), and (3) Australia's responsibility for his past and his future. From the age of 11, "they took him off me. He was … in foster homes, after foster homes".[77] In his lawyer's phrasing:

"Mr Nystrom has been in Australia since he was 27 days old, he's a product of the Australian community, and as such he is someone who should be rehabilitated within the Australian community. We shouldn't be exporting our difficulties overseas".[78]

More succinctly, in the words of a brother-in-law: "here Sweden, you have him, we stuffed him up, but you have him".[79]

A Final Comment

What happens when the push for change comes in less personalised fashion? When the push for change comes from stories about "women and children" and about "our own people", it may be especially easy to respond with some demonstration of sympathy (some claims of being, at heart, "compassionate"), the admission of errors in procedure, and the offering of some sacrificial heads who can be blamed for those errors. The policies in themselves, however, may remain unchanged beneath the surface shifts in procedures and people. The general frame may also remain one of control in the name of safety and "sovereign rights" rather than one of human rights and the obligations of care (the principles highlighted in the Palmer Report).

Suppose, however, that the push for change comes from sources that are likely to be stable over time (more stable than journalists' interests in news or people appointed to head a short-term inquiry) and, in addition, more likely to be alert to the slipperiness of political statements without actual legislative or regulatory change?

The next chapter takes up precisely that kind of source. The moves for change come from people who are long-term, elected members of Parliament: members, in fact, of Howard's own Party. Their push for change sweeps up some personalised narratives, giving it some of the emotional appeal that marks the narratives in this chapter. It also pushes, however, for change in the policies themselves.

69 Section 19, "Concluding Comments and Recommendations". In HREOC (2007) *Summary of Observations following the Inspection of Mainland Immigration Detention Facilities.* Available at: www.humanrights.gov.au/human_rights

70 ibid

71 Vanstone cited in *The Age*, 20/09/05

72 ibid

73 Nettle cited in *The Age*, 20/09/05

74 Metcalfe cited by Grattan and Topsfield, *The Age*, 04/09/05

75 David Humphries, *The Sydney Morning Herald*, 24/03/06

76 ibid

77 Mother's report cited by *The ABC Online* 09/11/06

78 Stuart Webb cited by *The ABC Online* 09/11/06

79 Darren Turner cited by *The ABC* 8/12/06

CHAPTER 9
Change: From Individuals to Groups to Policies

Any ANALYSIS OF change needs to consider both the forms of change that occur and the circumstances that prompt those changes. Any analysis needs also to ask: Are changes sustained? Do particular circumstances make a difference to the kinds of changes that occur on the margins or at the core of policies, for example, and to the extent to which these are sustained or quickly disappear?

The preceding chapter focused on circumstances marked by highly personalised narratives. These were stories about people who could readily be seen as in no way filling the picture of "illegals" who deserved "firm" treatment and exclusion from the country or from Australian society in general. They were "women and children" – children especially – and people who could be regarded as "one of us": a citizen (originally Filipina but a legal citizen) who was ill and in need of care but deported with no signs of concern for her fate, and "an Aussie girl" – also ill and in need of care but shunted between an official prison and a locked detention centre with many prison-style conditions.

The preceding chapter focused also on changes that many felt to be less than what might have occurred, and to risk not being sustained. Children, and their mothers, were removed to centres where "inconspicuous fences" replaced "barbed wire". They were still, however, in detention, and their fathers remained in detention centres. The story of the "Aussie girl" – Cornelia Rau – sparked a government inquiry and a major report (The Palmer Report). That report led to some highly visible changes at the head of the responsible government department but, in the eyes of many, to questions about whether "the culture" of the department, and the assumptions behind its procedures, had changed and would continue to change once public attention shifted to other newsworthy events.

What would happen, I asked, if the source of change was both more official and stable, and if the points of change that were directly sought were closer to policies themselves than to the procedures that went with those policies?

To answer that question, I turn to two further changes. The first of these – changes at the detention centre on Nauru – was especially marked by personal narratives, combined with the official weight of UNHCR. The second – changes in some detention policies – incorporated the personal narratives of some asylum seekers (mainly as the human face of arguments against indefinite detention), combined with local political push. The aim was a change in several aspects of policy and procedures, written into legislative agreements: a drive toward change that might have seemed "dry" and barely newsworthy. The challenge came, however, from a group within Howard's own party. The media promptly labelled them Howard's "rebels", with the contest between them and the Prime Minister a "David and Goliath" battle, and that "battle" became instantly newsworthy.

Change 1. "Closing" Nauru

At the end of Chapter 4, I commented that with the transfer of most of the *Tampa* refugees to Nauru, their story disappeared from news stories. Those who were transferred to New Zealand continued to be noted from time to time in the Australian press. The New Zealand stories were largely stories of an emphasis on family union and reunion, of relaxed internal borders (residency visas soon granted), and of the new residents as community assets.

Nauru, however, remained a detention centre and a closed world: requests for visas by journalists, lawyers and human rights advocates were consistently rejected. This suited an Australian Government determined to maintain the deterrent value of its border protection policy but keen that its human consequences remain hidden from view".[1]

What brought any change in media access? A new government was elected in 2005, and a new Minister for Internal Affairs – David Adeang – granted a Melbourne journalist Michael Gordon – more than a visa:

> "'You are welcome to visit at any time of your convenience', he wrote. It was Adeang who relaxed camp rules in March, allowing the asylum seekers freedom to leave the camp without escort in daylight hours, and provided written authority for me to speak freely and take pictures inside the camp".[2]

Now the detainees on Nauru began to wear a human face. Between 2001 and 2005, 2100 asylum seekers had spent time there. The majority of these had been through the processing of their applications for refugee status, most of those being accepted. A sizeable number – 470 – had voluntarily returned to their original countries, many with financial repatriation assistance. By early 2005, however, 54 remained.

Some of these had had their applications rejected but claimed that gross errors had been made in the processing. Others were still waiting to have their applications processed. A group of concerned Australians had continued to write to them. For most Australians, however, they were an unknown quantity.

Gordon's photographs and articles changed all

that. They covered stories of people who were lonely, depressed, close to despair. They also covered stories of sustained courage. Ali Mullaie was a prime example:

> "For three years, 22-year-old Mullaie has contributed his time and energy to Nauru's cash-strapped education system, receiving no pay in return. What is more remarkable is that, just four years ago, Mullaie could barely speak English and could not use a computer. And there is more. Refugees who have since settled in Australia and New Zealand credit him with equipping them for the transition, and Australians who began sending letters of support to those on Nauru call him an inspiration. Kids across the island, with affection, just call him Ali".[3]

The article prompted numerous letters to the Editor. They expressed "anger ... and pain", praise for Michael Gordon, worry about the reasons for Australia's actions ("Why are we torturing these people? What do we as a nation gain from it?"), the offer of assistance – for Mullaie – in finding work in the IT industry once he is released, and second thoughts about what the country was losing:

> "Here is a young man, bright, healthy, in the prime of life and desperate to make something of himself. He is eager to work hard, learn new skills and share these to build a better community, and he has proven this in circumstances in which most of us would be immobilised with despair. Yet, instead of harnessing this energy and putting his skills and enthusiasm to work for our future, we are spending millions of dollars keeping him locked away, going slowly mad. What an idiot nation we are".[4]

At this point, an editorial in *The Age* offered the Australian government a way to keep its basic frame but also "move on". The editorial was headlined "When A Solution Needs Solving". The spur was the need for change in the use of Nauru. The arguments for change, however, could

1 Michael Gordon, *The Age*, 16/04/05
2 Adeang cited by Gordon: ibid
3 ibid
4 Jen Harrison, Letter to the Editor, *The Age*, 16/04/05

apply to any policy. Here was a framing for change that could involve no loss of face, no damage to one's image as "resolute".

The editorial noted first that the context had changed:

"The time has come to give the remaining internees in Nauru new homes and new lives. The modern world is a complex, difficult place. Values and principles that appear to work to great effect in one set of circumstances will not necessarily be appropriate in perpetuity. Indeed, simply clinging on to a set of principles or a policy framework can end up being counter-productive".[5]

Added was a positive image for a government that was "brave" enough to change:

"These are hard lessons to swallow. They require fine degrees of judgement and, often enough, more than a little courage. It is difficult to change course, especially when others are watching. And when is the right time to make exceptions to the rules? This is the situation facing the Howard Government as it considers the fate of the 54 men, women and children who remain in detention on the cash-strapped island of Nauru".[6]

Change on the government's part could even be regarded as a sign of its success rather than a defect or as an admission of error:

"It is hard to see what harm could come to either Australian society or the Government's tough stance against unauthorised arrivals if the last internees on Nauru were accepted as migrants …. The boats have long stopped coming, the world is fully aware of the Government's approach, which is to turn away any vessels headed for this country, and the policy of mandatory detention remains in place. It is hard to see how it could damage either Australia or other countries to accept the detainees on Nauru as *special-case migrants*, without affecting refugee quotas".[7]

Appealed to also were sentiments presented as part of Australian identity:

"Indeed, simply to leave them there in the current stalemate seems to be contrary to a highly prized Australian value: the fair go. These people have done their time and have suffered enough" [8]

We shall see again the sense of "suffered enough" or "done their time"(in relation to the possibility of indefinite mandatory detention). It is part of a general value: the punishment should fit the crime. Even when no crime has been established, however, there is clearly popular value attached to the concept of "enough".

In effect, the way was opened both to claim success for a "hard" policy and now to "make exceptions to the rules" that would allow room also for compassion: compassion extended in this case to those who have "done their time and have suffered enough".

That "solution to the Pacific Solution" turned out to be adopted. It was helped by an April visit to Nauru by Neill Wright, regional representative of the United Nations High Commissioner for Refugees, who found the "situation not an acceptable one in humanitarian terms" and proposed the acceptance of those remaining "as migrants by Australia or other countries, with the number having no impact on refugee quotas" (in effect, they would become "special cases").[9] It was helped also by visits to Nauru by some Australian politicians, and by the strongly expressed view of a Senator-elect from a new political party (Family First) that Howard hoped to keep aligned with his party, maintaining his slim majority in Parliament: "I don't think stealing people's lives for two, three, four, five, six and seven years is what Australia, or most Australian families, would think was the right way".[10]

These comments were also followed up by a member of Howard's own party, Liberal MP Don Randall, this time referring to people in detention in Australia (Baxter): "I just think: what a waste of life. Those people could either be back in their own countries helping to rebuild or they could be in Australia helping us".[11]

An Immediate Outcome

Mullaie and 8 other Afghanis were judged to be genuine refugees and accepted for resettlement in Australia. They arrived in Melbourne on May 28. Mullaie was given an especially warm welcome by Ms Dorothy Babb – she had been writing to him for over 3 years. The last remaining family arrived in Canberra on June 29, 2005. This group, once labelled as "aggressive Afghanis", consisted of an extended family of 9, ranging in age from 7 to 39 years, and eager to pick up a new life: "I am just looking forward to feeling human, to living in a house and sending my kids to school".[12]

Nauru, *The Age* articles went on to say, was now all the more a "blighted isle". Even before "the Pacific Solution", it had gone from riches to rags and now a centre that had been a source of cash and local employment was disappearing. Except as a possible voice for Japan's bid to have a ban on commercial whaling lifted, Nauru apparently ceased to be a visible part of Australia's news events or policies: a marked change from its once praised status as an important member of Howard's "Pacific family".

Later Outcomes

Essential in the analysis of any framing and any response to dissent is attention to what happens over time. What happens over time, for example, to individuals such as Cornelia Rau or Alvarez Solon and to the changes recommended in the Palmer Report that the government – faced with media attention and public indignation – had requested? Changes in a department's culture and assumptions, we noted in Chapter 8, are not easy to sustain. Changes in public procedures and conditions – the face of detention centres, for example – may be changed but policies left as they were.

Policies such as mandatory detention, the "outsourcing" of processing to off-shore centres, and the placing of people – even when assessed as "genuine refugees" – on temporary visas for up to 5 years, for instance, may remain as they were.

Over time then, what happened to Nauru? In news reports, it was described as "closed". The media reports suggest that no one was left after "no family" remained.

In fact, 27 individuals were left there. Of these, 25 were given refugee status or humanitarian visas toward the end of 2005 – a move helped by a UNHCR advisory to the effect that there be no forced returns to Iraq (conditions had deteriorated there) and that the Iraqis on Nauru be given humanitarian visas.

The two who remained (both Iraqis) were described by Senator Vanstone as having received "adversary security assessments".[13] Their mental health was described by others as precarious, with one (Mohammed Faisal) reported by Nauru health workers as "suicidal" (he was airlifted to an Australian hospital) and the last (Mohammed Sagar) feeling the need to write to the Australian government "asking whether it will wait until he became suicidal before it acts to resolve his situation".[14]

With one to go, the end might seem clearly in sight. The surprise event was the sending of a new group to Nauru. Seven Burmese asylum seekers were transferred there from Christmas Island.[15] The reason offered was that "it is longstanding government policy that anyone arriving on an excised place will be sent to Nauru".[16] The Nauru centre was clearly still available, even though the official description might vary from "mothballed" to "open".

Sustained also was the cost of maintaining Nauru (described in one department statement as close to $15 million for the period July to December in 2005 as compared with close to $34 million in the previous year).[17] For those outside Howard's Coalition Party, cost became a further part of dissent: "That's $12 million a year ... just so John Howard can say he is still tough on border protection".[18] Comments on cost continued to be made (e.g., by a Labor Immigration spokesman in late 2006)

5 Editorial, *The Age*, 19/04/05

6 ibid

7 ibid, emphasis added

8 ibid

9 Neill Wright cited in *The Age*, 18/04/05

10 ibid

11 Don Randall cited in *The Age*, 21/04/05

12 Alieya Rahmati cited in *The Age*, 29/06/05

13 Vanstone cited by Michael Gordon, *The Age*, 06/11/06

14 Sagar cited by Michael Gordon, *The Age*, 06/11/06

15 *The Age*, 19/10/06

16 ibid

17 ibid

18 Democrats Senator Andrew Bartlett cited in *The Age*, 27/01/06

but overall it failed to have strong public appeal and, even in that Labor statement, emerged as an addendum to a focus on "the last remaining refugee on ... Nauru", the absurdity of his remaining there and the inevitability of a decline in his mental health. Labor went on to develop, as part of its platform for the election to come in 2007, the complete closing of off-shore processing centres (in both Nauru and Papua new Guinea). For the moment, however, the personal image still continued to carry the dissent from a frame of political necessity.

Change 2. Detention Policies: The Emergence of Party "Rebels"

The main space in this section is given to dissent that came from a group of politicians: members of Howard's own party. Their challenge, however, was not without its personalised narrative. I start then with one that was prominent: the human face of objections to the policy of indefinite detention within Australia (Peter Qasim).

A Human Face to Indefinite Detention (Peter Qasim)

Peter Qasim provided the recognised public face of what indefinite detention could mean, and how it could be changed. The underlying issue is one that applies in all countries. If an individual is categorised as not entitled to refugee status, but the country claimed as the state of origin will not accept him or her as "one of theirs", what should happen? How long can such people be held in detention? If they are released into the community, under what conditions should that be? Suppose being held indefinitely makes them severely depressed, perhaps physically unable to be moved from one country to another. What then? At what point do firmness, control, a show of strength, and strict borders need to be moderated or reframed? Peter Qasim personified all those questions.

Qasim described himself as from Kashmir, as an orphan, and as needing to flee after becoming involved with the separatist Kashmir Liberation Front. His application for refugee status was not accepted and at one point he requested return to India. India, however, would not accept his return, claiming no knowledge

and no responsibility for him. He became effectively stateless, a "non-returnable". By 2005, he had been in detention for more than 6 years. That surely met any criterion for "enough", especially with no crime established other than "illegal entry".

Qasim's iconic status is illustrated by comments from both sides of the press – conservative (Henderson) and liberal (Grattan). From the former came a rebuttal of DIMIA's claims that the release of Qasim would set an "attractive precedent': "There is no attractive precedent in serving, say, seven years at Baxter or Villawood detention centres".[19] From the latter came the comment that the "notorious Peter Qasim case has become a symbol, both of Howard's approach and the appalling system".[20] Adding a further dissecting voice was a Sydney entrepreneur (Dick Smith), often in the news by virtue of business ventures and solo piloting achievements and not widely regarded as a "bleeding heart".

Helping Qasim maintain public visibility were also the frequent references to his position by the Coalition Senators who were named by the media as "rebels".

Change from Within

This group achieved what would at one time have seemed impossible: changes to detention and visa policies in themselves. That achievement was not easy: a feature that makes it an important base for considering how dissent can produce change. For that reason, I note some of the details of this push for change and of way the media portrayed it.

Who were "the rebels"? The prime movers (sometimes described as "the hardliners" and the least willing to compromise) were Senators Petro Georgiou and Judi Moylan. Both had a history of interest in the principle of multiculturalism and tolerance. (Georgiou had been a staffer with a previous Coalition leader. This was Malcolm Fraser, who had expressed his dismay at Howard's retreat from the principles Fraser had worked for). Two others joined with them to prepare new bills (to be presented to Parliament as private members' bills) and to negotiate with Howard. They were Russell Broadbent and Bruce Baird. Between them, they covered several states: Victoria (Georgiou and Broadbent), West Australia (Moylan), and New South Wales (Baird).

What made their challenges newsworthy and appealing? Several circumstances were relevant. One was *the presentation of their positions as "commonsense"* (Howard's frequent claim for acceptance of his views). In Broadbent's terms: "My views are reflecting middle Australia. I'm no bleeding-heart liberal".[21] That kind of description was in nice contrast to an attack from another Member of Parliament (Sophie Panopoulus), describing the four as "behaving like political terrorists". With humour, Broadbent replied that, "there's not a bomb thrower among us".[22] The claim of "reflecting middle Australia" was also in contrast to a conservative journalist's description of voters likely to agree with the Georgiou group as a "handful of doctors' wives", and their supporters as "feral advocates for wannabe refugees to be released into the community without any restrictions".[23]

A second factor was *the image of a "David and Goliath" contest.* In Michelle Grattan's description: "The struggle over detention has turned into one of the most fascinating battles of wills under the Howard Government".[24]

"Howard has the party room on his side, and all the power of office. The rebels have only the moral force of their position and the strong support of those in the community who feel the present policy is traducing human rights in a way that 20 years ago would have seemed inconceivable in this country".[25]

On Howard's side was also the power to influence preselection when the next election came up. The "rebels" might not get Party support. "How these MPs fare in future will tell us a lot about the character of today's Liberal Party".[26] On the side of "the rebels" was the fact that they were already senior members of Parliament. People in their electorates also felt strongly about any punitive repercussions. As well, whatever the dissidents did, Howard was unlikely to offer any rewards: "Neither any longer has anything to gain or fear from the PM. What harm they have done themselves in this affair, they cannot now reverse".[27]

Adding to the drama of the contest was that, "Tampa-era" or no, Howard had always been known more for his "iron fist" than for his flexibility. And the conservatives have always prided themselves on the difference

between their "party discipline" and Labor's "factionalism". This was the first major public division since 1997 when 3 country members of the Coalition crossed the floor to vote against native title to rural land.

Relevant also were *the public nature of this contest and its timing.* The Government's Palmer Inquiry had made public news. Until the report was released, however, much remained unknown. A draft report was submitted in June, but not made public until July (2005). The Queensland Premier (Peter Beattie) announced that he had a copy. Christine Rau announced that her family did not.[28]

In this relative hiatus, the open struggle between Howard and "the rebels" made powerful news. The dissenters announced that they would be introducing two private members' bills.[29] Discussion within "the party room" was described in news reports as lively. A series of direct meetings with Howard then followed over the month of June, each duly reported by the press. Each of those meetings ended – until the last one – with no agreement achieved. Howard announced that he would not allow a conscience vote. (This would allow people to "cross the floor" rather than vote on party lines. When a Party's majority is slim – as in this case – and the opposition is united, a conscience vote means a party loss). Beazley announced that Labor would also not allow a conscience vote. The Greens announced that they were considering identical bills if the private members' bill did not appear or failed. All in all, here was a "cliff-hanger" story.

What did the "rebels" seek? An article written by Petro Georgiou describes their goals and the bases for those.[30] A first and critical base is the argument that the world

19 Henderson, *Sydney Morning Herald*, 07/06/05

20 Michelle Grattan, *The Age*, 15/06/05

21 *Sydney Morning Herald*, 15/06/05

22 ibid

23 Piers Ackerman, *The Daily Telegraph*, 21/06/05. Ackerman is a consistent Howard-supporter, attacking the "Howard haters".

24 Michelle Grattan, *The Age*, 15/06/05 under the headline "Tampa-era Howard rebuffs his rebels"

25 ibid

26 Editorial, *The Age*, 15/06/05

27 ibid

28 Grattan, *The Age*, 16/06/05

29 Georgiou, *The Age*, 26/05/05

30 *The Age*, 26/05/05

has changed. The current position, Georgiou noted, is no longer one of:

"widespread anxiety that we might be engulfed by a flood of bogus asylum seekers. That fear has not been realised …. Unauthorised boat arrivals have all but ceased and the great majority of asylum seekers who came by boat were found to be genuine refugees …. the activities of people smugglers have been curtailed."

With those changes in context, Georgiou argued:

"It's time to review the policy framework established under different circumstances and adopt *a more compassionate, transparent and accountable approach* while maintaining the integrity of our immigration and refugee system …. It is clear that additional measures are necessary to ensure that the system is compassionate, fair, accountable and subject to independent scrutiny".[31]

More specifically, the first bill would focus on "the plight of individuals who are suffering under the present system". Unless "a judicial officer" recommended otherwise, there would be changes related to:

- Children and families: Children under 18 and their immediate families would be released immediately while their applications are considered.
- Length of detention. People detained for more than a year would be released until their status was resolved.
- The end of temporary visas. People found to be genuine refugees and given temporary visas would be given permanent residency. (Temporary visas call for re-application after 3 years and offer no opportunity for family reunion.)

The second bill would propose "a model of reform so that the problems that have arisen under the current system do not occur". The main proposals dealt with:

- Permanent residency. This would be given from the start of those found to be refugees.
- Length of detention. Asylum seekers without visas would be detained only on specific grounds (e.g. to verify identity). After 90 days, the Department would need to show cause to a Federal Court.
- External review. Detention decisions would be subject to "Federal Court judicial scrutiny".

Overall, the frame offered by "the rebels" was presented as a shift in the implementation of a maintained basic agenda (a frame that Howard came to adopt when he finally announced change). As Howard had done in the past, "the rebels" invoked core Australian values:

"The measures I am proposing … in no way undermine our capacity to protect our borders and prevent abuse. One of the enduring strengths of this nation is our commitment to justice, tolerance and compassion for others. Our treatment of refugees and asylum seekers who have arrived uninvited must surely reflect those deeply held values".[32]

What did Howard eventually agree to? On June 17, 2005, Howard announced that the proposed private bills would be withdrawn. He had agreed that:

- Families and children would be placed in community detention rather than detention centres.
- On the timing of decisions: "The primary decision on an asylum seeker's case must be made within three months, and the Refugee Review Tribunal must also make changes within three months."
- On external review: "Long-term detainees who have been held for two years will have their cases referred to the Commonwealth Ombudsman for review …. Every six months a report on their assessment will be given to the Ombudsman who will give an assessment to the Minister …. a recommendation only".[33]
- On temporary visas: "thousands of those who are in Australia on temporary visas will be allowed to stay in Australia permanently".[34]

The changes, Howard argued, were "a sensible advance". They reflected his own sense that "the greatest areas of complaint really arise around the issue of time, and therefore quite a few of the announcements I am about to make relate to the issue of the time it takes to deal with

matters. I think they represent a sensible advance on the existing arrangements. They don't undermine the existing policy".[35] In effect, the problems lay – in Howard's description – not with the principles but with a few procedures.

Outcomes from These Changes

To start again from personal narratives, life changed for Peter Qasim. On July 17, 2005 Senator Vanstone announced that he would now move from a psychiatric hospital to live with a couple who had often visited him in Baxter. (He had been moved earlier from Baxter to this hospital.) He would be given a visa that would make him eligible for social support and, when he felt able to do so, to work. He could also apply for a permanent visa on humanitarian grounds (a visa always within the Minister's discretion even though his application for asylum was rejected).

Qasim's release was "welcomed by Petro Georgiou, the Liberal backbencher who forced the changes that helped free him". In a statement read to the press, Qasim commented that "I don't know what my future is now but I am happy to have the chance to have a normal life. I never wanted to be a burden on Australia". He "asked the media to respect his new life and leave his new family alone". He acknowledged that his time in detention was "a very hard time" but "I hope those memories will go away". He thanked his "loving, caring supporters", and "Mr Howard and Amanda Vanstone for showing me compassion". He also hoped others in long-term detention would soon be released.[36]

Barring some dramatic change in his circumstances, Peter Qasim is unlikely to return to media prominence. The events to watch for then have to do with whether similar releases occur for others who have also been in long-term detention and seem likely to remain there, but who have not been the public face of difficulty in the way that Qasim has been.

The responses to the regulatory changes were more varied. Piers Ackerman (a strong Howard supporter) saw the changes as of no importance: "Petro Georgiou, the Liberal Party's outspoken activist, may have won the hearts of a handful of doctors' wives in his electorate with his refugee campaign but that's about all".[37]

The dissidents "welcomed the deal", with Judi Moylan noting that "there have been compromises, that's true but …. we've worked constructively to get the key elements … laid out in the bill." The chairman of Justice for Refugees welcomed the extent to which asylum and detention issues were now "much more well known within the Liberal Party as well as the public". He was, however, unhappy that external review would occur only after 2 years in detention ("a year would be a better time span"). Nonetheless, "I suppose anything is a step in the right direction".

A spokesperson for the Refugee Action Coalition described the changes as "cosmetic", as "piecemeal changes by a Government that is desperate to look like it is doing something but there's nothing substantial here. Nothing that's going to address the fundamental questions of long-term detention or, to be honest, of women and children in detention".[38] The Ombudsman, one might add, has no judicial power. Mandatory detention was still the rule. And it could be for a long time.

And in the longer-term? This group of Senators provided a continuing watchdog and Parliament as a whole was now more alert to the negative public response that was likely to follow any obvious undoing of what had been achieved. Nonetheless, Howard was still ready to turn his policies and his procedures back to what they once were or to tighten them still further.

The events that occurred six months later made it vividly clear that the competition between policies and frames was far from over. Those events began with the arrival of 43 West Papuan asylum seekers. They came directly, by canoe, to the mainland (Cape York). They were promptly flown to the Christmas Island detention centre. Significantly:

1. They had reached the mainland: an area from which they could make a direct request for asylum, and they did so. This could hardly be the "excised" area that Christmas Island had been declared.

31 ibid, emphasis added

32 Georgiou, *The Age*, 16/05/05

33 Outlined on www.abc.net.au 18/06/05, emphasis added

34 ibid

35 ibid

36 All comments from an Editorial, *The Age*, 18/07/05

37 *The Daily Telegraph*, 21/06/05

38 All quotations from www.abc.net.au 18/06/05

2. Australia was the place of nearest sanctuary. Any return could only be to the country they had left.

3. Several Australian sources argued that they would be in danger if they were returned. They were from an area where promoting independence had led to oppressive action by the Indonesian armed forces. (West Papua had been claimed by Indonesia after Indonesia gained independence from the Dutch: a claim that the United Nations – those in favour included Australia and the United States – had agreed to in 1969. The other half of the country – once an Australian territory – is independent.)

4. The Department of Immigration granted humanitarian visas to the 43 on the grounds of a "well-founded fear of persecution".[39]

5. The Indonesian government issued strong protests, both before and after that decision. There were, it claimed, no human rights abuses in the area and there need be no fear of persecution. The "unfriendly" action was a threat to the new security pact that the two countries were negotiating. At risk also was the likelihood of the new group becoming aligned with activists already in Australia, raising the possibility that Australia might repeat the support of independence that it had given East Timor at the time of its moves toward independence from Indonesia.

Howard's response, in less than a month, was the tabling of a new migration act. In the words of one critic, "the optimism that many Australians felt following significant reforms … in 2005 has been cruelly dashed by the Government's wretched response to Indonesia's displeasure".[40]

What was so objectionable? A speech to the Senate by Petro Georgiou provides both an excellent review and a prime example of the framing that could be brought to bear to support dissent. That speech began with a reminder that he had voted earlier in favour of government actions. Now, however, *times had changed.* "The rationales for harshness … have been undermined in recent years." Most of the asylum seekers had turned out to be genuine refugees. There had been a major drop in the numbers arriving. We had come to recognise the harm of being in detention for long periods, perhaps indefinitely. "Revelations about the treatment of Cornelia Rau shocked us all".[41]

"The government, to its credit, did respond" and "the Prime Minister announced a program of significant measures". This new bill, however, "proposes a radical change to the framework that the Government committed to a year ago". If is passed:

1. *All "unauthorised" arrivals would have their claims assessed in offshore centres, regardless of where they landed.* In practice, some critics commented, the whole country would be "excised".[42]

2. *The position of children and families would again be in jeopardy.* "If Nauru agrees, the government will establish what it calls a village where women, children and families can live so that they are not in the processing centre. The village will have a fence around it …. patrolled by private security personnel".[43] The Nauruan government could also confine residents to their homes for an indefinite number of hours a day or days of the week. "The Australian government insists that this is not detention".[44]

3. *Decision-making power would be more firmly in the hands of departmental officers only.* On Nauru, "asylum seekers will not have a right of appeal to an independent statutory body". The Department's decisions, Georgiou reminded his audience, was not always accurate. In fact, 33% of all its decisions (90% of these related to Afghanis and Iraqis) had been overturned by the statutory Refugee Review Tribunal. Now, however, there would be no guaranteed statutory body, no "legislated framework of accountability". No reminder was needed of how poorly-based decisions by Departmental officers had been in relation to people such as Cornelia Rau.

4. *Indefinite detention was now more likely.* Other countries were unlikely to take those assessed as refugees. There had been set no explicit timetable for considering resettlement in Australia if no others volunteered. "The Minister would have a non-compellable, non-reviewable power to grant a visa if this would be in the public interest".[45]

5. *The decision to excise Christmas Island was based on the aim of deterring people smugglers who would avoid landing on the mainland.* There is now "no new threat" of smugglers for people coming from New Guinea.

6. *We must act in ways that are legal, honourable, and in*

line with Australian values. "We should not sacrifice Australian law" because of another government's complaints, however "understandable" they are. We need to remember that "taking in a stranger is an ancient and universal virtue". That "ancient and universal tradition is part of our refugee regime in Australia today The ... bill does not reflect this tradition. It does not uphold the deeply held Australian values of giving people a fair go, and of decency and compassion".

"I regret", Georgiou concluded, "that I cannot commend this bill to the House and I will be voting against it".[46]

And the government's response? Howard recognised that he would not have the numbers to have the bill passed. Some would vote against. Some would abstain. Their total number might not be large but, combined with the Labor vote, it would mean a defeat. Public opinion was also less supportive than before, if only because Australians found it less easy to "react to Papuans today" in the same "xenophobic" way they responded to Afghans and Iraqis in 2001.[47] A feeling of goodwill toward "the rebels" seemed also to be in place, plus resentment about pressure from Indonesia: enough for Kim Beazley, the leader of the Labor Party at the time, to describe the bill as a case of "Australian sovereignty traded away to appease another country".[48]

The outcome was withdrawal of the bill. No amendment would be offered. "The whole bill is out. I'm not saying that at some time we won't look at this or that aspect I believe in this bill but ... I accept that there aren't the numbers to pass it, and I'm a realist as well as a democrat".[49]

There would be, Howard continued, no negative actions taken toward the dissenters: "We are a broad church". And, after all, Nauru would remain as a resource for those "who arrive on excised islands". "The existing laws would be maintained and used to the full extent".[50]

Later Outcomes: Ripple Effects

Two further outcomes emerged, both notable as changes to watch for. One of these was a *spread of concern about indefinite detention beyond the context of asylum seekers*

reaching Australia. Increasingly, concern has come to be publicly expressed about the position of David Hicks. Hicks is an Australian who spent 5 years in the U.S. detention system at Guantanamo Bay without being brought to trial. The new Director of Military Prosecution (appointed in July 2006) described the treatment of Hicks as "abominable". "I don't care what he's done or what he's alleged to have done. I think he's entitled to a trial and a fair one and he's entitled to be charged and dealt with as quickly as possible. As is anybody".[51]

Even Howard, who staunchly resisted all moves to bring Hicks back to Australia for a specific charge and a proper trial (not the U.S. military trial that could occur), began to qualify his approval of Hicks' detention, commenting that "the acceptability of his being kept in custody diminishes by the day".[52] The definition of "long enough" may vary, but the sense of some limit clearly has voting power.

The second change is *the recognition that the UNHCR has a critical place: these decisions are not purely Australian matters.* The media account of events invoking a detainee identified to the public only as Palestinian and as "Hassan" provides an example.[53] "Hassan" had been in detention for almost 5 years. He had "exhausted all his Australian legal avenues for claiming asylum and was deported". That action, however, occurred "without his lawyers realising what had happened. They discovered (the next day) that their client had left the

39 *Sydney Morning Herald,* 24/03/06

40 David Manne – the Coordinator of the Victorian Refugee and Immigration Legal Centre in a speech given at the Castan Centre for Human Rights Law in Melbourne, 05?05/06. Available at: www.safecom.org.au/david-manne2006.htm

41 Speech by Petro Georgiou in the House of Parliament during the debate on the Migration Amendment Bill 2006: 09/08/06. Available at: http://parlinfoweb.aph.gov.au/piweb

42 For this account, I draw especially from Allard and Skegan, *Sydney Morning Herald* 24/03/06; Michael Gordon, *The Age* 15/04/06; David Manne op.cit. and Petro Georgiou op.cit.

43 Speech by Petro Georgiou in the House of Parliament during the debate on the Migration Amendment Bill 2006: 09/08/06. Available at: http://parlinfoweb.aph.gov.au/piweb

44 ibid

45 ibid

46 ibid

47 Michael Gordon, *The Age,* 15/04/06

48 Media Release by Kim Beazley 13/08/06

49 Howard cited in *The Age,* 14/08/06

50 ibid

51 Cited in *The Sydney Morning Herald,* 03/01/07

52 ibid

53 All comments from a report by Joseph Kerr and John Paine, *Sydney Morning Herald,* 06/09/05

country". The deportation took place also despite an earlier request by the UNHCR that it be informed if "Hassan" was to be deported (UNHCR had been asked the previous year to consider his case).

Deportation was actually stopped in Dubai, "at first for 24 hours while his lawyers spoke to him" (they had applied for a court injunction to stop the deportation) "and then for a further 48 hours after a request from the UN High Commissioner for Refugees". UNHCR provided fresh information on "Hassan's" national origins, "prompting Australia to fly him back to Sydney. He is now in Villawood detention centre".[54]

Over and above the drama of the block at Dubai (drama that helped the incident to be newsworthy), what stood out was the lack of effective links between the Department and the UNHCR. Meeting a UNHCR request is still at the Department's discretion. In the words of a Departmental "spokesman ... the fact that the case was under investigation by the UN did not bind Australia". The department did inform UNHCR of its decision to deport, but that notice was apparently not received "until 22 hours after the deportation". In effect, the Department's "culture" would still appear to be one of a strong preference for unilateral decision-making.

Set against that negative indicator of links to external bodies being accepted as important to establish or maintain, however, is the fact that the event did receive attention outside the Department and beyond Hassan's legal aides. A question was asked in the Senate (by the Greens Senator Kerry Nettle). The incident also was treated as worthwhile "news", with a headline given not to the block on deportation at Dubai but to the interaction with the UN: "UN inquiry failed to halt deportation".[55]

A Final Comment

The preceding two chapters have pointed to some general features of dissent and change, using the nature of circumstances and specific points of change as ways in which to dissect what occurs and what is sustained or chipped away, and to point to the need to monitor events over time. What is achieved in one year is not necessarily still observed in another. Media attention changes. So also do public sentiments, dissenting voices, decision-makers and decision-implementers.

The relevance of those analyses would be diminished, however, if they applied only to one country. In earlier chapters, Norway has been used as a benchmark for broader relevance. I return to it again in the next – the final – chapter, with events there used to bring out the relevance beyond Australia of the proposals outlined in Chapters 2 and 3 and then anchored and extended in the events described over the chapters that followed: proposals not only about competing frames, contest, dissent and change but also proposals about the significance of geographical, historical, and cultural contexts.

54 ibid
55 ibid

CHAPTER 10

Extensions: Other Countries, Continuing Questions

THE OVERARCHING AIM in this analysis has been to link representations of events related to asylum seekers and refugees with general analyses of how events of any kind are reported, read, or framed.

That linking benefits both sides. Representations of border-related events benefit by being placed within a larger body of analyses, promoting a deeper understanding of those representations. The larger analyses point, for example, to the need to always consider competing frames or definitions, the interplay of sources and media, the nature of expected audiences, and the ways in which initial accounts come to be challenged, sustained, or changed. They point also to the value of asking about contextual features that are likely to make a difference to the way accounts are shaped or received: features such as the presence of particular audiences, the way past events of this type have been handled, and the likelihood of particular dissenting voices being raised and heard.

In the reverse direction, the analysis of representations in general benefits from being anchored in some specific content. Such anchoring provides an opportunity to observe how general proposals work out in practice and to expand them. That way of proceeding – using particular content areas as an anchoring base – has a long history in analyses of how events or people are represented. The content areas turned to have ranged from political events to the ways in which people of "colour" are portrayed in the press, novels, film or television. The content area turned to in this volume – events related to asylum seekers, refugees and borders – have two particular advantages. They allow one to watch the use of two contrasting frames, the shape of initial frames and of dissent ("control" and "compassion"), the impact of events being part of "news culture", and – because they are continuing stories – the nature of change over time.

In pursuit of the double aim, the procedure up to this point has been one of looking at events that have occurred in a particular country, with attention to events over time in that country. A second check consists of asking whether the representation of events in some other place – some other country – has features similar to those noted for Australia. We should not expect the representations to be identical, in kind or in timing. Checking for similarities or differences in pattern, however, would provide a way of following through on the usefulness of what has been learned from the first anchoring base. It would also provide a base for asking, in relation to any series of events: Have some general principles and some specific guidelines emerged that indicate what to watch for as events continue to unfold?

This chapter turns first to some changes within Norway. The Norwegian setting offers a way of checking whether the implications and the manoeuvres we have come to be alert to in the course of examining Australian events will be useful when we turn to other places.

Does change, for instance, emerge again in the form of shifts in the balance between "control" and "compassion"? Is tension again often associated with who makes the decisions or is seen as the right person to make them? Is there a point where media input or media pressure is especially marked? Whose are the dissenting voices? Are dissent and the push for change focused on people "at the gates" (e.g., the size of the possible refugee intake), or on those already within the country, either as residents, entry-seekers being processed, or people marked for deportation but with no place to go? To the extent that questions such as these can help chart and highlight events and accounts in other countries, I extend what has been learned from exploring one particular series of events.

Between the two countries there are both similarities and differences. Among the similarities are commitments – at least in theory – to international obligations, a drop over time in the number of asylum seekers (allowing any government to claim success for its part), a rise in the challenges presented by those who are "non-returnable" and in distinctions between the "legals" and "the illegals". Similar also is an underlying concern with homogeneity and cohesion within one's society, accompanied by the wish to avoid any tag as "racist", and by the wish to see oneself (and be seen by others) as humane and as respectful of law and human rights. Among the differences are some aspects of geography. There is not, for instance, the same sense that there is in Australia of an open, unprotected coastline and of being "over-run from the north". The difference that seems especially important, however, is related to the nature of political divisions and the possibilities of dissent being expressed by members of political parties or converted into action by them. Major also is the direction of a shift: in this case from an initial emphasis on compassion and inclusion to a later emphasis on control and exclusion, calling in its turn again for some sympathy and moderation.

Some details on political patterns form then the first part of this chapter. It is followed by the chapter's main core: an account of Norwegian shifts. For a final section, the chapter turns to a set of continuing questions. These are questions prompted by the events considered throughout this volume and relevant to future analyses

of representations: representations of asylum seekers, refugees, and borders and representations of all events that call for a closer look at competing frames, appeals to various audiences, and points of dissent and change.

Political Parties: Some Australian Features

Between Australia and Norway is a large difference in the nature of political parties. Australia has two main parties, known as Labor and Liberal. Whoever leads those parties automatically becomes Prime Minister. The party usually referred to as Liberal is in fact a long-standing coalition (Liberal and National, with the latter – once known as the Country Party – having a predominantly rural base). The National group is by far the smaller partner. The Nationals have also only once voted differently from their senior partner (and even then only some of its members have done so). The Greens and the Democrats are both small parties. Their votes tend to shift depending on the issue, but their preferences are often closer to the positions of Labor than to those of the Liberals. A further small and relatively new party – the Family First Party – usually votes with the Coalition. A small set of Independents tends to shift positions with the issues at stake. The overall effect, however, is one of alliances and coalitions having less significance and being less likely to shift than is the case in several European countries, including Norway.

Within Australia then there is often the expectation that major shifts in policy would come if Labor were to regain power, ending the 10-year run that the Liberals have enjoyed (Labor was last in power from 1993-1996). The likelihood of that occurring where asylum seekers are concerned, however, is undercut by Labor also having in the main followed rather than challenged Howard's position on "illegals". Labor introduced mandatory detention when it was in power. In addition, the Labor leader during the dramatic events of 2001 (Kim Beazley) took a "me too" position toward the interception of "boat people". He deplored the way it was being done but not the policy itself. Even if reservations about future policies or accounts were felt by members of the Labor party, it appears, these be might left unvoiced if they placed the Party in danger of appearing "soft" rather than "firm" or "resolute". That

danger was certainly felt strongly in the election period of 2001: "None of Beazley's frontbench was willing to challenge their leader ... Too deeply ingrained in their political thinking by this time were the electoral consequences of appearing soft on asylum seekers".[1]

Change now seems more likely to come from a shift within sections of Labor or Liberal (more may now join or support the Liberal's "rebels", for example), or from a shift toward greater power in the hands of the small groups of Independents, Democrats, and Greens. Within any party, change may also come from the sense that the mood in the voting public is changing. That change might be toward recognition that detention conditions need reform, that the country can tolerate or even benefit from enlarging its refugee intake, or even that being flexible when circumstances change does not mean "being soft". How far such changes occur, and how far they influence voting patterns in widespread or local fashion, remains to be seen. One thing, however, is certain. No member of the small parties (no Independent, Green, or Democrat), and no member of a party without the majority of Parliamentary seats, can become Prime Minister or even a Minister responsible for a Government Department. Any country that allows a different pattern will inevitably follow a somewhat different course.

Clear also is the significance of who leads the dominant party. Australia has been unusual both because it has so insistently claimed the need for "border protection" and because its recent history has often been one of resistance to change. That record of minimal or slow change in the face of criticism, it has been suggested, may reflect in part the calibre of a particular leader. John Howard, it has been noted, is not a man who has made easy changes from his first description of border-related events. He could, for example, have modified his first description of "children thrown overboard", and still won the election. He "chose, instead, to stick to his guns though he knew the evidence for the original story was evaporating",[2] and he was under fire from a variety of directions:

"With his credibility in doubt over the children overboard claims, he found himself dealing with a press corps sniffing blood, furious public service mandarins, carping bishops, public enemies in the Liberal camp and disgruntled Navy officers who had at last found their tongues".[3]

That persistence on Howard's part has not been the case on all issues. After the election in 2001, for example, Howard made a distinction between what he called "core promises" and "non-core promises". Flexibility and change were appropriate for the latter. On border-related issues, however, he made changes only when Georgiou and his group threatened to bring private members' bills to Parliament.

His refusal to change may reflect his style or his sense that the majority of the voting public would approve of his "firm" and "resolute" stance. It will be worth noting, however, whether policy statements and actions change if and when Howard ceases to be the Liberal Party's leader. Unlike the President of the USA, an Australian Prime Minister can remain in that position until he chooses to step down, the party as a whole loses an election, or the party decides to change its leadership. All of those paths are still open, but the political patterns make policy change by the Liberal Party seem less likely than staying with the status quo.

Changes within Norway

We set aside from the start the notion that changes within Norway represent any "copy-cat" response to Australian shifts or "solutions". Human Rights Watch has certainly drawn attention to the readiness of some Australian Ministers to bring their "model" to the attention of Ministers in other countries. In a briefing paper, "Not for Export", they noted that in 2002 Philip Ruddock was touring several European countries, promoting Australia's "model":

"In a global political climate characterized by xenophobia and hostility toward migrants and asylum seekers, and a widespread desire to tighten borders and restrict entry, Australia's message has had some

1 Marr D. and Wilkinson, M. (2004) *Dark Victory.* Sydney: Allen & Unwin: 320
2 Marr & Wilkinson (2004) Op.cit.: p. 337
3 ibid: 366

resonance …. Austria, the United Kingdom and the Netherlands, for instance, are presently debating conversion of previously open reception centres into closed door detention facilities".[4]

To bring out Norwegian border-related events and representations, this overview is divided into two parts: one focused mainly on the years of 2001 – 2002, the other on later years (2004 – 2005 especially). It starts with a particular circumstance. As in Australia, this was again an election. The outcome of that election was a shift in the relative degrees of power held by several political parties, with a particular gain in strength by an anti-immigration party (the Progress Party).

To be noted first is a feature of the political pattern. Norway has a sizeable number of political parties (9, with 4 of these being the largest). Alliances are usually needed in order to form a government and decide on a Prime Minister. A small party then can wield considerable power. These alliances can also shift from one time to another.

In the 2001 election, for example, the Conservatives (Høyre) won the majority of seats. A member of the Christian Party, however (Kjell Magne Bondevik), became Prime Minister. In addition, Norway's anti-immigration party, the Progress Party (led by Carl I. Hagen) was now in a strong position to influence the choice of Prime Minister and the Centre-Right Coalition:

"With Bondevik as Prime Minister, the Conservative Ministers Per-Kristian Foss, Victor Norman and Erna Solberg put on track a sharp move to the right for Norway which is very much in Carl I. Hagen's spirit … After an extremely hard fight, he got his second budget agreement with the Government. A few billions were moved around, but most important for Hagen were some structural points in the agreement with the government. One can read these points as a government plan to bring in a number of Hagen's flagged interests".[5]

Several changes to immigration policies took effect in 2001 and 2002. One was a slight liberalisation of the rules for work related immigration. This included a quota of 5000 specialists from countries outside of the European Economic Area. The second was a reduction in financial support for asylum seekers whose applications had been denied but were still in the country, often because they could not be "returned". The third had to do with the timing of decisions and their consequences. The processing time allowed for presumed "groundless" asylum seekers or those with a criminal record was reduced (there was then less room for appeals). Legislation assuring permanent residency if processing was not completed within 15-months was removed.

Children and families, however, were to be given special consideration, at least when it came to being fed:

"It may be possible to introduce a packaged food system like they have in Denmark. Or the asylum seekers who have been refused asylum may be gathered in transit centres … where they are given food in the canteen …. they will also lose their work permit, rights to Norwegian education and other goods. But no-one will starve in Norway and we will make sure that children do not suffer".[6]

Later changes were even more strict. They were also more clearly responsive to media pressure. The conservative newspaper, *Aftenposten*, for example, ran a post-election "campaign" against "slack" government policies, with this slackness seen as often damaging to Norwegian society:

"*Aftenposten* has many times written about criminal asylum seekers, most of them with groundless applications, who use the 'waiting time' to, amongst other actions, gut Norwegian shops …. The Government has removed the allowance for the asylum seekers in Norway who have not been granted asylum, but in the waiting time many have been able to take on black work or get money in other ways".[7]

In what has been described as a "scramble to be the toughest in immigration policy",[8] all parties supported the increase in restrictions, particularly in relation to the so-called "groundless" asylum seekers from Eastern Europe. Two newspaper reports provide examples of moves that were clearly seen as newsworthy:

"One after the other the resolutions by the Progress Party fail. But words such as 'tightening' and 'restricting' are on everyone's lips when the Parliament discusses immigration and integration".[9]

"Restrictions and tightening made up the common melody when the Parliament yesterday discussed a large bundle of immigration policy themes: Requirement of pledges of allegiance to the Constitution, forced marriage ... criteria for family reunions, double citizenship, financial support for religious communities The Progress Party is far from being alone in this reining in Together with The Progress Party, the Socialist Left wants all weddings that are to form the basis for family reunion in foreign countries to happen in a Norwegian Embassy or Consulate The Labour Party and The Progress Party want to have a 'tightening of the meaning of family' in family reunion cases. The two parties want to consider other forms of 'sanction' with regard to criminals with dual citizenship The Labour Party, The Progress Party, The Conservatives and The Christian People's Party noted that 'religious leaders from a number of religious communities had spoken out in a way that shows a lack of Norwegian knowledge together with a lack of knowledge about Norwegian society and culture'. Such elementary knowledge will be required before the communities receive public support".[10]

The move toward tightening was reflected also in the "six months in Parliament" speech given by the Prime Minister. Bondevik gave immigrant crime and the need to be "less tolerant" prominence in this speech. He opened with a concern about the way Norwegians felt "depowered" in a "continually harsher and more complicated society". The Government now wished to work toward "a simpler, safer and freer daily life for Norwegian men and women". The Government was to focus more on "taxes ... bullying in schools, the health system ... littering of public spaces and, as has been a hot theme this week, criminal asylum seekers and immigrants".[11]

Criminality was certainly a strong theme, firmly located in people other than "us":

"From the time we took over government we have made it clear that we will not accept or be silent about criminality amongst foreigners and immigrants in Norway. We are working to make it possible for the police ... to go into the fingerprint archives of foreigners who have sought asylum in Norway. The police have expanded powers to search people and cars to find weapons. There shall be a stricter punishment for the use of knives. People with presumed groundless asylum applications shall be sent to separate centres with quick processing. Those without reason for asylum will be told quickly to leave the country We are working for a more effective deportation of those who have received a negative response".[12]

What prompts such negative views of "foreigners and immigrants"? One basis was the nature of the stories made prominent in media reports. That emphasis and that basis were, for example, part of a comment in an essentially conservative paper:

"A change in climate has happened in the immigration debate. For a long time FrP (the Progress Party) has had this case to themselves, with their demands for stricter policies, while the other parties sought to distance themselves from FrP. The recent focus on genital mutilation, honour murders, forced marriage, arranged marriages for children and gang criminality makes it no longer possible to pretend that immigration and integration policies don't bring problems with them".[13]

Media representations were also explicitly recognized as a source of pressure by Anita Appelthun Sæle (Christian People's Party), together with the hope that the media

4 Human Rights Watch (2002a) *"Not For Export": Why the International Community Should Reject Australia's Refugee Policies* A Human Rights Watch Briefing Paper, September 2002: 6-7

5 Halvor Elvik, *Dagbladet*, 28/12/02, under the headline: "Most Powerful Without Power".

6 Solberg, *Aftenposten*, 14/01/02

7 *Aftenposten*, 04/02

8 *Aftenposten*, 19/04/02

9 ibid

10 ibid

11 Statsminister Kjell Magne Bondevik, *Norge i fornyelse*, Aftenposten 18/04/02

12 ibid

13 *Aftenposten*, 24/04/02

would soon turn to other topics:

"This is a problem we cannot deny, that the Parliament has a crisis oriented approach to these cases. This debate is triggered by the media's documentation of violence and force, of circumcision and honour murders. But soon the camera lenses will look in another direction and then it is important that the Government gives priority to improved integration – in the months when the media do not force us in either action or attitude".[14]

In all, this post-election period was one where the control of "problems" – problems seen as created by "foreigners" already in the country – was dominant. References to "compassion" were strikingly absent. That imbalance, however, was bound to be a source of tension sooner or later. The Christian People Party described itself as a "Party of Compassion". Increasing restrictions on asylum seekers were an invitation to tension within the party and outcry from traditional backers such as the Church.

The Years 2004 – 2006

This period stands out as a time when calls for compassion showed a sharp rise. Of particular interest then are, as in Australia, the voices expressing those concerns and the circumstances that prompted them.

One of those circumstances was the Governments' proceeding to new restrictions, even though this was a time when the size of the problem – at least as measured in numbers – had dropped. As in many parts of Europe and in Australia, the number of asylum seekers arriving in Norway had fallen dramatically: from 17 480 in 2002 to 15 049 in 2003. At the same time, "presumed groundless" applications had fallen from 30% in 2002 to 5% in 2003.[15]

The drop in numbers attracted competing explanations. The reason, according to one conservative Member of Parliament, lay in the success of the Government's policies. Not so, said NOAS (Norwegian Organisation for Asylum Seekers). A newspaper report summarises the differences in position:

"In an interview with *Dagbladet* 18/10 … Erna Solberg

explains the major reduction in the numbers of asylum seekers without mentioning what is … the most important reason for the reduction. NOAS agrees with the Minister that a quicker processing of so-called 'obviously groundless' asylum seekers has led to a reduction in the number of applicants from some countries. NOAS has also been positive about initiatives aimed at reducing the number of (groundless) applicants from countries in Eastern-Europe. The reduction in applicants from Eastern Europe, however, took place mainly in 2002 and in part in 2003. The reduction from 2003 to 2004, which *is almost 50%* (against approximately 20% in Europe in general), is based primarily on a restriction of practices towards asylum seekers who are coming from areas of conflict such as Somalia, Chechnya and Afghanistan. Despite the fact that conditions have not become any better there … and despite the fact that the UN's High Commissioner for Refugees advised against it, we have seriously restricted the possibility of asylum seekers from there gaining protection in Norway. When Norway has to a great extent denied asylum applicants against the UN's advice, this will naturally lead to a lowering in the number of asylum applicants".[16]

Contributing to such actions was a concern with costs. In the words of Erna Solberg, "the budget rests" on a reduction in the number of people applying for asylum in 2004:

"To be able to reach this result, the Government launched a new package of restrictions …. The following initiatives were enforced from January 1:
- 48 hour processing for asylum seekers from safe countries.
- Offer of shelter is refused after final processing is negative, with the exception of families with children.
- Allowance is removed in the first transit phase for those who have received a final negative result and have stayed beyond their deportation deadline, as well as for asylum seekers who do not assist in clarifying their own identity. The Government also received Parliament's support for a proposal to lower the threshold for deportation in asylum seekers. This means that for-

eigners can be deported for criminal activities with a lower level of sentencing than previously".[17]

Noted also was a move toward more marked and more central political control over immigration and asylum policies: "There has developed a need for better coordination between political goals and the immigration office's priorities and practice. There is therefore a need for a greater level of political direction".[18]

These changes had several consequences. The Ministry for Local Government could now have a stronger influence over departmental decisions. The lower level of sentencing that would call for deportation meant that any illegal activity that received a three-month sentence could lead to being sent out of the country despite family ties. The forced removal of failed asylum seekers from shelters and the withholding of financial assistance to those who could still not be deported had the most visible effects. People who felt they could not return despite their deportation orders could now be found, and seen, living on the streets in Norway's cities. The consequence was also a rise in dissent.

Reactions to the Restrictive Policies

From NOAS (the Norwegian Organisation for Asylum Seekers) came a strong negative assessment:

"Never before has Norway witnessed a greater tightening in asylum policy than that under the existing Government ... the restrictions over the last year have been so many, and so profound, that there is reason to talk of an 'annus horribilis' It is particularly the dropping of the right to food and shelter when an asylum application is refused which leads NOAS to react".[19]

"To refuse asylum seekers food and shelter is one of the most brutal instruments to be used in Norwegian asylum policies. Refused asylum seekers who are scared to return home now shall simply be starved out of the country. Even more paradoxical is the fact that this includes a number of refugees from Ethiopia. We have seen them starve on our TV-screens – now we shall se them starve in the streets of Oslo, Bergen and Svolvær We have documented for Parliament

and the Government that those who shall now be put on the streets and who have now for a while been refused food, include victims of rape and torture and previous political prisoners".[20]

NOAS also commented negatively on the "politicising" of the asylum approval procedures:

"The Government's suggestion is a loss for those of us who have wished to maintain the individual refugee's application for shelter as a sober, judicial and human rights issue rather than a heated and political one. To the extent to which the right of asylum will be carried out in a correct and defensible way in Norway will, with the suggested model, depend to a great degree on the current Minister ... and will be wildly different with a Dørum, Solberg or a Sandberg in the ministerial office. The individual's possibility of asylum should not swing as often and as strongly as the political debate".[21]

Negative reactions came also other non-Government sources, including the Bishop of Oslo, Gunnar Stålsett:

"The asylum policies remind one more of brutality than humanity. It is completely clear that it is the Government in total that must answer for the asylum policy. They have a collective responsibility ... I know that deep within the Christian People's Party there is concern about the refugee policy".[22]

From within that party (the party to which Bondevik belonged) there did indeed come public reservations. In one gentle expression of dissent:

"I think that we should take a position where we are heedful of the High Commissioner's proposals

14 *Aftenposten*, 24/04/02
15 Tjessem and Berglund Steen, *Dagbladet*, 08/10/04
16 ibid
17 www.hoyre.no accessed in April 2005
18 ibid
19 Berglund Steen from NOAS in *Dagbladet*, 11/09/04
20 Tjessem, press release for NOAS, 20/06/04
21 Tjessem and Berglund Steen from NOAS in *Dagbladet*, 08/10/04
22 *Dagbladet*, 11/09/04

... and I feel concern that we are not in lines with his suggestions ... Despite the fact that the UN High Commissioner for Refugees recommends not pushing Iraqi refugees home, they are still having their rights to food and shelter taken away from them after their applications for asylum have been rejected".[23]

Reactions from the Left were stronger: "To refuse people food and a place to live is an inhumane policy. The Christian People's Party must also be held responsible. As long as they sit quiet as mice, it seems that they have lost their core values of compassion and humanity".[24]

Some newspapers also reacted to the new policies with condemnation. *Dagbladet*, for example, ran a series of articles in early September about individuals who were "victims" of the new asylum policies. That series included a story of 19-year-old Yawar Sultan who drowned himself after a month without shelter or food.

Confronted with a question by *Dagbladet* as to whether this action was a consequence of the asylum policies that the Government had brought in, Prime-Minister Bondevik expressed concern:

"Of course it is not. If anyone is in danger, one must take the consequences of that. Then they will of course get shelter. But one cannot always judge this in advance. To save lives is always the overriding principle. We don't send people back if we think that their lives are in danger. In total I think Norway has a humane refugee and asylum policy".[25]

As the number of people living on the streets increased, however, individual councils also began to react. Some, such as the city of Trondheim, began to offer emergency assistance. The Minister for Local Government, Erna Solberg (Conservative Party), responded with derision:

"If local politicians want to make Trondheim Somalia's largest city, by all means. But myself I don't think that is a very good idea. I say that because that will, in practice, mean free immigration for people from Africa's horn. It will be interesting to follow free-state Trondheim".[26]

Somalians, claimed Solberg, were simply here "to get a better life".[27]

The sight of people living on the street (including the street where many of the national newspapers had their head offices) led, however, to a negative reaction even within the conservative media. At stake was the extent to which different "views of humanity" would prevail:

"Political leaders in Trondheim, Bergen and Oslo reacted to the Government's position that asylum seekers who are to be sent out of the country shall be refused all forms of help. The conflict is an example of what sort of divisions can arise between local and central authorities. The consequences of how it is solved depend in the end on what sort of view of humanity we subscribe to So-called unreturnable asylum seekers are of course a problem. Some are left in a hopeless no-man's land, because they may not stay, but they also have no place to be sent to.

Statements from the Ministry for Local Government note that these people also have no right to emergency help. It is here that the conflict with the councils arises. The councils are bound by the law of social help: A regulation, which is an important founding stone in our society. Whether it is the Progress Party's bureaucracy in Oslo, or Labour's representatives in Trondheim, they all react in the same way: People in our communities and in dire need shall receive help".[28]

At stake also were the relative powers of local councils and central Departments or Ministries:

"Erna Solberg does not want a strict Norwegian refugee and asylum policy undermined by individual councils or local communities who work from different criteria. She has a point there. Even if the towns themselves support the UN's view, this doesn't provide a basis for setting their own policies.

That means that the main question is how the daily practicing of policies harmonises with Norwegian laws and regulations. In our view, it is the councils' understanding of their own responsibilities of people in need that shall be placed first. It is an important part of our founding values".[29]

Council and media reaction peaked around Christmas

time, 2004. The image of homeless on the streets did not harmonise with the festive season or with Norway's self-image. The Prime Minister and the Social Services Minister, Høybråten (also from the Christian Party) both stated publicly that help would be offered: "It is our moral requirement, no matter what is stated in laws and by-laws, to help people in acute desperation. We shall help!"[30]

The central Government, and the Minister for Local Government (Erna Solberg), eventually backed down, offering shelter in hospices for those who were to leave hostels after their applications were rejected, together with 60 kroner a day to cover all basic needs. In a sign of change also toward those outside the gates, the Government also increased, in 2005, the number who would be granted asylum:

"For a long time, Norway took 1500 a year but the Bondevik government halved the number in 2002. When the Bishops, among others, protested, the Government increased the number to 1000 this year".[31] Compassion was apparently not to be restricted only to those who were visibly starving on one's own streets.

A Continuing Contest

From events in 2006, I take an event that brings out the way the frames of compassion and control or safety continue to be contested after each apparent settlement. Continuing also, and always worth monitoring, are the emergence of dissent and of struggles over whose shall be the deciding voice.

These events revolve around a hunger strike that began with a group of 23 Afghanis and expanded to at least 60. The strike was in protest about orders that they should leave the country after their applications for asylum were turned down (the start of the strike – May 26 – was the scheduled day for return). All had been offered transportation back to Afghanistan and 5 000 Norwegian kroner as "start capital", plus assistance from the International Organisation of Migration on return. All 23 had declined. They rejected not only the Government's offer but also the argument that it was safe to return: "It is not safe for us in Afghanistan

we cannot return. We fear for our lives".[32]

This hunger strike might have gone unnoticed. The strikers, however, had chosen a prominent place to make their point. They set up tents outside the Oslo Cathedral in downtown Oslo. Priests attached to the Cathedral felt they should be prepared to help. The City Council grew concerned about "unsanitary conditions", pointing out that there "is a single toilet ... and that is closed at night".[33] On those grounds alone, Council could ask the city police to move them to some other spot. From the Council's point of view, however, "it is up to the Norwegian Government to solve the underlying problem".[34]

The Government, however, had a different view: one bolstered by there being, in this newspaper account, "approximately 2 000 Afghan refugees in Norway without permission to stay".[35] It stood firm. So also did the hunger strikers until the end of negotiations during the 26 day hunger strike: days in which the media regularly reported the numbers who grew weaker, were given medical treatment, or taken to hospital.

Into those negotiations entered people with several backgrounds. An early contributions was the president of the *Norwegian Red Cross*: Thorvald Stoltenberg (speaking independently of his son, Jens, a member of the Labor Party who had in September 2005 become Norway's new Prime Minister). Joining him were representatives of a refugee aid group (*Flyktninghjelpen* – The Norwegian Refugee Council). A UN delegation also took part in some of those meetings, "after the hunger

23 Ivar Østberg, Member of Parliament, in *Dagbladet*, 11/09/04

24 Socialist-Left representative Karin Andersen, cited in *Dagbladet*, 11/09/04

25 Bondevik cited by Raanes in *Dagbladet*, 11/09/04. In fact one further change in policy was an opening up of deportation to countries where torture or the death penalty is likely or allowed. This change was made in 2002. *Aftenposten*, 04/03/02

26 Solberg in *Adresseavisen*, 18/09/04

27 Cited by Berglund Steen in *Klassekampen* 05/11/04. According to UNCHR, however, Somalians from southern Somalia, where most of the asylum seekers were coming from, were in need of international protection

28 *Aftenposten*, 22/09/04

29 ibid

30 Cited by Lillevold in *Dagbladet*, 24/02/05

31 *Aftenbladet* 04/05: The power of Bishops may be partly a function of Bondevik's being a priest as well as a Prime Minister

32 Statement by spokesman Zahir Althari cited in *Aftenposten* 31/05/06

33 Oslo City Council Leader Erling Lae cited in *Aftenposten* 31/05/06

34 ibid

35 *Aftenposten* 31/05/06

strikers demanded UN participation".[36]

The Outcome?

The Prime Minister continued to "stand firm". He "refused to order a new review of their individual cases, claiming that hunger strikes can't be used to change immigration policies in Norway".[37] Two members of the Left-Centre Government, however, opted for change. They were the Minister for Finance (Kristin Halvorsen) and the Minister of Labor and Social Inclusion (Bjarne Håkon Hanssen). The end-result was a distinction between parts of Afghanistan: "no Afghans from outside the capital Kabul shall be sent home before the end of the year at the earliest".[38] (Kabul was regarded as an area that the current government did control). In addition:

> "All Afghan refugees will now receive legal aid to reassess the grounds for rejection of asylum. The Government also promised to abide by the United Nations High Commissioner for Refugees (UNHCR) recommendation for returns to Afghanistan, and that no one would be sent back before the UNHCR considered it safe".[39]

The Afghan spokesman "characterized the decision a victory for both the refugees and the Government".[40] The Minister for Labor and Social Inclusion (Hanssen) offered a comment more in line with what was also a standard reform in Australia: The policies have not changed, just some of the implementation procedures "the Afghans had not achieved asylum via the strike, just an opportunity for assistance in examining their case".[41]

At base, they were no longer in public and highly visible view. With a restriction to Kabul, they also began to be no longer in Norway. Shortly after the hunger strike – in August, 2006 – Afghanis began to be deported to Kabul after a brief review by the Immigration Appeals Board (Utlendingsnemnda). By the end of 2006, 73 Afghanis had been deported, while 4 had received further asylum.[42] Among groups concerned with the status of refugees, there was still concern as to whether thorough reviews were carried out.

Questions to Carry Forward

The Norwegian events have highlighted again the need to consider any series of events in terms of distinctions among people (e.g., "legal" and "illegal" refugees), the forms taken by dissent, the effects of particular contexts, and the nature of justifications (e.g., referrals and framing in terms of "control", "compassion", "security", and "rights").

This final section takes up a second way of extending what is learned from the analysis of any specific series of events. It does so by referring to the general proposals about representations of any kind, first offered in Chapters 2 and 3 and picked up again at various points in the course of anslysing specific events. The return notes both what we might now be alert for when analysing any other set of events and what we would now add to the general proposals first offered.

As a general principle, for example, there is value – when ever we deal with a series of events – in being alert for both the forms and the circumstances of stability or change. If there has already been some movement toward change, for instance, will those moves increase, go no further, or fall away in the course of a reversion to an earlier state: to an earlier "hard line", say, with "tight controls"? More specifically, we might watch for change in the lives of specific people, the shape of decision-making norms and procedures, and the framing of representations (e.g., the use of particular kinds of justifications for the actions taken). Among the circumstances of change we might be alert to are the ebb and flow of populations, the relative power of various political parties or dissenting voices, and the occurrence of events (bomb attacks in other cities, for example) that act like catalysts, prompting moves that take change further or reverse it.

In general also, we should expect to find that the analysis of any specific set of events will extend the proposals or concepts that are already contained within past analyses. We should be able, for example, to add to ideas about competing frames, how people maintain their position as "leaders" or "primary definers", concepts of "control", the management of dissent, and the significance of contexts.

The starting point is a return to Proposal 1: All events

may be represented in more than one way, with an ensuing contest between competing frames and attempts on each side to make that representation be the one most attended to or accepted.

Proposal 1. Competing Frames and the Management of Contest

The several chapters have brought out some recurring forms of contest. One is between positions that are "hard", "firm", or "resolute" and positions that are "soft" or "flip-flopping" (being "flexible" can be risky). Another contrast, often overlapping, is between definitions of problems in terms that are essentially people-oriented and terms that are not people-oriented (e.g., the real problem is territorial "integrity" or financial costs).

The first competition – "hard" vs. "soft" – is one that Gramsci's analysis of leadership would lead one to expect.[43] To maintain a definition of events that keeps a population in line with one's views, he argued, those who wished to lead needed always to demonstrate "leadership". This opposition of terms – claims of being "firm" while one's opponent is "soft" – should then be expected to appear especially in Parliamentary debates and at time close to election: the case both in Australia and Norway.

Is there anything new to be added? Of interest is the emergence of ways in which the proponents of a "firm" position might be persuaded to make occasional breaks from that position, or might legitimise doing so. In the case of SIEV X, for example, Howard was offered – in an editorial – the arguments that victors can be merciful and that he had the "courage" to make exceptions (Chapter 6). His "leadership" was then not in dispute. He himself also presented the changes he made in the wake of pressure from members of his own Party as changes in the implementation of his policies (not in the policies themselves) and as made possible by the success of those policies ("the boats have stopped coming") (Chapter 9). Others might point out that boats had "stopped coming" in other countries also. "More boats" or "fewer boats" coming to our shores, however, is a more concrete sign of success and firm leadership. It is also more likely to be persuasive to audiences content with surface arguments or preoccupied with other concerns or more "newsworthy" dramas.

The second form of competition that has emerged – between people-oriented and other frames – is the one that has received less attention in past analyses. It is certainly especially relevant to any events involving asylum seekers or refugees.

On the face of things, terms such as "asylum seeker" or "refugees" would seem to draw immediate attention to the plight of people: to concerns with what they were fleeing from and what they desperately sought. How then are those concerns, and some sympathy with their position, turned aside?

One way that stands out consists of cutting out terms such as "asylum-seekers" or "refugees". Howard's representations offer a striking example. The term to use is "border protection". Our borders are "extensive", "unprotected", and impossible to keep under surveillance: more so than is the case for any other country. If anyone is under threat or in danger, then, it is ourselves. Under threat also are *our* "sovereign rights". Others seek to take over what should be our decisions: "We shall decide who comes to our country, and under what circumstances". Even the obligation to abide by any past international agreement then readily becomes construed as "interference", as one more threat to "our sovereign rights".

A further way that has emerged with particular clarity consists of defining the situation in economic terms. There are times when opening the doors to new people can be presented as essential for the nation's economic growth, and times when the financial cost – and again the dangers to "us" – puts into the background concerns with the state of those excluded. In related fashion, people can be turned into commodities: into "non-returnables".

36 *Aftenposten* 14/06/06
37 *Aftenposten* 20/06/06
38 *Aftenposten* 21/06/06
39 ibid
40 ibid
41 ibid
42 *Klassekampen*, 04/01/07. The hunger strike had been newsworthy, but the later actions – especially when dissent appeared in legal-style phrasing, were not. Return to Kabul was also seen by many as still dangerous and against international advice. Little media attention, however, was given to the individual deportations.
43 See, for example, Gramsci, A. (1971) *Selections from the Prison Notebooks*, London: Lawrence and Wishart

The risk, however, is that ruling "people" out of the frame can prompt claims that one "lacks compassion", is not "humane": claims that might be made about individuals or about countries as a whole.

Those claims, we have seen, may be met in several ways:

As an individual, I am certainly capable of sympathy. It is, however, directed toward other people. Howard, for example, expresses his concern not for the "children overboard" or the adults in sinking boats, but for the Australian Navy: for those "young men and women" asked to carry out such difficult tasks and doing so in ways that the country should be proud of. Of course we shall "help people in acute desperation" states the Norwegian Prime Minister. And of course we shall give special care to those most in need or most vulnerable: children "shall not starve".

The country's record as a whole is one of compassion. To take a Norwegian statement, "In total, I think Norway has a humane refugee and asylum policy" (statement from the Prime Minister in 2004 – Bondevik [44]). What happens in this particular instance can then be overlooked. Criticism from another country about actions in particular instances can also be deflected by comparing "my total record" with "your total record". *Per capita*, Howard argued in a similar example of such deflection, Australia takes in more refugees than Norway does. Any Norwegian criticism in a situation of the kind that the *Tampa* presented can then be discounted.

The people being talked about are not truly deserving. The distinctions drawn among people or among events are a critical part in any analysis of representations. Those drawn among people have emerged as especially important in the present cases. Not deserving of help or sympathy, for example, are people who can be dubbed as "economic refugees", seeking only the benefits of another country's welfare or higher wages. Somalian refugees in Norway, in one description had only economic interests: they wanted only "to get a better life". The sympathy and help that might go with earlier persecution, hunger or trauma do not apply. The same exclusion applies to people who are outside the law: "illegals", "criminals", possible "terrorists". They do not really care for their children, to take one of Howard's statements.

They attempt to sway our judgements by "moral blackmail" (but we will not be "intimidated"). They engage in "genital mutilation, honour murders …. forced marriage, arranged marriages for children, and gang criminality" to take one Norwegian list. Even when they are not so horrific or are not outside the law, they are "not the kind of people we want to have here". Only when they are visibly homeless on a city's streets, and without food – as occurred in Norway – do they then fall into the category of "must be helped", regardless of the other categories into which they fit.

The people selected for actions of exclusion are those most readily perceived as "not deserving" or "not the kind of people we want". In 2006, for example, Australia strips a man of permanent residency and deports him (to Sweden, where he was born and resided for 25 days) because of a criminal record (Chapter 8). Norway proposes, in 2006, that even a 3-month jail sentence should be grounds for deportation. The debate can then also be quickly moved to the question: should any jail sentence be served here or there?

The people selected for positive action are defined as individuals, deflecting attention from the group they represent and from any change in general policy. This child, for example, we will grant time outside a detention centre. To this adult, we will allow time outside for psychiatric attention. As long as the rest are "coping", then no change should be made. It is then a major contrast when dissenters argue that detention *per se* is harmful, especially when it is prolonged. It should not be necessary to demonstrate severe self-harm or severe breakdowns. It is also a major change when the position taken by the family of a badly-treated detainee (Cornelia Rau) is not that she as an individual deserves apologies or legal compensation. Instead, the critical issues consist of the way detention centres operate and the conditions that all detainees face. That insistence on the group as well as the individualized human face is a major competing frame. It runs counter to any department's goal of restricted change. Unfortunately it also runs counter to the usual focus, in the popular media, on individuals: on people as making news, rather than issues. All attempts to keep attention on both individuals and the group they represent then warrant particular monitoring.

Proposal 2. The Interactions between Contributors to Frames and Contests

The general proposal is that these interactions between media and sources especially are not one-way. They are instead marked by negotiations, alliances, challenges and moves toward control.

Most of the discussion related to this proposal have focused on government sources and on media in the form of the press, television, or radio. The starting point is typically a rejection of intervention being any simple passing-on of information from one to the other (e.g., from government sources to the media). At the least, media representatives seek to place themselves in positions closest to those "in the know", and government sources cultivate some media sources in order to ensure a friendly reception and a helpful repetition of the frames they wish to promote (Chapter 2).

What can we now add to an existing literature? And what stands out as worth monitoring over time or in any new set of events? Noteworthy are the following:

The significance of what makes "news". Individual people make news. Issues do not. Stories stay alive, or "news" stays alive, by constantly "moving on", with a new revelation or a new surprise, or a new shock coming up each day or each issue. Small wonder then that successful campaigns to raise concerns about a group of people – or about a general policy – take the form of a series of stories about individuals. Here, for example, is one child after another in a detention centre. Here is one case after another of long-term and potentially indefinite detention, or of gross departmental error, each contributing to the same message but each a "new" story.

The several forms of control that can be exercised. Control can come from the media. Government's do need a favourable press, especially at election times. More visible, however, are the forms of control that government sources can and do exercise. Highly visible in the events considered in this book is the direct refusal of access, justified by declaring an issue as one of "defence" and an area as "operational", open only to Army or Navy personnel. How that type of action avoids claims of censorship inevitably raises questions. At what point can restrictions on access or on reporting be claimed as

excessive or as not legitimate, or bypassed?

Less obvious, however, are forms of control and utilisation that build on features of the media. Governments can take advantage of media interest in "moving on", pacing the delivery of news so that any "digging in" becomes unlikely. They can deliver news in "doorstop" sessions, inevitably brief and terminated at will. They can, as Howard especially did, discuss events with selected sources on talk-back radio, responding only to primed questions and allowing their interviewers to go beyond what they themselves would say, but would like to have put into words and taken in by their audiences. For those "excess" versions – those expressions that *I* would not use – *I am then not responsible.*

The need to look especially to occasions when the media do "dig in" or stay with a story. "Investigative reporting", in one journalist's view of the current Australia scene, is on the wane: a demise helped by the extent to which government departments pressure newspapers, threaten legal action, express displeasure, or raise objections that delay a story beyond its newsworthy date.

All the more reason then to single out for current and future attention any occasion of persistence. To what extent, we would now ask, is there a recurrence of the kind of sustained questioning that marked the "Children Overboard" affair? Here there was resentment at earlier denials of access (e.g., to the *Tampa* itself and to all associated with the *Tampa* or with the move to Nauru), and no clear basis for making this event "operational" and "off-limits". Here also was the admission that there was some information – some actual footage – that the media might expect to be given but that was tantalisingly "not available" for release, at least "not as yet". Here as well some alternative sources began to emerge. Here – to take one final feature – was an attractive target for criticism. A member of the press might hang back a little from claiming that the Prime Minister had been deliberately misleading. That restriction does not apply, however, to a man already unpopular with the press for his restrictions on access to other material (material related to "union-busting" actions).

The same features might not apply to other occasions. Clearly needed, however, is a closer inspection of other occasions with an eye to bringing out the circumstances that give rise to "digging in" rather than "moving on".

Proposal 3. Audiences Always Matter

Producing a frame, or announcing one's own definition of an event, is an empty step unless others listen, accept the message, or are at least moved by it toward your view.

That aspect of representations has long been recognized. It has given rise to analyses of what other people regard as news, what formats they expect narratives or news of various kinds to follow, what they pay attention to, or remember and interpret what they hear.

The nature of interpretations is the aspect I see as especially highlighted by the events considered. In the wake of Howard's electoral victories in 2001 and 2004, for example, several analysts asked: How could this "dark victory" have been achieved?[45] Did no one read the newspaper accounts of his representations and evasions in relation to "children overboard" or SIEV X? Was no one listening?

One proposal stemming from these analyses was that we need to know more about popular interpretations of what politicians say: e.g., "they all tell lies". A subtler addition had to do with what are regarded as *serious lies* or unacceptably wrong actions (not just mistakes or misdemeanours). Within Australia, at least, those definitions appear to be shifting in the direction of accepting actions that would once have cost a government official his or her job. We need to understand more fully how the level of seriousness or the type of action deemed "too much" changes with regard both to refugees and to all representations.

On the need to monitor and to analyse more fully, for instance, are the underlying assumptions held about what "works", and the distinctions drawn among people ("us" and "them" especially).

Highlighted also is the need to ask when it is easy or difficult to have a statement accepted with little or no inspection. It becomes easier to do so, for example, when the events described take place in areas about which little is generally known. The "far north" of Australia is one instance. Who knows just where these places are or what is closest to what? The difference between being returned from Norway to Kabul or to regions outside Kabul provides another. How much awareness is there that the new Afghani government, so widely described as making it "safe to return", has little control over regions outside the capital?

Events involving legal issues often suffer from the same general lack of any detailed understanding. The differences between temporary, bridging, and permanent residency visas, for example, are not well understood, except by refugees themselves. For most audiences, the critical distinction is between the first "yes" or "no". Legal distinctions and court judgements – that are vital for refugees – outside judgements about levels of compassion – will be followed only by a few, and may readily be seen as flying in the face of "common sense". How, for example, can it be "within the law" to take away a visa that says "permanent residency" and deport someone to a country where they happen to have been born but practically never lived? "The law" and "the courts" can easily be seen as lying outside "common sense", as too complex for anyone but lawyers to attempt to understand, and as not especially "newsworthy". Critical issues such as whether courts or government officials make decisions about deportation, for example, then get less media attention than they deserve and special efforts need to be made to personalise them.

In addition to what lies outside popular knowledge or interest, we need to learn more about popular assumptions. There is, for example, a widely-held assumption that "deterrence" and "examples" are effective. They "work". Governments then can justify actions on the grounds that, though they cause hardships to some, they "send a message" to others. The limits to deterrence theories in the face of desperation (for asylum seekers) or the low likelihood of being caught (for people smugglers) are less widely considered, and it is not clear as yet how that closer understanding could be achieved. The more effective area of study, if one wishes to change policy, seems likely to be the views held by various audiences as to what represents "enough": enough time in detention, enough time in waiting for a decision or an assessment, enough hardship before help is given.

What then needs to be added to or carefully watched when it comes to popular distinctions among people? Critical clearly are any distinctions between "women and children" and "others". What makes the treatment of "women and children" so sensitive – so much a marker for our "compassion and humanity" – is far less

clear. Important to consider also are any distinctions between the "legals" and "the illegals" (or "the criminals"), between those who wait in an orderly fashion and the "queue jumpers" who bounce out of position some patient and orderly person waiting in the queue. Arguments for including those not in the queue then have to be made for "special" or "extra" quotas. Critical also – and pervasive – are distinctions between "us" and "them", between those we know and "strangers".

There has been a great deal written about perceptions of "us" and "them" (Chapter 3). Highlighted as a gap by refugee events, however, are the circumstances under which "we" – usually the possessors of virtue – begin to feel "shame" in relation to the treatment of others. Australians, for example, write "letters to the Editor" in which they say the Government's actions make them ashamed to be Australian. Norwegians ask what has happened to its "core values of compassion and humanity". Governments then need to offer assurance that "there is no need to feel any sense of shame. The country as a whole has a record of respect for law, concern for others, and meeting the "moral requirement to help others". It is our critics who should themselves feel shame, and look to their own reputation. The response is somewhat off-target, deflecting attention from the specific Government actions that are being found "shameful". Highlighted for analysts, however, is the need for closer dissection of what prompts in audiences that particular feeling.

Proposal 4. All Accounts and Interpretations Change over Time

The critical questions then have to do with the forms that change takes, the extent to which change is sustained, and the circumstances that prompt change or help sustain it.

Highlighted in the several chapters have been several forms of change: changes, for example, in the frames that are offered, in the terms used (e.g., the declining frequency of terms such as "asylum" and the rise of terms such as "refugees" and "border protection"), the decision-making power of various figures, the extent to which changes are made for individuals (leaving unaltered the treatment of groups or the policies themselves)

and the extent to which changes are sustained: remaining in place or held to only while there is some heat to the dissent. Noted also have been the ways in which changes are described: as "major shifts" or "flip-flops", for example, or as "sensible advances" given the proven success of one's earlier position.

At this point, I note first the nature of changes in decision making power, and then, less briefly, turn to the circumstances that influence the occurrence and the staying power of changes.

The shape of decision making has clearly emerged as a significant content area for analysis of change. In both countries, one area of tension and change had to do with who should make what decisions: a country or an international agency or, within a country, a central Ministry or a local group. In both countries also, there were ambiguities with regard to how far international agreements were binding or left a great deal open to discretion. Who is seen as having the right to decide? What leads agreements to be made and to be seen as needing to be observed? When do terms such as "sovereign rights" or "international agreements" come to be raised? These now emerge as questions whose pursuit would deepen our understanding of refugee-related accounts and interpretations.

Circumstances Influencing Change

Among the circumstances indicated so far as worth closer analysis and monitoring over time are certainly the visibility of particular events or people, the power of particular political voices, changes in the ebb and flow of people across borders, and the occurrence of incidents that provoke fear, panic, or the sense of a necessity of change.

The visibility of particular events or people. People who are "out of sight" are also often "out of mind". People "starving in the streets of our cities", especially at Christmas time, for example, are highly visible, calling not only for their removal but also for their being housed and fed. Striking also are variations in visibility related to attention in the media. At one point, for example, a Norwegian newspaper runs a series of stories illustrating the "problems" and the "awful behaviours" of immigrants. At another point, the paper runs a series of stories documenting and personalising their

hardships. In Australia, a paper runs a series of stories that document day after day the personalised stories of people – children especially – in detention centres. There is clearly no need to document further the power of personalised narratives: narratives that present the human face of issues. What we now need to know more about is how particular narratives come to arise when they do and how people – politicians or activists of various kinds – come to capitalise on them, yield to them, discount them, or wait until the news "moves on".

Changes in the relative power of political voices. Expressions of dissent and approval can come from a variety of sources. Changes in any of these – in the credibility and appeal of religious groups or of interviewers on talkback radio – are worth noting as events unfold.

Some of those changes in potential voices, however, make little or no difference to accounts or actions involving refugee-related events, or may alter only some aspects of them. It is tempting, for example, to expect that within Australia a shift in power from one to the other of the two major parties (the Liberal to the Labor party) would make a major difference to all aspects. Both parties, however, have shown the same tendency as that noted in Norway at a time close to elections: competing for an image as "tough, firm, and resolute".

A subtler aspect of power shifts has to do with responses to dissenting voices within ones own group or one's own political party. These voices are less easy to discredit. They need then to be somehow claimed as a positive, perhaps a sign of "healthy debate" even within a party that values "discipline". An example comes from one response to Howard's "rebels". Their actions prompted a columnist's approval of the fact that "the push for change has come from the conservatives" and that the "debate" had not been "distorted by … opportunists, such as socialists, atheists and given groups, who seized on a new way of whipping up hatred for Howard" – or by "the splenetic vendettas of John Valder and the New Matilda crowd whose hyperbole about concentration camps put most of the Government and its citizens on the defensive".[46] This columnist, as one might infer, is a strong supporter of Howard's Government.

One last question about dissenting voices has to do with the occurrence of orchestration, especially over time. Analyses of dissent have long noted the tendency of dissenting voices to be "fragmented", easily picked off by changes in line with their special interests. All the more reason then to give particular attention to occasions and to issues where voices are orchestrated and where some degree of coordination is sustained. "The fate of children", for example, has emerged as an issue that can have co-ordinating power. Pointed to also is the existing presence of organizations with some independent bases of continuity. Law societies provide one example. International organizations such as UNHCR provide another, with their relevance and contributions to keeping issues alive warranting particular attention.

The ebb and flow of people across borders. Governments are happy to regard changes in the number of people seeking entry into their country as matters that reflect only their policies. "The boats have stopped coming, the number of asylum seekers has dropped. Our policies have clearly worked." Analyses of migration movements are more likely to attribute particular drops to worldwide shifts in population movements or to the pressures that drove people to seek to move in the first place. It is not only within Australia, for example, that "the boats have stopped coming". That drop is, in fact, occurring across the world. Worth watching now, however, are occasions that may prompt a return of the fears evoked at earlier times.

The occurrence of fear-provoking incidents. The variety of incidents that could revive a sense of threat is potentially large. We need to ask: What incidents have this effect? What are the ready-made fears, traditions, or assumptions that may be easily tapped into? What forms does dissent take when moves are made to make these incidents the basis for action? An example is provided by the bombing in 2005 of parts of the London railways and bus system. Within England, that incident revived interest in national identity cards. It also led to the forced deportation of people expressing "anti-British" rhetoric. Within Australia, it was the basis cited for Howard's putting forward, in September 2005, a new set of "anti-terrorist" plans. In the process of being drafted, he announced, were laws that would allow federal police to detain people under suspicion for 48 hours without charge. State governments would be asked to detain suspects for up to 14 days. Added to

these proposals for "preventive detention" were plans for easier "search provisions", the wider use of electronic tracking devices, and more severe penalties for leaving luggage unattended in airports or "inciting violence".

Included also were several changes "under consideration" that were less readily related to terrorism. The waiting time for citizenship would be extended from 2 to 3 years, and citizenship applications would be security checked. Police powers would also be extended to require journalists to hand over notes and recordings, even if these were of interviews with confidential sources.[47]

The response to the drafted changes, however, also showed that dissent could still be active and widespread. Some of the questions and criticisms had to do with the limited consultation with other members of Parliament. Some had to do with the restrictions placed on the opportunities for the press, the public, or the courts to examine actions classed so readily as "security" matters. Some had to do with why the plans had no "sunset clause": no provision for review after a set period. Without this clause, new regulations can sit on the books indefinitely. Many of the concerns also had to do with the weakening of civil rights and of the power of the law, and with the extent to which the extent to which the new measures were in proportion to the likelihood of terrorist attack within Australia. In short, expressions of concern came from many quarters, with the new proposals then remaining as "drafts", as "under construction".

A Final Comment: Why Representations Matter

Does it matter if the representations of events take one form or another? The analysis of representations can become relatively academic if they do not matter.

Gramsci offers one answer. Representations matter, he argued, because they are part of "lived practice". They are part of what we routinely do or avoid, what we feel we should do or what we think of as taboo or best avoided.[48]

Representations that involve issues of "us" and "them" have a further significance. They justify acts of exclusion and inclusion, both when it comes to moves from one country to another or, within a country, to movement from being on the margins to being more of a full participant in a country. The views that are held out to us as reasonable ways of looking at the world – at ourselves and others – influence, in every content area, what we see as possible, tolerable, ideal or out of the question. A view of diversity as possible or positive – a view of diversity that does not automatically convert into problems – opens the way for tolerance. Whenever the necessity for exclusions and limits – internal or external – meets official approval or is successfully sold to the public, we weaken the perception of diversity as possible and strengthen the likelihood of people turning to a narrow "social cohesion" frame. In that frame, only being surrounded by people like ourselves can make a good life feasible. Tolerance is likely to become an early casualty when views of that kind are promoted and not challenged. Exploring the nature of continuity and dissent, noting the moves and countermoves that can occur or are likely to occur, coming to understand the circumstances that can maintain a particular view of the world or make dissent effective. These steps forward help make possible a world in which both a cohesive civil society and a tolerance for diversity are both possible.

44 Bondevik cited by Raanes in *Dagbladet*, 11/09/04
45 Marr D. and Wilkinson, M. (2004) *Dark Victory*. Sydney: Allen & Unwin
46 Miranda Devine, *Sydney Morning Herald*, 24/3/05
47 All references to these plans are from articles in the *Sydney Morning Herald*, 6/9/05. Articles by Tom Allard; Marian Wilkinson; Cynthia Benham and Marion Wilkinson; Mark Metherell, Marian Wilkinson, Andrew Clenell, and Tom Allard.
48 Gramsci, A. (1971) *Selections from the Prison Notebooks*. New York: International

Bibliography

PHILIP MARFLEET

Butalia, U. (1998) *The Other Side of Silence: Voices from the Partition of India*. New Delhi: Penguin

Cahalan, P. (1982) *Belgian Refugee Relief in England During the Great War*. New York: Garland

Cohen, R. (1994) *Frontiers of Identity: The British and Others*. London: Longman

Colley, L. (1992) *Britons: Forging the Nation 1707-1837*. New Haven: Yale University Press

Cottret, B. (1991) *The Huguenots in England*. Cambridge: Cambridge University Press

Gwynn, R.D. (1985) *Huguenot Heritage: The History and Contribution of the Huguenots in Britain*. London: Routledge and Kegan Paul

Hartop, C. (1998) "Art and Industry in 18th Century London", *Proceedings of the Huguenot Society of Great Britain and Ireland*, Vol. 27, No. 1

Kay, D. and Miles, R. (1992) *Refugees or Migrant Workers? European Voluntary Workers in Britain 1946-1951*. London: Routledge

Kay, D. and Miles, R. (1988) "Refugees or Migrant Workers? The Case of the European Volunteer Workers in Britain", *Journal of Refugee Studies* 1988, Vol. 1, Nos. 3-4

Kershen, A.K. (1997) "Huguenots, Jews and Bangladeshis in Spitalfields and the Spirit of Capitalism". In A.K. Kershen (Ed.) *London: the promised land? The Migrant Experience in a Capital City*. Aldershot: Avebury

Kushner, T. and Knox, K. (1999) *Refugees in an Age of Genocide*. London: Frank Cass

Lee, G.L. (1936) *The Huguenot Settlements in Ireland*. London: Longmans Green

Loescher, G., and Scanlan, J. (1986) *Calculated Kindness: Refugees and America's Half-Open Door, 1945 to the Present*. New York: Free Press

Marfleet, P., G. Dona, A. Fabos., M. Korac, and S.M. Sait (forthcoming 2008) *Encountering Refugees*. Cambridge: Policy

Merriman, N. (Ed.) *The Peopling of London*. London: Museum of London

Murdoch, T.V. (1985) *The Quiet Conquest, the Huguenots 1685-1985*. London: Museum of London

Museum of London (1996) *The Peopling of London: An Evaluation of the Exhibition*. London: Museum of London/University of East London

Porter, B. (1979) *The Refugee Question in mid-Victorian Politics*. Cambridge: Cambridge University Press

Porter, B (1984) "The British Government and Political Refugees, 1880-1914". In J. Slatter (Ed.) *From the Other Shore*. London: Frank Cass

Radstone, S. (2000) *Memory and Methodology*. Oxford: Berg

Smiles, S. (2002) [reprint of 1874 edition] *The Huguenots: Their Settlements, Churches and Industries in England and Ireland*. Honolulu, Hawaii: University Press of the Pacific

Smith, L. (2005) *Forgotten Voices of the Holocaust*. London: Ebury Press

Soguk, N. (1999) *States and Strangers: Refugees and Displacements of Statecraft*. Minneapolis: University of Minnesota Press

Trouillot, M-R. (1995) *Silencing the Past: Power and the Production of History*. Boston: Beacon Press

Webster, W. (2000) "Defining Boundaries: European Volunteer Worker Women in Britain and Narratives of Community", *Women's History Review* Vol 9. No. 2

Young, J.E. (1990) *Writing and Rewriting the Holocaust: Narrative and the Consequences of Interpretation*. Bloomington: Indiana University Press

KATHERINE GOODNOW

Allan, S. (1999) *News Culture*. Birmingham: Open University Press

Atkins, D. (2002) In D. Soloman (Ed.) *Howard's Race: Winning the Unwinnable Election*. Sydney: Harper Collins

Allotey, P. and Reidpath, D. (2003) "Refugee Intake: Reflections on Inequality" Australian and New Zealand Journal of Public Health, Vol. 27, No. 1, February 2003: 12-16

The Auditor-General (2005) *Management of the Detention Centre Contracts - Part B*. Audit Report No. 1 2005–06 Canberra: Australian National Audit Office

Australian Press Council (2002) *2001-2002 Report on Free Speech Issues* at: http://www.presscouncil.org.au/pcsite/fop/fop_ar/ar02.html

Australian Press Council (2004) *2003-2004 Report on Free Speech Issues* at:

http://www.presscouncil.org.au/pcsite/fop/fop_ar/ar04.html

Australian Senate, Legal and Constitutional Committee (2001) *Hansard*, February 10, 2001. Available at: www.aph.gov.au/hansard/senate/committee/s726.pdf

Bashford, A. and Strange, C. (2002) "Asylum-Seekers and National Histories of Detention". In C. Mason (Ed.) *Australian Journal of Politics & History*, Vol. 48, No. 4, December 2002, 509-527

Bateson, G (1995) "A Theory of Play and Fantasy". In *Psychiatric Research Reports*, 2, 39-51

Becker, K. (1967) "Whose Side Are We On?" In *Social Problems*, 14 (3), 239-247

Charlton, P. (2002) "Tampa: The Triumph of Politics". In D. Solomon (Ed.) *Howard's Race: Winning the Unwinnable Election.* Sydney: Harper Collins

Corbett, D. (2002) "Asylum Seekers and the New Racism". In *Dissent*, No.8, 46-47 and 59

Deacon, D. and Golding, P. (1994) *Taxation and Representation: The Media, Political Communication and the Poll Tax.* London: John Libbey

Fishman, M. (1980) *Manufacturing the News.* Austin: University of Texas Press

Fonteyne, J.P. (2002) "Illegal Refugees or Illegal Policy?" In C. Reus-Smith (Ed.) *Refugees and the Myth of the Borderless World 16.* Canberra: National Library of Australia

Galtung, J. and Ruge, M. (1981) "Structuring and Selecting News". In S. Cohen and J. Young (Eds.) *The Manufacture of News*, Revised Edition. London: Constable

Geertz, C. (1973) *The Interpretation of Culture*, NY: Basic Books

Gillian, F.D. Jr. and Bales, S.N. (2001) "Strategic Frame Analysis: Reframing America's Youth". In *Social Policy Report*, 15, 3-14

Gissler, S. (1997) "Newspapers' Quest For Racial Candor". In E.E. Dennis and E.C. Pease (Eds.) *The Media in Black and White.* New Brunswick, NJ and London: Transaction

Gitlin, T. (1980) *The Whole World is Watching: Mass Media in the Making and Unmaking of the New Left.* Berkeley: University of California Press

Goffman, E. (1974) *Frame Analysis.* New York: Harper and Row

Goodnow, K. (1994) *Kristeva in Focus: From Theory to Film Analysis.* Bergen: Department of Media Studies

Goodnow, K. (1998) *Refugee Policies, Media Representations.* Bergen: Department of Media Studies

Goodnow, K. (1999) "Norway: Refugee Policies, Media Representations". In O. Tveiten (Ed.) *Bosniske Krigsflyktninger i Mediebildet –Nordiske Perspektiver.* Copenhagen: Nordisk Ministerråd

Gramsci, A. (1971) *Selections from the Prison Notebooks.* New York: International

Habermas, J. (1992) "Further Reflections on the Public Sphere". In C. Calhoun (Ed.) *Habermas and the Public Sphere.* Cambridge, Mass: MIT Press

Hall, S. (1981) "The Determinations of News Photographs". In S. Cohen and J. Young (Eds.) *The Manufacture of News.* Revised Edition, London: Constable

Hall, S. (1982) "The Rediscovery of Ideology: The Return of the Repressed in Media Studies". In M. Gurevitch, T. Bennett, J. Curran and J. Woollacott (Eds.) *Culture, Society, and the Media.* London: Methuen 56-90

Hall, S. (1990) "The Whites of Their Eyes: Racist Ideologies and the Media". In M. Alvarado and J.O. Thompson (Eds.) *The Media Reader.* London: British Film Institute

Hall, S., Critcher, C., Jefferson, T., Clarke, J. and Roberts, B. (1978) *Policing the Crisis: Mugging, the State, and Law and Order.* London: Macmillan

Hallin, D.C. (1986) *The 'Uncensored War': The Media and Vietnam.* New York: Oxford University Press

Hallin, D. (1987) "Hegemony: The American News Media from Vietnam to El Salvador - A Study of Ideological Change and its Limits". In D. Paletz (Ed.) *Political Communication Research.* Norwood, NJ: Ablex

Hermann, E.S. and Chomsky, N. (1988) *Manufacturing Consent: The Political Economy of the Mass Media.* New York: Pantheon

Human Rights and Equal Opportunity Commission (HREOC) (2004) *A Last Resort: The Report of a National Inquiry into Children in Immigration Detention.* Available at: www.humanrights.gov.au/human_rights/children_detention_report

Human Rights and Equal Opportunity Commission (HREOC) (2007) *Summary of Observations Following the Inspection of Mainland Immigration Detention Facilities.* Available at: www.humanrights.gov.au/human_rights

Human Rights Watch (2002a) *"Not For Export": Why the International Community Should Reject Australia's Refugee Policies.* A Human Rights Watch Briefing Paper, September 2002

Human Rights Watch (2002b) *"By Invitation Only": Australian Asylum Policy.* Vol.14, No.10 (C) – December 2002

Human Rights Watch (2002c) *World Report 2002: Refugees, Asylum Seekers, Migrants, and Internally Displaced Persons* at: www.hrw.org/wi2k2/refugees.html

Iyengar, S. (1991) *Is Anyone Responsible? How Television Frames Political Issues.* Chicago: University of Chicago Press

Kevin, T. (2004) *A Certain Maritime Incident: The Sinking of SIEV X.* Melbourne: Scribe

Kirk, L. (2002) *First Speech to Senate.* Available at: http://www.senatorlindakirk.net/index.php?page=speeches&year=2002

Kristeva, J. (1982) *Powers of Horror: An Essay on Abjection.* New York: Columbia University Press

Kristeva, J. (1991) *Strangers To Ourselves.* New York: Columbia University Press

Kristeva, J. (1993) *Nations Without Nationalism.* New York: Columbia University Press

Laclau, E. (1990) *New Reflections on the Revolution of Our Time.* London: Verso

Laclau, E. and Mouffe, C. (1985) *Hegemony and Socialist Strategy.* London: Verso

Marr, D. and Wilkinson, M. (2004) *Dark Victory.* Sydney: Allen & Unwin

Master, C. (2003) "The Death of Investigative Journalism". Available at: http://evatt.labor.net/news/186.html

Mathew, P. (2003) "Legal issues Concerning Interception". In the *Georgetown Immigration Law Journal*, 17 Geo Immigr L J: 221 – 249

Miller, D. (1994) *Don't Mention the War: Northern Ireland, Propaganda and the Media.* London: Pluto

Mouffe, C. (2000) *The Democratic Paradox.* London: Verso

Myers, F. (1986) *Pintupi Country, Pintupi Self: Sentiment, Place and Politics*

among Western Desert Aborigines. Washington D.C.: Smithsonian
Institute Press and Canberra: AIAS

Nichols, G. (2005) "Deportation: How Australia Reversed the Burden
of Proof". In *Australia Policy Online,* Melbourne: Institute for Social
Research, Swinburne University of Technology. At: www.apo.org.au/
webboard/results.chtml?filename_num=12135

Palmer, M.J. (2005) *Inquiry into the Circumstances of the Immigration
Detention of Cornelia Rau.* Canberra: Commonwealth of Australia

Rose, N. (1999) *Powers of Freedom: Reframing Political Thought.* Cambridge:
Cambridge University Press

Rothwell, D. (2002) "The Law of the Sea and the MV Tampa Incident:
Reconciling Maritime Principles with Coastal Sovereignty". In 13 Pub L
Review 118

Rushdie, S. (2005) "The First Casualty". In *The Guardian Review,* June 25,
2005

Scheel, T. (2003) "Internasjonalt Etterspill etter '*Tampa*-saken': Hvem
har Ansvar for de Skipsbrudne?" In *Navigare,* 2-200310. Oslo: The
Norwegian Maritime Directorate

Schlesinger, P. and Tumber, H. (1994) *Reporting Crime: The Media Politics
of Criminal Justice.* Oxford: Clarendon

Soloman, D. (2002) *Howard's Race: Winning the Unwinnable Election.*
Sydney: Harper Collins

Svabø, T. (2002) *Tampa.* Lysaker: Dinamo Forlag

Tajfel, H. (1981) *Human Groups and Social Categories: Studies in Social
Psychology.* Cambridge: Cambridge University Press

Tajfel, H. and Turner, J.C. (1986) The Social Identity Theory of Intergroup
Behaviour. In S.G. Worchel and W. Austin (Eds.), *Psychology of
Intergroup Relations* (2nd edition: 7-24). Chicago: Nelson-Hall

Tuchman, G. (1978) *Making News: A Study in the Construction of Reality.*
New York: The Free Press

UNCHR (2000) *Interception of Asylum-Seekers and Refugees: The
International Framework and Recommendations for a Comprehensive
Approach.* Executive Committee of the High Commissioner's Programme,
Standing Committee, 18th Meeting EC/SO/SC/CRP.17

Williams, R. (1989) "Hegemony and the Selective Tradition". In S. de Castell,
A. Luke and C. Luke (Eds.) *Language, Authority and Criticism.* London:
Falmer

Wilson, C.C. and Gutiérrez, F. (1995) *Race, Multiculturalism, and the Media.*
(2nd edition) Thousand Oaks CA: Sage

Young, I.M. (2000) *Inclusion and Democracy.* Oxford: Oxford University
Press